W9-CFB-867

Città di Lugano

Edited
by
Rudy Chiappini

Christo and Jeanne-Claude

Museo d'Arte Moderna
Città di Lugano Skira

Christo and Jeanne-Claude

Museo d'Arte Moderna
della Città di Lugano
Villa Malpensata
12 March
18 June 2006

Front cover
Christo e Jeanne-Claude
Valley Curtain, Grand Hogback, Rifle, Colorado, 1970–72
Photo Harry Shunk
© Christo 1962

Back cover
Christo and Jeanne-Claude
The Gates, Central Park, New York City, 1979–2005
February 2005
Photo Wolfgang Volz
© Christo 2005

© 2006 by Museo d'Arte Moderna della Città di Lugano
© 2006 by Skira editore, Milan

Texts: © 2006 Authors
Works: © Christo
Work no. 82: © Museum Boijmans Van Beuningen, Rotterdam
© Jasper Johns, Robert Mangold by SIAE 2006

Printed in Italy
in February 2006
by Skira, Geneva-Milan

ISBN-13: 978-88-7624-625-8
ISBN-10: 88-7624-625-8

Distributed in North America by Rizzoli International Publications, Inc.,
300 Park Avenue South, New York, NY 10010.
Distributed elsewhere in the world by Thames and Hudson Ltd.,
181a High Holborn, London WC1V 7QX, United Kingdom

Exhibition project and organization
Rudy Chiappini
Director of the Museums of the City of Lugano

Scientific coordination
Nicla Borioli
Gaia Regazzoni

Counselling
Josy Kraft

Realization
Fondazione Lugano Arte

Secretariat
Sabina Bardelle
Marie Kraitr

Administration
Mauro Bonardi

Installation
Dicastero Attività Culturali

Luca Bottinelli
Riccardo Darni
Adriano Frapolli
Marco Jelmini
Alessandro Lucchini
Fabrizio Malfanti
Luigi Molteni
Antonio Ponzio
Bruno Tosi

Educational activities and guided tours
Francesca Bernasconi
Debora Caccaviello
Tiziana Lotti
Maria Pasini

Conservation
Mario Graf

Insurance
Lloyd's London

Transportation
Kraft ELS AG, Basel

The exhibition is supported by
Corriere del Ticino

Catalogue edited by
Rudy Chiappini

Editing
Nicla Borioli
Gaia Regazzoni

Graphic design
Marcello Francone, Skira, Milan
Studio Grafico Maurice Hoderas, Lugano

Translations
John William Gabriel, Worpswede
Carol Lee Rathman, Milan

Press office
Sabina Bardelle, Dicastero Attività Culturali,
Città di Lugano
Skira Editore – Mara Vitali Comunicazioni,
Milan

Internet
www.mdam.ch

The exhibition has been organized with the support of the Canton Ticino authority and the contribution of Credit Suisse.

The Direction of the Museo d'Arte Moderna di Lugano would like to thank the following museums, institutions, private collectors and all those who wished to remain anonymous, for kindly agreeing to lend the works of art:

Bank Leu, Zurich
Finter Bank, Zurich
Fondation Beyeler, Riehen/Basel
Fondazione Marconi Arte Moderna e Contemporanea, Milan
George Weston Limited, Toronto
Kröller-Müller Museum, Otterlo
Kunsthaus Zürich, Grafische Sammlung, Zurich
Lilja Art Fund Foundation
MCM Group Art Collection, Lyss
Musées d'Art et d'Histoire de la Ville de Genève, Geneva
Musée National d'Art Moderne, Centre Pompidou, Paris
Museum Boijmans Van Beuningen, Rotterdam
National Gallery of Art, Washington
Sonnabend Gallery, New York
Staatliche Museen zu Berlin, Nationalgalerie, Berlin
Stedelijk Museum voor Actuele Kunst, Ghent
Verlagsgruppe Passau, Passau
Whitney Museum of American Art, New York

Ettore Camuffo, Venice
Cyril Christo, New York
Stefano Contini, Venice
Anita Grossman, New York
Hamacher Family
John Kaldor, Sydney

We are deeply grateful to the many people who have offered help, information and advice to ensure the success of the exhibition. In particular we would like to thank:

Thomas Ackermann, Zurich
Christoph Becker, Director, Kunsthaus Zürich, Zurich
Harry Bellet, Paris
Renato Belotti, Lugano
Gerda Berger, Staatliche Museen zu Berlin, Nationalgalerie, Berlin
Ernst Beyeler, Director, Fondation Beyeler, Riehen/Basel
Rom Bohez, Stedelijk Museum voor Actuele Kunst, Ghent
Hasso Böhme, Zurich
Joanne Brown, Toronto
Cécile Brunner, Kunsthaus Zürich, Zurich
Julie Chill, Whitney Museum of American Art, New York
Vincenzo Di Pierri, Zurich
Angelika Diekmann, Passau
Alma Egger, New York
Sjarel Ex, Director, Museum Boijmans Van Beuningen, Rotterdam
Nadia Forloni, Fondazione Marconi Arte Moderna e Contemporanea, Milan
Carter Forster, Whitney Museum of American Art, New York
Claire Fortune, New York
Franco Greco, Lugano
Chantal and Urs Greuter, Zollikon
Anthony Haden-Guest, New York
Peter and Else Hamacher, Meerbusch
Albert Hazan, Geneva
Monika Heldstab, Zurich
Jonathan Henery, New York
Astrid Holmgren, Staatliche Museen zu Berlin, Nationalgalerie, Berlin
Thomas and Ingrid Jochheim, Recklinghausen
Viviana Kasam, Milan
Josy Kraft, Basel
Elisabeth and Patrice de Laage, Paris
Toni Liquori, Montclair
Olga Makhroff, Musée National d'Art Moderne, Centre Pompidou, Paris
Giorgio Marconi, Fondazione Marconi Arte Moderna e Contemporanea, Milan
Albert Maysles, New York
Tanja Meding, New York
Cäsar Menz, Director, Musées d'Art et d'Histoire de la Ville de Genève, Geneva
Erwin and Ruth Morscher-Stöcklin, Basel
Margaret Nab, Kröller-Müller Museum, Otterlo
Tanja Narr, Fondation Beyeler, Riehen/Basel
Adrian V. Nösberger, Zurich
Alfred Pacquement, Director, Musée National d'Art Moderne, Centre Pompidou, Paris
Roberto Papis, Musées d'Art et d'Histoire de la Ville de Genève, Geneva
Enzo Pelli, Lugano
Ferruccio Piffaretti, Lugano

Earl A. Powell III, Director, National Gallery of Art, Washington
Alison Quirke, Botany
Urs. M. Rickenbacher, Lyss
Claude Ritschard, Musées d'art et d'histoire de la Ville de Genève, Geneva
Ettore Robbiani, Zürich
Enzo Rossi, Galleria d'Arte Contini, Venice
Peter-Klaus Schuster, General Director, Staatliche Museen zu Berlin, Nationalgalerie, Berlin
Alan Shestack, Deputy Director and Chief Curator, National Gallery of Art, Washington
SGA Affichage, Lugano
Horace Solomon, New York
Ileana Sonnabend, New York
Barbi Spieler, Whitney Museum of American Art, New York
Evert J. van Straaten, Director, Kröller-Müller Museum, Otterlo
Sarah Taggart, Sharon
Giulio Tega, Milan
Alicia B. Thomas, National Gallery of Art, Washington
Trasporti Pubblici Luganesi SA (TPL), Lugano-Pregassona
Marco Tucci, Munich
Massimo Vitta Zelman, President, Skira, Milan
Wolfgang Volz, Düsseldorf
Carole Lee Wovell, Denver
W. Galen Weston, Toronto
Margreet Wafelbakkek, Museum Boijmans Van Beuningen, Rotterdam
Derrick Widmer, Aarau
Queenie Wong, New York
Vladimir Yavachev, New York

It is with particular satisfaction that the City of Lugano hosts this important retrospective organized by the Museo d'Arte Moderna, dedicated to the famous artistic couple, Christo and Jeanne-Claude. The event crowns a series of exhibitions of international prominence that have projected our city onto the leading museum circuit in Europe, attracting the attention of critics and of the public, fostering acquaintance with inestimable works.

The show – which became a reality thanks to a lively and constructive alliance with the artists, and benefited from their enthusiastic and conscientious participation in the project, supporting it in all of its phases of realization – celebrates an original and fertile creative partnership. This alliance has had the merit of stretching the existing limits, of forging a new and broader concept of art as an interdisciplinary activity bridging the different spheres of knowledge, connecting the opposite sides of human nature: intuition and intellect, creative instinct and planning logic. Each proposal presented has its own, unmistakeable tone, which invites a reconsideration of the habitual and conceals a complex planning process behind it, always intent on translating the idea and the artistic inspiration into a feasible and irrefutable reality, as Werner Spies perceptively highlights in his essay in the catalogue.

It is a privileged and unique opportunity for becoming thoroughly acquainted with the artistic output of two icons of the contemporary panorama, and for experiencing an ephemeral art, usually intended for sites that lie outside the spaces traditionally reserved for artistic production. Through preparatory sketches, studies, collages, and scale models – which in themselves are true works of art – the exhibition offers the opportunity to learn about the complexity of the design processes undertaken by the artists, and unveils the reality of creations of a transitory nature, of which nothing will remain but the memory.

The City Authority thanks Credit Suisse for having assured once again its decisive backing, following what is by now a decade-long, proven collaboration, which works to promote the spread of art in the territory.

Aware of the difficulties inherent to the organization of exhibitions of this magnitude and complexity, the Municipality wishes to express their gratitude to all those who have supported the initiative and contributed to the effort, once again making it possible for the City of Lugano to step out into the international art scene, with a thought-provoking show, one that offers the public a multifaceted panorama of great cultural and interdisciplinary worth.

The Municipality

Many of the shows that the Lugano Museo d'Arte Moderna has organized in recent years have become cultural events of international stature, well received by the critics and rewarded by the public's interest. This is the case with the important retrospectives of Francis Bacon, the first show of his to open following his death, Emil Nolde, never until then the subject of an anthological show in the Italian cultural milieu, Chaïm Soutine, Edvard Munch, Amedeo Modigliani, Marc Chagall, and Egon Schiele. In others, light has been shed on the work of painters whose experiments, little known to the broad public, played a fundamental role in the art history of the century of the avant-gardes and of movements: what comes to mind is the "revelation" in Europe of the paintings of Thomas Hart Benton, considered the father of modern American painting, or the prematurely deceased Antonio Saura, the Swiss artist Varlin, Constant Permeke, a seminal master for an entire generation of post-war artists, or the extraordinary expressive language of Jean-Michel Basquiat.

Such events have made Lugano a touchstone for connoisseurs and art lovers worldwide. The show dedicated to Christo and Jeanne-Claude aims to carry on in this direction, once again privileging the quality and authenticity of the creations, and at the same time offering a special opportunity for a first-hand experience of the work of these two leading artists of our times.

From this point of view, the Lugano exhibition can be seen as a unique opportunity, the first in Europe, to examine systematically the key moments in Christo and Jeanne-Claude's career, from the first *Packages* of the late 1950s to the preview presentation of their next large project, *Over the River*, planned for completion in 2009. Forty-five years of activity on the front, lived out as absolute protagonists of post-war art, from the oil barrels to the *Store Fronts*, from the provocative blocking of Rue Visconti in Paris to the first wrapping of a public building (Bern Kunsthalle, in 1968), the monumental projects *Wrapped Coast*, *Valley Curtain*, *Running Fence*, *Surrounded Islands*, the wrapping of the Pont-Neuf in Paris and, unforgettably, of the Reichstag in unified Germany, and, most recently, *The Gates*, which magically transfigured New York's Central Park. Their work has always been ahead of its time, heralding upcoming tendencies, and backed by an extraordinary perseverance and a creative fertility of rare intensity.

Having succeeded in making this in many respects exceptional show a reality is for our museum a cause for great satisfaction, and at the same time, an inspiration.

Thanks are due to all the people who have contributed to the success of this show, first among all, the lenders and the authors of the essays included in the catalogue. My gratitude goes also to Credit Suisse for their continuous and valuable support, to Josy Kraft for his helpful suggestions, and to all my staff for the excellent job they have done.

And, lastly, an immense thank you to Christo and Jeanne-Claude for their steady involvement and cordial and open-handed cooperation, for having believed in this project and helped it to grow to the very last with love and care.

Rudy Chiappini
Director
Museums of the City of Lugano

Contents

Christo and Jeanne-Claude
Rudy Chiappini

The creative moment is in itself a moment of solitude that seems *a priori* to exclude all relationships, and all the more so the relationship *par excellence*, that of the couple.

When two artists enter into a close emotional and romantic rapport, the moment of inspiration must inevitably denote a diminishing of the attention paid to the other.

In the act of bringing a work of art into being, of realizing something new and unique, the presence of the companion, who uses similar means of self-expression, can be highly beneficial in terms of moral and personal support, but can also develop into a condition of rivalry.

Cases showing a clear benefit from this state are rare, however on-the-mark, concentrated in precise moments and confined to given periods; even rarer are the opportunities for mutual enrichment. On this last point, we must in any case make it clear that we do not mean just in the sense of "influence", that is, the inability of one to achieve certain expressive results without the input of the other.

An artist, a creator, does, in fact, need others – not owing to a shortage of ideas or the means for translating them into innovative language, but inasmuch as, in the broader sense, he or she feels a deep-seated and profoundly human need to exchange ideas, to discuss them, to test them as sources of inspiration.

In this respect, Christo and Jeanne-Claude represent the most extraordinary artistic partnership of our time.

Of course, there have been other couples who also marked the twentieth century for their outstanding creativity. Jean Arp and Sophie Täuber carried out their artistic activities in parallel during the period between the two world wars, and after Sophie's untimely death, Jean continued for years to perpetuate this fertile sharing of vision, taking up and reworking his works, recreating in this way a dialogue and an exchange that had been abruptly terminated.

The roles were in some respects reversed in the case of Lee Krasner, whose artistic talent was sacrificed for fifteen years, subordinated in the service of the brilliant, but sick and alienated figure of Jackson Pollock. Only after the death of her companion did her work regain the vigor and intuitive freshness that had for so long lain dormant.

It appears easy, as a consequence, to point out that during the life, or at least during the period of the relationship, the woman's creations are inevitably pushed into the background, perhaps because they are too much in synch, and therefore in competition, with those of the man.

The relationship of competition and rivalry has been absolutely surmounted, indeed is out of the question and non-existent in the case of Christo and Jeanne-Claude, whose artistic partnership is based on solid and deep foundations, on equal dignity, and respect for the individual roles.

The first wrapped objects and the tied packages that Christo did toward the close of the 1950s are incontestably his invention. Their autobiographical content is unequivocal. They reveal, perhaps unconsciously, the repressive atmosphere of his past, the hardships of growing up in Communist Bulgaria. They bear witness to the artist's sense of cultural isolation when he was new to Paris. They are the emblem of an intellectual exile and the determination to lay claim to an expressive freedom overstepping convention, making the commonplace mysterious, and conferring on ordinary objects a new value of an existential import.

Like few other contemporary works of those years – Jean Fautrier's experiments with thick impastos, Antoni Tàpies burnt earth, Yves Klein's irreverent, provocative performances, Joseph Beuys' shamanistic inventions, Lucio Fontana's controlled austerity in his pierced canvases, the new painting of the latest, up-and-coming American generation, Jackson Pollock and Jasper

Johns – "these expressionist packages", as Burt Chernow has pointed out, "with their cloudy pasts, obscure presents, and unknown futures, demonstrated a fresh and compelling vision"[1].

Collage and assemblage techniques using poor materials were adopted by a growing number of artists from the United States and Europe. Christo's use of fabric, cords and everyday objects was in line with this trend, though conceptually his work and experiments were unlike any other's.

But already in the early 1960s – to be precise, starting with *Dockside Packages*, large-scale structures improvised in 1961 at the Cologne harbor for his solo exhibition at Galerie Haro Lauhus, and especially with *Wall of Oil Barrels, The Iron Curtain, Rue Visconti, Paris, 1961–62*, a project that deepens the meditation on the concepts of borders, separation, passage, done in Paris in Rue Visconti, in the heart of the Latin Quarter – Jeanne-Claude actively participated in the realization of their creations on both the organizational and the aesthetic levels.

"My drawings make up the basis of the project. I am the one who puts our ideas down on paper, then we do the rest together", Christo has stated several times since 1994, stressing the importance of Jeanne-Claude's role in the course of the past forty-five years, recognizing the shared paternity of the projects realized, and, consequently, those to come.

In effect, Christo and Jeanne-Claude's new strategy has progressively hinged on the monumental size and spectacular dimension of their projects, and the public's growing involvement in the large environmental projects, from *Wrapped Coast* to *Valley Curtain, Running Fence* to *Surrounded Islands*, the wrapping of the Pont-Neuf in Paris and of the Reichstag in Berlin following the unification of the two Germanies, and from *The Umbrellas* to *Wrapped Trees*, up to *The Gates* recently realized in New York and the upcoming *Over the River* in Colorado.

Many critics, recognizing in this tendency one of the main characteristics of the couple's artistic activity, have erroneously endorsed the idea of Christo as the brilliant creator of the landscape works and Jeanne-Claude as the inspiring muse, skilled at exploiting the full potential of communications media and arousing public acclaim for her husband's projects.

At first, in the 1970s, the artists were satisfied with this division of tasks, even if in fact it detracted from Jeanne-Claude's decisive influence and participation. It was a position adopted and defended by the artists themselves, especially as far as public opinion was concerned, in order to deal with the early problems of launching an artistic approach that was completely new,

and establishing themselves in the United States, where in any case they were seen as foreigners.

In 1994, Jeanne-Claude finally revealed their strategic decision: "In the beginning it was hard enough trying to explain that each project was a work of art. Trying to explain that it was a work of art by two artists would have been out of the question"[2].

And, indeed, with the radical changes in the historical context that in the 1980s had led to the process of collaboration between different artists working on shared creative projects, Christo was the first to give full recognition of Jeanne-Claude's direct role in conceiving the projects and sharing in all the related creative and artistic decisions, from the conception to the realization.

Their partnership, which has continued for over forty-five years, and has taken shape in grandiose and ephemeral works, in temporary monuments that acquire permanence only in the collective imagination, is one of the most extraordinary artistic adventures of the twentieth century. Their experiments are always in the avant-garde, and often foreshadow new trends, such as the Nouveaux Réalists or the American Land Art; in whatever case, they are unconventional, and have always been shot through with an intrinsic, deep-seated creative energy and a constant, unflagging commitment to overcome the ostracism of bureaucracy, the scepticism of the politicians, the incredulity of many.

It is an energy found only by whoever strongly believes in what he or she is doing, as it is primarily a personal challenge, for a personal, private gratification, free from the conditioning of the critics, the museums, collectors and collecting.

And if, on the one hand, their path has taken the tricky conceptual direction that leads from traditional sculpture to the temporary, ephemeral work of art, the cohesive element in their poetic logic can be identified, as one of the most insightful champions of Christo and Jeanne-Claude's work, David Bourdon, wrote, as "revelation through concealment"[3], in masking the normal function or the normal appearance of an object, shifting it to a "different", "other" context and dimension.

This has intensified the feelings of uneasiness and astonishment before their works, able to change the established equilibrium between appearance and reality, asserting the potential of a new visual approach and a new individual awareness in dealing with the ordinary.

It is an uneasiness deeply ingrained in Christo and Jeanne-

Claude, which, like Ariadne's thread, has guided them, permitting them never to fail to live up to their own truth. This is a delicate side of their innermost self, which cannot be overlooked in examining the nature of their artistic experiments. But it is also a difficult trait to understand and to articulate in all of its complexity, the hidden sides pulled from the darkness of the unconscious, touching on their primal feelings, primitive urges, the conflicts of their interior existence that are and remain impenetrable.

Humans with no recall of history and themselves are at the mercy of destiny, are irresponsible wretch who lack the energy to look at the world with eyes that see.

Christo and Jeanne-Claude's projects, instead, have the power to measure up to the landscape, they converse with nature, fuel the awareness of reality not only to reveal its beauty or to reiterate its value, but also to bear witness to its fragility and the ephemeral nature of things and of humans.

[1] Burt Chernow, *XTO + J-C. Christo and Jeanne-Claude: A Biography*, with an epilogue by Wolfgang Volz, New York, 2002, p. 81.
[2] Ibid., p. 198.
[3] David Bourdon, *Christo*, New York, 1970, p. 9.

The Freedom to Be Christo and Jeanne-Claude
Albert Elsen

Christo and Jeanne-Claude's art is the creation of temporary, beautiful objects on a vast scale for specific outdoor sites. It is in the populist nature of their thinking that they believe people should have intense and memorable experiences of art outside museums. Otherwise there is no rational purpose for their projects. They do not satisfy our practical needs. No causes are pleaded. The projects are their own reason for being, but in the late twentieth century they are also tributes to artistic freedom. Christo and Jeanne-Claude confront what does exist with what they alone have determined can exist as a dramatic and beautiful form.

Their art, therefore, is the result of intelligence and aesthetic intuition added to the natural and built environment. We often understand all this only when we have experienced the projects directly and realized that, in a poetic way, our lives have been changed, as has our comprehension of what art can be and do.

The couple's art is a unique mixture of self-assertion and self-effacement. They do not sign their finished projects, but they are unmistakably theirs. Unlike a warrior-ruler such as Napoleon, who is forever associated with sites by force of arms, Christo and Jeanne-Claude's permanent identification with places and historic structures is by the force of art. They borrow land, public structures and spaces; sites used and built by others and already filled with associations that may or may not have anything to do with art. They momentarily intervene, creating, as they put it, "gentle disturbances" between earth and sky in order to refocus our impressions of an old historic structure or of the earth itself. Christo and Jeanne-Claude believe the temporary nature of their projects gives them more energy and intensifies our response. But once they have wrapped a structure or intervened in a place, they are forever associated with that site.

No artists in history have spent as much time introducing themselves and their art to people around the world as Christo

and Jeanne-Claude. The success of their projects with the public in Switzerland, Germany, Australia, Italy, France, Japan, the United States and elsewhere is due, in no small part, to their accessibility and natural gifts as teachers. They were the first artists to voluntarily conduct human as well as environmental impact reports for their projects. Most artists feel that having to educate the public directly takes too much time away from their own work. For Christo and Jeanne-Claude, verbal interaction with the public is a genuine part of their creativity.

Actually, they have several motives for this extraordinary expenditure of time away from the studio as they are artists who waste nothing. On a practical level, by informing all those who will be involved with their projects, they make their realization possible. On a personal level, they genuinely care about people and their responses to their art. Their projects are not completely thought out and settled beforehand, but evolve slowly over the years. Thus, on a professional level, each meeting and every conversation encourages the artists to think freshly about unforeseen implications, to make new associations and adjustments. Talking about their art is like the making of Christo's drawings and collage studies; it allows their subconscious to intervene and their critical minds to assess what they have done.

Christo and Jeanne-Claude's early background only partially explains the couple and their art. His birth in Bulgaria and classical education at art academies in Sophia and Vienna, and her traditional upbringing, did not anticipate the emergence of their unconventional art or its method of financing. Nevertheless, the fact that he came from a socialist country may explain why the realizing of their art requires hundreds, if not thousands of people, and also that it is free to the public. [...]

As artists, Christo and Jeanne-Claude are as unclassifiable as their art. They are at once painters and sculptors, and yet neither, just Christo and Jeanne-Claude. We can see for ourselves

how their original vision is seconded by Christo's solid draughtsmanship and numerous preliminary studies for a project, both of which are legacies of his early academic education, certifying his credentials as an artist in the traditional sense. His use of Cubist-derived collage to unite drawings, fabrics, maps and photographs is the mark of a modern artist. Beginning with his training as a painter working on stretched canvases, fabric has always been essential to Christo's art. The fabric itself supplies their color: the off-white of *Wrapped Coast*, the orange of *Valley Curtain*, the white of *Running Fence*, the rich champagne-gold of *The Pont Neuf Wrapped*, the flamingo pink of the Miami *Surrounded Islands*, the planned golden-saffron *Gates* for Central Park in New York City, the blue and yellow of *The Umbrellas* project. As modern artists they are sensitive to the beauty and expressive character of the continuously sustained linearity of a project such as *Running Fence*, or the complex spatial relationships with their octagonal umbrellas on different elevations in Japan and California. Their use of volumes and voids for *The Pont Neuf Wrapped* was like creating a draped reclining figure sculpture. The effect of changing light and shadows on their colored fabrics and sensitivity to the inherent beauty of engineered structures, such as those for *The Umbrellas*, mark Christo and Jeanne-Claude as artists at home with the tradition of not just modern but Western art.

Christo's escape from Bulgaria and subsequent arrival in Paris in 1958 opened his thought to Western modern art and gave him a lifelong appreciation of artistic freedom. His marriage with Jeanne-Claude – who would make a better chief executive officer than most who run our big corporations – was in a sense a wedding of socialism and capitalism. She has been crucial to conceiving and carrying out, together with Christo, their unprecedented method of personally financing their projects, thereby taking full advantage of the capitalist system. Together, Christo and Jeanne-Claude work at overseeing all operational details of these daunting projects and at planning their realization.

In the words of Jeanne-Claude, each one of their works is a "scream of freedom". It is as if they were saying with each project: we could not do this or be ourselves under a totalitarian regime. A few works have direct political reference. One of their early projects in Paris was to erect a temporary street barrier of oil barrels as a reference to the Berlin Wall built in 1961.

All of Christo and Jeanne-Claude's art, however, is about what free artists can do. Exercising their liberty, these artists, who are American by choice, remind us that unfettered artists' "vision" means to see what we can not see and to think not the unthinkable, but rather the unimaginable. They are visionaries of the visible, artists who are at once abstract in their thought about forms, but who tend to visualize them when inspired by certain specific sites where they feel comfortable with their knowledge of the culture. The strongest motivation for actually realizing the final project, rather than stopping with the studies, is that to do so satisfies their curiosity about what they could and could not imagine really look like on the site.

The Umbrellas project is a dramatic answer to the question: how shall we live and make responsible use of our freedom? The couple's personal moral and artistic imperative seems to be to *only connect*: connect people with people such as those on the Pacific rim; connect the elements of art and nature such as light, space and color; connect art and engineering to show that they are not enemy faculties; connect people with beautiful materials and structures; connect people with their past and present.

Contrary to traditional sculpture and painting, Christo and Jeanne-Claude's work is only finished when it has gone. How ironic then that their ephemeral projects recall that art's purpose includes protecting us – in the words of a poet – against our vanishing. The documentation and studies for their projects are permanent and they will remind future generations that in this century our civilization produced, supported and benefited from artists who gave new meaning to the word "civilized". By wrapping the oldest and most handsome bridge in Paris that had, through centuries of familiarity and neglect, become invisible, or "vanished", they restored its visibility, drew attention to the simple elegance of its form, and reminded Parisians that the Pont-Neuf was crucial to the history and beauty of that city.

No past or present artist known to this writer has done more to honor work and workers by their art than Christo and Jeanne-Claude. This is because they have effectively redefined the meaning of the "work of art". Rather than a noun referring to a finished object, for Christo and Jeanne-Claude "work" is a verb. It comprises the processes of design and fabrication, public education and the efforts to overcome those legal and bureaucratic restrictions and delays that irritate, frustrate and discourage other artists who make outdoor art. The pair not only relied on a cadre of engineers and professional construction supervisors, but, as in the Miami project, they have provided work for hundreds of people unemployed for lack of skills.

To weave and sew the twenty-four-and-a-half miles of fab-

ric for *Running Fence* they put a small town back to work for a year as its parachute factory was closing at the end of the Vietnam War. By permanently recording the physical and intellectual efforts that go into the construction of their projects, these artists pay tribute to workers of all types. Both Christo and Jeanne-Claude think of themselves as workers. They do not accept voluntary labor, not just for insurance purposes, but because they believe honest labor should be paid for. Christo and Jeanne-Claude are paid a modest salary from the corporation set up for each project and they live in a spartanly furnished lower Manhattan loft that is mostly workspace.

Over the last forty years, no other artists have been more indefatigable, difficult or impossible to discourage, more resourceful and ingenious in problem solving. What other artists know the sheer ambition of Christo and Jeanne-Claude's projects and pay for them entirely by the sale of Christo's studies and not sponsors, gifts or grants?

Many things that are wrong with art in public are the result of not having learned from these humane artists. Such art should not be arrogant, intimidating or confrontational, but joyful and uplifting; the beautiful is always welcome; the public should not be damned but informed, and permanence is not an imperative. When talking in 1976 with California Bay Area artists about *Running Fence*, I was interested to find a consensus of opinion about Christo and Jeanne-Claude's influence. All agreed: Christo and Jeanne-Claude gave us new incentives to be daring.

Excerpts from *Christo*, exhibition catalogue, The Art Gallery of New South Wales, Sydney, 1990. Edited and revised by Susan Astwood in 2001.

Works 1958–1968

Wrapping Things Up: Finality in the Early Works of Christo and Jeanne-Claude

Molly Donovan

Christo and Jeanne-Claude's wrapped works remain at the center of the popular imagination and in certain critical minds in regard to the artists' output. The formal convention of wrapping is important to their work overall, though conceptually it occupies a position only in their early career. The wrapped works bracket the first seventeen years, from 1958–75, of their nearly half-century career. Thereafter, the wrapped works have given way to more open, tensile structures that exude an openness of form, free from the constrictions of the early sculptures. That has not stopped the public and critics from strongly associating their body of work with the practice of wrapping. The artists have argued this[1], and Christo asserts the last discrete wrapped object was made in 1965 (cat. no. 10)[2], now forty years ago. The literature dates the conception of the last project to incorporate wrapping at 1975 (*The Pont Neuf Wrapped, Paris, 1975–85*)[3].

Still the association persists.

From where does this miscomprehension stem?

It comes, in part, from the extended realization periods for the projects. For example, the *Wrapped Reichstag, Berlin* project was conceived in 1971 and not realized until 1995, bringing the idea of wrapping forward by twenty-five years. Beyond that, however, selective memories have privileged Christo and Jeanne-Claude's wrapped works. They struck a lingering note so attenuated, they and the concept of wrapping have become synonymous. For *The Gates, Central Park, New York City, 1979–2005*, *The New Yorker* cover illustrated people wrapped in saffron colored fabric strolling through Central Park. All this despite the absence of one wrapped element in *The Gates*.

Why?

This insistent reading, though incomplete, underscores the impact of their early work and the fertile associations conveyed by their artistic practice. These enclosed forms, with their connotations of censorship and concealment, may be seen in light of Cold War Europe and America and the cultural anxiety, fear, and uncertain identity that pervaded society. The early wrapped works provide creative analogs to the construction of the Berlin Wall (begun August 13, 1961), the separation of Eastern and Western Europe, the idea of closed statehoods, and the mighty struggles of the Superpowers. Who was better positioned to represent this paradigm than a refugee from Eastern Europe to the West?

Christo escaped post-war Communist Bulgaria to Vienna via Prague in 1956, then moved to Geneva in 1957. Following a restrictive, traditional art education in Bulgaria at the Sophia Fine Arts Academy, Christo devoured every available cultural experience he could afford in the West. In December 1957, he visited the Kunstmuseum in Basel, and went on to museums in Lucerne, Zurich, Geneva, and Lausanne among others[4].

Wrapped cans and oil barrels

In his travels, Christo saw works by Jean Fautrier, Nicolas de Staël and the early work of Jean Dubuffet, all of whom shared a vocabulary of thick, impastoed canvases, and non-traditional media, including sand and pebbles. Following this exposure, in Geneva, January 1958, Christo made his first wrapped objects. He started with an empty paint can, covered it in resin-soaked canvas, then bound it in twine and added layers of varnish, sand and paint to create a textured surface. Thus began Christo's *Inventory*, which grew into a group of objects to which he added for the ensuing two years. Parallel production of other wrapped objects would continue into the mid-1960s. Christo does not assign a reason or event that led him to cover objects. In hindsight, they appear as a complex reaction to his entry in the West; packaged objects reflecting capitalism, while also referring back to the closed culture of Communism[5].

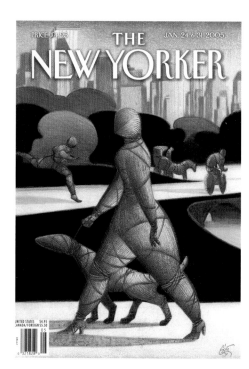

The look of the early objects authored by Christo may be seen as direct responses to his new experiences and exposure in Western Europe, and to the art being made there. (For clarification, Jeanne-Claude collaborates with Christo on the large-scale projects alone, leaving the early objects and preparatory studies for the projects to Christo's hand.) Still, his works are important in ways differentiated from his contemporaries. In choice of humble materials, connections might be made between his work and that of Arte Povera (literally "poor art"), but Christo considered the group's selection of materials luxurious in comparison to his own[6]. Likewise, the literalness of his work was not completely aligned with the literary contrivances of the Nouveaux Réalistes, despite inclusion in several of their exhibitions[7]. Additional associations included the Fluxus group, as well as the artists publication *KWY*. Ultimately, Christo's individuality would characterize his sculptural output quite apart from his contemporaries; although, early on there were several points of intersection.

Traditional boundaries of artistic media began to break down in the post-war era. Christo's early work contributed toward this end. His early sculptures straddled the concerns of painted surfaces, discrete sculpture, temporary installations, and architectural works. The latter would signify his legacy with Jeanne-Claude into the twenty-first century. The earliest objects, however, engage with contemporary concerns between the fields of painting and sculpture.

Christo's wrapped cans – seen in *Shelves* (1958; cat. no. 1) – relate to the work of an American contemporary, Jasper Johns, whose plaster *Ale Cans* were made two years later. Christo and Jeanne-Claude first saw Johns' work and met him at the Galerie Rive Droite in 1959, at the American artist's first exhibition in Paris. The cans of each artist exhibit heavily worked surfaces towards painterly, expressive ends. Conceptually, Christo's and Johns' cans share the idea of concealing and translating an everyday object into an enigmatic *objet d'art*. Both artists benefited from the example of Marcel Duchamp, whose ready-mades were "promoted to the dignity of art through the choice of the artist", as described by André Breton[8]. Christo's cans gain additional meaning relating to the closed statehood of his Eastern European background, and his new Western environment – something Johns' cans do not signify.

Descriptively titled, *Shelves* evokes a food storage system, with its wire mesh covering containers on ledges[9]. Christo relates this work to the boxes placed outside windows in Europe for cool storage when one has no refrigeration. Knowing these from his youth in Bulgaria and again in Paris[10], Christo creates in *Shelves* a nostalgic connection between everyday experiences from his homeland and his new surroundings.

Issues of scale increased with each of Christo's moves further West. This trajectory continued through his final relocation to New York City with Jeanne-Claude and their son Cyril in 1964. The growth relates at once to Christo's Bulgarian youth and his exposure to the West. Christo's mandatory involvement in Bulgarian *agit-prop* activities entailed painting large billboard-size portraits of Communist leaders. Additionally, advising the farmers in the arrangement of farming equipment and hay bales in the landscape for passers-by on the Orient Express allowed him to judge distance and scale in the environment. In Vienna, Christo saw the film *Gone with the Wind* and was impressed by the expansive scale depicted. He apparently stayed up that night "thinking about the Americans and their giganticism"[11].

As early as 1958, the use of small concealed cans made in Geneva expanded to larger containers, specifically oil barrels, as in *Wrapped Oil Barrels* (1958; cat. no. 2)[12]. The use of oil barrels from early in his career identified the world oil culture at a prescient moment: oil consumption would remain a significant source of global conflict from the post-war era into the present. In one form, Christo brilliantly captured the various issues of power, commerce, and containment confronting Westerners in the late 1950s. Similar concerns surrounding a globalized society that constructs identity through consumption and branding are still addressed by artists nearly fifty years later[13].

In June 1962, Christo and Jeanne-Claude realized the *Wall of Oil Barrels, The Iron Curtain, Rue Visconti, Paris, 1961–62*, an installation of 240 fifty-two gallon barrels on a narrow street in Paris[14]. Christo's remarkable collage marking its conception is seen in *Projet du mur provisoire de tonneaux métalliques, Rue Visconti, Paris VI* (1961; cat. no. 33). The most politically charged of their early temporary installations, the *Iron Curtain* was triggered by the construction of the Berlin Wall. It also conjoined in meaning with the 1961 Algerian War, as well as the historic barricades used in the streets of Paris by nineteenth-century revolutionaries. The avant-garde nature of the *Iron Curtain* is underscored by its overt political function as a public disturbance, having blocked traffic on a city street for eight hours, angering pedestrians and motorists. Made without a proper permit despite the artists' attempts, it flew in the face of civil authoritarian structures. The installation likewise made

an important artistic gesture outside the established gallery, museum, and private collection spaces and into the streets of the city. Through this early example of installation art, Christo and Jeanne-Claude made a lasting contribution to art of the ensuing decades.

In the late 1960s, the barrels returned to discrete sculptures, including *28 Barrels Structure* (1966–68; cat. no. 37), its related study *28 Barrels Structure, Project* (1968; cat. no. 36), *56 Oil Barrels Construction, Project for Martin and Mia Visser* (1967; cat. no. 34), and another study for a potential commission at the Kröller-Müller Museum (1967; cat. no. 35). These works were made for private collectors and museums, the sale of which funded the large-scale projects. To this day, Christo's early works and preparatory studies function as commodities to fund large-scale projects with Jeanne-Claude, appropriating the capitalist model for their own use. These discrete sculptures no longer cause public disturbances, but here resemble the setback-style skyscrapers popular in New York from 1916–60, their shapes determined by zoning codes[15].

Packages

Like the wrapped cans and oil barrels, Christo's packages deny the pleasure associated with viewing. The supporting form of the packages, however, was determined by Christo rather than a manufactured object, thereby allowing greater variety and creative autonomy. Many of Christo's early packages, such as *Package 1958* (cat. no. 7), convey the shallow relief and object quality of Dubuffet's and Antoni Tàpies' paintings. Christo describes *Package 1958* and several related works as *bas-relief*, a term associated with antique sculpture. The artist knew these ancient forms from his studies of Greek and Roman statuary and from the legacy of his paternal grandfather, the founding academician of the Archeological Institute of Sophia. Christo also relates this format to an installation strategy for studio visits when artists prop their paintings on the studio floor or ledge and against the wall for viewers to see[16].

The artist applied lacquer to his wrappings until 1961, exemplified in *Package 1958*, giving them a sculptural hardness, and aged, old-world effect. Another work of great variety, *Package 1961* (cat. no. 11), marks a lingering vestige of lacquer, a medium which Christo abandoned shortly after making this sculpture. This dark anthropomorphic construction of sticks and fabric evokes the existential sculptural bodies of Alberto Giacometti. Starting in 1959, Christo began to make packages with-

out lacquer, and the unfinished canvas began to take on a crisp, clean primacy. A work like *Package 1960* (cat. no. 14) signaled a new direction for Christo's work, a fresh start symptomatic of his increasingly independent vision and positivistic outlook.

Like the later oil barrel constructions, *Package 1960* reads as a tall building. Indeed, it foreshadows models for wrapped public buildings such as *Lower Manhattan Wrapped Buildings, Project for New York City*, 1964. Scale also had its referent in paintings, for *Package 1961* (cat. no. 8) calls to mind the expansive canvases of Jackson Pollock. Christo first saw his work in the 1959 exhibition *Jackson Pollock and New American Painting* at the Musée National d'Art Moderne in Paris. *Package 1961* purports to be the largest package made by the artist[17], and indicates a decisive move toward monumentality.

Christo's early art reflects a play of opposites, harkening back to his early education in Karl Marx and Friedrich Engels' models of dialectic materialism. Accordingly, his monumental objects have counterparts in the most intimate of works. *Package 1965* (cat. no. 10) among the smallest of packages, belongs to a group of twelve miniatures kept for years in a suitcase until their recent discovery by the artists. Christo considers this work one of his last discrete packages. Later works such as *Wrapped Paintings 1969* (cat. no. 16) and *Package (Grand Empaquetage Noir) 1969* (cat. no. 15) were meant as a separate activity as a way to "practice with large pieces of fabric"[18] for the upcoming large-scale projects (the *Wrapped Kunsthalle Bern* in 1968, the *Wrapped Museum of Contemporary Art, Chicago* in 1969, and the *Wrapped Coast, One Million Square Feet, Little Bay, Sydney, Australia*, 1968–69). The architectural quality of these works, particularly *Wrapped Paintings 1969* with its building-like profile and vertical orientation, share a vocabulary with other artists. Robert Mangold's hallmark wall series addresses similar considerations about the object-ness of painting and the context of installation. Christo, who studied architecture in Bulgaria, and expresses an ongoing keen interest[19], has forged connections between architecture as a packaging and marketing tool to project an image or idea.

Package (Grand Empaquetage Noir) 1969 intervenes in interior space with its dramatic flow of black tarpaulin on the floor. The fabric is released from its support and bindings at the bottom, allowing the fluid, sculptural properties of fabric to be celebrated, rather than tamed. *Grand Empaquetage Noir* recalls the exquisite employment of drapery by sculptors toward expressive ends throughout history, from Gian Lorenzo Bernini's

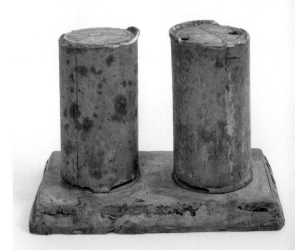

Jasper Johns, *Ale Cans*, 1960. Collection of the artist. © 2005 ProLitteris, Zurich.

Robert Mangold, *Brown Wall*, 1964. Private collection, Switzerland.

Christo, *Lower Manhattan Wrapped Buildings,*
Project for New York City, 1964.
Photo Wolfgang Volz. © Christo 1964.

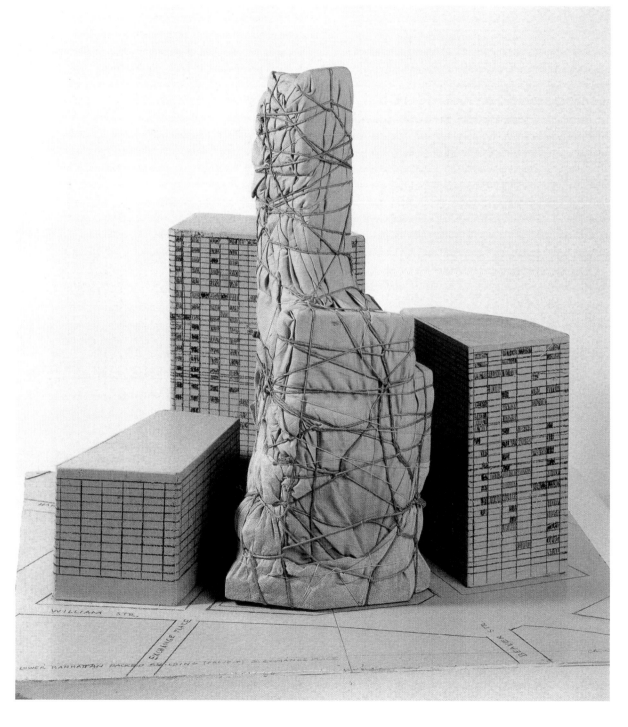

28

Baroque *Ecstasy of St. Theresa,* 1647–52, to Beverly Semmes'
more recent columnar *Four Purple Velvet Bathrobes,* 1991.
Christo and Jeanne-Claude's primary choice of fabric, capable
of both constricting and liberating, parallels the ideals of sta-
sis and kineticism imparted in their work.

The early sculptural investigations vary in orientation as well
as size, for *Package 1961* (cat. no. 12) presents a horizontal ex-
panse nearly as wide as *Package 1962* (cat. no. 13) presents a
vertical one.

Wrapped objects

Less abstract and enigmatic than the packages, the wrapped ob-
jects tantalize viewers with recognizable banal subjects that
Christo transformed. The source for the objects remained stead-
fastly secondhand, never storebought. Most often obtained from
the renown *marché aux puces* (flea market) in Paris, these ob-
jects are of uncertain provenance, in keeping with Christo's
early choice of humble materials. Many of the wrapped objects
represent a hybrid of packages and recognizable objects, as in
Package on a Table (1961; cat. no. 17), and *Empaquetage sur
Diable* (1964; cat. no. 21). Others lay bare the visual conceit
through the use of once translucent polyethylene, now colored
with age: *Package on Luggage Rack* (1962; cat. no. 18) and
Wrapped Table and Wrapped Chair (1963; cat. no. 20). Closer
to Duchamp's ready-mades, the wrapped objects nonetheless
bear the hand of the artist.

Wrapped magazines and portraits

Christo's early wrapped works evoke sepulchral notions, the
shroud-like coverings conjuring funereal forms and mummifi-
cation. The wrapped magazines and portraits covered in plas-
tic convey immediate sensations of fear and death, claustrophobia
and suffocation[20]. Transparent plastic creates a window onto the
subject that serves a memorial function, although he or she may
still be living.

An exception is *Wrapped Magazines on a Stool* (1963; cat.
no. 19), that followed the death of Marilyn Monroe in 1962,
where the subject of the top magazine's cover is visible through
the plastic. The proliferation of news coverage on the popular
icon's death at age 36 made magazine covers with her image
easy to come by. Christo used her image in a number of wrapped
magazine works dating from 1962–63[21]. He did not then know
of Andy Warhol's portraits of Monroe[22], whose series on the
Hollywood star followed her death.

The two artists differ significantly, for Warhol's style often mimicked slick commercialism while Christo's response bore the mark of his humble Eastern European background. However, the formats and subjects of Christo's art cross with that of Warhol at various moments, given their joint interest in popular culture and its sociological effects. A fine example of this is the vertically stacked images in Warhol's silkscreened *Three Marilyns* (1962) and Christo's *Wrapped Magazines* (1964; cat. no. 23)[23]. At the time of his exhibition at Galleria Gian Enzo Sperone in Turin, 1964, Christo had seen magazines on racks such as this. Like Warhol, Christo underscores the quotidian subject of his work, and the objectification and commodification of beautiful women through popular media.

1962 marked the beginning of the wrapped portraits, though they differed from the wrapped magazines given that the underlying images were painted by Christo, not selected from the mass media. The wrapped portraits represent a death of the author, for they mark a moment when the portraits were being replaced by the wrapped works as a means of income. Christo's early portrait commissions, which he signed "Javacheff", his surname, supported him as a stateless refugee while he made wrapped objects on the side, signing them "Christo". The wrapped portraits thereby incorporate Javacheffs into Christos, and memorialize the former.

One of many portraits Christo made of Jeanne-Claude, *Wrapped Portrait of Jeanne-Claude* (1963; cat. no. 22)[24], recalls their first meeting in Paris in 1958 when Précilda de Guillebon, Jeanne-Claude's mother, commissioned Christo to paint her portrait. Like his other wrapped works, great variety attended the wrapped portraits. *Wrapped Portrait of Horace* (1967; cat. no. 24)[25], comprises a painted canvas rolled up on a tube which was then wrapped and bound in plastic. Christo likens the cylindrical format to a traditional artistic practice of rolling canvases often employed for the safe transport of a painting[26].

"Cratères"

The year 1959 marked the first American and Soviet space missions that produced images of the earth and the far side of the moon. For many, they stimulated the popular imagination with thoughts of space travel and provided visual representations of the earth's and moon's surfaces. The images further fueled the so-called "Space Race" of the Cold War initiated in 1957 with the Soviet launch of Sputnik, the first artificial satellite. Christo's response to these events seems readily apparent in *Untitled*

(Cratères) (1959; cat. no. 6) with its bowl-shaped depressions and accompanying voids, and the light palette characteristic of early moon imagery. The artist acknowledges this connection[27].

Christo's *Cratères*, literally craters, with their craggy voids and incisions, confront seemingly different issues than the packages and objects. Yet, their connections to political and cultural tensions between Eastern Europe and the West and their response to popular imagery remain consistent. Beyond that, the style reflects knowledge of the European art world in 1959, specifically Tàpies and his accreted, mixed media canvases with incised surfaces, exemplified in Christo's *Untitled (Cratères)* (1959; cat. no. 5). The devices of the hole and the slit here must be considered in concert with issues of perception and viewership that concerned Christo from his earliest artistic practice in the West. They represent the imperceptible and unseen components of our visual world, much in the same way the contents of the packages remain hidden behind fabric.

Show Cases, Store Fronts and Show Windows

Christo's interest in perceptual effects extended to the conditions of display and the power struggle for visual and physical access to a space. Using the construct of glass vitrines and store fronts, Christo inverted their traditional revelatory functions by obscuring interior views and preventing entry. These insidious works covered the glass with fabric or paper, shutting out the consumer or viewer. Primarily architectural works, they created a physical blockade between the individual and the power structure whether commercial or, by implication, governmental. In the end, their gesture of teasing then denying marked an inherent antagonism and critique of the structures of control for visual information and the pleasure associated with freedom.

The show cases began in Paris in 1963, as in *Show Case* (1963; cat. no. 25). Between 1964 and 1967, the idea graduated to life-sized store fronts, complete with real doors and windows. They marked Christo's first use of true architectural scale. This gave the works a physical, human referent that created a physical frustration in response to their barrier-like effect. Early store fronts made use of salvaged architectural remnants, as in *Yellow Store Front* (1965; cat. no. 30), and cat. nos. 26–29. Later store fronts (cat. no. 31), and the related show windows, for example *Double Show Window* (1965–66; cat. no. 32), shift toward a Minimalist austerity and machine aesthetic. The formality of these later structures signifies an authoritarian architecture used for corporate or civic use. The voids of the win-

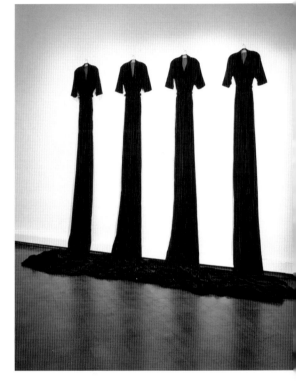

Beverly Semmes, *Four Purple Velvet Bathrobes*, 1991. Denver Art Museum Collection (Funds from Alliance for Contemporary Art, Mr. & Mrs. Bernard Rosen, Judy and Ken Robins, Carley Jane Warren, Carol and Lerry Levin, and Jerry and Jo Anne Friedman, 1991.884).

The Brandenburg Gate in Berlin.

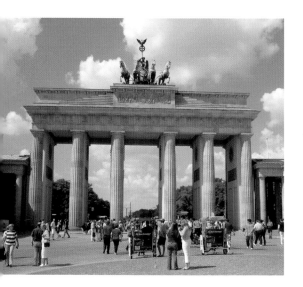

dows may be seen in relation to the negative space in another architectural form – that between columns in Neoclassical structures that house state governments. The Brandenburg Gate in Berlin provides a pertinent example in this case: like the store fronts and show windows, the Brandenburg Gate teases with the prospect of entry, when it represents a nearly impenetrable border divide between East and West[28].

Public projects
1961 marked an important conceptual shift from Christo's wrappings to the early public projects he authored with Jeanne-Claude. Through the 1960s, Christo made wrapped objects alongside the large-scale public projects with Jeanne-Claude; however, by the end of the decade, he increasingly focused his energies on the public projects.

Two collages by Christo from 1961, *Projet d'un édifice public empaqueté* (cat. no. 38), and the aforementioned *Projet du mur provisoire de tonneaux métalliques, Rue Visconti, Paris VI*, signal the origin of conception for the projects. It is perhaps the manifesto-like *Projet d'un édifice public empaqueté* that best summarizes the early intent for the public projects that have reached so deeply into the collective consciousness. In this document, Christo lays out several basic ideas involving the use of fabric, issues of public display, and the binary concepts of packaging/concealment and openness/freedom. Those themes became recursive[29] throughout Christo and Jeanne-Claude's work.

The monumental wrapped building in the surrealistic collage appears as an alien-like giant package about to encroach on the public space; it's an absurd, but potentially menacing figure. By the end of the 1960s, the artists would realize this project in *Wrapped Kunsthalle Bern* in 1968 and the *Wrapped Museum of Contemporary Art, Chicago* in 1969.

It is fitting that their projects should exist outside the prescribed system of art making and exhibition, following his break from a totalitarian regime. Christo appropriated the very word "projet", first used in the *Iron Curtain* collage, from the work projects he was required to engage in as a student in Bulgaria, and gives the term new currency in his own work.

Wrapping as ending
When asked about the steadfast focus on the wrapped works, Christo reflected on the English usage for the word "wrap" relating to a summation, as in the phrase "to wrap things up"[30].

Having taken the form to its logical conclusion, Christo's packages, wrapped objects and portraits come to represent the finality of his past in Communist Bulgaria and a slow giving way to the openness and freedoms he has experienced with Jeanne-Claude in the West. The early wrapped works provide a map for the direction of the later work, making them essential to understanding Christo and Jeanne-Claude's joint career as a dialectic of first closed then open sculptural forms that declare the case for freedom. However, even in the early career, the wrapped works represent but a portion of the production, for the store fronts, oil barrels and *cratères* offer counterparts and nuanced views of a complex approach to art. Thinking in terms of the wrapped works alone, leads to the one-sided outlook Christo escaped in post-war Communist Bulgaria.

[1] In a telephone conversation with the author, September 23, 2005, Christo recalled that *Package 1965* (cat. no. 10), was one of, if not the last, discrete wrapped packages he made.
[2] Christo and Jeanne-Claude address the discrepancies that persist in the descriptions of their work in *Most Common Errors / Erreurs les plus fréquentes*, Paris, 2000, authored by them. Throughout this corrective text, and in their lectures, they mention the misnomer that they are "wrap" artists.
[3] The author has written about this previously in "The Fabric of Art", in *Christo and Jeanne-Claude in the Vogel Collection*, exhibition catalogue, National Gallery of Art, Washington, 2002, p. 14.
[4] Burt Chernow, *XTO + J-C. Christo and Jeanne-Claude: A Biography*, with an epilogue by Wolfgang Volz, New York, 2002, p. 49.
[5] For a fuller discussion on Christo's response to the commodification of the object, see Molly Donovan, "Packaging an Aesthetic", in *Christo and Jeanne-Claude: The Weston Collection*, Toronto, Toronto, 2002. The wrapped objects have been seen against the biographical backdrop of Christo's experience growing up in post-war Communist Bulgaria, and the timing of their making that closely followed his escape to the West: Chernow, 2002, p. 50; and Donovan, "The Fabric of Art", 2002, p. 16.
[6] Conversation with Christo, November 14, 2005.
[7] The important *New Realists* exhibition at New York's Sidney Janis Gallery, 1962, among others.
[8] Christo recalls first knowing Duchamp's work from his 1957 visit to the Kunstmuseum in Basel. Conversation with Christo, November 14, 2005. André Breton, Paul Eluard, *Dictionnaire abrégé du Surréalisme*, Paris, 1938, p. 18.
[9] *Shelves* survives as part of Christo's *Inventory*, most of which was destroyed in Paris by an unwitting landlord.
[10] Conversation with Christo, September 23, 2005.
[11] Chernow, 2002, p. 46.
[12] Made in Gentilly, this sculpture remained apart from the objects in *Inventory*.
[13] Related ideas describing contemporary artistic practices are mentioned in the press release for the 2006 Whitney Biennial.
[14] The first public outdoor barrel structure was *Dockside Packages, Cologne Harbor, 1961*.
[15] Later barrel projects, namely *The Wall, 13,000 Oil Barrels, Gasometer, Oberhausen, Germany, 1999*, included an increasing element of control in arrangement of color and finish previously unseen with the barrel structures. The appearance of chance elements was absent in the *Gasometer*, with its carefully arranged colors (deep orange, yellow, two different blues, gray, green, and ivory) and a greater proportion of yellow.
[16] Conversation with Christo, September 23, 2005.
[17] Ibid.
[18] Conversation with Christo, November 14, 2005.
[19] Ibid.
[20] Here the plastic-wrapped visage calls to mind the incessantly repeated image of

a murdered Laura Palmer wrapped in plastic from the popular "Twin Peaks" television series in the late 1980s – early '90s, as well as those in snuff films.

[21] Among others, *Wrapped Magazines*, 1962 (Sonnabend Collection, New York), and *Wrapped Magazines*, 1963 (Samuel and Ronnie Heyman Collection, New York).

[22] Conversation with Christo, September 23, 2005.

[23] Also worth comparison are Warhol's soup cans and Christo's wrapped cans, as well as Warhol's *Silver Clouds*, 1966, and the Christos' pneumatic sculptures like *Air Package, Stedelijk Van Abbemuseum, Eindhoven, The Netherlands, 1966*, and *5,600 Cubicmeter Package, Documenta 4, Kassel, 1967–68*.

[24] Like earlier packages, this work is also meant to be leaning against a wall.

[25] Horace Solomon was an early collector of Christo's in New York, and then husband of gallerist Holly Solomon.

[26] Conversation with Christo, September 23, 2005.

[27] Ibid.

[28] Christo knew of the Brandenburg Gate through the media, but did not see it until 1976 while working on the *Wrapped Reichstag*.

[29] Pamela M. Lee says of the term "recursion" that it "names an increasingly important model of temporality in the post-war era, one with peculiar implications for the art of the 1960s… self-reference… self criticism… self-reflexivity". *Chronophobia: On Time in the Art in the 1960s*, Cambridge (Mass.), 2004, p. 61.

[30] Conversation with Christo, November 14, 2005.

31

Packages

In Paris, in 1958 [Christo] made his first series of objects, called *Inventory*, in which he mixed wrapped, painted, and unmodified articles. This variety of treatment, however, was soon reduced, either by the use of repeated identical objects or by the total wrapping of objects. In 1959 he made tables which carried wrapped objects, packaged in such a way as to obscure their identity. Here Christo began an exploration of the geometry of surfaces; as the covering stretched from point to point of the enclosed object or objects, the connections made new forms as they spanned the area. There was an ironic play between the new surfaces and the concealed supports; the packaging obscured, wholly or in part, the core, but without destroying the impression of containment.

Two exhibitions at the Galleria Apollinaire, Milan, demonstrated the range of this work by 1963.

The first show consisted of numerous packages, containing objects made bizarre by the wrapping: each known object was close at hand and, at the same time, removed. Transparent plastic was stretched or crumpled in improvised membranes. There were references to the ubiquity of modern packaging and to striptease, in which delays and refusals to unwrap are central. [...]

The second exhibition in Milan consisted of one huge package that almost filled the gallery, in its scale recalling a 1961 project of Christo and Jeanne-Claude for a wall of oil barrels and built in the Rue Visconti, Paris, in 1962. The project is presented with high specificity. The street is measured, the shops are listed, an historical point of interest is quoted from a guide book, and the materials are specified: "Metal barrels used for transporting gas and oil (with different labels, like ESSO, AZUR, SHELL, BP) of fifty or two hundred liters capacity", and so on. [...]

Objects such as a chair, a pram, or a bicycle, built for use, when mantled or inverted, both invite and resist participation. The function of these objects is interrupted by Christo at the level of use, not of symbolism. He is not making the objects enigmatic or dreamlike; he is violating our operational relationship to the objects. They are distorted, but not hallucinated. It was Christo's intention to provoke reactions in the spectator, but these were to be physical and behavioral, rather that erotic, as in Dada and Surrealist objects. [...] When a known object cannot be operated in the customary ways, the reflexes of the spectator, in terms of expectation and reaction, are aroused, but suspended. Belief in a reflective, participatory mode of art is central to Christo and Jeanne-Claude's work, both the earlier objects by Christo and their later environments. [...]

Constant in Christo's early art is the use of objects at the same size as life, either by incorporating real objects in his art or by simulating real places. [...] Plastic or fabric membranes [were] stretched over objects, so that the top skin, the outside of the package, determined the content of the work, and not the contents within. The identity of the internal supporting objects was withheld rather than obliterated, because Christo, like other artists of his generation, wanted to combine, in a double focus, an untransformed object with a new object, the work of art. The tendency of figurative art has been to synthesize signs for objects with properties internal to the work of art, to produce a sign-cluster readable both as referent and as formal structure. The work of art is in the middle, in a complex state of mediation. In Christo's packages, however, we are faced with an original object, a core he has not made, and a skin that he has. [...]

As of the packages, it is true to say that there is concealment but no illusion. The responses generated by the screened object or the familiar façade are based on the objective act of making a package or screening a window. The factual basis of such art is neither transcended nor undermined: it is the source of the mystery. Christo is the antagonist of the imaginary.

Excerpts from Lawrence Alloway, *Christo*, Verlag Gerd Hatje, Stuttgart, 1969. Edited and updated by Susan Astwood, June 2000.

32

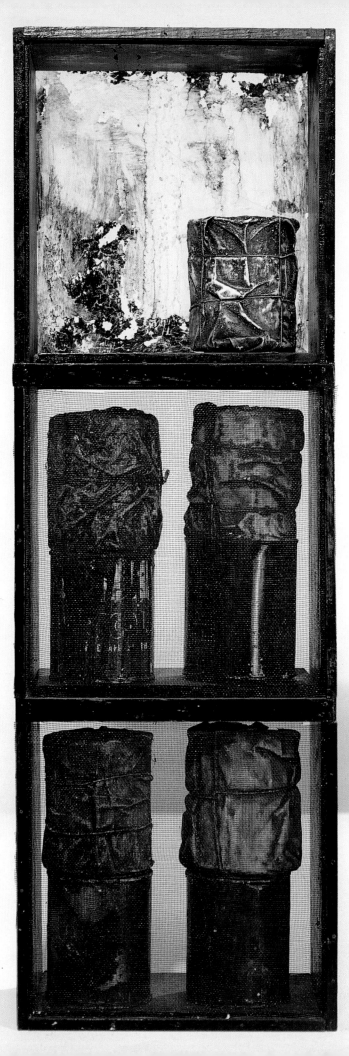

34

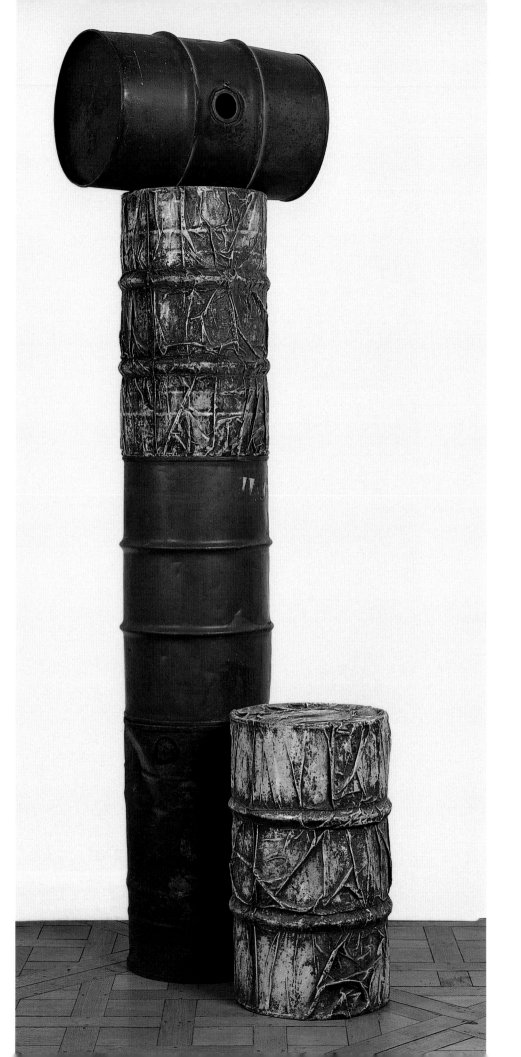

3.
Wrapped Oil Barrels
1958–59

35

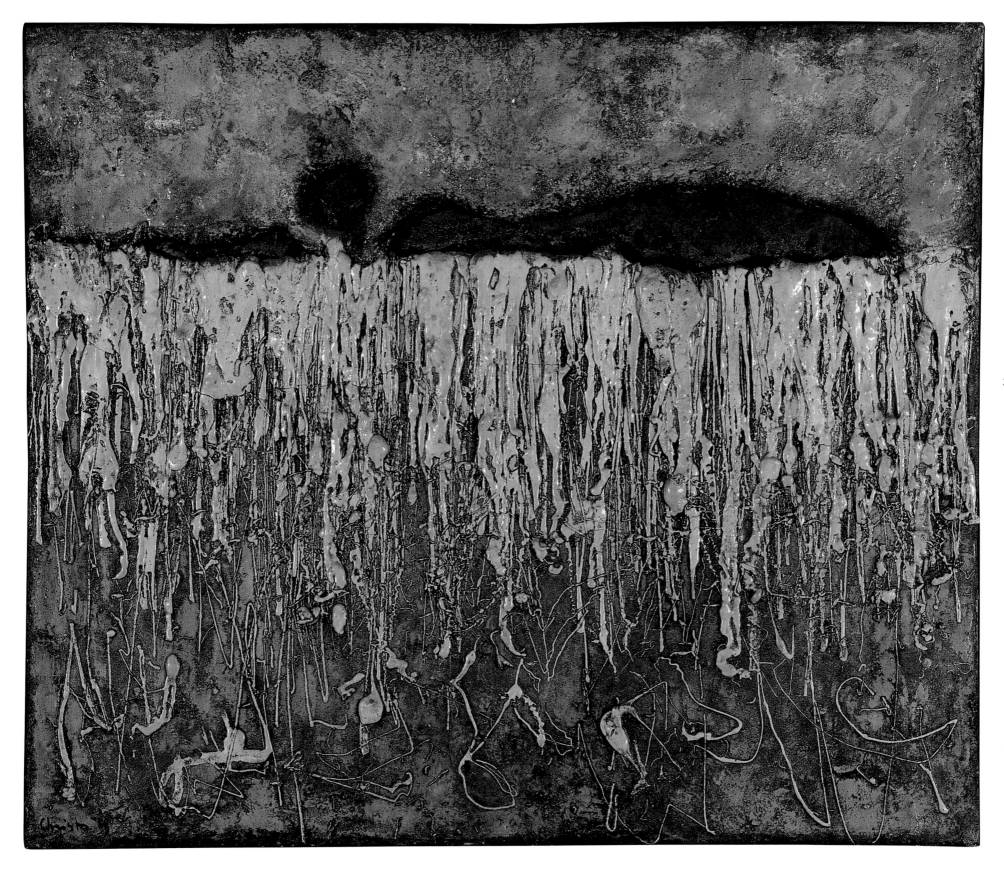

5.
Untitled (Cratères)
1959

6.
Untitled (Cratères)
1959

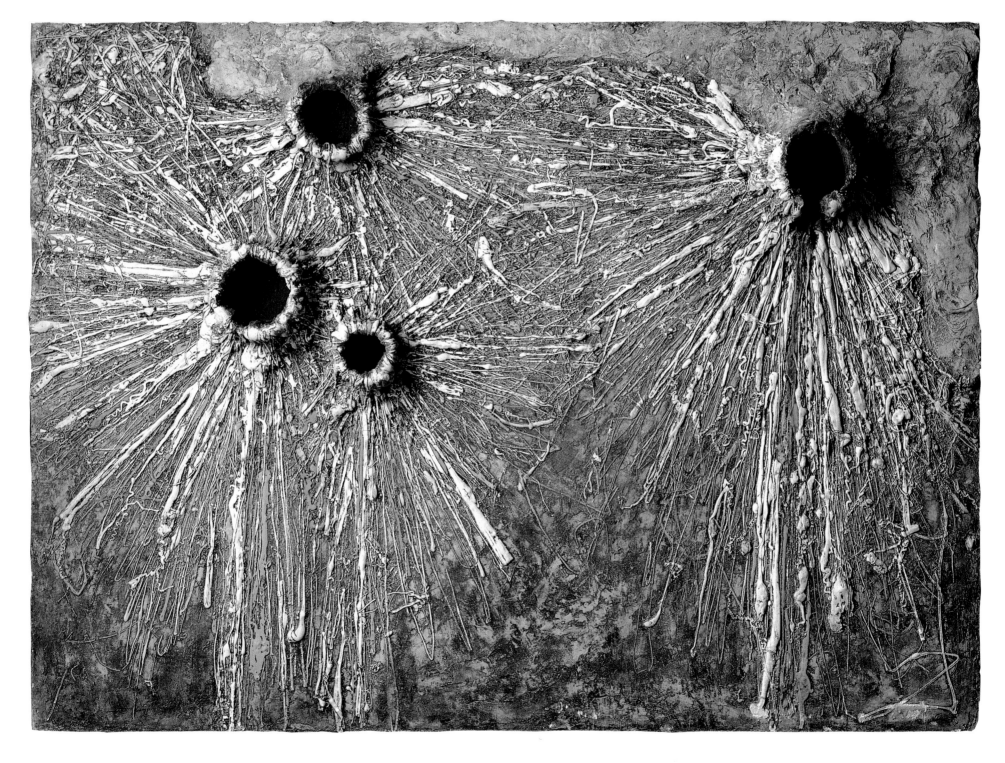

8.
Package 1961
1961

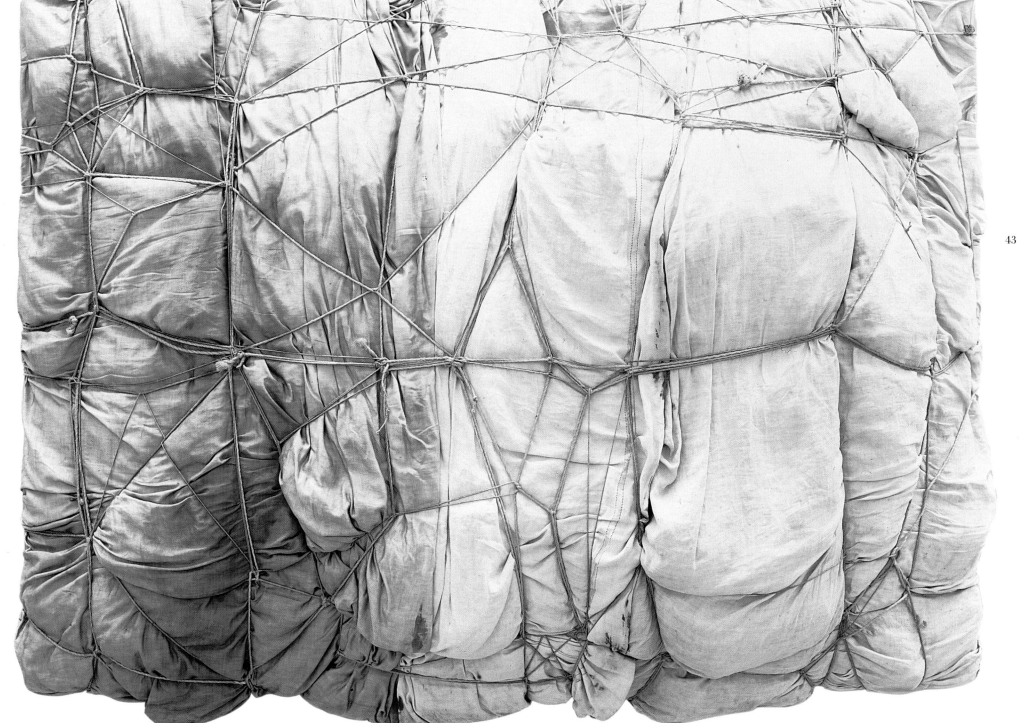

43

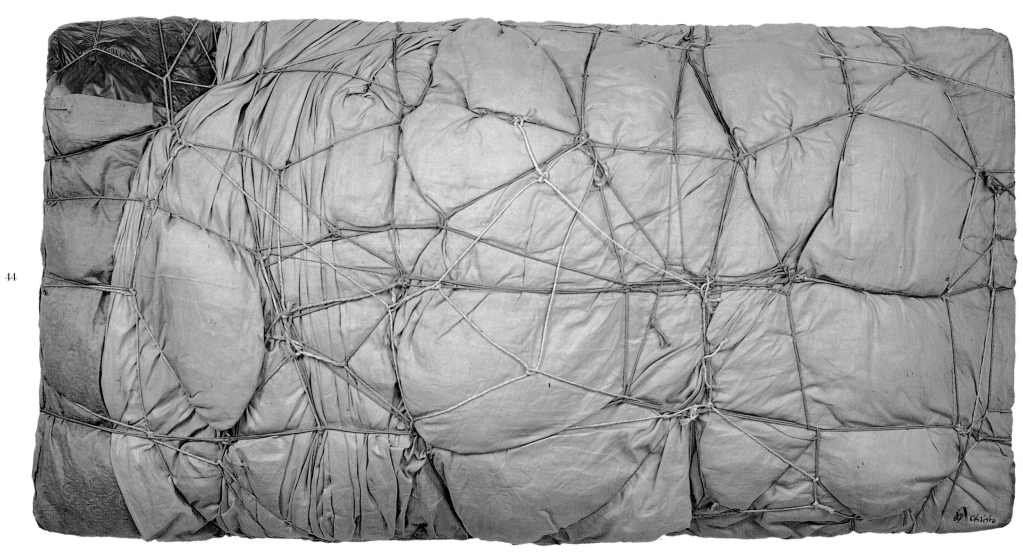

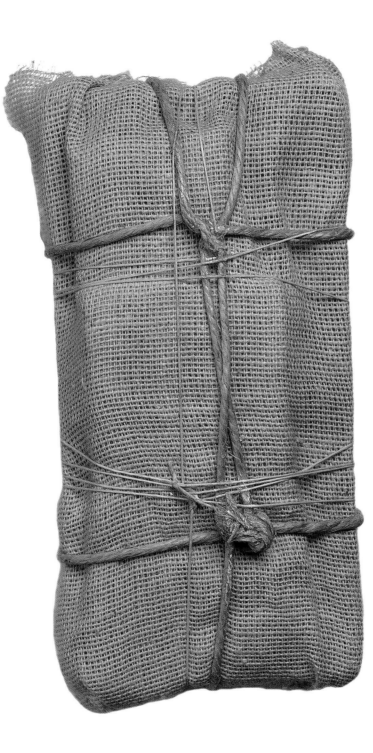

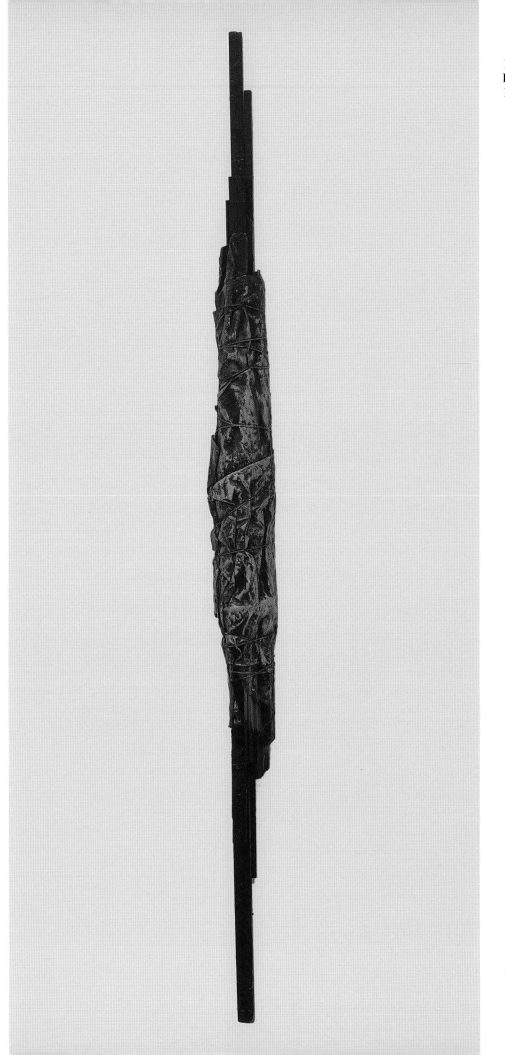

46

11.
Package 1961
1961

12.
Package 1961
1961

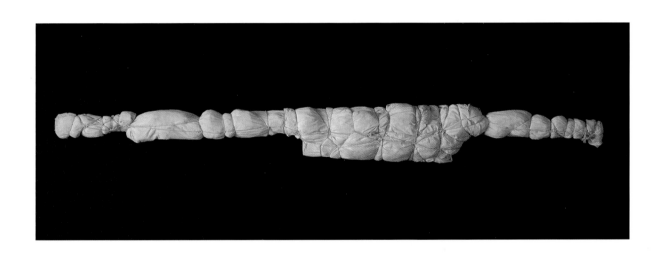

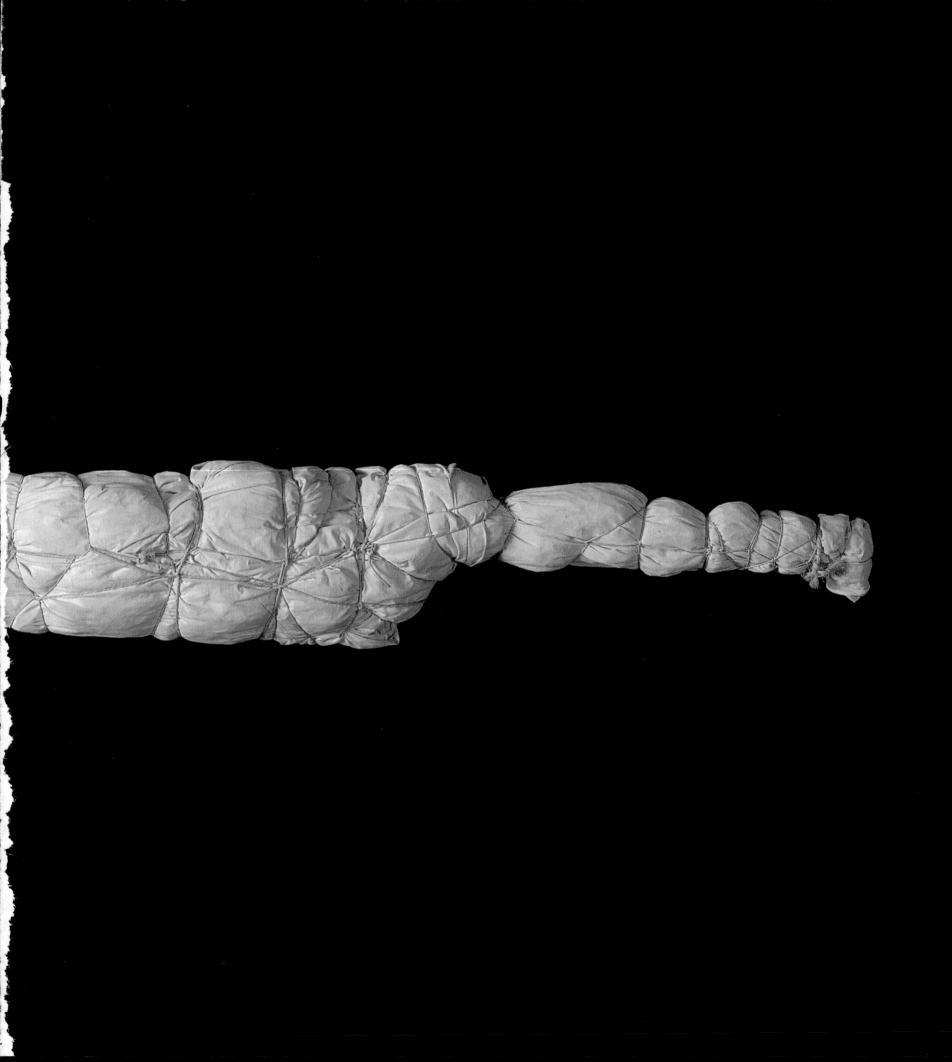

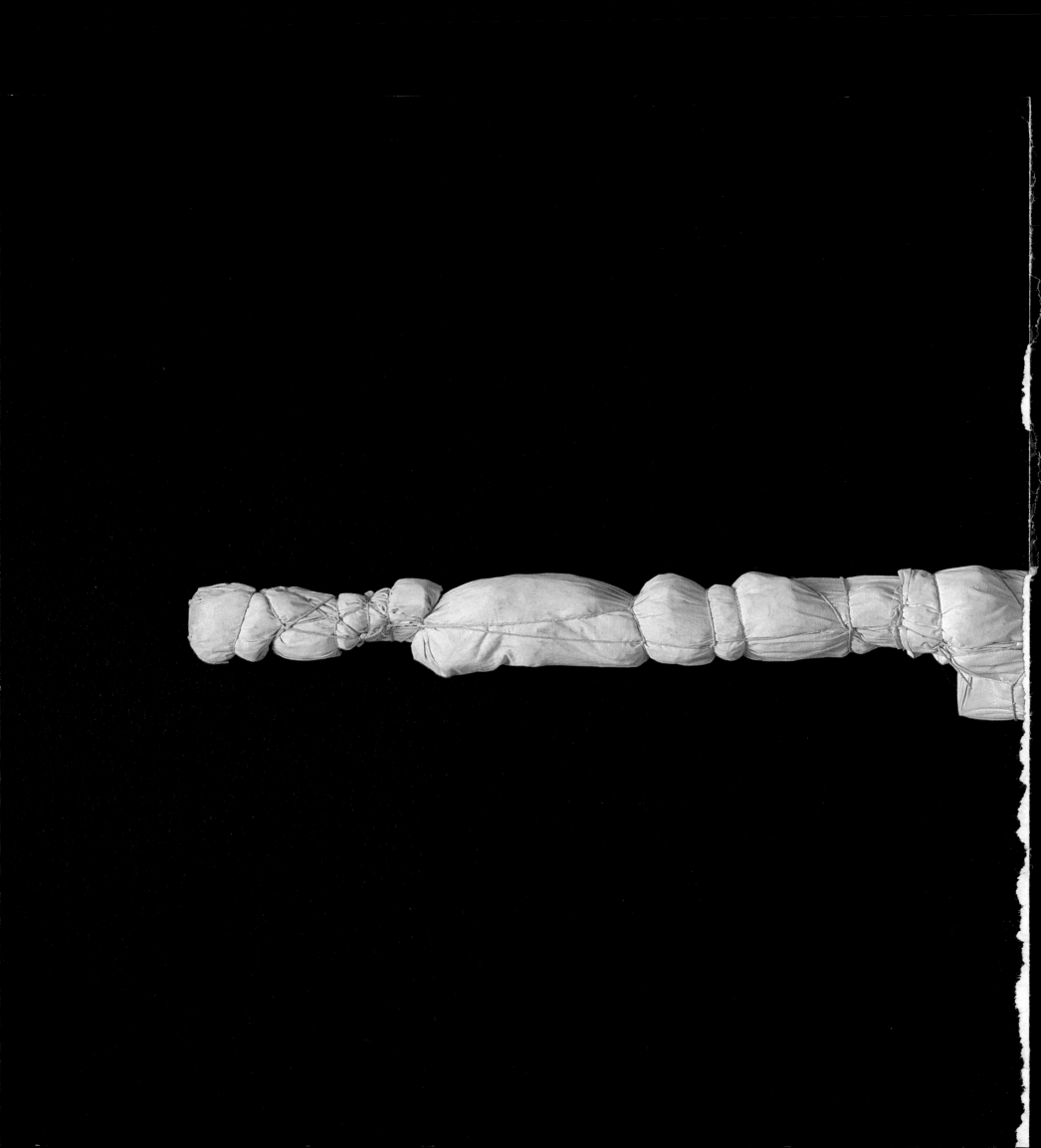

48

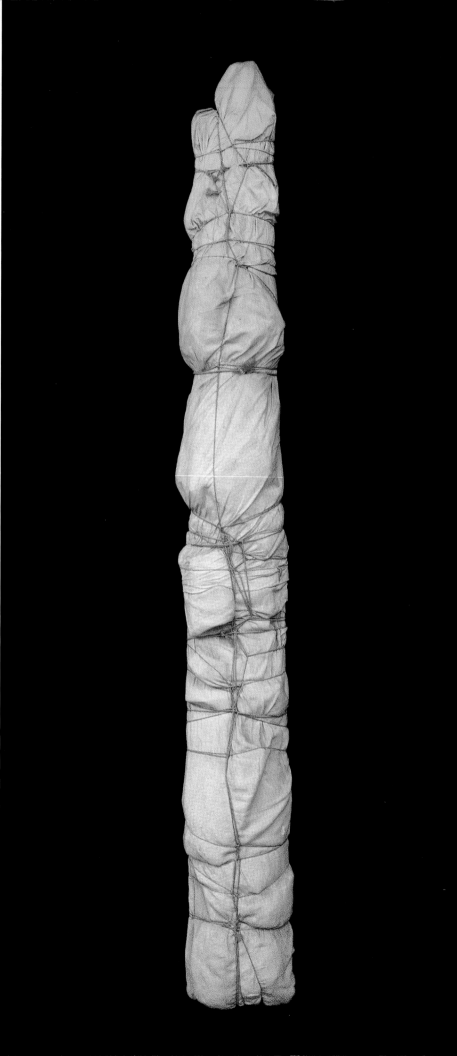

13.
Package 1962
1962

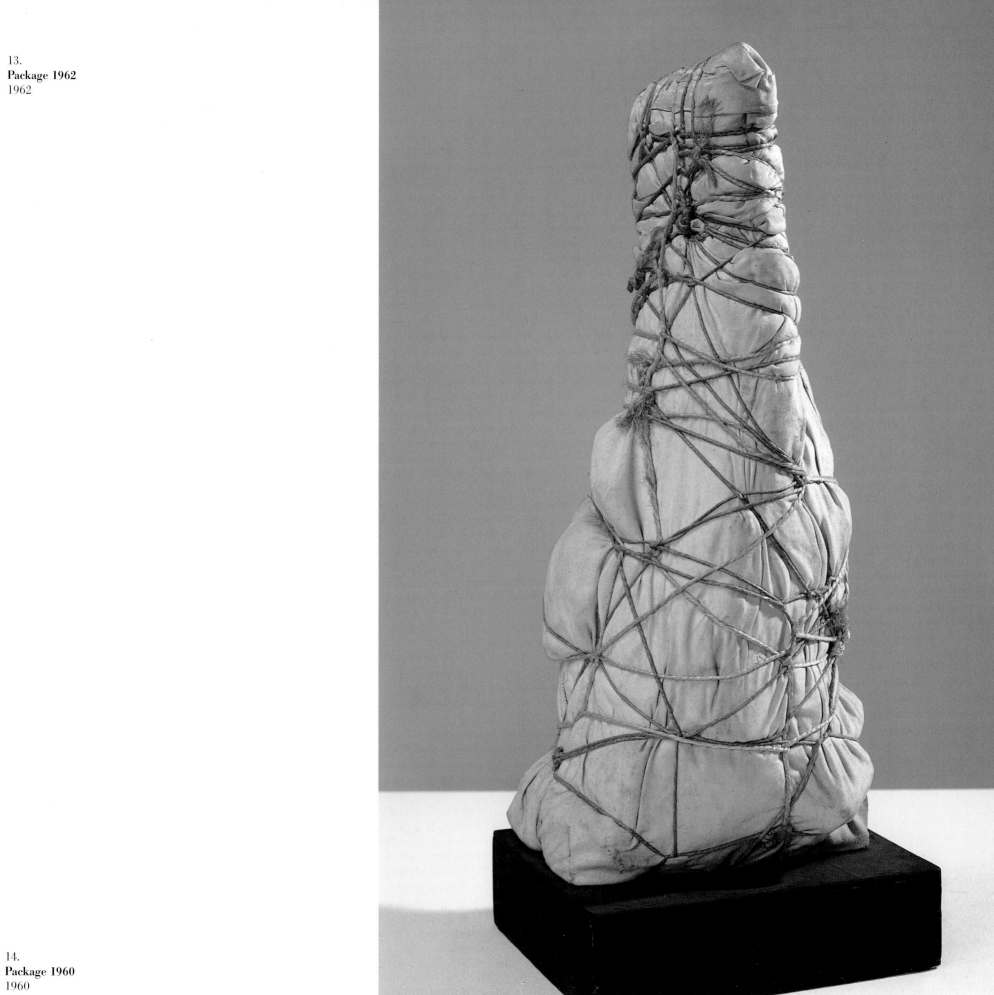

14.
Package 1960
1960

15.
Package (Grand Empaquetage Noir) 1969
1969

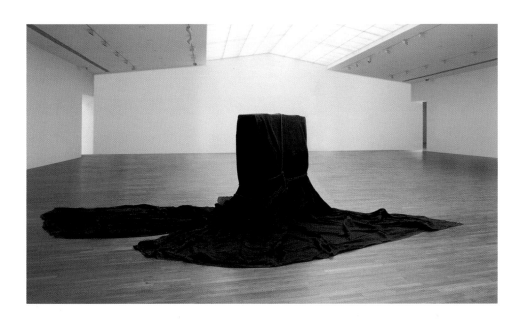

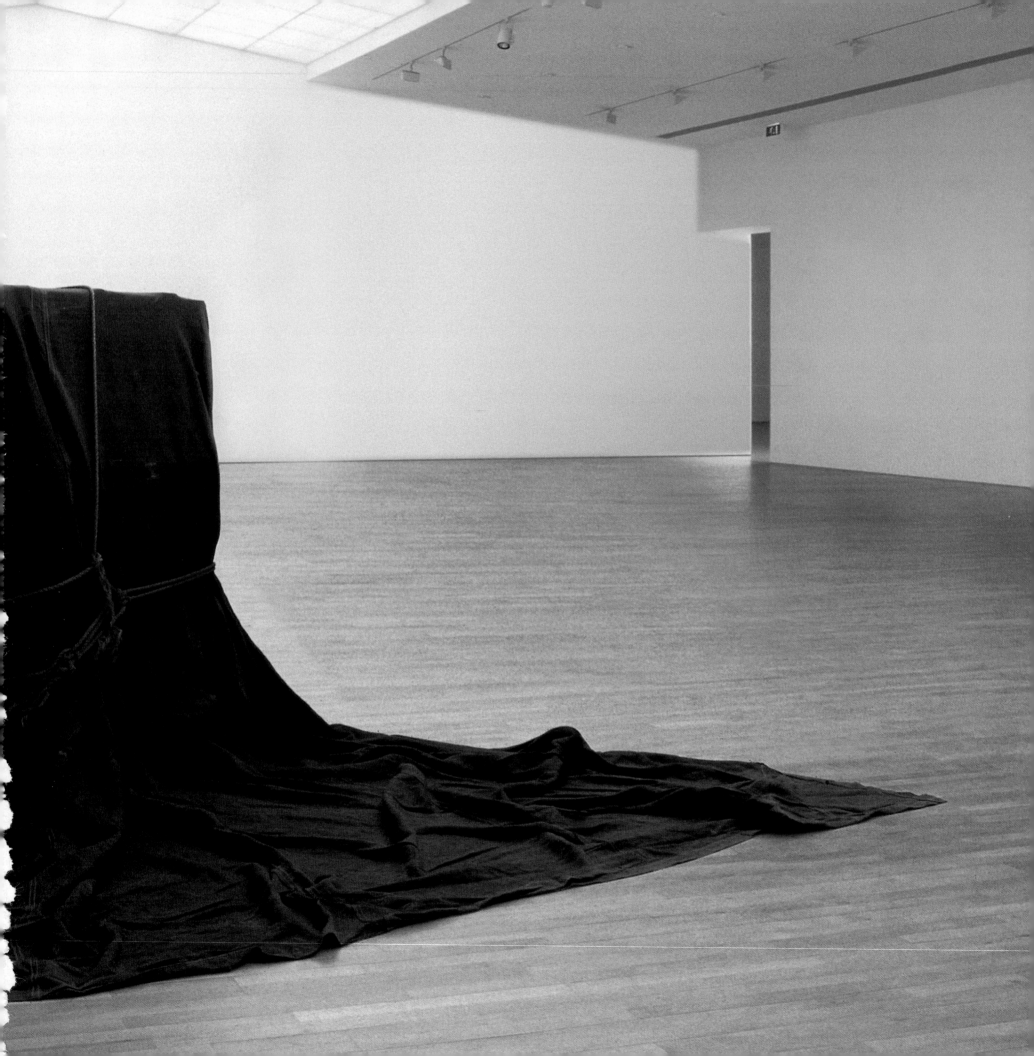

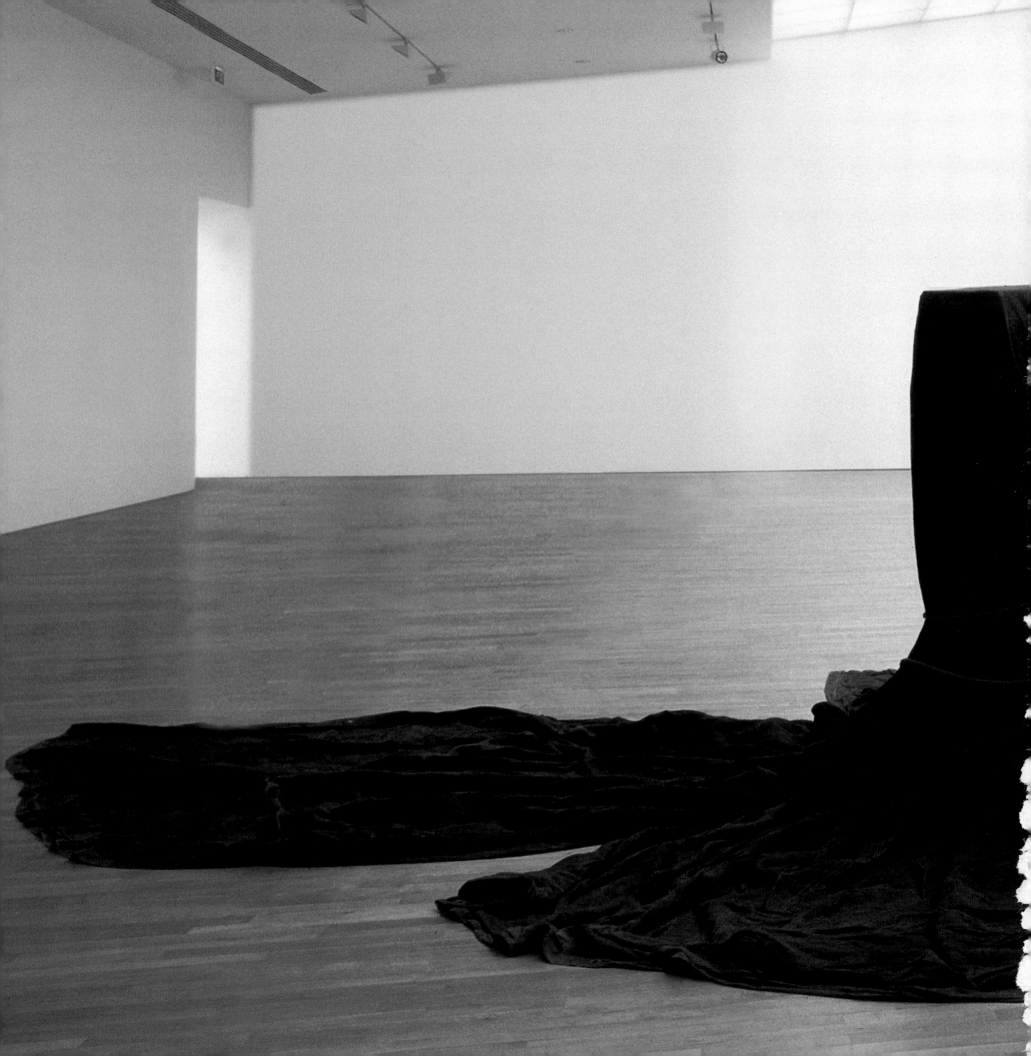

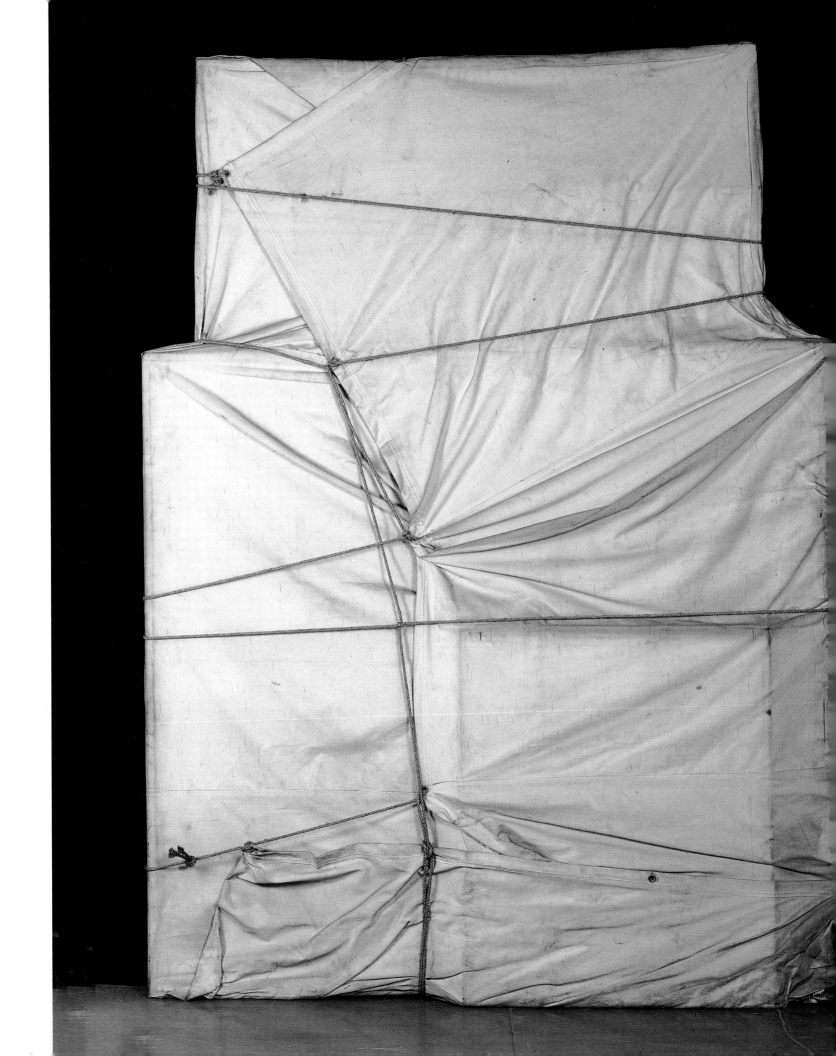

17.
Package on a Table
1961

54

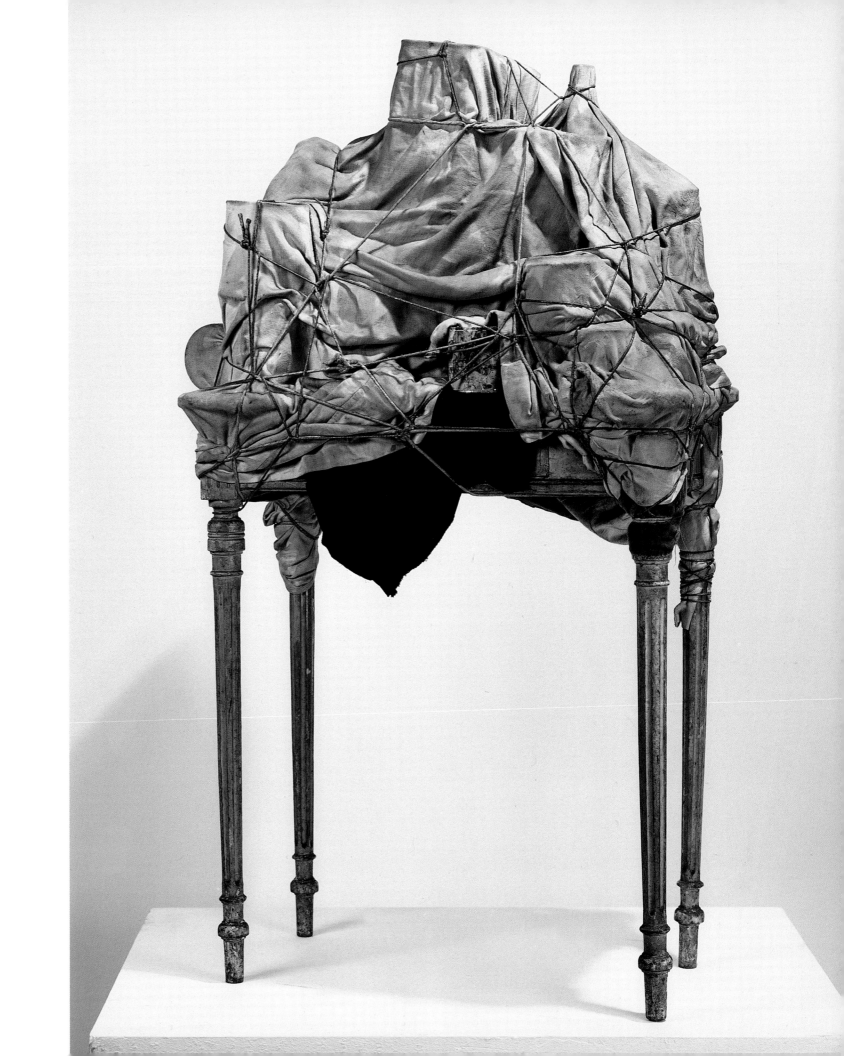

18.
Package on Luggage Rack
1962

19.
Wrapped Magazines on a Stool
1963

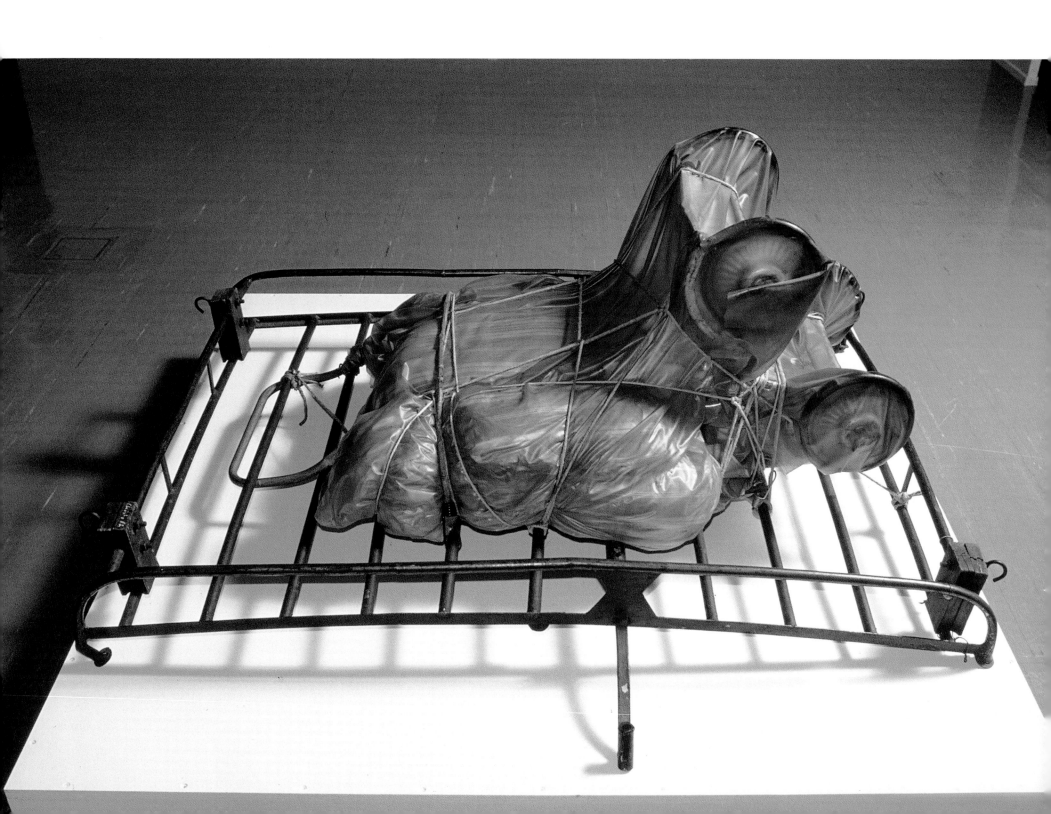

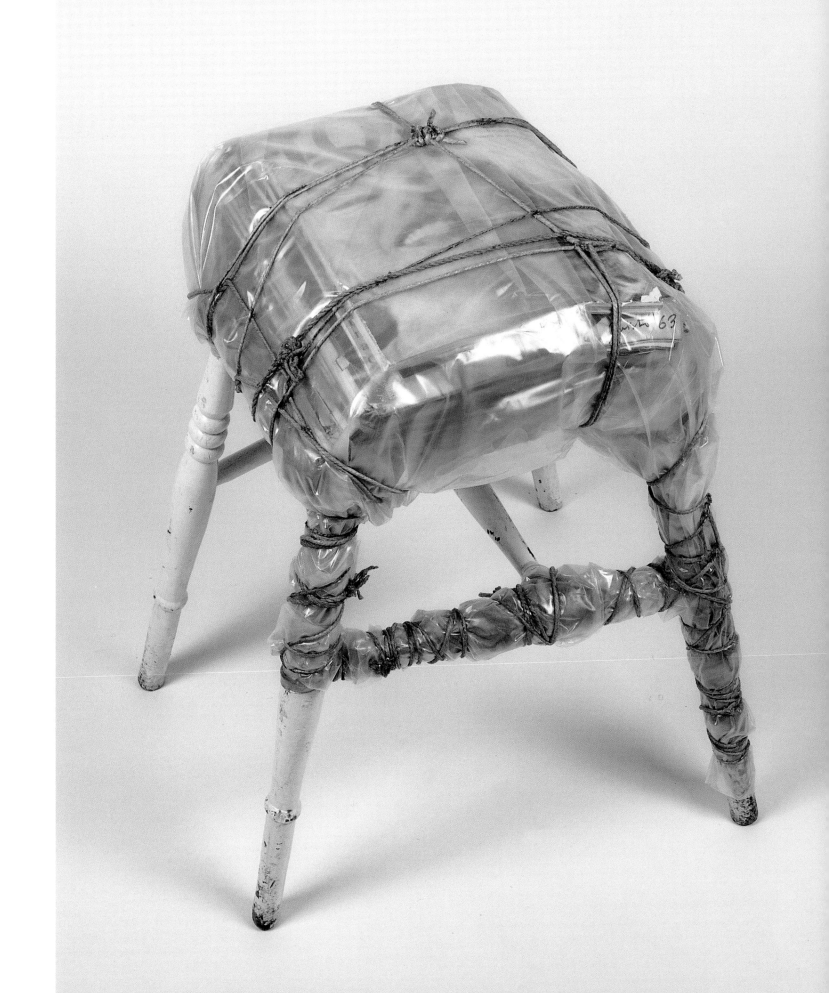

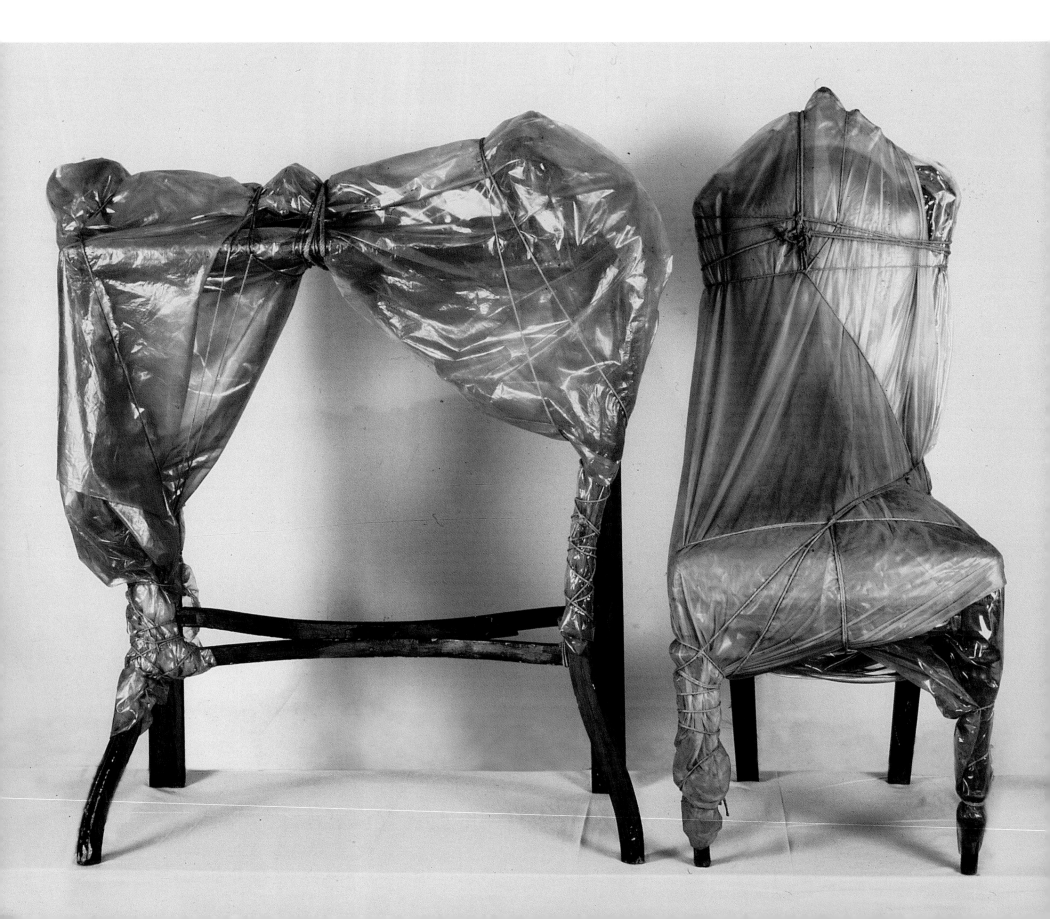

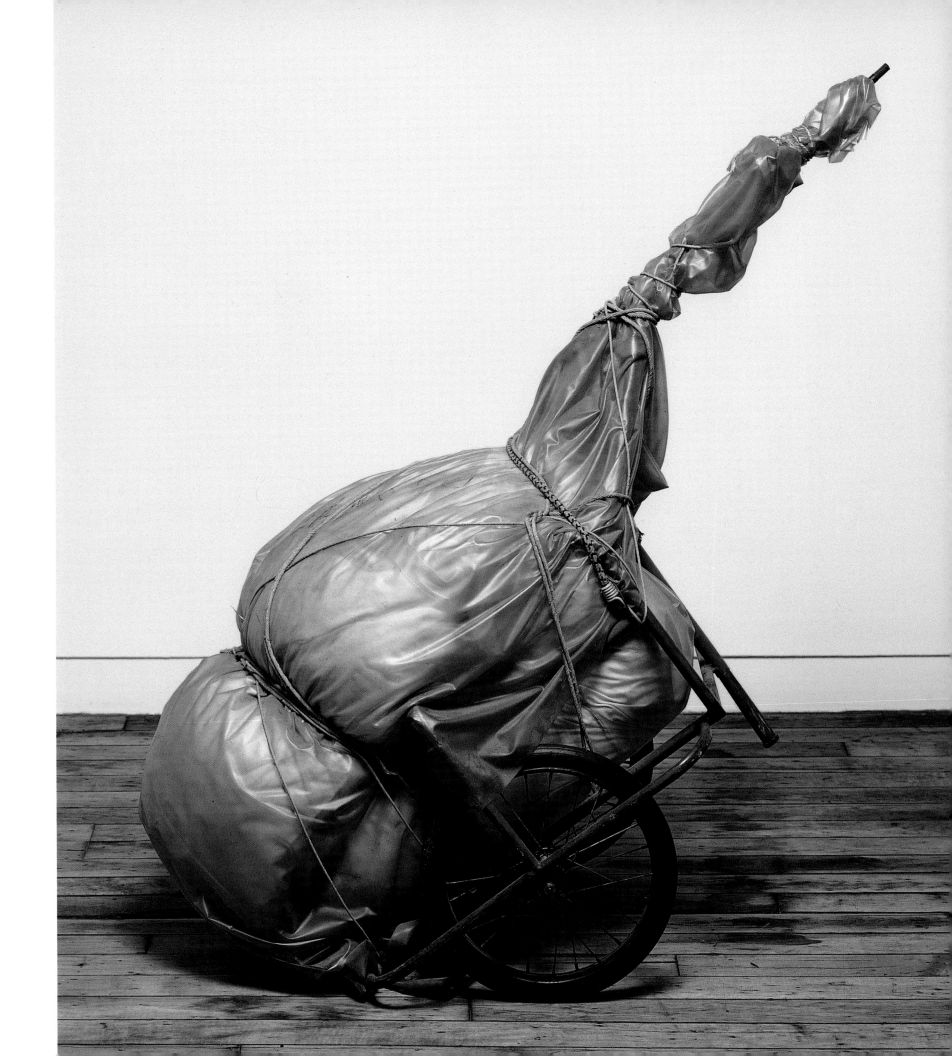

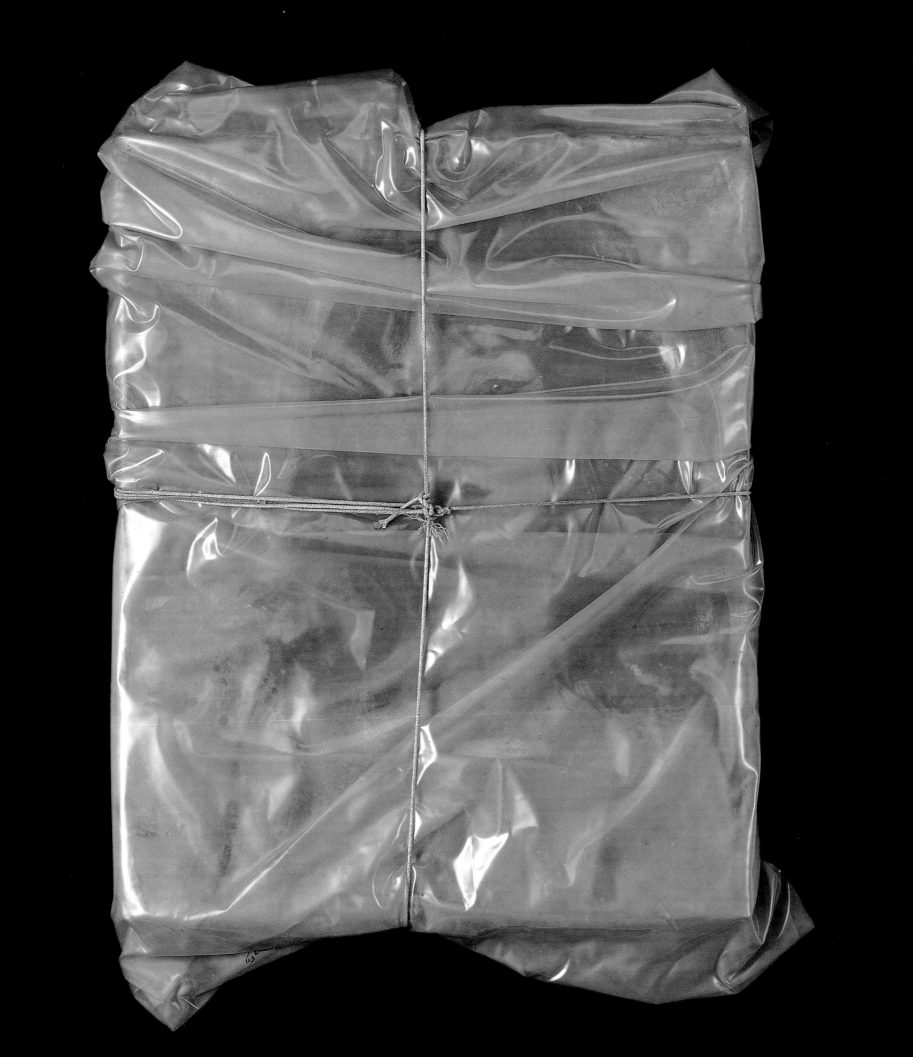

62

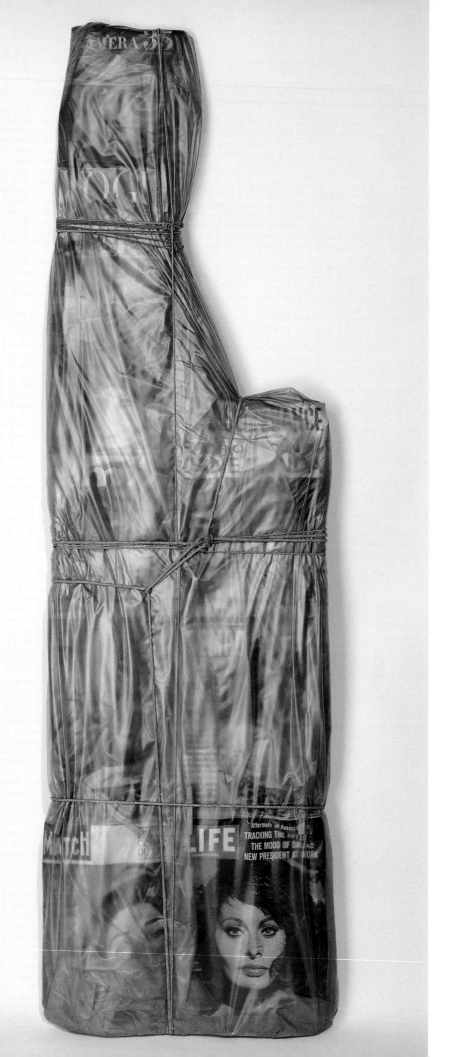

24.
Wrapped Portrait of Horace
1967

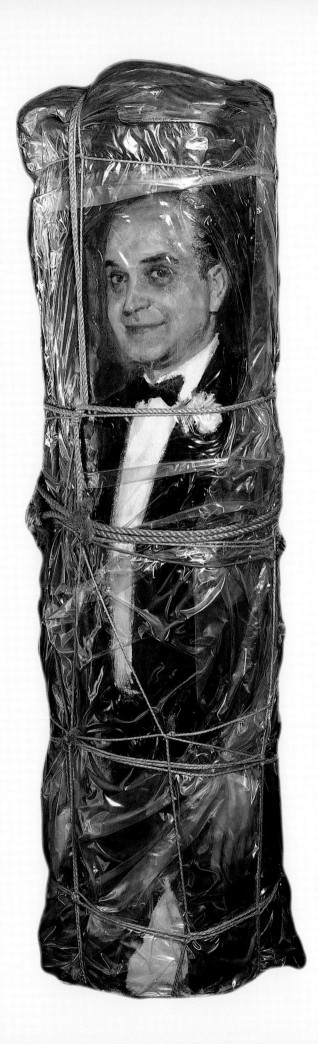

Vitrines and Store Fronts

Gradually Christo moved away from the object, a shift that came about empirically as a result of anxious work, and not as the result of planning. In 1963 he made a group of *Vitrines* which, in retrospect, are of the greatest importance. These showcases had paper or fabric on the glass to hide the interiors, but electric lights inside attracted attention to the denied function of display. Christo's earlier objects had been characterized first by textural contrast and later by a substratum of organic reference in the membranes of polyethylene. With the vitrines, however, he avoided any associative elements: aluminum, glass, fabric, paper, electric light were used straight, in a way that prefigures all his subsequent work.

In New York in 1964 Christo made his first *Store Front*; it is both an extension of the *Vitrines* of the previous year and a fantastic expansion to full architectural scale. The idea of packaging now appears as the shielding of the internal space from the viewer. Christo constructed a *Store Front*, of vernacular New York design, which confronts the spectator solidly. However, the points at which we expect to enter, either by looking in the window or by opening the door, are inoperative. It is as fully sealed as the bricked-up houses that coincided with the line of the Wall in Berlin.

The early *Store Fronts* are touched by the romanticism of old New York, an effect emphasized by the tender and exact sense of human scale implicit in the architecture which Christo scrupulously preserves. The *Store Fronts* radiate a kind of suspense, as if the blocked windows or the closed door might admit one if you only knew the hours of opening. However, our perceptual and physical links are arrested as the invitation stays unfulfilled. What Christo has done is to turn physical space into psychological response, as the façade becomes a wall, absolutely canceling the inside.

In 1965–66 the development of the *Store Fronts* paralleled that of the packages and moved to a stricter, harder form. The later façades are more severe and less diverse in color. Christo evokes the mid-century production line rather than the nineteenth-century craftsman as the source of form. It is worth remarking, as a sign of Christo's tact (which is a short word for unostentatious thoroughness), that the style characteristics of both types of store front are inconspicuous. The older architectural forms have a minimum of specific ornamental details and the new *Store Fronts* have the anonymity of standard parts. […]

The early packages were domestic in scale, but soon expanded from table tops to the hardware of transportation, culminating in 1963 with the wrapping of a Volkswagen. In the following year he began, with the *Store Fronts*, to play with the paradoxes of inside-outside space. In the studio or gallery, space is suddenly reversed, as the spectator confronts the one-sided, faithfully-scaled stores; doors, windows, fascias, all human in scale, but not serving as an outlet for goods. The result is not a frustration of consumer expectation, but an experience of re-contextualization. […]

The *Store Fronts* have subtle correspondences with the space of urbanism, as well as being one-to-one replicas of architecture's human scale. For instance, it is psychologically true that we experience most buildings that are sited directly on the sidewalk mainly in terms of the first story; the second floor and above are virtually invisible. Hence the store front (or the foyer) is, in itself, the best known, the most public zone of a building; the threshold is the focus of attention. Thus, when Christo seals his show windows with fabric sheets or with paper, he cancels the internal space that we anticipate and defines space as what is between us and the glass. The spectator's investigative, voyeuristic impulse is converted into an experience of himself, as an object in space.

Excerpts from Lawrence Alloway, *Christo*, Verlag Gerd Hatje, Stuttgart, 1969. Edited and updated by Susan Astwood, June 2000.

64

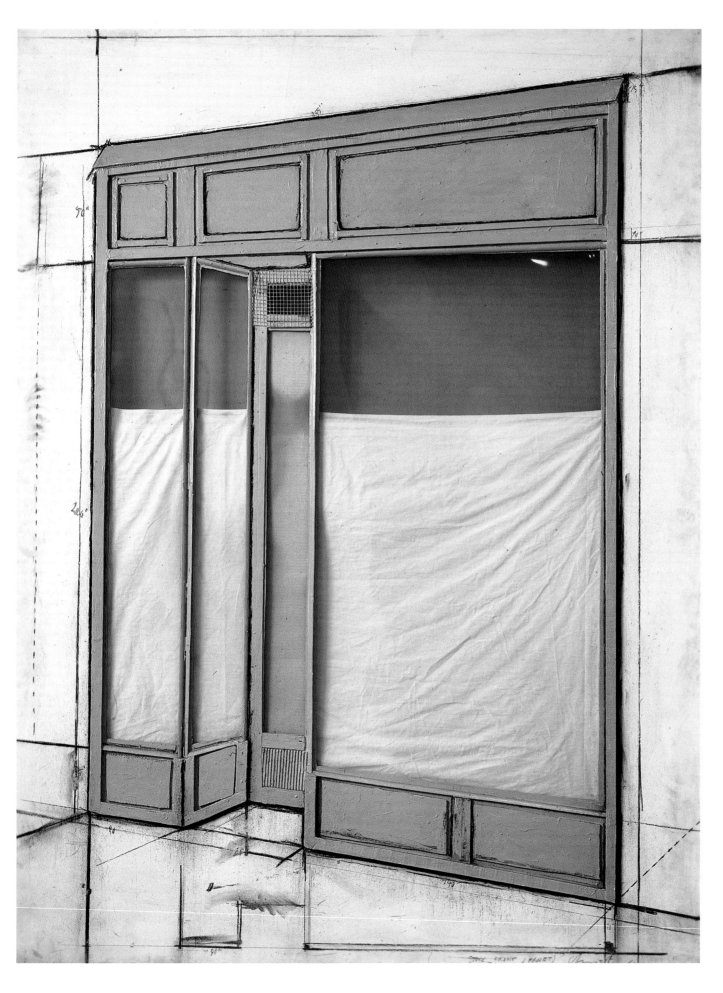

26.
Store Front, Project
Collage, 1964

66

27.
Store Front, Project
Collage, 1964

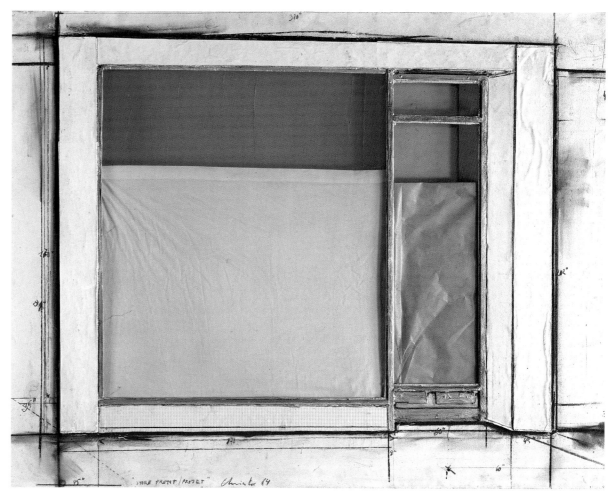

28.
Double Store Front, Project
Collage, 1964

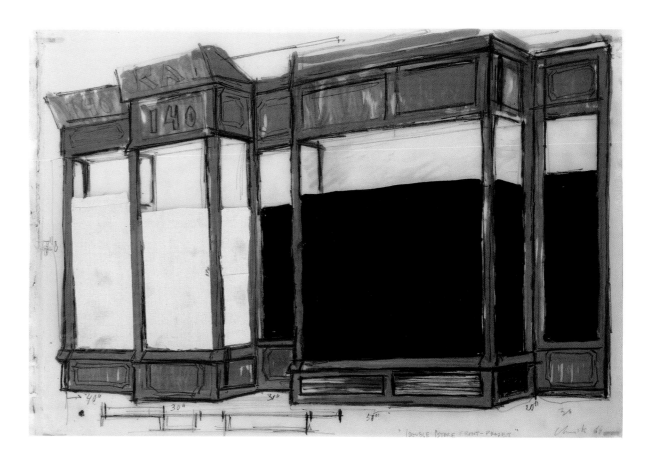

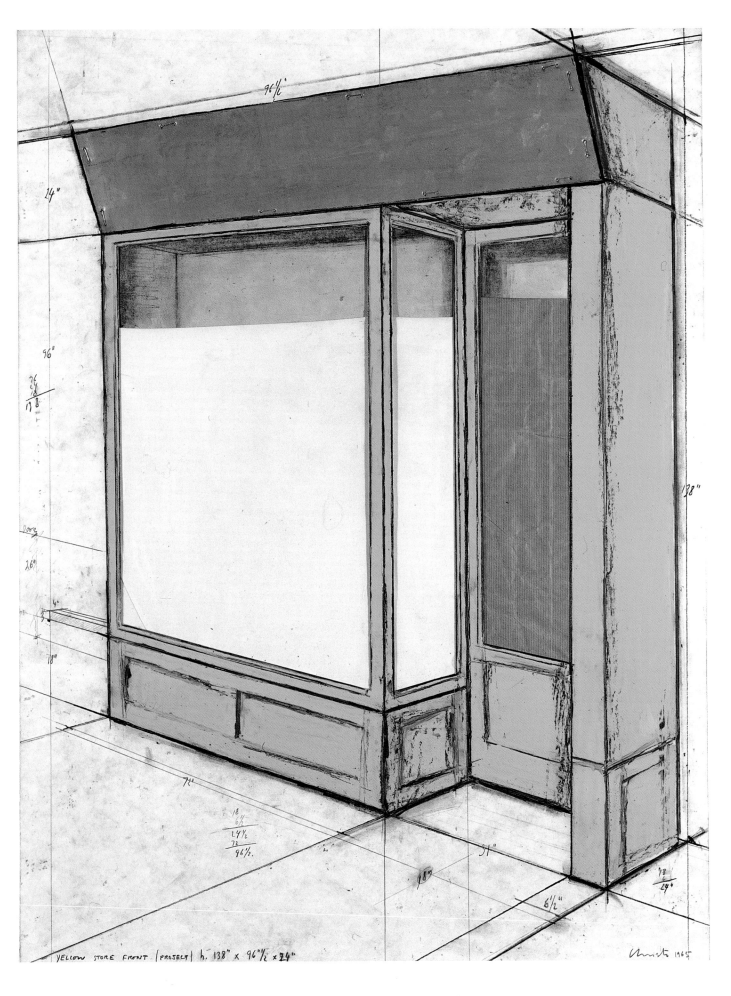

29.
Yellow Store Front, Project
Collage, 1965

68

YELLOW STORE FRONT (PROJECT) h. 138" x 96"½ x 24" Christo 1965

30.
Yellow Store Front
1965

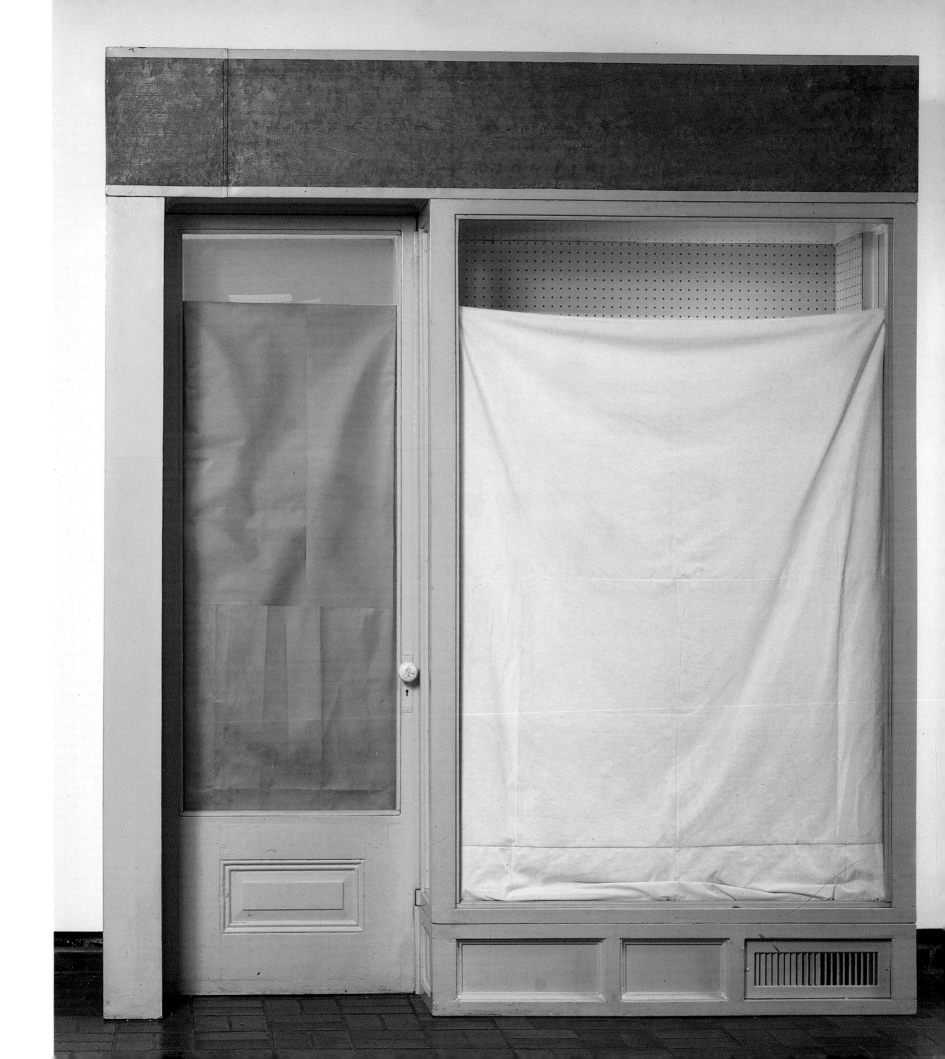

**Three Store Fronts, Project for the
Stedelijk Van Abbemuseum, Eindhoven,
Holland**
Collage, 1965–66

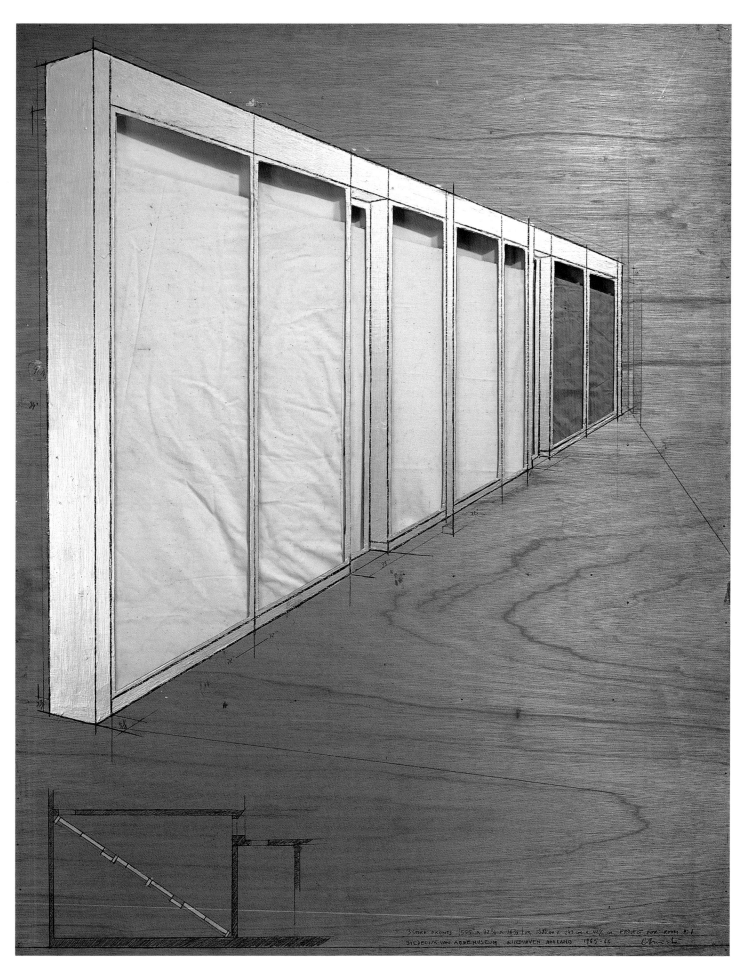

70

Double Show Window
1965–66

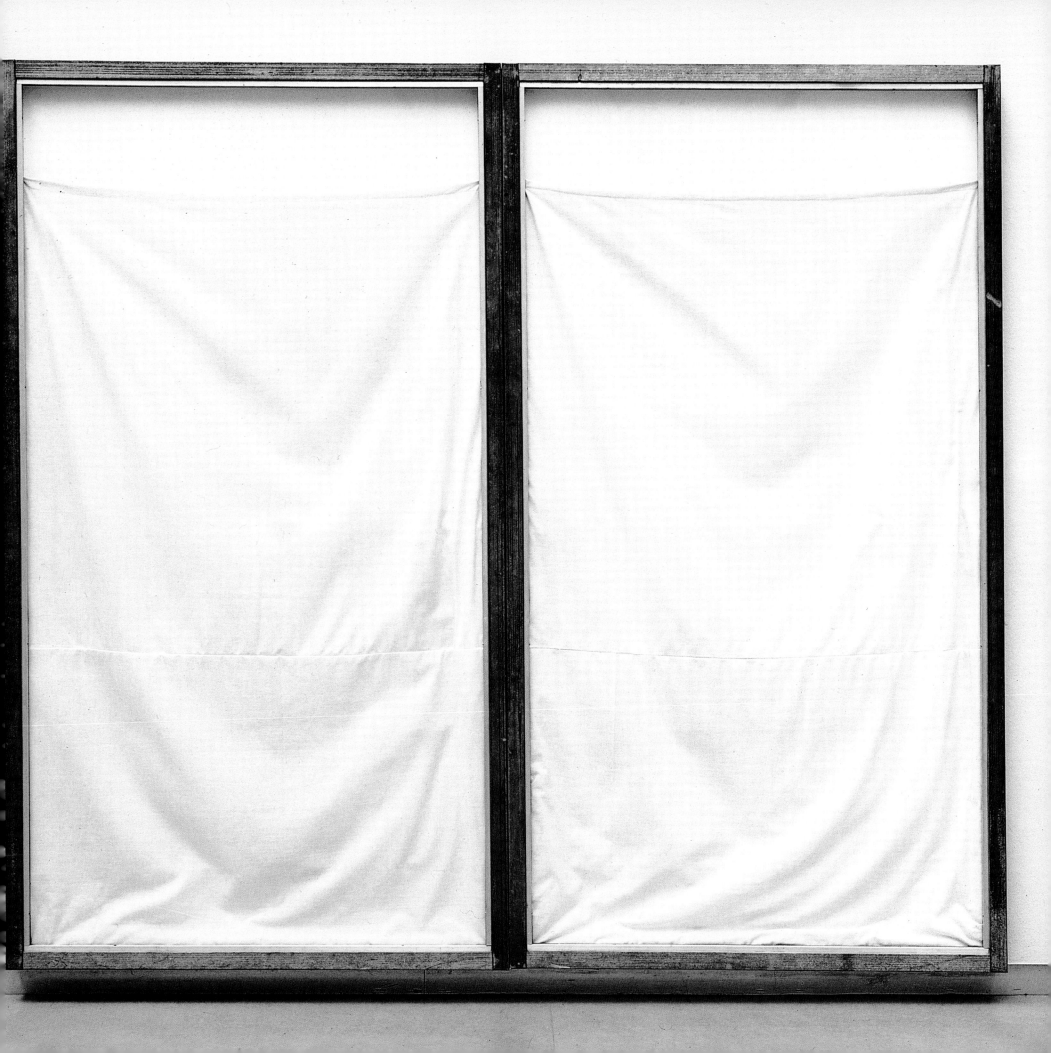

Wall of Oil Barrels, The Iron Curtain, Rue Visconti, Paris, 1961–62

During 8 hours on the evening of June 27, 1962, Christo and Jeanne-Claude closed the Rue Visconti with 240 oil barrels.

The art barricade was 4.3 × 3.8 × 1.7 meters (14 × 12.5 × 5.6 feet). It obstructed most of the traffic of the Paris Left Bank.

The artists did not alter the industrial colors of the oil barrels, leaving the brand names and the rust visible.

Rue Visconti is one of the narrowest streets in Paris. Since the sixteenth century many illustrious tenants lived in the houses of the Rue Visconti, such as [Jean] Racine, Adrienne Lecouvreur, [Ferdinand-Victor-Eugène] Delacroix and [Honoré de] Balzac.

The Berlin Wall had been built in August of 1961 and Algerian War protest demonstrations and barricades were taking place in Paris at the same time as Christo and Jeanne-Claude created their temporary work of art.

Text from Christo and Jeanne-Claude for a permit application to the French governmental agency - The Paris Préfecture

Project for a Temporary Wall of Oil Barrels
Rue Visconti, Paris VI·

Rue Visconti is a one-way street, between Rue Bonaparte and Rue de Seine, 176 meters long with an average width of 4 meters. The street ends at number 25 on the left side and at 26 on the right. It has few shops: a bookstore, a modern art gallery, an antique shop, and electrical supply shop, a grocery store. "At the angle of Rue Visconti and Rue de Seine, the cabaret du Petit More (or Maure) was opened in 1618. The poet [Antoine Gérard de] Saint-Amant, an assiduous customer, died there. The art gallery that now stands on the site of the tavern has fortunately retained the façade and the seventeenth-century sign" (Rochegude and Clébert, *Promenades dans les rues de Paris. Rive Gauche*, Denoël, Paris, 1960, p. 134).

The *Wall* will be built between numbers 1 and 2, completely closing the street to traffic, and will cut all communication between Rue Bonaparte and Rue de Seine.

Constructed with 50 liter capacity oil barrels, the *Wall* will be 4.3 meters high, and will be as wide as the street: 3.8 meters.

This Iron Curtain can be used as a barricade during a period of public work in the street, or to transform the street into a dead end. Finally its principle can be extended to a whole area or an entire city.

Christo and Jeanne-Claude, Paris, October 1961

Wall of Oil Barrels, The Iron Curtain, Rue Visconti, Paris, 1961–62

Oil drums: street blockades and temporary monuments

In 1958, Christo began working with oil barrels, because they were the largest containers he could find that were both unbreakable and cheap. Since then, he has stacked numerous barrel structures sometimes with the intent to create massive, freestanding forms, and sometimes with the intent to create environmental obstructions. At the beginning, Christo and Jeanne-Claude were living on the Ile Saint-Louis and Christo was doing most of his work in a tiny studio, a former maid's room, on Rue de Saint-Senoch. Buying used oil barrels from drum yards, he carried the dirty barrels one by one to his seventh-floor studio. There, he cleaned and wrapped them, then carried them down seven flights and over to Avenue Raymond Poincaré, where he stored them in a cellar that had been put at his disposal by Jeanne-Claude's parents. Over the months, the cellar accumulated stacks of wrapped and unwrapped barrels, plywood boxes, and packed bottles, becoming the environmental collection of containers that Christo called *Inventory*. […]

In conjunction with his first personal exhibition in 1961 at the Haro Lauhus Gallery in Cologne, Christo exhibited his first outdoor barrel structures. The gallery was very near the Cologne waterfront where Christo sighted several stacks of oil drums, cardboard barrels, and paper rolls. Viewing them as familiar art materials, he instantly recognized their sculptural possibilities and set about "borrowing" them. Rearranging the piles of cardboard barrels and rolls of paper, he proceeded to shroud them in tarpaulin, which he secured with cord. The tarpaulin, which served to protect the paper and cardboard against exposure, was borrowed from the dockworkers, who received a generous tip from the artist for their cooperation and patience.

The large assemblages of oil drums that they used along the Cologne waterfront were hardly distinguishable from the ordinary stockpiles that are ubiquitous harbor-side presences. Because of the visual similarity to longshoremen's work, it almost appeared that the artists had merely photographed "found" stockpiles, but this was not the case. All had been composed, rearranged, or at least altered by the artists, who, in order to manipulate these bulky materials, utilized a number of construction machines, including tractors, hoists, and cranes. The structures were an early indication of Christo and Jeanne-Claude's predilection for creating sculptures that almost pass for ordinary phenomena that one scarcely notices in everyday life. […]

[But the first true intervention realized in a public space was] Christo and Jeanne-Claude's wall of 240 oil drums, which they called *Le Rideau de Fer* or *Iron Curtain*, that they erected in the Rue Visconti on Paris's Left Bank in 1962. On this street, which dates back to the sixteenth century, nearly every address can boast of illustrious former tenants, such as [Jean] Racine, Adrienne Lecouvreur, [Ferdinand-Victor-Eugène] Delacroix, and [Honoré de] Balzac. Christo and Jeanne-Claude chose Rue Visconti not because it is so rich in historic lore, but because it is one of the narrowest streets in Paris. It is a one-way street, as well as a principal cross street between two main arteries to the Right Bank. Consequently, for eight hours on the evening of June 27, the blockade, which was nearly 14 foot high, thoroughly obstructed all traffic not only in the Rue Visconti, but in several surrounding streets as well.

The wall of barrels [hence took on an effect] similar to the packages, which rob objects of their usefulness – it denied and canceled out the utilitarian function of the street. The *Iron Curtain* was also a comment on the Berlin Wall, which had been constructed in August, 1961. Because of their standardized shape and serial arrangement, the stacked barrels focused attention on the often chance harmonies of colors, rust, paint, and metal. By leaving the brand names visible, they blocked any symbolic interpretations and reinforced their literalist use. The artists did not alter the color of the barrels (each oil company uses a different color), so the overall structure had a dappled surface, almost like a hugely enlarged detail from a Pointillist painting. […]

[Nonetheless, one has to bear in mind that despite the importance of the planning stages] the main focus of Christo and Jeanne-Claude's activity is always the end result rather than on the process, and while the manifestation may be brief enough to qualify as an "event", it is by no means a Happening. […] "All Happenings are make-believe situations", Christo says. "Everything in our work is very strongly literal. If three-hundred people are used, it is not because we want three-hundred people to play roles, but because we have work for them. […] If we use cranes, it is to do real work, and the crane man must be conscientious or it will not work. Our work may look very theatrical, but it is a very professional activity."

Excerpts from David Bourdon, *Christo*, Harry N. Abrams, New York, 1970. Edited and updated by Susan Astwood, June 2000.

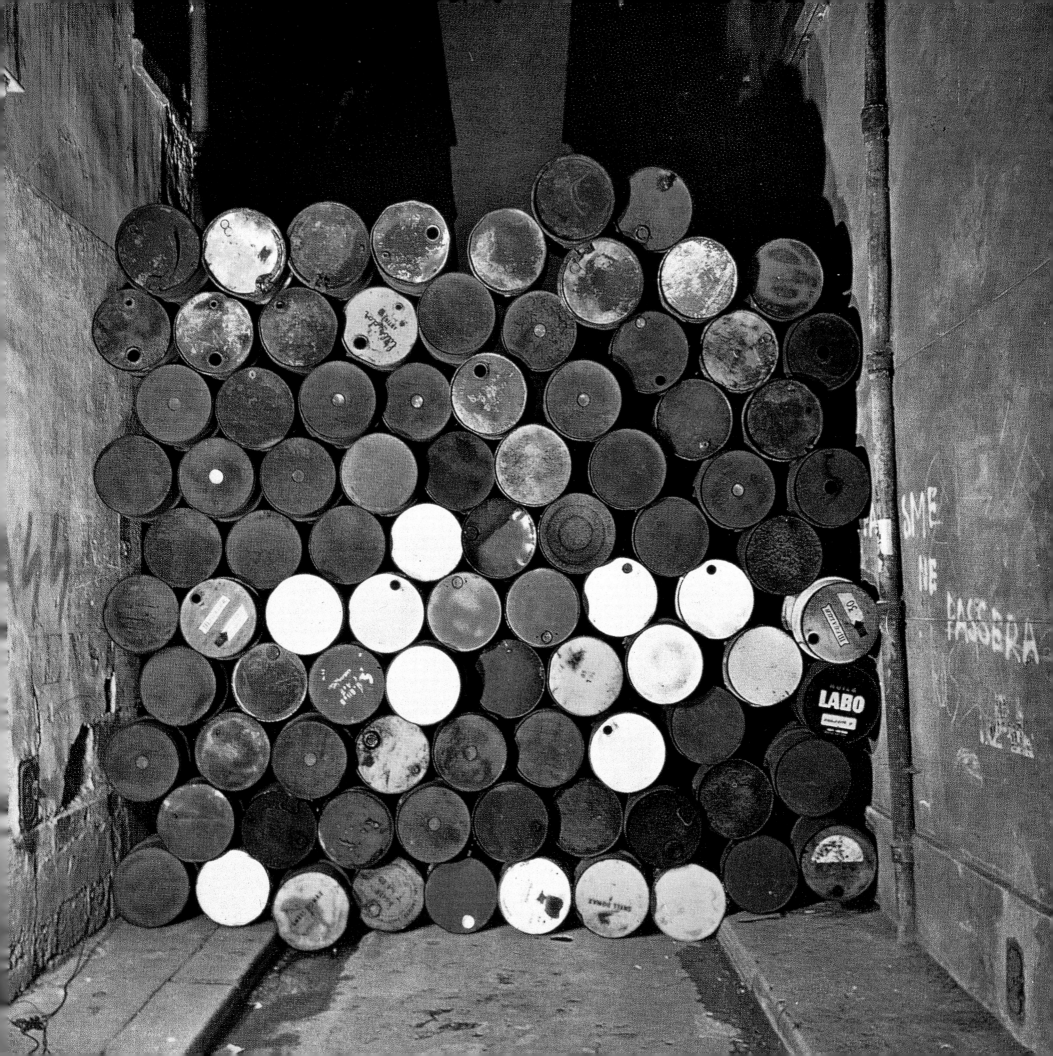

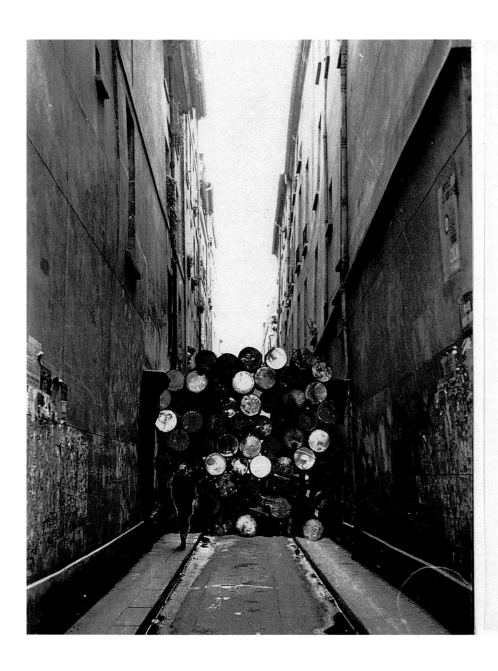

PROJET DU MUR PROVISOIRE DE TONNEAUX METALLIQUES
(Rue Visconti, Paris 6)

Entre la rue Bonaparte et la rue de Seine, la rue Visconti, à sens unique, longue de 14o m., a une largeur moyenne de 3m. Elle se termine au numéro 25 à gauche et au 26 à droite.

Elle compte peu de commerces: une librairie, une galerie d'art moderne, un antiquaire, un magasin d'électricité, une épicerie... "à l'angle de la rue Visconti et de la rue de Seine le cabaret du Petit More (ou Maure) a été ouvert en 1618. Le poète de Saint-Amant qui le fréquentait assidûment y mourut. La galerie de peinture qui remplace la taverne a heureusement conservé la façade, la grille et l'enseigne du XVII ème. siècle" (p.134, Rochegude/Clébert - Promenade dans les rues de Paris, Rive gauche, édition Denoël).

Le Mur sera élevé entre les numéros 1 et 2, fermera completement la rue à circulation, coupera toute communication entre la rue Bonaparte et la rue de Seine.

Exclusivement construit avec les tonneaux métalliques destinés au transport de l'essence et de l'huile pour voitures, (estampillés de marques diverses: ESSO, AZUR, SHELL, BP et d'une contenance de 5o l. ou de 2oo l.) le Mur, haut de 4 m., a une largeur de 2,9o m. 8 tonneaux couchés de 5o l., ou 5 tonneaux de 2oo l., en constituent la base. 15o tonneaux de 5o l., ou 8o tonneaux de 2oo l. sont necessaires à l'éxécution du Mur.

Ce "rideau de fer" peut s'utiliser comme barrage durant une période de travaux publiques, ou servir à transformer définitivement une rue en impasse. Enfin son principe peut s'étendre à tout un quartier, voir à une cité entière.

C H R I S T O
Paris, Octobre 1961

77

**56 Oil Barrels Construction, Project for
Martin and Mia Visser**
Drawing, 1967

78

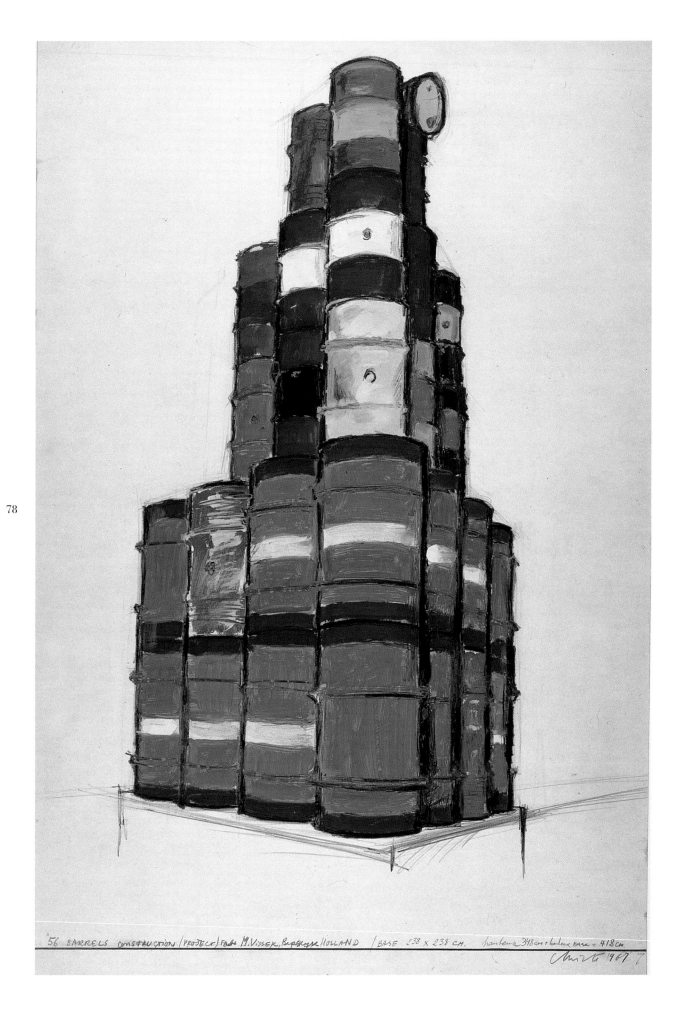

'56 BARRELS CONSTRUCTION (PROJECT) FOR M.VISSER, BERGEYK HOLLAND / BASE 238 X 238 CM. hauteur 348cm+hauteur base = 418cm

Christo 1967

35.
Study for 8 Barrels Construction
Sent by Mail
Drawing, 1967

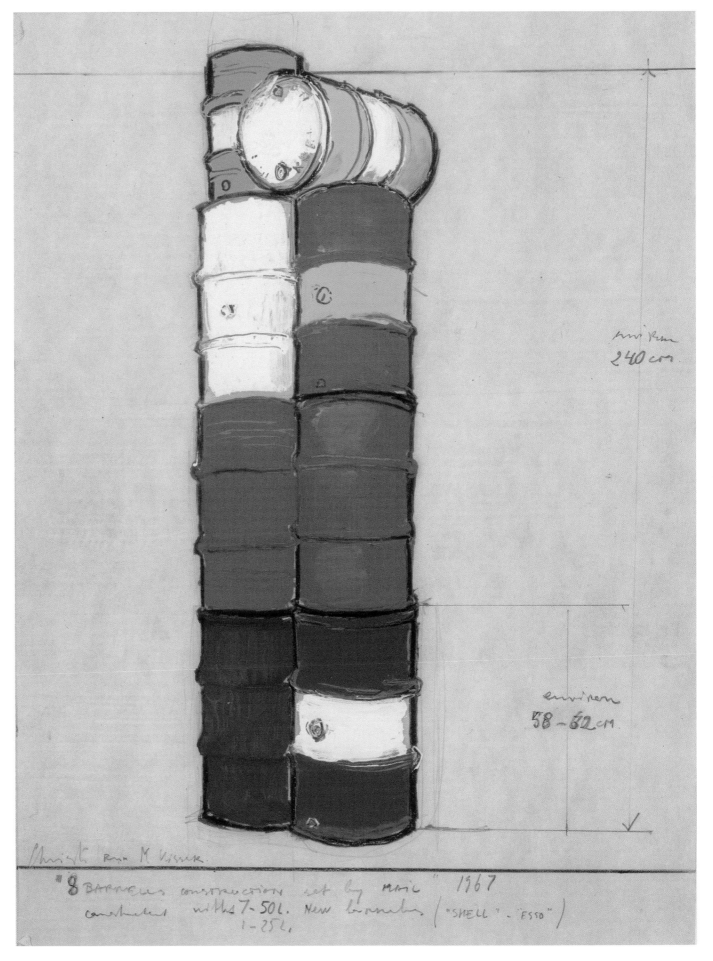

36.
28 Barrels Structure, Project
Drawing, 1968

37.
28 Barrels Structure
1968

"28 BARRELS STRUCTURE — 50 LITRE EACH BARRELS — AGIP, SHELL, ESSO and BP ! Christo 1968

80

273 cm

273 cm.

39 cm

59 cm.

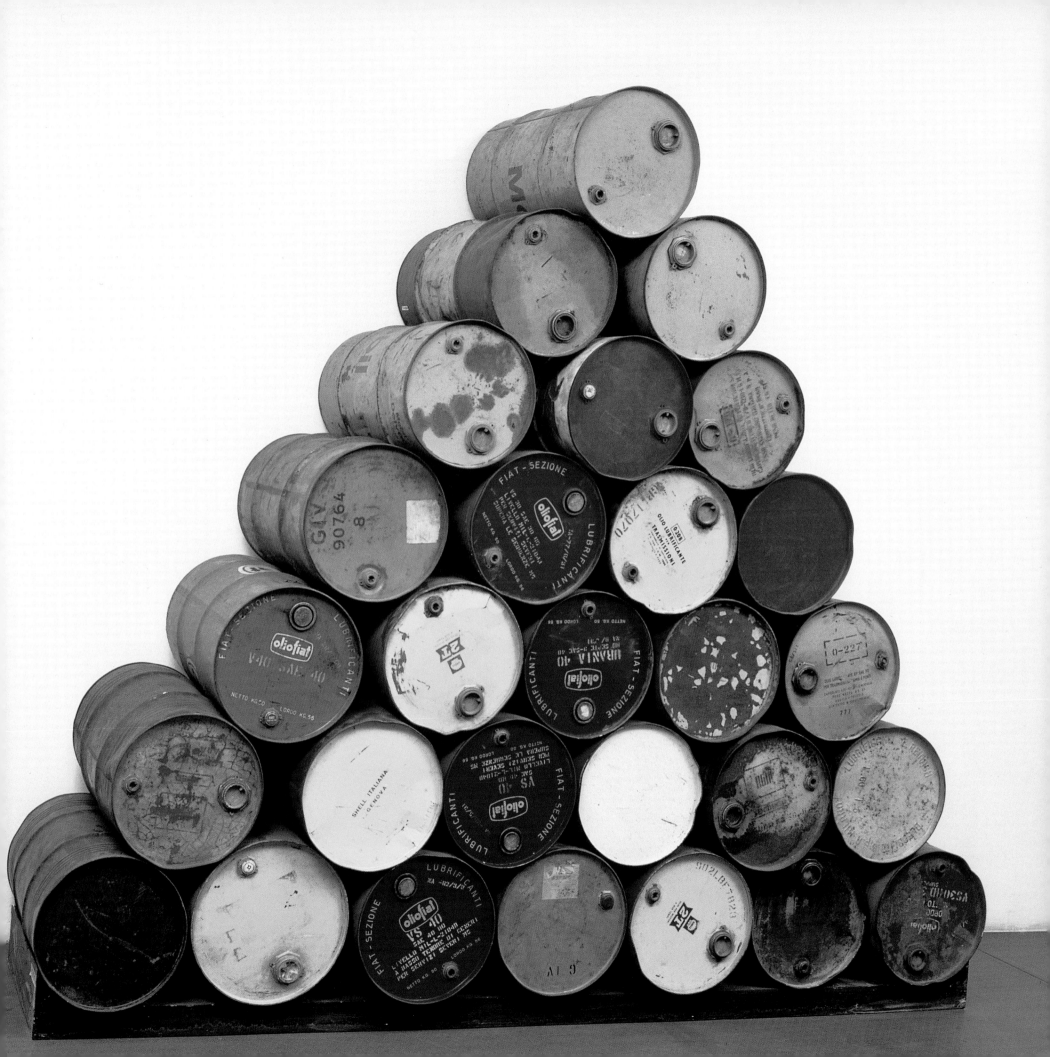

Projet d'un édifice public empaqueté, 1961

Temporary Monuments

Christo and Jeanne-Claude made other Temporary Monuments, in addition to the Rue Visconti Wall: in Cologne and in Gentilly. These works, improvised with urban waste (the only material available in sufficient numbers or sufficient bulk) were accompanied by projects for work on a bigger scale, without the materials of junk culture.

In 1961 Christo drafted a *Projet d'un édifice public empaqueté*, to be "completely enclosed because wrapped on every side. The entrances [would have been] underground, placed about fifteen or twenty meters from the building. The packaging [...] of rubberized tarpaulin and plastic material [would have been] reinforced at average intervals of ten to twenty meters, by steel cables and ropes. The wrapped building could [have been] used as:

1. Stadium with swimming pools, football field, Olympic stadium or hockey and ice-skating rink,

2. Concert hall, conference hall, planetarium or experimental hall,

3. Historical museum, of recent or modern art,

4. Parliament or prison".

[This statement] is a clue to another aspect of Christo's aesthetics, which has to do with the location of meaning, usually regarded as the central value of art, transmitted by the artist and received by the spectator. In architectural terms, however, Christo proposes to locate meaning in the subsequent usages of a building, and speculates on what these might be. Similarly in his objects and thresholds he is creating a situation in which meaning is in the variables of the spatial experience of the spectator and cannot be predicted accurately by the artist. Thus meaning follows the making of the work of art, instead of preceding it, or growing with it.

Christo's category of Temporary Monuments is important, an acknowledgment, among others in the post-war period, that the value of art is not exclusively bound to ideas of fixity or permanence. He has accepted a temporary status for his art when he has packaged whole trees, which will die and shrink, or girls whose tolerances of their mantles is limited. Other temporary situations were Christo and Jeanne-Claude's arrangements of oil barrels, on the docks in Cologne and in the street. The aesthetic of an expendable art is no less serious, no less rigorous, than that attached by idealist art criticism to supposedly immutable works.

The huge scale at which Christo and Jeanne-Claude are now able to work presumes impermanence. The art is occasional, but our involvement with an occasion can be as satisfactory, as absorbing, as with art of a hypothetical permanence.

In 1968 Christo and Jeanne-Claude wrapped the Kunsthalle, Bern, to celebrate the museum's fiftieth anniversary; the nature of the building provided the occasion. At Spoleto, Christo and Jeanne-Claude wrapped two buildings, on the occasion of the city's festival.

At Kassel, for Documenta 4, Christo and Jeanne-Claude demonstrated their capacity to work on a huge scale, not by covering an existing structure, but by creating an entirely new form. The *5,600 Cubicmeter Package* is a 279-foot high fabric envelope with a diameter of 33 feet. It was designed by the artists in consultation with Mitko Zagoroff, an engineer at Massachusetts Institute of Technology. [...]

One advantage, or beauty, of the artistic process since the sixteenth century has been that it is a situation of total control; all decisions, conceptual or technical, originate with the artist. To work on the scale of the *5,600 Cubicmeter Package*, on the contrary, involved other people beside the artists, from the planning to its building. The artists are thus engaged socially, in a way dissimilar from the traditional studio situation. [...]

[The artists] have found a way of making current art operate on the scale of the city, without resorting to covert forms of Baroque monumentality, as in most new works intended for public sites. They propose, as a reality, a new spatial scale for art which would at least match, in duration and area, a carnival or a play. [...]

[In the same way one can assert that] Christo and Jeanne-Claude's monuments are important because they realize, in terms of objects, a scale which otherwise remains largely untouched in art, except in later Happenings. [...] The problem is to get art on the new scale out of the project stage into the realm of objects and events (without just littering up the world with bigger Henry Moore's and Alexander Calder's). Christo and Jeanne-Claude do this, without any softening of the line their art was following before they went public.

Excerpts from Lawrence Alloway, *Christo*, Verlag Gerd Hatje, Stuttgart, 1969. Edited and updated by Susan Astwood. June 2000.

38.
Projet d'un édifice public empaqueté
Collage, 1961

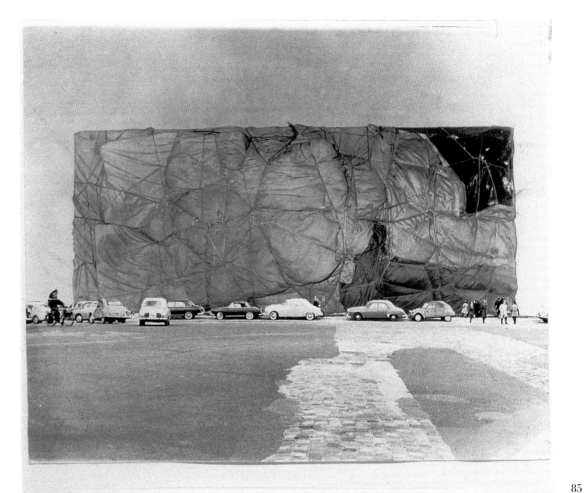

PROJET DE UN EDIFICE PUBLIC EMPAQUETE

I. Notes générales:
Il s'agit d'un immeuble situé dans un emplacement vaste et régulier.
Un bâtiment ayant une base rectangulaire, sans aucune façade.Le bâtiment sera completement fermé-c'est à dire empaqueté de tous les côtés. Les entrées seront souterraines, placées environ à 15 ou 20 metres de cet edifice. L'empaquetage de cet immeuble sera éxécuté avec des bâches des toiles gommées et des toiles de matiere plastique renforcée d'un largeur mouenne de 10 à 20 metres, des cordes métalliques et ordinaires. Avec les cordes de métal nous pouvons obtenir les points, qui peuvent servir en suite à l'empaquetage de bâtiment. Les cordes métalliques évitent la construction d'un échafaudage. Pour obtenir le resultat nécessaire il faut environ 10000 metres de bâches, 20000 metres de cordes métalliques, 80000 metres de cordes ordinaires.
Le present projet pour un edifice public empaqueté est utilisable:
I.Comme salle sportive-avec des piscines, le stade de football, le stade des disciplines olimpiques, ou soit comme patinoire à glace ou à hockey.
II.Comme salle de concert, planetarium, salle de conférence et essais expérimentaux.
III.Comme un musée historique, d'art anciéne et d'art moderne.
IV.Comme salle parlementaire ou un prison.

CHRISTO
octobre 1961, Paris

Projects from 1968 to Today

The Fascination of Ephemeral Projects

Werner Spies

The present exhibition amounts to a stocktaking of astonishing, truly baffling proportions. It features some of the monumental projects undertaken over the past four decades by Christo and Jeanne-Claude – often in face of universal resistance. Were it not for the eye-witnesses, the photographs and films that preserve after-images of these compelling, unforgettable mirages, one might well doubt the reality of these achievements. One is tempted to speak of a sort of game played with the category of Wonders of the World, of visual superlatives. Perceptual experiences, alienations, enjoyments, diversions created with entirely disproportionate effort – these are apparent on first glance and need no further interpretation. One is put in mind of the marvelous images which the Surrealists pursued with an eye to disrupting common sense reality, or of the gigantic, skyscraping helmet that suddenly crashed down into the courtyard of Horace Walpole's *Castle of Otranto*. Or one is reminded of Salvador Dalí's compulsive notion of making a full-scale bronze casting of the Place de l'Opéra in Paris, complete with opera house and surrounding buildings, pedestrians, dogs and automobiles.

The surprises Christo and Jeanne-Claude confront us with reflect a provoking and paradoxical vision. Their effect is ultimately surreal, simply because what we see puts logic and causality out of joint. Their works negate function and utility. In his novel *Man without Qualities*, Robert Musil once described the effect caused by this type of change and alienation. At one fell swoop, everything familiar is called into question. Musil writes, "Normally a herd of cattle means no more to us than beef out to pasture. Or a picturesque subject against a background. Or we hardly notice it at all. Herds of cows by mountain paths belong to the mountain paths, and one would never become aware of what one feels at the sight of them unless an electric standard clock or a toll station stood in their place".

Yet as a review of twentieth-century art shows, works that even slightly exceed the normal scale of sculpture are rare. It is almost solely in cases where an artist doubles as his own patron (as in the Palais Idéal by the postman Cheval, or the Watts Towers by Simon Rodia) that the resulting work attains to monumental proportions.

Beyond imagination

All of these herculean tasks performed by Christo and Jeanne-Claude challenge us to forsake pragmatic, habitual perception and experience and become receptive to things and atmospheres that have nothing to do with utility or consumability. This is also the reason why, in the initial phases of a project, resistance to the artists is so aggressive and hysterical. They suggest putting into practice things that appear senseless to a normal way of thinking and the priority it attaches to efficiency. Yet again and again, as soon as the phase of realization has begun, the critics fall silent. Even Christo and Jeanne-Claude's most vitriolic opponents are converted into proselytes. Perhaps this is because the visions they have made reality between Australia and California, Paris and Japan, Berlin and New York, far surpass any notion of what can emerge in a studio, or from a studio. All of their projects appear to be fueled by fantasies, and yet on closer scrutiny one can detect no interest in utopias on the part of Christo and Jeanne-Claude. At a precise moment, something that appears unimaginable and entirely unfeasible is swept away by an irrefutable reality. And the artists' efforts always concentrate on what is possible, technically feasible. This explains why they have almost never tackled anything that might elude practical execution. Still, every project that has resulted from their decades-long collaboration represents the translation of an idea that initially existed only in their minds. From this point of departure they develop a precise agenda. Behind every envisioned project

lies a thorough knowledge of topography, meteorology, and the social environment on which the finished work will depend. Each project begins with a study of materials and their tensile strength, wind velocities, the design of moorings that must be constructed and anchored in the ground. Each time, different techniques are employed. Because each project presents new problems that require new solutions. In other words, Christo and Jeanne-Claude's activities in advance of a project amount to feasibility studies.

From early on, the artists' approach has excluded anything that might smack of commissioned work. Their desires and decisions are impervious to outside influence. At most, Christo and Jeanne-Claude agree to inspect a certain site with an eye to creating a project there, as in the case of the *5,600 Cubicmeter Package, Documenta 4, Kassel, 1967–68* or *Wrapped Kunsthalle Bern, 1968* for the art museum of that name. Yet they insist that the form of the envisaged work be left entirely up to them. Nor do they cater to public tastes or expectations. The stringency of their attitude goes very far. In an interview published in the French daily *Le Monde* on the occasion of *The Gates, Central Park, New Yok City, 1979–2005*, Christo and Jeanne-Claude stated, "We never think of the public. Artists create for themselves. If somebody else likes it, it's a plus. But we do this for ourselves"[1]. Nor – and this is a highly crucial point – do they permit their works to be usurped by advertisers. In the course of their dealings with sponsors, the artists have declined highly lucrative offers. The issue of the financing of their projects is raised again and again. It is difficult to convince a broad public that these gigantic projects are in fact paid for by the artists themselves. They are repeatedly suspected of accepting public or corporate money. But Christo and Jeanne-Claude have managed to refute such allegations every time. Quite the contrary, the artists function as free enterprisers, as their own sponsors, so to speak. The capital required to execute a project is raised through the sale of collages, drawings, and the early works of the 1950s and 1960s. Also important in this connection are the employment opportunities generated by a project. As the artists point out, they provide work for many people over a period of weeks, and additionally finance a certain number of longer-term jobs. It is also part of their independence that the products offered in connection with their large-scale projects – the souvenirs – are not sold for Christo and Jeanne-Claude's benefit. In this case, too, manufacturers, charitable institutions, printers, and agents are the only ones who profit from the couple's fertile imagination.

The political and social message

In all of their activities, the artists' prime concern is for the greatest possible degree of liberty and self-responsibility. This stance, based on the autonomy of the artist and mistrustful of incursions on the part of organizations and governments, reflects one of Christo and Jeanne-Claude's most fundamental beliefs. Their inordinate desire for freedom and independence largely goes back to Christo's early experiences in Communist Bulgaria. His dislike of public commissions represents a reaction to the state regimentation and official aesthetic with which he had to cope in his young years in Sophia. Yet memories of these years have also had crucial positive effects on his later oeuvre. As a student at the Sophia Fine Arts Academy, Christo Javacheff already developed a taste for short-lived memorabilia of the kind that would become the subject of his large-scale projects. He and his fellow students were sent to the cooperative farms to advise the farmers how to park their tractors and combines well in view for passers-by on the Orient Express. These fictitious flourishing business operations were intended to demonstrate the superiority of the Socialist order to travelers from capitalist countries. By his own account, this experience of deception à la Potemkin profoundly shaped Christo's approach.

His profound belief in artistic independence can be traced back to his first Paris years and the discovery of Dada and Surrealist autonomy. Christo settled in what was then still the world capital of art in 1958, after emigrating from Bulgaria and spending a semester at the Vienna Fine Arts Academy. In Paris emerged the first *Packages* and *Wrapped Objects*. The earliest larger-scale projects included the barricade of different colored oil barrels with which Christo and Jeanne-Claude blocked entry to Rue Visconti in 1962. It is intriguing how the idiom of Pop and Nouveau Réalisme was combined here with a political, ideological statement. The barricade can surely be seen to allude to the building of the Berlin Wall and to the artist's earlier life behind the Iron Curtain. An involvement with the work of Man Ray and of Marcel Duchamp proved crucial as well. Yet lurking behind the poverty of materials, the worn and battered nature of the early works, there was obviously that nausea triggered by the stuff of this world which, preached by Jean-Paul Sartre, was the philosophy of Paris at the time. Nothing, not even the creviced and fissured surfaces of Alberto Giacometti's faces and Jean Fautrier's relief paintings, could have expressed the faulted idealism of the post-war period more strongly by its very absence. Christo's concrete, ultimately engaged works were new for the

French scene of the day, since Art Informel and Op Art had largely driven subject matter of any kind out of the studios. The staging in the midst of the French capital decisively rejected any form of government regimentation. Christo and Jeanne-Claude completed their daring project with lightning speed, unimpressed by regulations, under the eyes of officials and police. The factor of time, rapidity of execution, would in fact make an essential contribution to the success of their future projects. The artists had planned their action down to the last detail. In a concerted action, the barrels were brought to the site within minutes. Seen in this light, the artists' first public appearances represented more than contributions to avant-garde art. Each work can be viewed as a didactic statement. Each formed the focus of a reflection on societal issues. Questions of ecology, of landscape protection, of the acculturation and integration of marginal social groups, obviously played a central role.

The inimitable tone
Anyone who has witnessed more than one of the large projects not only retains indelible memories of extravagant events, but recalls the unique, inimitable tone of the atmosphere surrounding each project. The completed works evince crucial technical, sociological, and aesthetic differences. This is why a review of the projects brings such an astonishing diversity to light. As the present stocktaking indubitably shows, Christo and Jeanne-Claude do not repeat themselves. Nor can any tendency to produce ever larger, more exorbitant works, or to impress viewers with sheer quantity, be detected. It is true that the enterprises they undertake must be comparatively monumental, impossible to overlook, if they are to have the desired effect. Yet setting new, statistically verifiable records is not the artists' concern. Behind their efforts stands nothing measurable, only the will to protract utopia a bit more every time. Apart from the spectacular, large-scale projects that cast their spell over millions of viewers, we find numerous smaller ones, like pieces of chamber music, which retain a proximity to the paradoxical, surrealist magic of things. These include the erotic wrapping of female bodies, fountains, and trees, or the disturbing plays on mystery lurking behind the *Show Cases* and *Store Fronts*. The sense of threat evoked by this concealment from the gaze is disquieting. The criminalistic aspect of these pieces triggers suspense, since it enables us to project our own fantasies and imaginings into things half seen and only adumbrated.

Turning now to the projects gathered in the present exhibition, *Wrapped Coast, One Million Square Feet, Little Bay, Syd-ney, Australia, 1968–69* already evinced dimensions that far exceeded anything previously seen in twentieth-century art. 1.5 miles (2.4 kilometers) of coastline were concealed beneath a special fabric secured by polypropylene ropes. And with every succeeding work, the artists took a further, surprising vantage point on places and landscapes. Whether designed for an urban location or for some distant, rural area, every project revealed the inimitable touch of Christo and Jeanne-Claude. They continually called themselves into question, attempting by means of diametrically opposed tasks to avoid repetition, the danger of "the look".

Places of memory
Twelve projects have been selected for Lugano. All of these – with the exception of *Over the River, Project for the Arkansas River, Colorado* – have been completed. *Over the River* is earmarked for 2009 at the earliest in the artists' schedule. The exhibition shows the phases through which each project runs. There is a succession of three, clearly distinct periods: preparation, completion, and finally the memory of the frenetic days of finishing the project, carefully recorded in books and films. For after a project is over, it vanishes from the site without a trace. What remains is a scene bristling with clues, a two-dimensional sculpture reduced to drawings and photographs. In many cases, long years of preparation were necessary, and some projects – such as *The Pont Neuf Wrapped, Paris, 1975–85, Wrapped Reichstag, Berlin, 1971–75*, and *The Gates* – even required decades. Such long-term deadlines are a measure of the resistance triggered by Christo and Jeanne-Claude's suggestions. Not coincidentally, the resistance to projects for urban sites has been far greater than that to rural ones. Too diverse and powerful are the various interest groups that involve themselves in the negotiations. In every case, the artists' patience and stamina have been put to a hard test. And always Christo and Jeanne-Claude have triumphed over the timidity and resistance of their erstwhile opponents. As this indefatigable desire to put their ideas into practice indicates, they are solely concerned with translations into reality, not with a mere accumulation of conceptual works. This is why the designs made in the studio, which provide the basis of discussion, always remain related to a specific site and an envisaged execution.

The voluntary and pragmatic aspect of these artists' approach, a free-enterprise undertaking independent of any intermediary gallery, was bound to draw attention in a country like

the United States. A case in point was the reaction of the *New York Times* to *Surrounded Islands, Biscayne Bay, Greater Miami, Florida, 1980–83*. The prestigious paper devoted page one to photographs of this work in progress in Miami. Probably never before in the paper's history was a living artist given such a place of prominence. The reasons behind this page-one appearance are revealing. For the first time, a bank granted a high loan to enable a project for which the artists themselves intended to raise over three million dollars through the sale of drawings, collages, and early works. The loan was underwritten by Citibank. And the artists' own investment suddenly catapulted them into the company of the largest US private institutions involved in the furtherance of art. After Exxon and Philip Morris, wrote *The Wall Street Journal*, the Christo corporation ranked number three. This stupendous combination of planning, private financing, and execution was recognized as a sign of the inimitable and innovative character of Christo and Jeanne-Claude's method.

The works on view here have found a place in the collective memory. They have enjoyed publicity of unprecedented scope. Hardly anyone is capable of resisting the magnetism of news about Christo and Jeanne-Claude. This interest began very early on. Back in 1976, the *Los Angeles Times* noted the following about the media reaction to *Running Fence, Sonoma and Marin Counties, California, 1972–76*: "By now most media-consumers know about Christo's *Running Fence*. In case you've been in a coma this month, the project consists of sections of heavy white fabric put together to form a curtain nearly 24 miles long and 18 feet high in rural Northern California". Each project consists of many parts. On the one hand, the drawings and collages reflect the preparations, introduce the project to the audience in detailed form. On the other, the finished works live on in books, films and documentations. The artists place great store in making a seamless record of their working process, since it provides evidence for future, more skeptical generations that these large-scale undertakings were in fact realized and not simply simulated on an editing table. The designs produced in the studio show how the artists conceived the work. They also familiarize us with numerous technical details, which in the course of time and actual involvement with the project are ever more precisely defined. Slight modifications in planning, a concern with alternative textiles or colors, are recorded in the drawings. It is revealing in this regard that every one of the collages contains technical specifications. This is a fundamental trait of

Christo's drawing oeuvre. The large-format works often have the form of diptychs. A smaller panel shows elevations, maps, and provides a commentary to the main drawing, which gives a visual impression of the planned work. Yet the designs contain an aesthetic statement as well. They acquaint us with the artists' mode of perception. Renderings that convey the effect of the work as a whole alternate with close-ups that focus on a certain aspect or angle. Already in this phase, the multi-perspective character of the undertaking becomes evident. Different times of day, sunlight or moonlight, clouds, rain or fog – the various effects of these artificial incursions into the natural environment or the city are already probed in the designs. In view of these sketches, one is tempted to speak of anticipatory instructions in viewing and experiencing.

"Reward of anxiety"

The photographs by Wolfgang Volz, which finally record the process of making and the finished work, not only provide detailed pragmatic and aesthetic information based on the existing visual score of the drawings. They underscore the drama and tension that accompany every one of Christo and Jeanne-Claude's appearances and works. Their record of the participants' faces is revealing. The expressions of Christo, Jeanne-Claude, and their hundreds of participants run the entire gamut of human emotions. Expectation, effort, the anxiety felt by the artists and their helpers – again and again we become witness to moments in which the project seems in jeopardy. All of this is revealed in the photographs of Volz, Christo and Jeanne-Claude's incomparable eye. A shot of fear keeps the participants holding their breath to the very end. Yet this atmosphere of tension, building up and increasing, also makes for the success of a project. A "reward of anxiety" has to be there in the back of the participants' minds. After all, the artists themselves have made risk the very elixir of their lives. The accumulation and degree of tension differ from project to project. In some, success depends on a sharply defined, planned moment when the drama of the enterprise reaches its culmination. At such precarious moments, the evaluation of a project – the aesthetic discussion – tends to shift entirely to the aspect of production. One might say that the fact of objective success temporarily takes precedence to aesthetic judgment. The photos and films that record this excitement are revealing, since they reflect a modification in the perception of art: aesthetics are supplanted by a technical frisson. For both onlookers and participants, an ultimately unexpected and

unpredictable experience ensues when the work of art abruptly materializes in a landscape or a city.

This sudden finish to many projects – such as *Running Fence* or *The Gates* – is usually preceded by days of uncertainty. This could be felt on a grand scale in New York's Central Park. Even people who had followed Christo and Jeanne-Claude's monumental projects for nearly forty years were confronted by something new in New York: an unprecedented sense of dealing with two entirely different works. Entering Central Park unprepared on the eve of the opening of *The Gates*, one had the impression of seeing a finished, logically consistent work. This was underscored by the intellectual and urban context which the artists had been able to secure. The reddish-yellow frames of the gates in the bare park seemed wonderfully to jibe with what the New York aesthetic had been advancing in wave after wave since the 1960s: the self-sufficiency of Primary Structures, a Minimal Art impregnated against every commentary and all romantic sensibility. In fact, never before had Christo and Jeanne-Claude approached so closely to Conceptualism. The vinyl frames from which the fluttering lengths of textile would later be unfurled, seemed like a commentary on the works of Donald Judd, Fred Sandback, Dan Flavin, or Sol LeWitt. Yet the next morning brought a moment that invalidated all such interpretations.

The opening of *The Gates* took place at lightning speed. This extreme rapidity was an integral part of the project's execution. A slow, gradual unfurling would have ruined the effect of surprise. All of the efforts and hopes invested in a project concentrate on this moment of truth. Either the undertaking succeeds at a predetermined point in time, or it fails. A project so carefully planned on such a grand scale leaves very little room for correction and improvisation or changes in schedule. Everything has to be worked out in advance, down to the tiniest detail. Every possible difficulty has to be simulated on the drawing board and in life-size tests, and solutions must be found in time. A review of the material presented in this exhibition shows how far-ranging this palette of solutions can be.

Titanic changes in the landscape

The differences between the various projects are immediately obvious. Some of them are inscribed into an almost pristine landscape; others concretely address the reality of a city and the habits of its populace. Yet even in cases where the artists seem to work uninhibitedly in the isolation of a rural site, their activity reflects an involvement with people and customs. In the beginning

stood a titanic change in the landscape. In 1969, Christo and Jeanne-Claude transformed the coastline of Little Bay in New South Wales, Australia. It was as if huge icebergs had somehow been swept up to and over the shore. The idea of an unpopulated distant continent was amplified by this incursion. How different was the impression created by *Running Fence*! A subtle, elegiac work, *Running Fence* stood in sharp contrast to the dramatic glaciation of the Australian coast – a 24.5 miles (39.4 kilometers) long, 18 feet (5.5 meters) high fence made of heavy white fabric. It was built in 1976 through northern California, between Petaluma, the state's chicken farming capital, and Marin County. An unforgettable alliance between the countryside and its aesthetic occupation came about. The course of the fence not only objectively reflected the property ownership of individual ranchers, who, often after endless negotiations, finally made their land available or refused to do so. Aesthetic decisions also repeatedly determined the path the textile curtain took. It emphasized the contour lines of the landscape, sometimes by following them, sometimes by altering them, cutting off the tops of hills, inscribing a gentler, more dreamlike topography into the existing one. The profile of the bare, scorched grazing land was exploited to produce a continuous serpentine line that emphasized its heights and depths. It was reminiscent of flowing, spontaneous *écriture automatique*. Like a line in some gigantic abstract drip painting, the fluttering, windblown fence passed through the land until finally plunging into Bodega Bay, where Hitchcock's film *The Birds* was made. On the occasion of this work, which played out in largely unpopulated areas of Northern California, a first, quite precise sociological survey of a region was undertaken. The debates over the almost 40 kilometer-long band memorably showed that truly freely accessible locations are few and far between. The fabric fence drew reactions from groups as diverse as environmentalists and ranchers.

The islands reverie *Surrounded Islands* evoked an entirely new kind of visibility. The amniotic sacs in which the islands in Biscayne Bay floated became a symbol of the island nature of life. It was a deeply moving message to the viewer. A work located in the midst of an enormous metropolitan area, addressed to millions, contained no human presence – unpopulated islands were presented as a land of promise by Christo and Jeanne-Claude. An inaccessible world lay temptingly before our eyes. *Running Fence* and *Surrounded Islands* were replied to a few years later by an incursion into the precincts of Paris, *The Pont Neuf Wrapped*. Anyone who was tempted to think that the artists' suggestions

would be more readily accepted in Paris than in the distant climes of California or Florida, where missionary work for contemporary art had to be undertaken in the two artists' name, discovered with some surprise that this was not the case. Not only the technical but the sociological and political problems took on an entirely new cast. Yet – and this deserves emphasis – Christo and Jeanne-Claude's works are fueled by resistance. Their execution fairly depends on a high degree of confrontation. Basically there is no project that can do without, or wishes to do without, such resistance. This is related to the striving for autonomy mentioned above, because, again, the projects are not commissioned works. To be sure, the prestige and above all the flawlessness and care with which their various projects are carried out give the artists a bonus. But this does not exempt them from having to run the gauntlet of public opinion every time. Their struggle for permission to wrap the Pont-Neuf lasted ten years. Their advocacy of the project in Paris began democratically, at grass roots level. First of all, the artists set out to convince people living in the neighborhood of the bridge. They created a favorable climate by spreading the word about the plan. There was no café or shop where they did not introduce themselves and explain their project, their "gift to the city". Thanks to their gentle power of persuasion, evident in all of their projects, Christo and Jeanne-Claude managed to overcome all indifference and skepticism. Gradually, as at previous sites, a lobby from below began to form in Paris. The sales staff at the Samaritaine department store were as much a part of it as the *bouquinistes* along the Seine. The couple showed them films, held lectures, discussed the project with them. The debate soon shifted to a level that ensured great and decisive publicity. As mentioned, there was no lack of official resistance in France. Basically no other project of Christo and Jeanne-Claude's – apart from that for the Berlin Reichstag – reached such high political echelons in its final phase. The nation's president, ministers, mayors, representatives, everyone became involved. By comparison, the battle against the resistance mounted by American pragmatism to such apparently absurd and unnecessary projects was ultimately easier to fight. To be sure, the "uselessness" of the undertakings presented a problem to many people, here as there. Yet it was precisely this lack of purpose, as Christo and Jeanne-Claude explained at the public hearings, that represented the aesthetic value of their work. The protocols of the hearings on *Running Fence*, *Surrounded Islands*, and *The Gates* reflect the energy and persistence with which the artists attempted to convey this to the public.

This first act in the successive phases of a project basically has little to do with art and evaluation. It is more reminiscent of an inventors' fair or a basement hobby room. Everything in this context bears a close relationship to a pragmatic evaluation of art of the kind popularized in America by the educator and philosopher John Dewey. An interest in quantity is satisfied by the sheer data provided – volumes, surface areas, tons, labor time, costs, required workforce. By comparison with such factors, the issue of the aesthetic message tends to remain secondary.

As soon as all the technical, environmental, and social conditions were fulfilled, Christo and Jeanne-Claude could count on official permission for *Running Fence* or *Surrounded Islands*. In this regard, *The Umbrellas, Japan-USA, 1984–91* project evinced a fascinating difference, a strategy of a new type. The gigantic undertaking paid tribute to modern communication technologies. For the first time, a project spanned two continents. It included California on one side of the Pacific and Ibaraki in Japan on the other. Entirely different problems arose in the course of this transcendence of borders and continents, bringing differences and similarities in mentality to light. The different colors symbolized this antinomy. With this work, too, Christo and Jeanne-Claude made a contribution to the discussions on the issue of delocalization which were then just getting underway. There can be no doubt that *The Umbrellas* played itself out against the background of a world that had entered the phase of globalization. At the same time, its fine adjustments alluded to the particular preferences and behaviors that retained their uniqueness under the yellow and blue umbrellas.

Temporary monuments
Wrapped Reichstag, the spectacular undertaking in Berlin, brought a further culmination. The work lay like a great crystal, an enormous block of ice, in the midst of the endless cityscape. This project went far beyond any previous one on an urban site. For the first time, the artists themselves made incursions into the object to be wrapped. Their alterations in the projections and pinnacles of the monumental building profoundly changed the appearance of the plastic volume: complicated contours and decorative elements were glossed over, and the edifice was brought into focus, even amplifying the Reichstag's martial character. The planimetric superstructures over which the metallic fabric was laid, honed down the building to the point that it had the effect of a prime example of crystalline architecture. The result was more reminiscent of Bruno Taut and Paul Scheerbart's

visions of a glass architecture than of the Wilhelmine penchant for overdecoration. One might even maintain that this concealment of decorative fussiness was intended as a kind of political and moral statement. Recalling the words of architect Adolf Loos, who declared ornament to be a crime, Christo and Jeanne-Claude's purified building might be viewed as a symbol of a new historical beginning.

Another, and most recent, triumphant event was *The Gates* in New York, which drew a crowd of millions in 2005. The paths in Central Park were traced by a total of 7503 gates, omitting as good as no piece of ground through which the landscape gardeners had laid out a footpath. As a result, the whole affair of Christo and Jeanne-Claude and Central Park remained quite rational. The various components had been defined and established from the start. The height of the gates was set at 16 feet (4.87 meters). On first glance, one might have thought Christo and Jeanne-Claude had tried their hand as architects in this New York project, then as graphic artists attempting to supplement the accumulation of gates by something in the nature of a signature gesture. Yet the course of *The Gates*, whose saffron yellow material filled the park with a continuous, lethargically Buddhist tone, had nothing to do with a free graphic design. The regular rhythmical sequence of the saffron cascades of vinyl and synthetic fabric was interrupted by something else. You discovered this as you walked the paths and noticed the trees and branches. Nowhere did the structures touch a tree trunk or even a single twig. At every point where the branches of a tree hung down low, the erection of a gate had been waived. It explained the existence of gaps, the intervals where no gates appeared. It was also quite logical, since otherwise the blowing fabric might have become caught in branches. These intermissions sharpened our sense of vulnerability and nuances.

Also interesting was the sociological aspect of the project. There were no privileges and no marginalizations in the park or around it. Every neighborhood, the good and not so good addresses, were given equal attention. Abundance even reigned at the edge of Harlem. At some spots, such as around Summit Rock, Great Hill, and Fort Clinton, the presence of the gates culminated in true fireworks of flaming saffron.

Today our eyes turn to the year 2009, the year in which another gigantic undertaking is scheduled to take place, in the Western state of Colorado. In *Over the River*, yet another mood is envisaged. Expansive areas of fabric panels are to be stretched like a roof high above the water of the Arkansas River for a length of 6.9 miles (11.1 kilometers). The sunlight falling through the silver fabric, the clouds schematically visible through the translucent material, will suffuse the water, the landscape, and the countless rubber rafts, canoes and kayaks and their crews running the river's rapids with a transforming light.

Christo and Jeanne-Claude build temporary monuments. Their removing takes place just as much to schedule as their creation. What the artists construct with admirable precision lives for only a few days as a real, physically graspable phenomenon. The apparitional nature of their works is part of their fascination and popularity. Like a dream, they descend on reality and vanish again, without disturbing, let alone destroying, a single thing. In face of this ghostly festival architecture, the viewer rubs his eyes. What he sees eludes familiarity and habituation. One of the artists' crucial messages is surely their wish to avoid cluttering up the world still more. Without disturbing, let alone destroying, anything, they bow off the stage each time. This explains why a certain melancholy lies over these sites that have embedded themselves in our memory. We can feel it: no other artist has interlinked planning, execution, and disappearance in the way and to the degree that Christo and Jeanne-Claude have. This is surely the reason why politicians and interest groups initially react with such mistrust to an activity that obstinately undermines the claim to permanence on which our society rests. Yet it is just this insouciance, this cheerful improvisation that waives all thought of profit and utility, that lend their projects their worldwide, unprecedented popularity.

[1] "Nous ne pensons jamais au public. Un artiste crée pour lui-même. Si quelqu'un d'autre aime, c'est un plus. Mais nous faisons cela pour nous." Corine Lesnes, "Jeanne-Claude, l'art de n'être qu'un avec Christo", in *Le Monde*, February 12, 2005.

5,600 Cubicmeter Package, Documenta 4, Kassel, 1967–68

At the occasion of the Documenta 4, 1968, in Kassel, Germany, Christo and Jeanne-Claude created the largest ever inflated structure without a skeleton.

After 3 unsuccessful attempts, it was erected on August 3, 1968 with the assistance of five cranes, two of which were 66 meters (216.5 feet) high and weighed 200 tons each.

The pair of giant cranes, the tallest Europe had to offer, had been operating separately in northern France and Hamburg, Germany, and it took two weeks just to make arrangements for both cranes to arrive simultaneously in Kassel, to elevate the inflated air package from its horizontal position on the ground to its vertical position.

The 6,000 kilograms (13,227 lb) air package consisted of an envelope made of 2,000 square meters (22,222 square feet) of Trevira fabric coated with PVC and tied with ropes.

The heat-sealed fabric envelope was restrained by a net made of 3,500 meters (11,483 feet) of rope specially prepared by professional riggers and secured by 1,200 knots. The elevation took 9 hours.

Once elevated, the *5,600 Cubicmeter Package* stood 85 meters (279 feet) tall, with a diameter of 10 meters (33 feet).

Chief engineer Dimiter Zagoroff designed a 3.5 ton, 11 meter (36 feet) diameter steel cradle-like base to support the air package 11 meters (36 feet) above the ground. The steel cradle was hinged on a central steel column anchored in a 1-ton concrete foundation.

Air pressure was maintained by a centrifugal blower run by a variable - speed electric motor. A gasoline generator stood by, in case of power failure.

To keep the air package in its vertical position, steel guy wires were anchored to 12 embedded concrete foundations, six 10-tons and six 18-tons, which were completely removed when the air package was taken down three months later.

All expenses of the project were borne by Christo and Jeanne-Claude through the sale of original drawings, collages, editions and early works.

The artists do not accept sponsorship of any kind.

The land was restored to its original condition.

5,600 Cubicmeter Package, Documenta 4, Kassel, Germany, 1967–68

Air packages: wrapping the immaterial
Christo and Jeanne-Claude's most spectacular air package is the *5,600 Cubicmeter Package*, a colossal column of air-filled, synthetic fabric created for *Documenta 4*, the 1968 international art show in Kassel, Germany. The huge, sausage-shaped structure set new statistical records for inflatable sculptures in terms of height (85 meters, 279 feet) […]. At the time, technically, it was Christo and Jeanne-Claude's most ambitious undertaking. […]

Research for the project began in November, 1967, at the Massachusetts Institute of Technology, where Christo and Jeanne-Claude worked in close consultation with a technical advisor, Dimiter S. Zagoroff, a specialist in mechanical engineering. […] The package was designed to have an outer envelope of nylon-reinforced polyethylene, which was ordered from a manufacturing firm in Sioux Falls, South Dakota, and delivered to Kassel, ready for inflation. The outer envelope contained a smaller envelope of clear Mylar plastic, to be inflated with helium to aid in the erection. […]

In April, 1968, Christo and Jeanne-Claude made a second trip to Kassel to oversee the laying of the concrete foundations and to make arrangements with various contractors. Their technical advisor, Zagoroff, arrived in mid-May and stayed on as a site engineer for nearly three months. The central foundation had to be 3 meters (10 feet) deep; otherwise, the wind might have whipped the 85 meter (279-foot) package around the meadow and turned it into a colossal menace. A total of 168 tons of concrete foundations was laid in five days […].

The first attempt at launching the balloon began on a rainy Monday morning, June 24. The rain turned into a storm and the polyethylene skin, after three hours of inflation, was suddenly rent by a 10-foot rip. […]

The rip was repaired, and a second attempt was begun two days later on June 26. This time, the balloon stayed erect for ten minutes, when the skin developed a big rupture at the base. Once more, it toppled to the ground. After the second failure, the polyethylene skin, presumably "reinforced", was junked and a new skin was ordered. The new skin was a synthetic textile named Trevira, a polyester fiber material made in Germany, which was sprayed with a solution of polyvinylchloride (better known by its initials PVC), a thermal plastic polymer substance thoroughly resistant to water, acid, and alkalis. […]

The colossus was finally erected on August 3, with the assistance of five cranes, two of which were 66 meter (216.5 feet) high and weighed 200 tons each. The pair of giant cranes, the tallest Europe had to offer, had been operating separately in northern France and Hamburg, Germany, and it took two weeks just to make arrangements for both cranes to arrive simultaneously in Kassel. […]

The first three unsuccessful erections sparked many titters in Kassel's art community about Christo and Jeanne-Claude's inability to get their package up. But as soon as the air-inflated structure was successfully erected and held in position by guy wires, the *5,600 Cubicmeter Package* assumed a more universal significance. […]

If the *5,600 Cubicmeter Package* inadvertently aroused prurient interest Christo and Jeanne-Claude could at least claim that it had redeeming social value – large numbers of people seemed content to while away hours in its presence.

The success of the Kassel package demonstrated that Christo and Jeanne-Claude's entrepreneurial skills were on a scale equal to that of the sculpture itself. By sponsoring their own technical research, they maintained total control over the project, assuring that the engineering aspect remained subservient to their initial concept. While they delegated authority to engineers and contractors, they assumed ultimate responsibility for all design and technical decisions.

In spite of the costliness of the project, Christo and Jeanne-Claude assumed all financial obligations as well. In financing their own work, Christo and Jeanne-Claude displayed a fund-raising ability that is cause for wonder among many people and a source of profound consternation for other artists. And raising funds to pay for the *5,600 Cubicmeter Package* proved to be nearly as difficult as raising the balloon physically.

Excerpts from David Bourdon, *Christo*, Harry N. Abrams, New York, 1970. Edited and updated by Susan Astwood, June 2000.

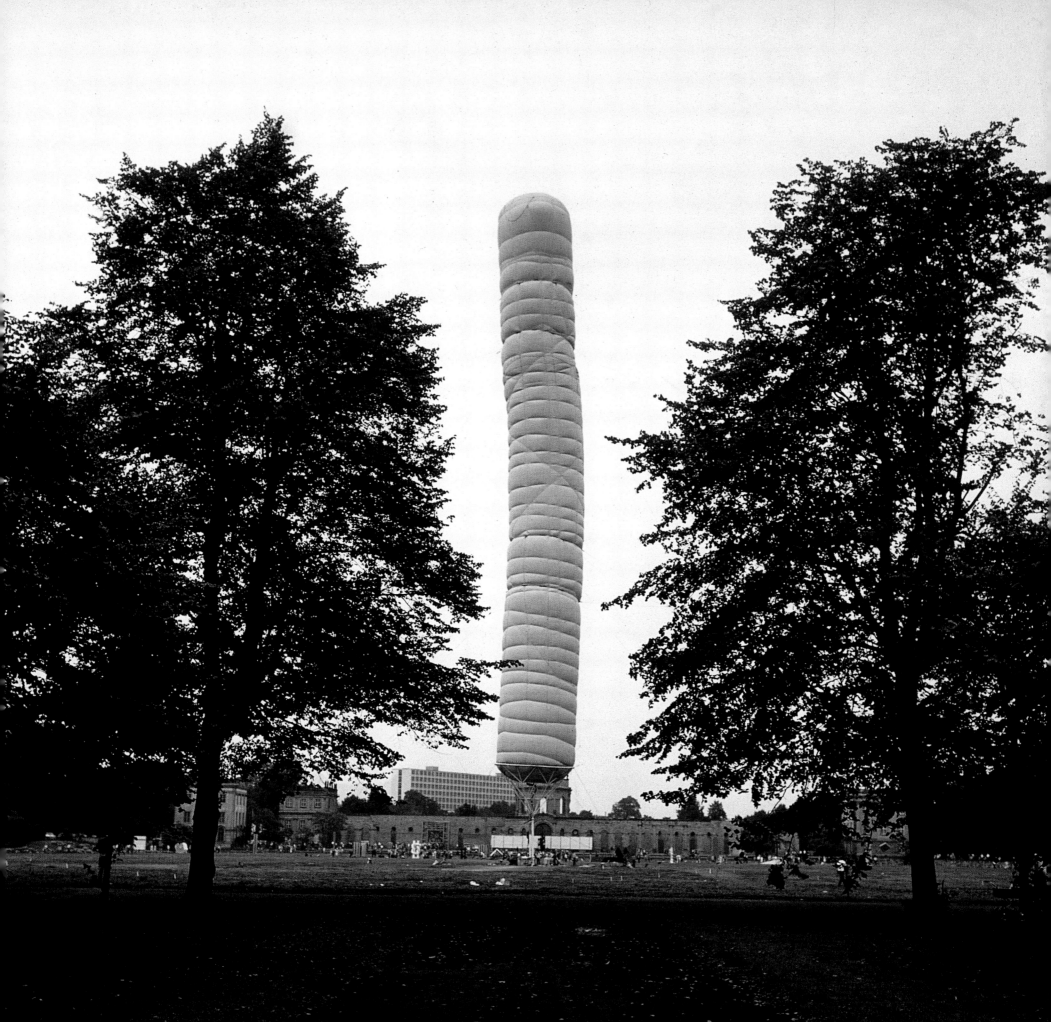

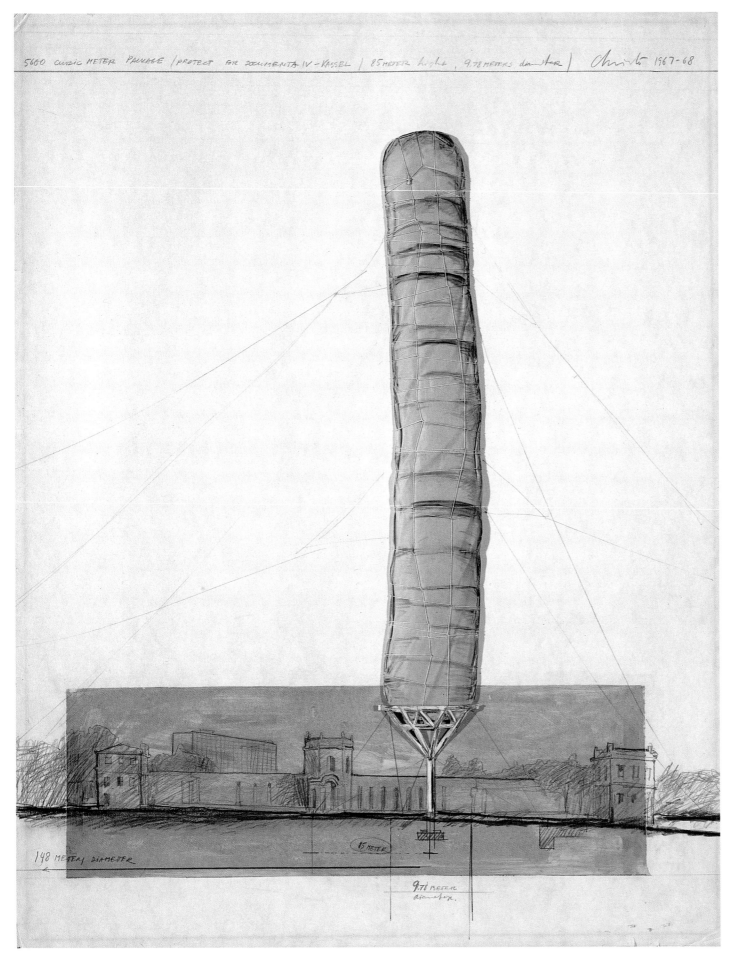

5600 CUBIC METER PACKAGE (PROJECT FOR DOCUMENTA IV-KASSEL) 85 METER high, 9.78 METERS diameter) Christo 1967-68

100

148 METERS DIAMETER

15 METER

9.78 METER diameter

39.
5,600 Cubic Meter Package, Project for Documenta 4, Kassel
Collage, 1967–68

40.
200,000 Cubic Feet Package (5,600 Cubic Meter), Project for Documenta 4, Kassel
Drawing, 1968

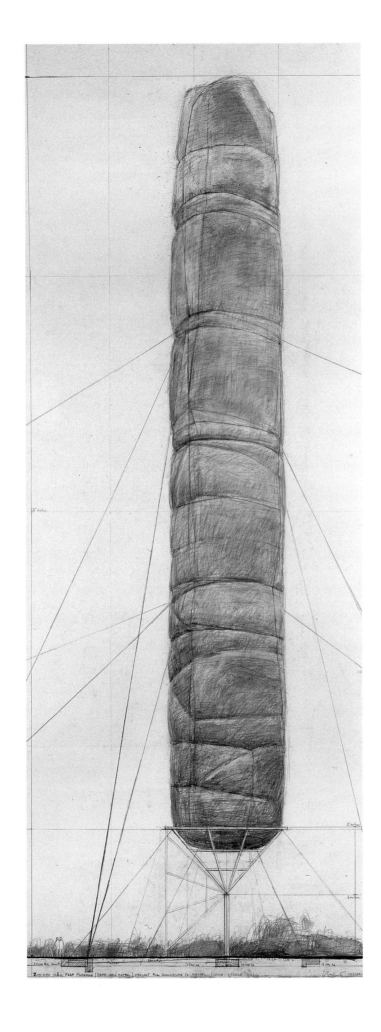

Wrapped Kunsthalle Bern, 1967–68

Wrapped Kunsthalle Bern, 1968

In 1968, the Bern Kunsthalle celebrated the fiftieth anniversary of its foundation. In spring of the same year, Denise René and Hans Mayer had passed through Bern to pick me up on their way to the inauguration of the Fondation Maeght in Saint-Paul de Vence. During the dinner that followed, I was seated next to Christo. I asked him if he had ever wanted to wrap up the Bern Kunsthalle. This was to be his first wrapping of a public building after the medieval tower [*Wrapped Tower, Spoleto, Italy, 1968*] and the Spoleto Fountain.

1968 was also the Documenta year when Christo and Jeanne-Claude were invited to create in the Karlsaue a 5,600-cubic meter air package, at the time the largest inflated structure without a skeleton. They had the discarded skin of the package sent from Kassel to Bern. With the assistance of a dozen construction workers and the local fire brigade, the building was wrapped in 2,430 square meters of polyethylene, tied with 3,050 meters of nylon cord. [...]

During the work, insurance companies refused to underwrite the building. Although polyethylene is not easily combustible, it is still inflammable if exposed sufficiently long to the flame of a cigarette lighter. The firemen interrupted their work — notably, the stitching on the high section of the building,

accomplished with the help of aerial lifts. In the town hall, nobody wanted to take such a risk, so I did. Fortunately, no "night bird" alighted to set fire to the plastic; otherwise, I would have had to work at the Kunsthalle to the end of my days to repay the damage, little by little, in the form of withholdings from my monthly salary. [...] Nothing happened, and Christo and Jeanne-Claude put two collages up for sale to cover the cost of the night guards hired for the occasion.

But, how is it that the firemen participated in this event? During the preparatory phase, I had called the city's mayor to inform him of the project. I told him that the artists were from New York, and he answered: "We must be generous in this case". He proposed approaching the chief of the fire brigade, Captain Rüfenacht, who listened to what I had to say and thought about it. I had avoided speaking of art to him. [...] This is why I asked him: "Do you know the Kunsthalle?" He: "Yes". I: "Could you describe it?" He paused at length. [...] This is why I told him: "You see, this is the reason why we are wrapping it. You can be sure that when the wrapping is removed – the Kunsthalle will become a gift – the whole world will be looking at the building with greater attention". This argument convinced him, and the entire company of firemen were on location with their aerial lifts to meet Christo upon his arrival. [...]

The reactions were overwhelming. Articles appeared in publications from New York to Moscow. Some voiced their complaints. Claiming to have seen a snow-covered building at the height of July, they threatened to set fire to it. Others parked a wrapped Volkswagen in front of the structure. To put it briefly, there was quite a lot happening that week. In any case, we could not leave the wrapping in place any longer, as the ubiquitous, twenty-four hour surveillance was a heavy item in our budget.

On an aesthetic level, the wrapped Kunsthalle was a masterpiece, a sculpture of sublime beauty, shining in the sunlight. The inauguration photograph shows the young people of Bern either electrified or speechless with astonishment before the flowing lines of this "glacier".

Christo and Jeanne-Claude helped me to continue along the path I had chosen: to broaden the Kunsthalle's horizons. Already in 1967, we had offered the world's first science fiction show, and Switzerland's first Living Theater performance. The wrapped jubilee celebration in 1968, followed by *When Attitudes Become Form* in 1969, was the straw that broke the back of the camel of comprehension. I am still rather proud today of this intense vitality of the 1960s.

Christo read the following remark, amused: "We took the environments by eleven other artists and wrapped them. We

had our whole environment inside". My heart was set on transforming the Kunsthalle entrance into an obstacle course — this was the time when all the museums were seeking a broader public and more active participation on the part of the visitors. Schnyder installed in the entrance a plastic curtain with such a heavy tab/handle on the zipper closure that as soon as the intrepid visitor lifted it, it fell right back down. Once past this obstacle, the visitor had to make it across, lurching or reeling, Rinke's water cushion — another path should have been provided for handicapped persons. After regaining his balance, the visitor then found his way blocked by Warhol's wall of Brillo boxes, and so on and so forth... until he ended up once again gazing at the wrapped Kunsthalle.

Excerpts from the text by Harald Szeemann in *Christo and Jeanne-Claude: Swiss Projects 1968–1998*, exhibition catalogue, CentrePasquArt, Biel/Bienne, 2004.

104

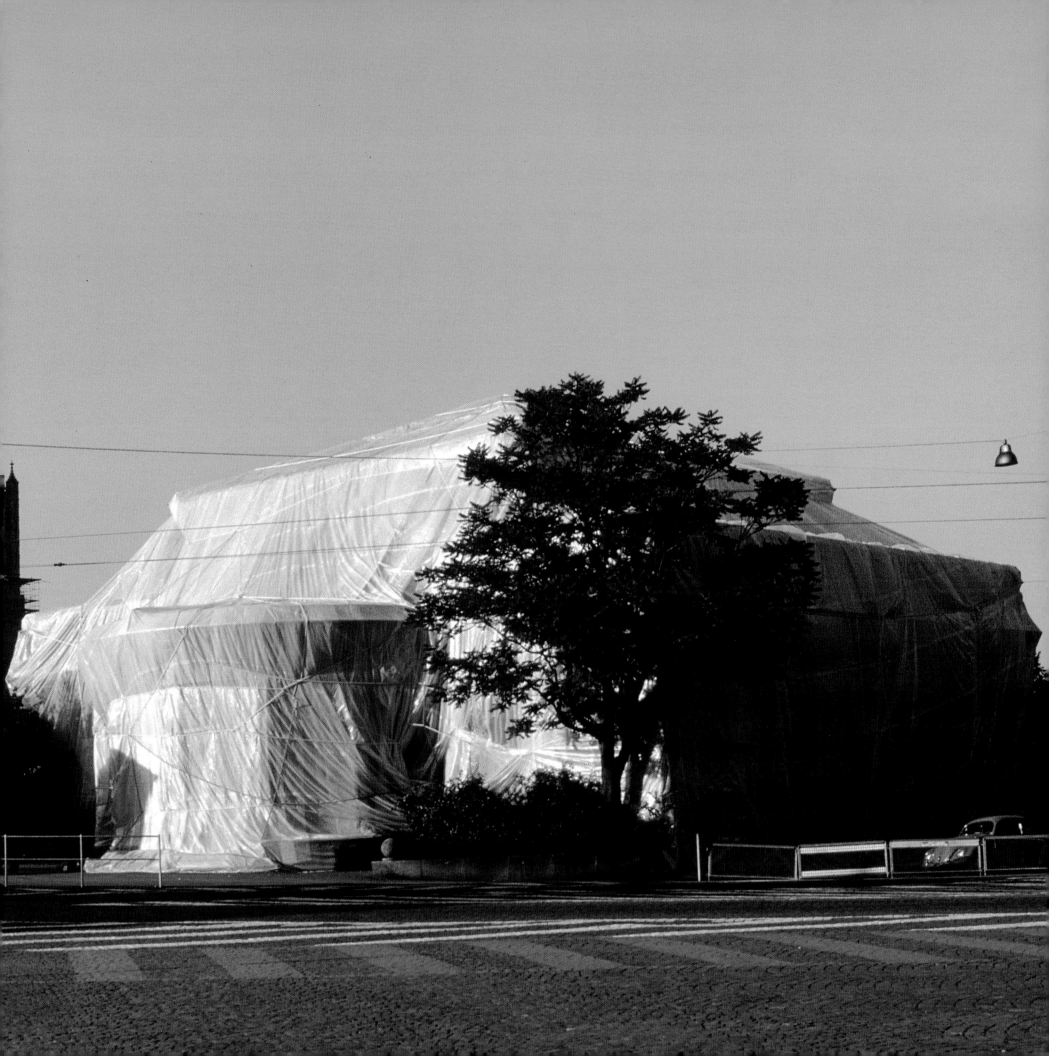

41.
**Kunsthalle Bern Packed, Project for
50th Anniversary of the Kunsthalle,
Bern, Switzerland**
Drawing, 1968

42.
**Kunsthalle Packed, Project for Kunsthalle
Bern, Switzerland**
Collage, 1968

106

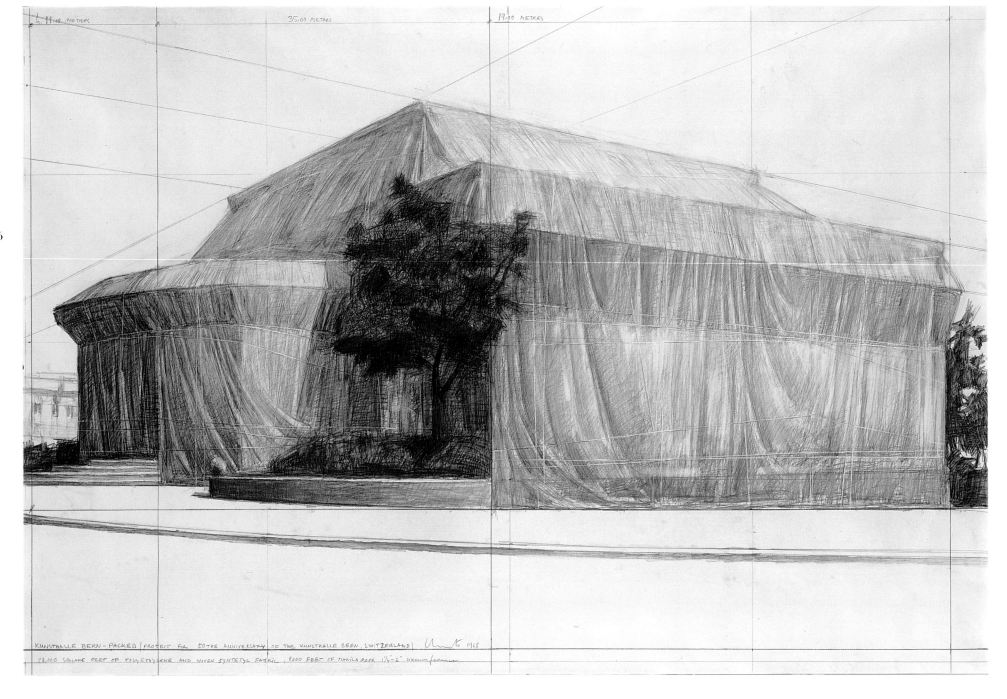

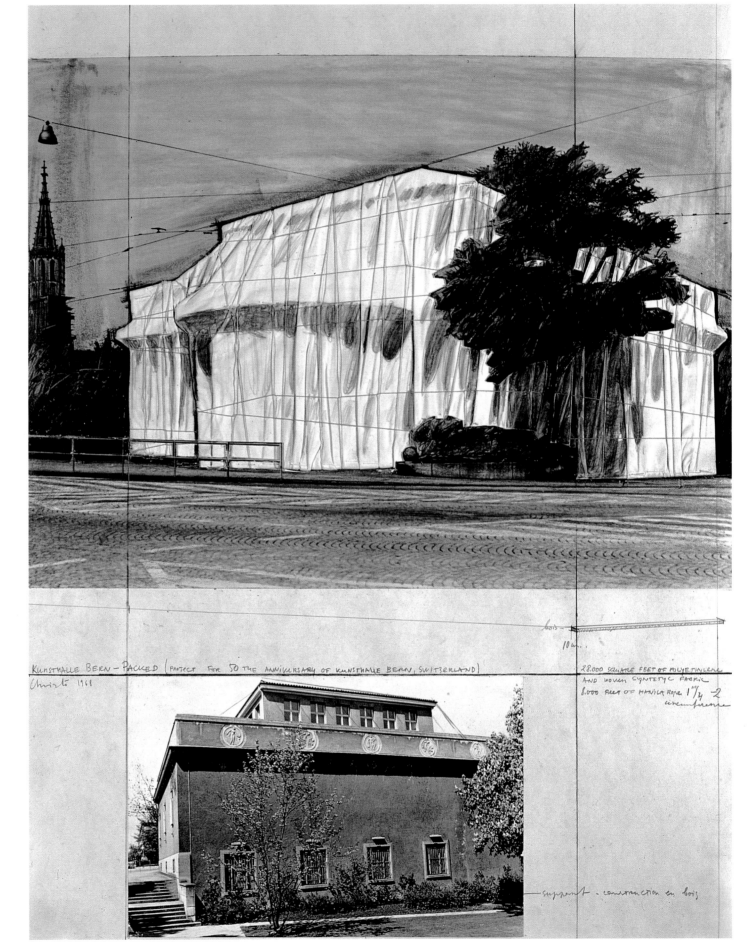

KUNSTHALLE BERN – PACKED (PROJECT FOR 50 THE ANNIVERSARY OF KUNSTHALLE BERN, SWITZERLAND)

Christo 1968

28.000 SQUARE FEET OF POLYETINLERE AND WOVEN SYNTETYC FABRIC
8.000 FEET OF MANILA ROPE 1"1/4 2 circumference

support - construction en bois

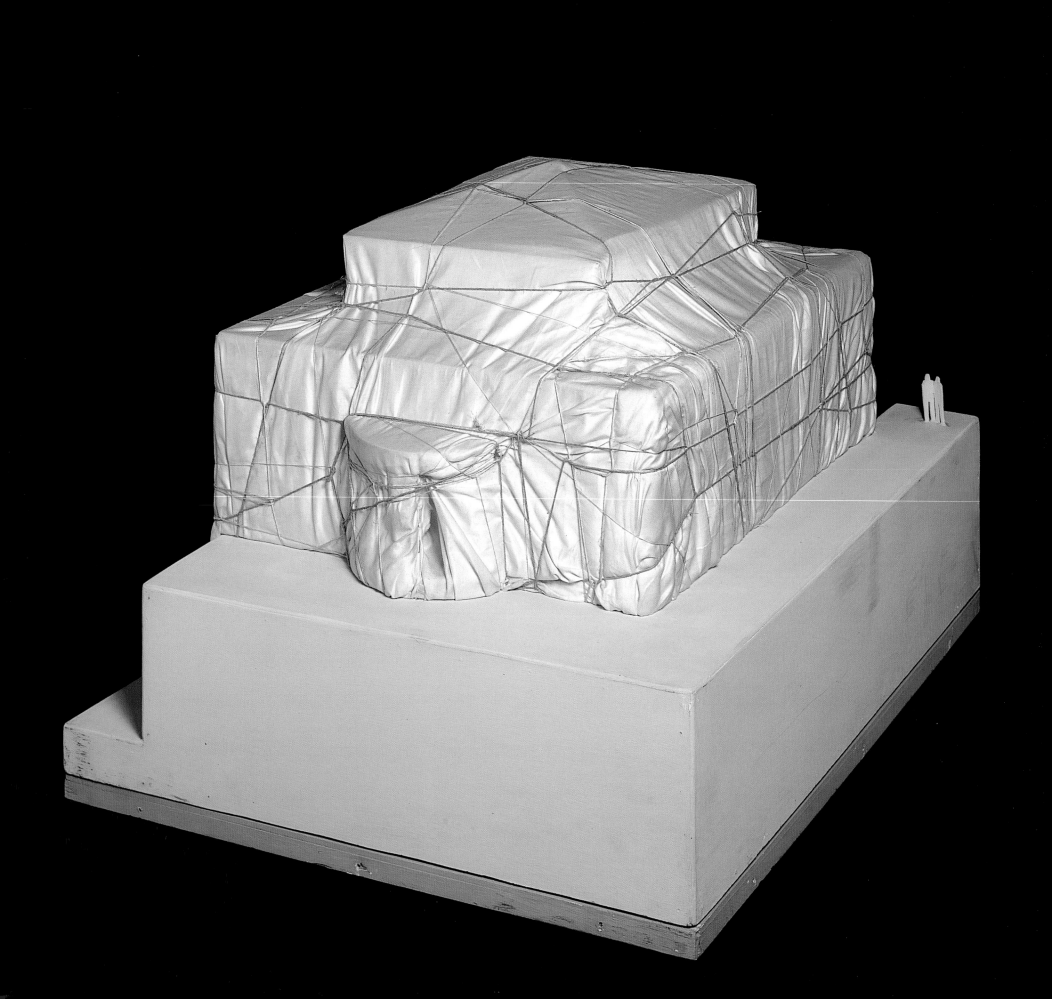

43.
Kunsthalle Wrapped, Project
Scale model, 1967

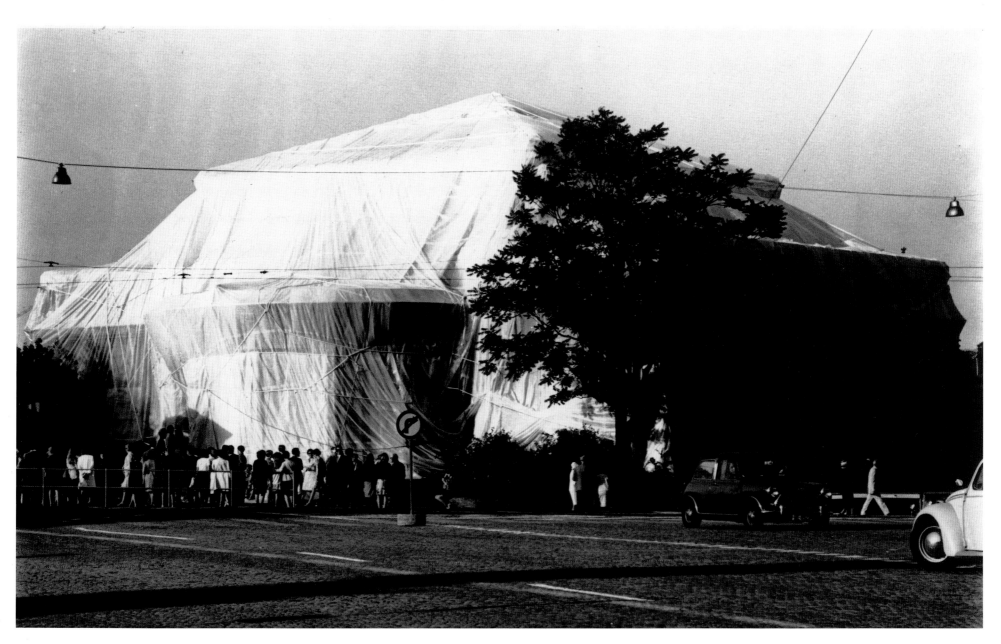

Wrapped Coast, One Million Square Feet, Little Bay, Sydney, Australia, 1968–69

Little Bay, property of Prince Henry Hospital, is located 14.5 kilometers (9 miles) southeast of the center of Sydney.

The South Pacific Ocean cliff-lined shore area that was wrapped is approximately 2.4 kilometers (1.5 miles) long, 46 to 244 meters (150 to 800 feet) wide, 26 meters (85 feet) high at the northern cliffs, and was at sea level at the southern sandy beach.

One million square feet (90,000 square meters) of erosion control fabric (synthetic woven fiber usually manufactured for agricultural purposes), were used for the wrapping, 56.3 kilometers (35 miles) of polypropylene rope, 1.5 centimeter (0.6 inch) diameter, tied the fabric to the rocks.

Ramset guns fired 25,000 charges of fasteners, threaded studs and clips to secure the rope to the rocks.

Mr. Ninian Melville, a retired major in the Army Corps of Engineers, was in charge of the climbers and workers at the site.

17,000 manpower hours, over a period of four weeks, were expended by 15 professional mountain climbers, 110 workers: architecture and art students from the University of Sydney and East Sydney Technical College, as well as a number of Australian artists and teachers. All climbers and workers were paid with the exception of eleven architecture students who refused to be paid.

The project was entirely financed by Christo and Jeanne-Claude through the sale of Christo's original preparatory drawings, collages, scale models, early *Packages* and *Wrapped Objects* of the 1950s and 1960s, and lithographs.

The artists do not accept sponsorship of any kind.

The coast remained wrapped for a period of ten weeks from October 28, 1969. Then all materials were removed and recycled, and the site was returned to its original condition.

Wrapped Coast, One Million Square Feet, Little Bay, Sydney, Australia, 1968–69

Australian coast: a terrestrial wrap-up

Christo and Jeanne-Claude's wrapped buildings and oil-barrel blockades, which initially appeared of monumental size, indicated that the artists saw their work in terms of an imposed confrontation with society. They had removed their work from the usual precincts of art – museums and galleries – and put it outdoors, where it was capable of engaging the man-on-the-street, who was probably oblivious to the aesthetic issues involved. From these early inclinations toward large-scale and covert monumentality, they have focused their aspirations on even greater spaces and spectacles, displaying terrestrial ambitions that culminate most dramatically in their wrapping of [about]one-mile coast in Australia. [...]

Christo and Jeanne-Claude intended from the beginning that the synthetic fabric-covered terrain provide a tactile as well as visual experience, with spectators being permitted to walk upon the wrapped ground. [...] Christo and Jeanne-Claude did succeed in wrapping a shoreline the following year, 1969, when they created their most spectacular "package" – the mile [and-a-half]- long *Wrapped Coast* at Little Bay, near Sydney, Australia. The rock-bound coast, blanketed in opaque fabric, had the guise of a totally synthetic landscape, a setting worthy of science fiction, or as Jan van der Marck described it, "the most fully artificial landscape experience this side of the Sea of Tranquillity"[1].

At the very least, the *Wrapped Coast* was one of the most extraordinary images and memorable art spectacles of the 1960s. As a uniform surface, the extensive time had the effect of masking out coloristic and textural details while, at the same time, it also seemed to emphasize existing contours, bulges, and depressions, bringing them in-to sharper and more perceptible relief. The actual shapes and contours of the site became prominently displayed in a way that was not previously discernible. The shrouded [...] phenomena such as sea, sky, wind, and rain seemed, from the center of the package, to be strangely unreal (the sea and sky were much too blue!), as if all of nature had been put into a new context. [...]

The official "opening" day lured two-thousand-five-hundred spectators. The sheer size of the project seemed to impress most viewers. Even those who had come prepared to scoff, and who still refused to accept it as art, had to concede the site was dramatically transformed. The *Wrapped Coast* appeared deceptively soft and elastic, but the billowing swags and folds of synthetic fabric concealed jagged rocks and gaping holes. [...]

The Australian venture originated in the fall of 1968, when Christo and Jeanne-Claude had the good fortune to receive a visit from John Kaldor, a Hungarian-born textile man from Sydney, who was in New York on a business trip. Being an art collector, Kaldor sought out Christo with the intention of purchasing a work and ended up buying a small black *Package*. When he returned to Australia, Kaldor wrote to Christo, asking whether he would be interested in visiting Australia, and while he was there, "perhaps give a couple of lectures" and "arrange an exhibition"[2].

The Sydney textile company that Kaldor worked for sponsored an annual sculpture scholarship of $3,000 and Kaldor thought it would be "much more interesting for the development of art appreciation in Australia, if instead of sending a promising local artist overseas, we would invite an outstanding young person to Australia, so that both the local artists and the public would benefit from his presence"[3]. To his surprise, Kaldor received a hasty reply from Christo, saying that while he was in Australia he would like to execute a most ambitious project – a wrapped coast. [...]

The next step was to have the coast photographed and surveyed so that Christo and Jeanne-Claude could get some idea of the topography – a variegated terrain with jagged cliffs, averaging 50 feet in height, a deep gully, often used as a rubbish dump, and a flat, sandy beach. The site was documented so thoroughly in aerial photographs and contour maps that Christo, without leaving New York, was able to make accurate scale models and collages which closely approximated the final results. The two artists and Kaldor, though separated by half the world, together investigated various wrapping materials – reinforced paper, aluminum sheeting, canvas, jute, and dozens of others, some of which were put through extensive tests for strength and durability at the University of Sydney. They finally settled upon a loose-woven polypropylene, normally used to prevent soil erosion caused by wind and rain. [...]

From the moment the project was publicly announced, it received massive and relentless attention from the news media. The *Wrapped Coast* was satirized by cartoonists, condemned by conservationists, defended by culture-hungry columnists, and ended up as a national *cause célèbre*, the most controversial art project in Australia since the [...] Sydney Opera House. By the time Christo, Jeanne-Claude and Cyril arrived in Sydney on the first day of October 1969, Christo was greeted as an international celebrity. [...]

The actual wrapping commenced October 5, with an enthusiastic, if sporadic, labor force comprised of hundreds of Sydney College and East Technical College art students and four teachers. All were paid. Unfortunately, the wrapping coincided with exam time, and many of the students were unable to appear regularly. On Sunday, Octo-ber 19, not a single art student appeared on the site. The coordinators were forced to hire more paid laborers (there were sixty hired workers paid by the hour) in order to finish the job in the scheduled time. [...] Upon completion of the *Wrapped Coast*, total man-hours were logged at 17,000. Once realized, the *Wrapped Coast* required a four-man maintenance team during the four weeks it was opened to the public. [...]

On October 15, the greatest calamity came from the South Pole in the form of a violent storm. The polypropylene wrapping, designed to withstand winds of 145 kilometers (90 miles) an hour, was subjected to an unexpected gale of over 160 kilometers (100 miles) an hour which thoroughly lacerated about a third of the fabric along the cliff face. The destroyed section was at the northwestern end, the highest and most difficult section to drape, and the most vulnerable to wind. The wrapping that had been well secured with ropes resisted the gale well. But along the northwestern section, the enormous sheets of fabric, which had just been draped over the cliffside, had not yet been secured with ropes, when the gale suddenly arrived. Along the upper edge of the cliffs, a sharp upward draft intersected the lateral wind, causing the fabric to thrash about in contradictory directions heaving and tossing like a white plastic land mass in an apocalyptic earthquake. The tattered fabric had to be junked and replaced with [...] new material. Because of this setback, the *Wrapped Coast* was not completed until October 28.

[1] Jan van der Marck, in *Christo*, exhibition catalogue, National Gallery of Victoria, Melbourne, 1969, p. 14.
[2] John W. Kaldor, letter (February 12, 1969) reproduced in *Christo: Wrapped Coast, One Million Square Feet*, Minneapolis, 1969.
[3] Ibid.

Excerpts from David Bourdon, *Christo*, Harry N. Abrams, New York, 1970. Edited and updated by Susan Astwood, June 2000.

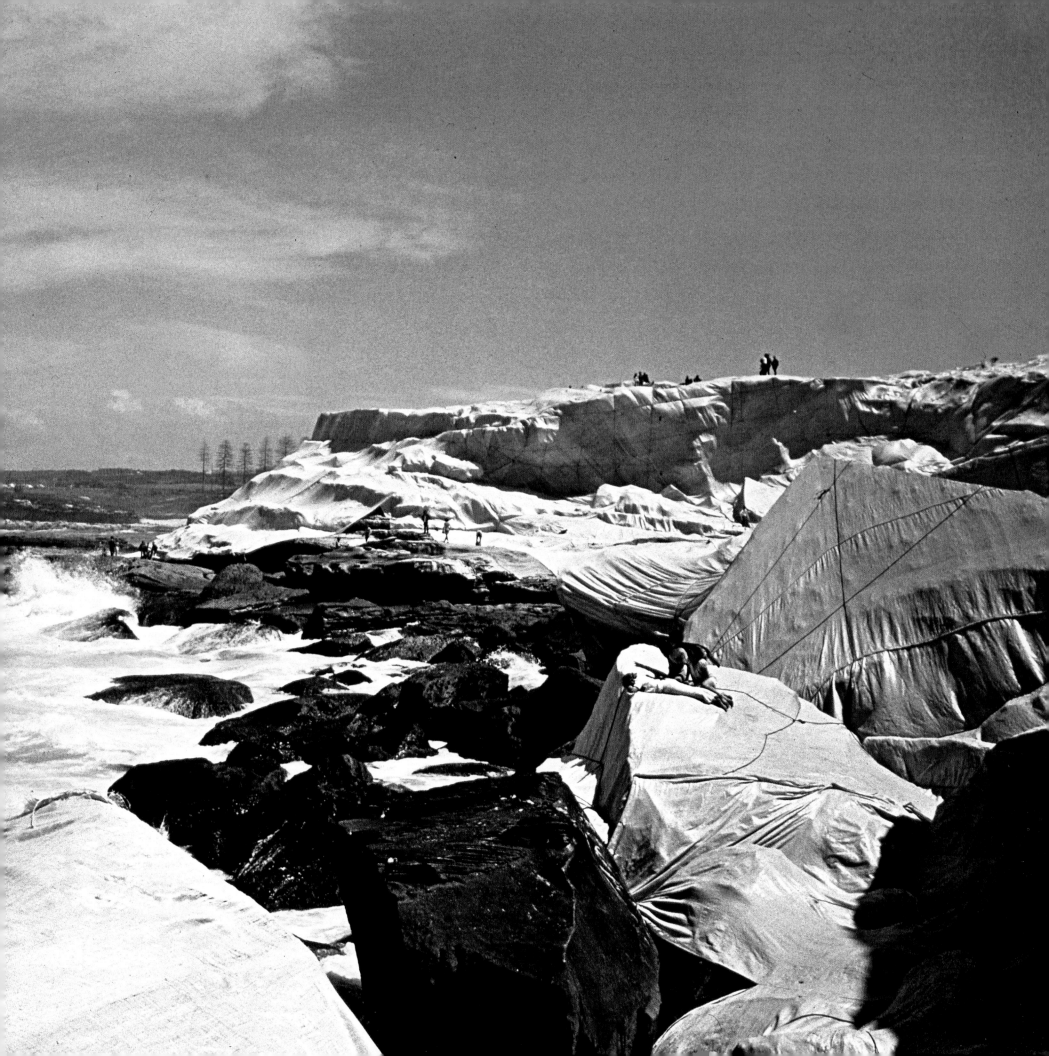

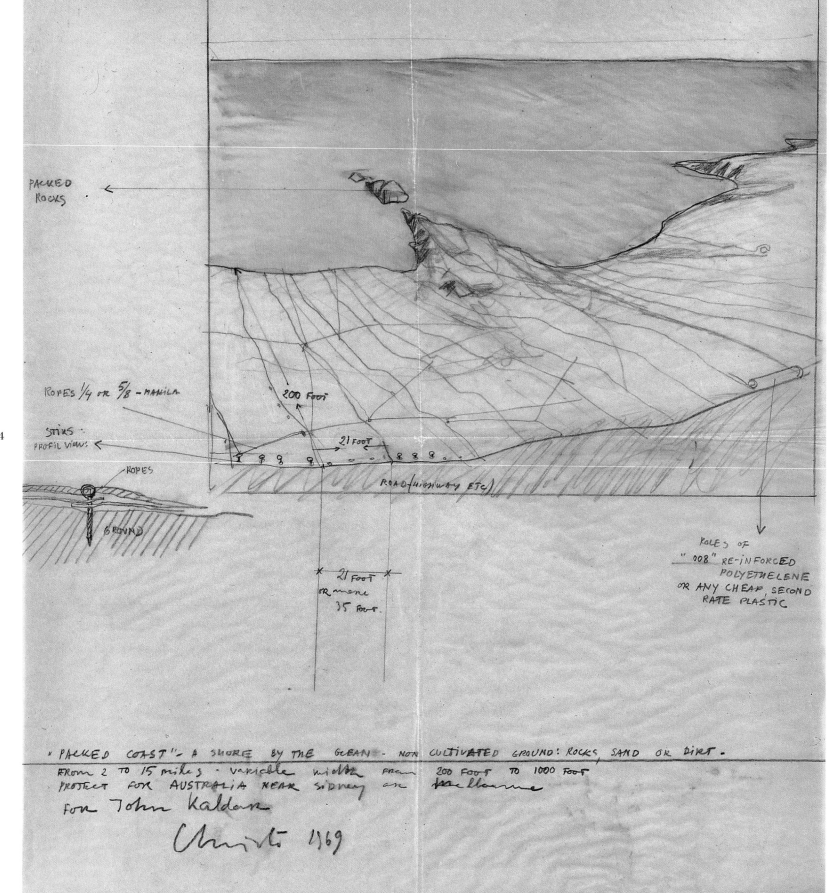

44.
**Packed Coast, Project for Australia,
near Sydney**
Drawing, 1969

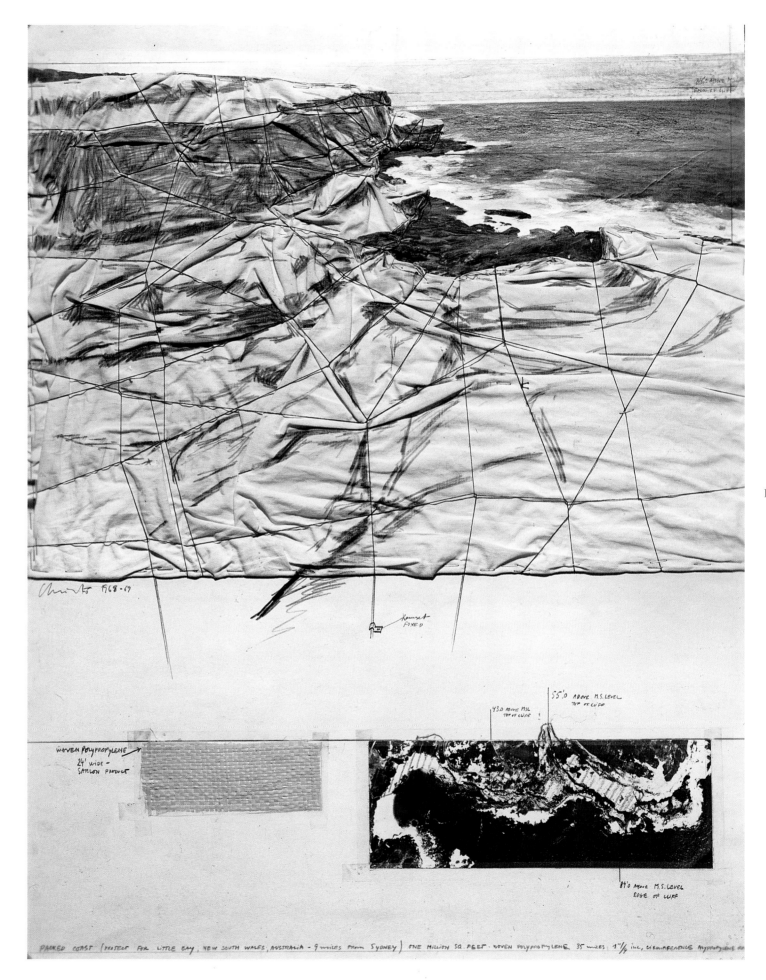

115

45.
**Packed Coast, Project for Little Bay,
New South Wales, Australia**
Collage, 1968–69

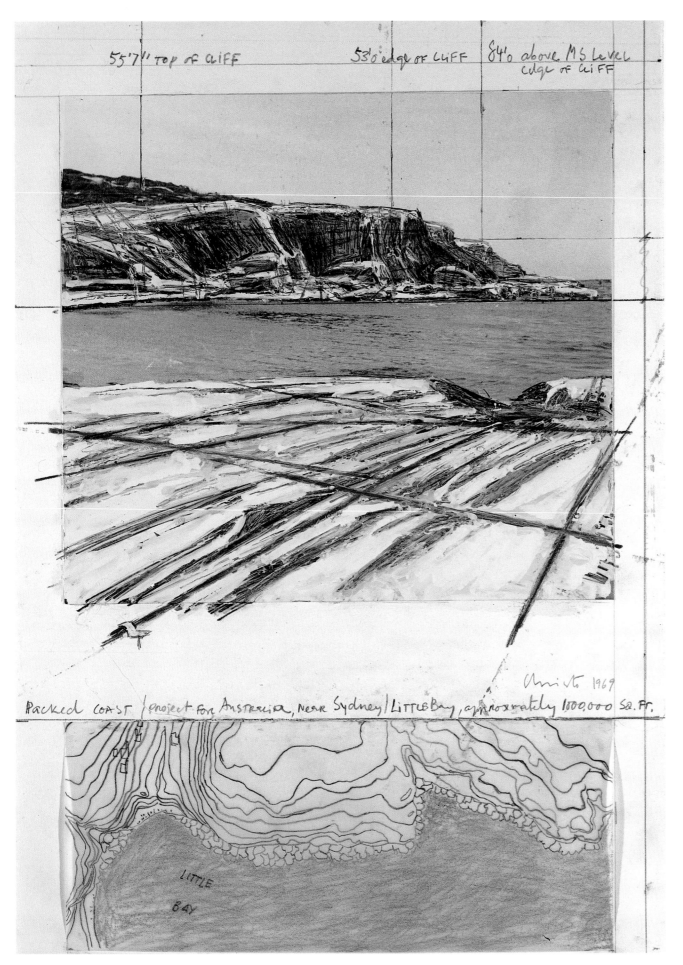

55'7" TOP OF CLIFF 53'0 edge OF CLIFF 84'0 above MS LeVeL
 edge OF CLiFF

Christo 1969

Packed COAST / Project For Australia, Near Sydney / LittleBay, approximately 1000,000 sq. Ft.

LITTLE

BAY

116

47.
Packed Coast, Project for Australia,
New South Wales, Little Bay
Drawing, 1969

117

48.
Wrapped Coast, Project for Australia
Scale model, 1969

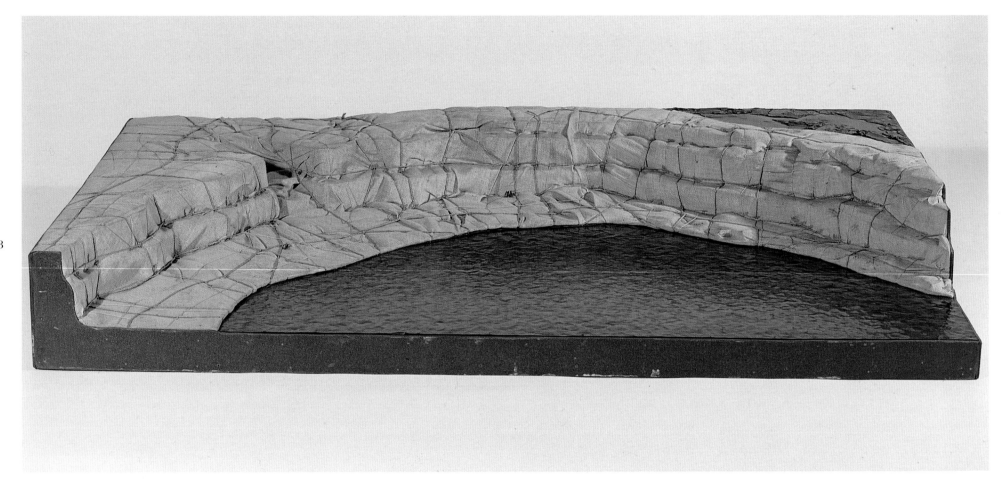

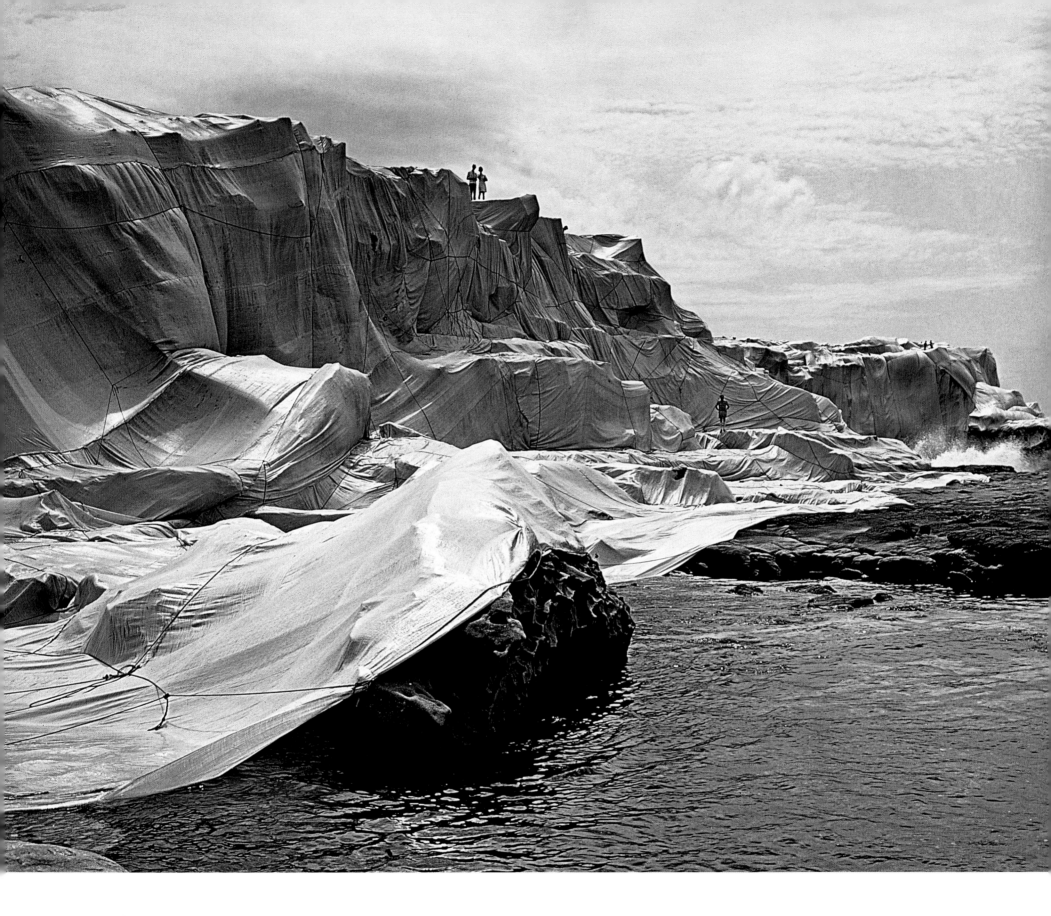

Valley Curtain, Grand Hogback, Rifle, Colorado, 1970–72

On August 10, 1972, in Rifle, Colorado, between Grand Junction and Glenwood Springs in the Grand Hogback Mountain Range, at 11 a.m. a group of 35 construction workers and 64 temporary helpers, art school and college students, and itinerant art workers tied down the last of 27 ropes that secured the 12,780 square meters (142,000 square feet) of woven nylon fabric orange Curtain to its moorings at Rifle Gap, 7 miles (11.3 km) north of Rifle, on Highway 325.

Valley Curtain was designed by Dimiter Zagoroff and John Thomson of Unipolycon of Lynn, Massachusetts, and Dr. Ernest C. Harris of Ken R. White Company, Denver, Colorado. It was built by A&H Builders, Inc. of Boulder, Colorado, President, Theodore Dougherty, under the site supervision of Henry B. Leininger.

Because the Curtain was suspended at a width of 381 meters (1,250 feet) and a height curving from 111 meters (365 feet) at each end to 55.5 meters (182 feet) at the center, the Curtain remained clear of the slopes and the Valley bottom. A 3 meter (10 foot) skirt attached to the lower part of the Curtain visually completed the area between the thimbles and the ground.

An outer cocoon enclosed the fully fitted Curtain for protection during transit and at the time of its raising into position and securing to the 11 cable clamps connections at the 4 main upper cables. The cables spanned 417 meters (1,368 feet), weighed 49,895 kilograms (110,000 pounds), and were anchored to 784 metric tons (784 short tons) of concrete foundations.

An inner cocoon, integral to the Curtain, provided added insurance. The bottom of the Curtain was laced to a 7.6 centimeter (3 inch) diameter Dacron rope from which the control and tie-down lines ran to the 27 anchors.

The *Valley Curtain* project took 28 months to complete.

Christo and Jeanne-Claude's temporary work of art was financed by the Valley Curtain Corporation (Jeanne-Claude Christo-Javacheff, President) through the sale of the studies, preparatory drawings and collages, scale models, early works, and original lithographs.

The artists do not accept sponsorship of any kind.

On August 11, 1972, 28 hours after completion of the *Valley Curtain*, a gale estimated in excess of 100 kph (60 mph) made it necessary to start the removal.

Valley Curtain, Grand Hogback, Rifle, Colorado, 1970–72

Christo and Jeanne-Claude began discussing their idea for *Valley Curtain, Grand Hogback, Rifle, Colorado, 1970–72*, in June of 1970, eight months after *Wrapped Coast*. At the same time, Christo also made studies for *Wrapped Walk Ways*, a project that was intended to take place simultaneously in Ueno Park, Tokyo, and Sonsbeek Park in Arnhem, Holland, as well as a collage for a *Wrapped Island* (envisioned somewhere in the South Pacific).

Neither of the latter two projects was ever realized, but both were forerunners of other major projects – *Wrapped Walk Ways, Loose Park, Kansas City, Missouri, 1977–78*, and *Surrounded Islands, Biscayne Bay, Greater Miami, Florida, 1980–83*, respectively. Meanwhile, as plans for *Valley Curtain* moved ahead, in November 1970, Scott Hodes, the artists' young lawyer, decided to create a corporation to build the upcoming project in Colorado, offering tax advantages and protecting them from personal lawsuits in case something went wrong. All subsequent projects followed this model.

Work on *Valley Curtain* intensified in January 1971 with the completion, by engineers Lev Zetlin Associates of New York, of a structural feasibility study. The project involved hanging an enormous orange curtain, weighing 8,000 pounds, from a support system consisting of four cables, spanning more than 1,250 feet across Rifle Gap, over Colorado State Highway 325 (the design included an arched opening at the bottom of the curtain to allow traffic to pass through). In May, the construction company Morrison-Knudsen signed on as the building contractor for *Valley Curtain*, and in July, Philippe de Montebello (then director of the Museum of Fine Arts, Houston) organized a pre-project exhibition of *Valley Curtain* drawings, collages, scale models, surveys, and photographs. […]

In October 1971, attempts to raise the *Valley Curtain* failed from a combination of bad engineering and lack of coordination; the wind caught the fabric during the elevation, before the workers had secured it, and the curtain shredded like tissue paper.

Christo and Jeanne-Claude left Colorado in frustration, but they returned the following summer with a new engineer – they hired Dr. Ernie Harris, the engineering inspector for the State of Colorado – and a new builder-contractor, Theodore Dougherty, of A&H Builders, Inc., a local firm, and they completed the project on August 10 – although the wind once again destroyed the work after only 28 hours. All this was captured in a documentary film made by David and Albert Maysles, who thereafter filmed most of Christo and Jeanne-Claude's projects. *Valley Curtain* was the most expensive project they had done up to that time, costing around $800,000.

Excerpts from Jonathan Fineberg, *Christo and Jeanne-Claude: On the Way to The Gates, Central Park, New York City*, exhibition catalogue, The Metropolitan Museum of Art, New York, 2004.

122

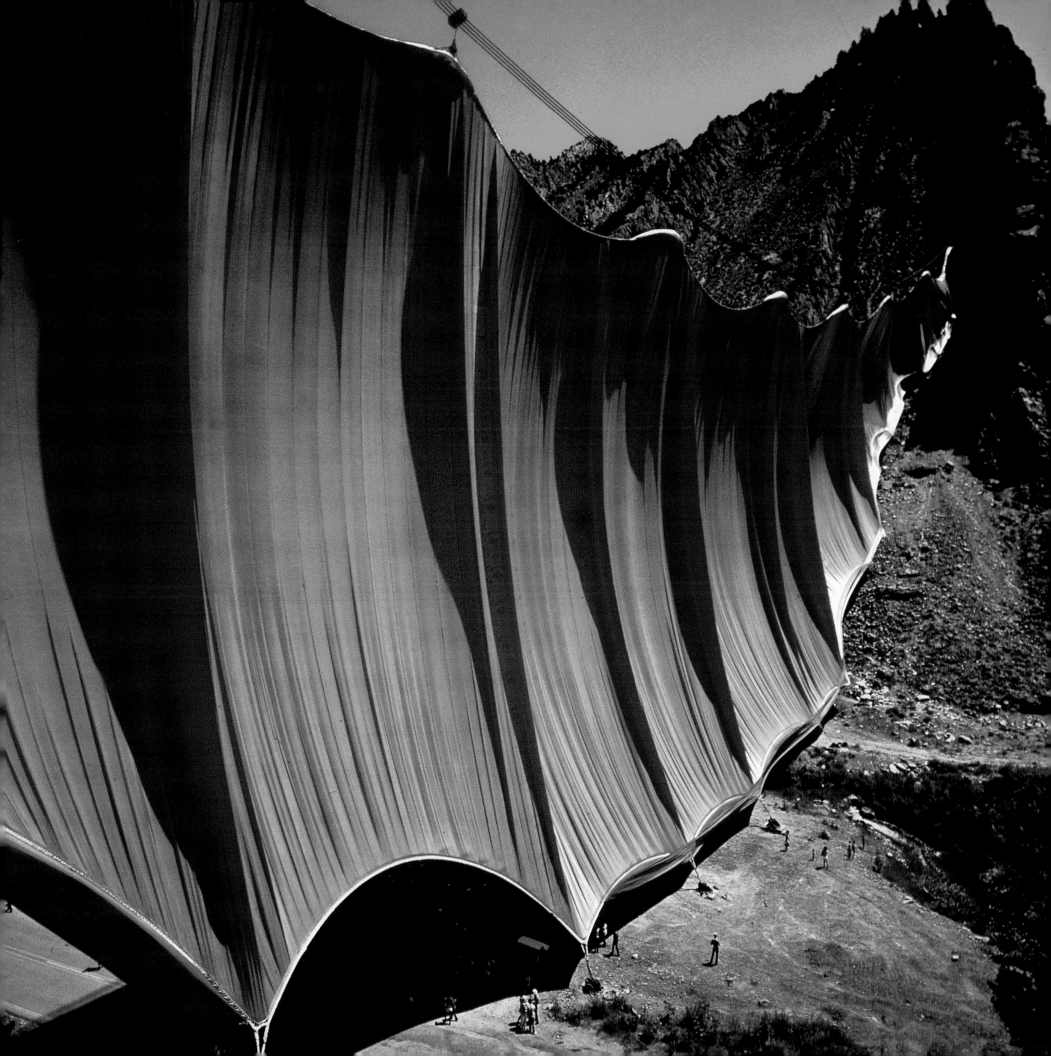

124

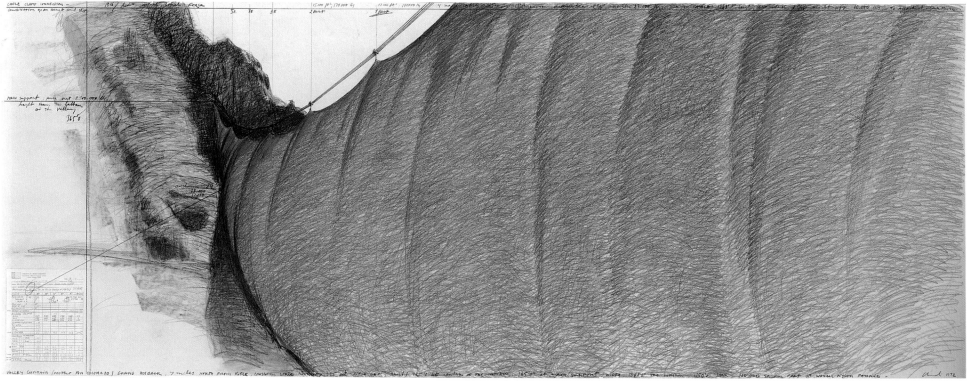

50.
Valley Curtain, Project for Colorado,
Grand Hogback, 7 miles North from Rifle
Drawing, 1972

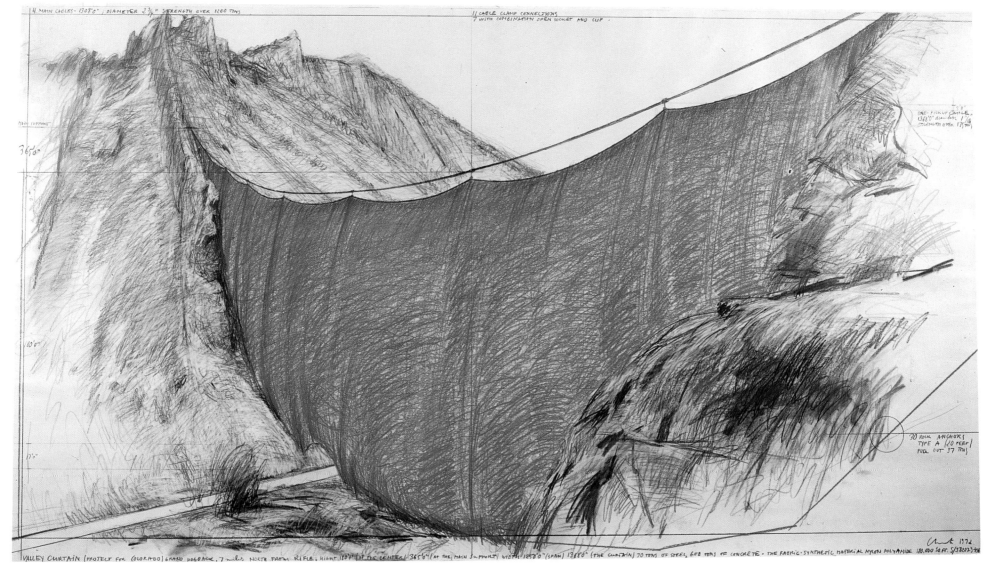

125

51.
Valley Curtain, Project for Rifle, Colorado
Collage, 1972

52.
Valley Curtain, Project for Rifle, Colorado
Painted photograph, 1972

126

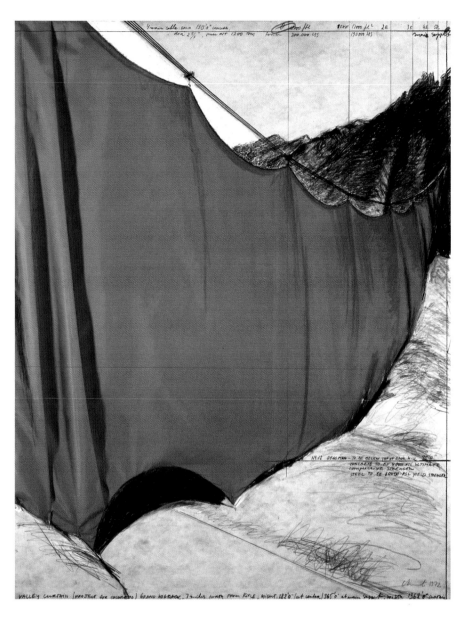

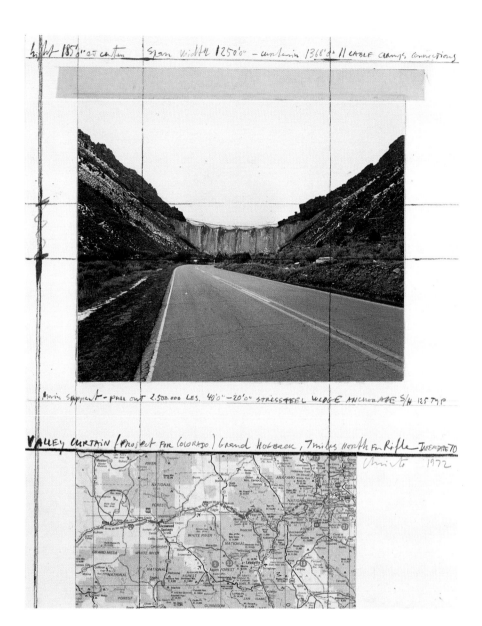

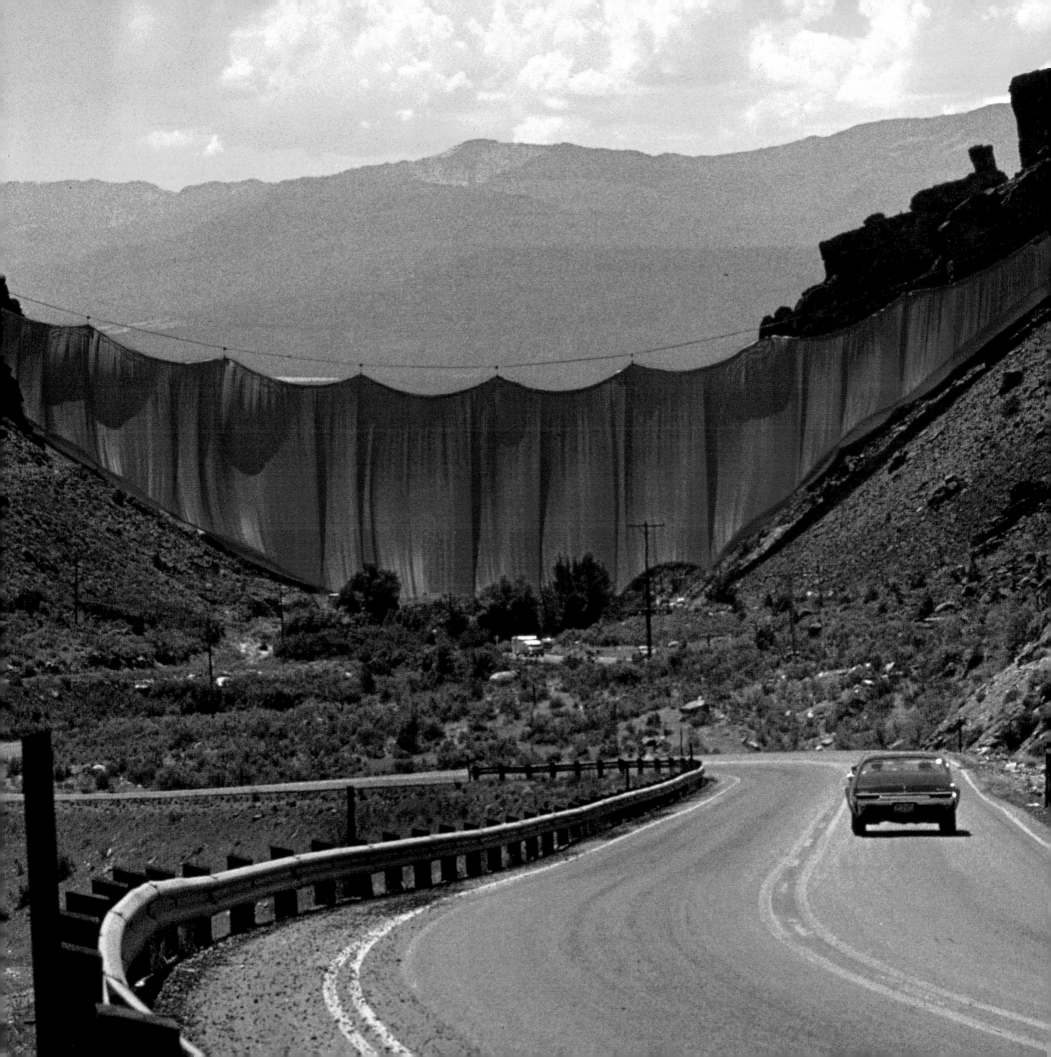

Running Fence, Sonoma and Marin Counties, California, 1972–76

Running Fence, 5.5 meters (18 feet) high, 39.4 kilometers (24.5 miles) long, extending East-West near Freeway 101, north of San Francisco, on the private properties of 59 ranchers, following the rolling hills and dropping down to the Pacific Ocean at Bodega Bay.

The *Running Fence* was completed on September 10, 1976.

The art project consisted of: 42 months of collaborative efforts, the ranchers' participation, 18 public hearings, 3 sessions at the Superior Court of California, the drafting of a 450-page environmental impact report and the temporary use of the hills, the sky and the ocean.

All expenses for the temporary work of art were paid by Christo and Jeanne-Claude through the sale of studies, preparatory drawings and collages, scale models and original lithographs. The artists do not accept sponsorship of any kind.

Running Fence was made of 200,000 square meters (240,000 square yards) of heavy woven white nylon fabric, hung from a steel cable strung between 2,050 steel poles (each: 6.4 meters / 21 feet long, 8.9 centimeters / 3.5 inches in diameter) embedded 91 centimeters (3 feet) into the ground, using no concrete and braced laterally with guy wires (145 kilometers / 90 miles of steel cable) and 14,000 earth anchors. The top and bottom edges of the 2,050 fabric panels were secured to the upper and lower cables by 350,000 hooks.

All parts of *Running Fence*'s structure were designed for complete removal and no visible evidence of *Running Fence* remains on the hills of Sonoma and Marin Counties.

As it had been agreed with the ranchers and with County, State and Federal Agencies, the removal of *Running Fence* started fourteen days after its completion and all materials were given to the ranchers.

Running Fence crossed 14 roads and the town of Valley Ford, leaving passage for cars, cattle and wildlife. It was designed to be viewed by following 65 kilometers (40 miles) of public roads, in Sonoma and Marin Counties.

Running Fence, Sonoma and Marin
Counties, California, 1972–76

Christo and Jeanne-Claude's next major
project, *Running Fence, Sonoma and Marin
Counties, California, 1972–76*, was a gleam-
ing ribbon of white fabric panels, 18 foot
high and 24.5 miles long, that intersected
14 roads and U.S. Highway 101, ran across
private ranches, beside subdivision homes,
through the middle of a town, and into the
Pacific Ocean at Bodega Bay north of San
Francisco.

It was so large that one could not see
the entire project even from an airplane.
Running Fence took [almost] four years of
negotiations with the 59 private ranchers
who owned the land, required a 450-page en-
vironmental-impact statement, prompted 18
public hearings (including 3 sessions of the
Superior Court of California) to obtain the
permits, and cost a total of $3.2 million.

Christo made the first drawing for what
would become *Running Fence* in 1972 and
titled it *The Divide*. During June and July
1973, Christo and Jeanne-Claude traveled
to California, searching for a suitable site for
Running Fence. Once they chose the site, the
artists commissioned careful engineering
drawings as well as topographical maps and
scale models. They also had their photo-
graphers taking pictures of the landscapes
they saw.

Christo based drawings on these pho-
tographs, and, in some cases, he painted di-
rectly on the photographs to study his for-
mal concepts in relation to the sites. As ear-
ly as 1961, Christo had used photomontage
and photo collage to visualize his projects,
and in the course of the 1960s he increas-
ingly included photographic documentation
in his collages, setting a formal precedent
for the collage sections of Robert Smith-
son's *Nonsites* and other such documentary
presentations by artists of the decade.

[Christo and Jeanne-Claude's] deter-
mination was tested [through the realization
of] *Running Fence*, where they met strenu-
ous opposition in court and in the press;
when I later asked Jeanne-Claude what was
one of the things that stood out as singular
for her in *Running Fence*, she replied: "It
was the first time we were sued"[1]. Indeed,
they were in court right up to the end.

At the last moment before the unfurl-
ing was complete, it looked like the courts
might issue a restraining order to stop the
Fence from going into the ocean. So Christo
and Jeanne-Claude went into hiding so that
an injunction could not be served. But the
judge sensibly concluded that such an or-
der was pointless, since the *Fence* would
come down in two weeks anyway, and he re-
fused to issue such a demand. *Running
Fence* finally went up on September 10,
1976, and remained for fourteen days.

[1] Christo and Jeanne-Claude, interview with Jonathan
Fineberg, New York City, July 25, 2003.

Excerpts from Jonathan Fineberg, *Christo and Jeanne-
Claude: On the Way to The Gates, Central Park, New
York City*, exhibition catalogue, The Metropolitan Mu-
seum of Art, New York, 2004.

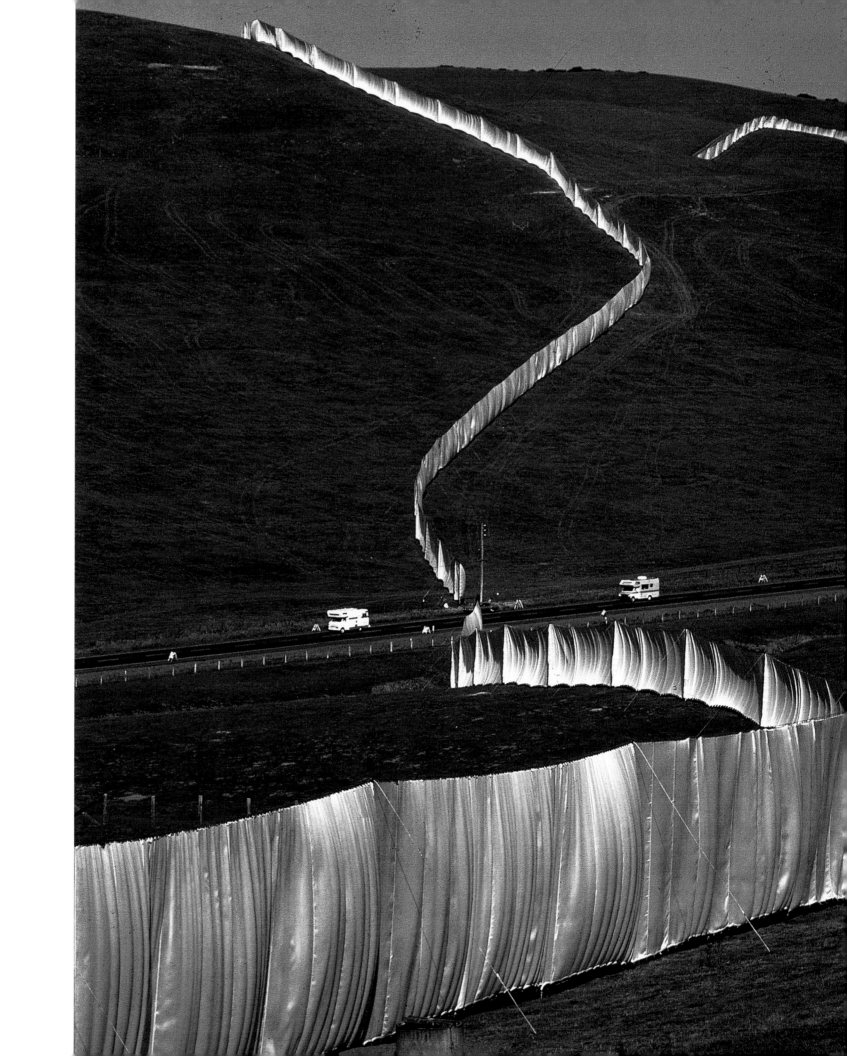

53.
**Running Fence, Project for Sonoma
and Marin Counties, California**
Drawing in two parts, 1973

132

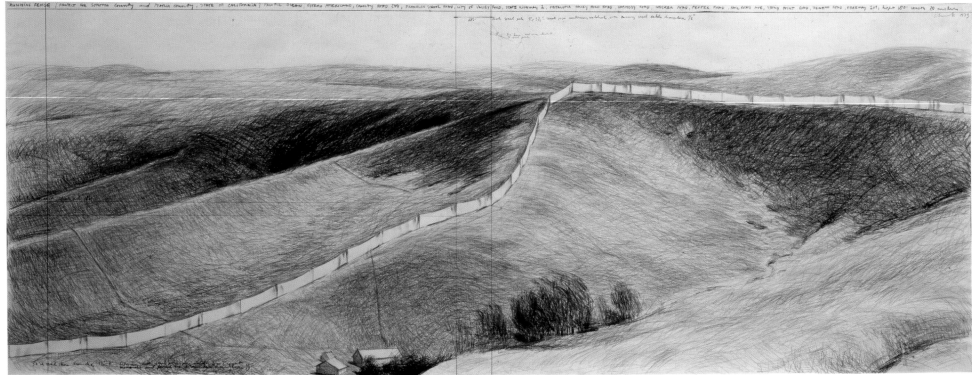

54.
**Running Fence, Project for Sonoma
and Marin Counties, California**
Collage, 1975

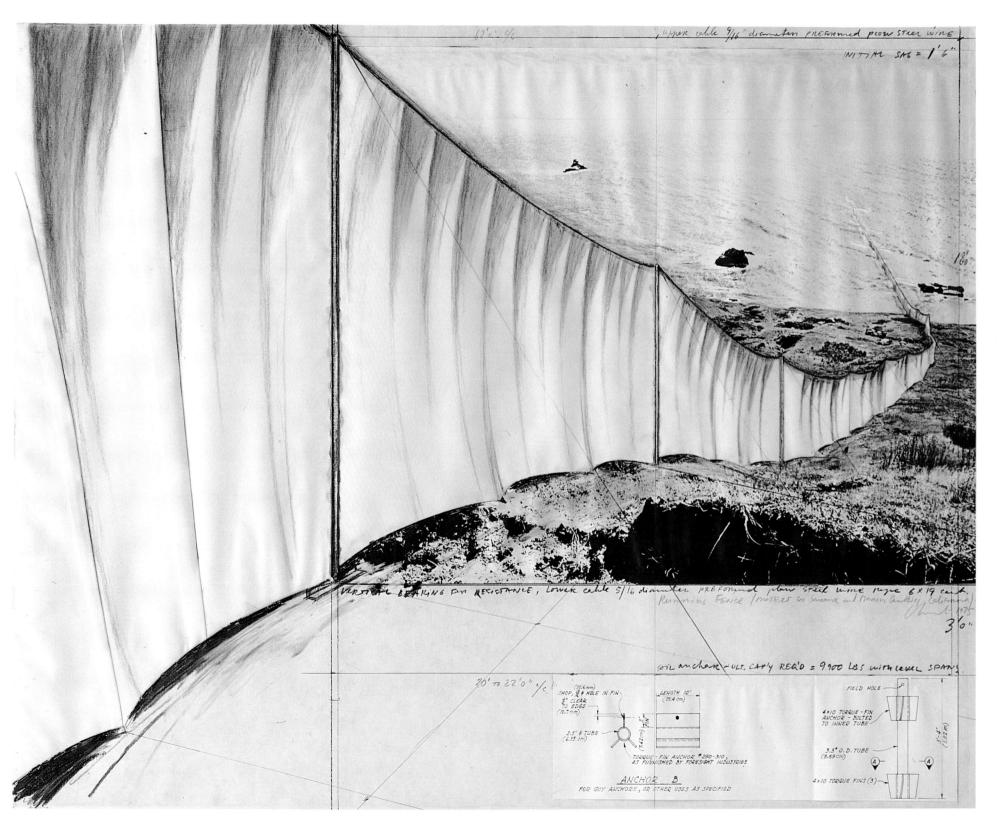

133

**Running Fence, Project for Sonoma
and Marin Counties, California**
Drawing in two parts, 1976

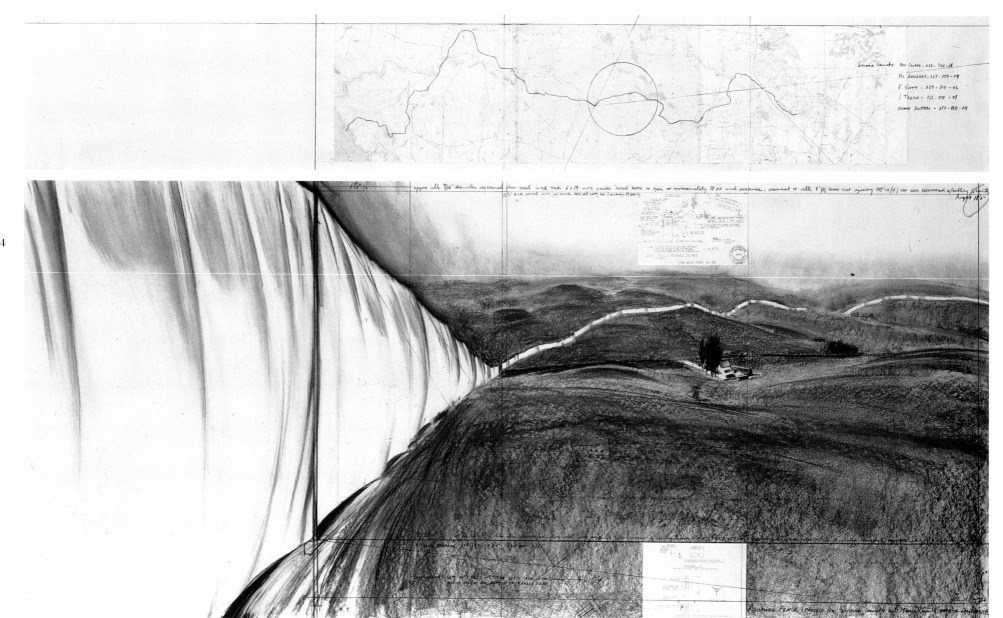

56.
**Running Fence, Project for Sonoma
and Marin Counties, California**
Drawing in two parts, 1976

135

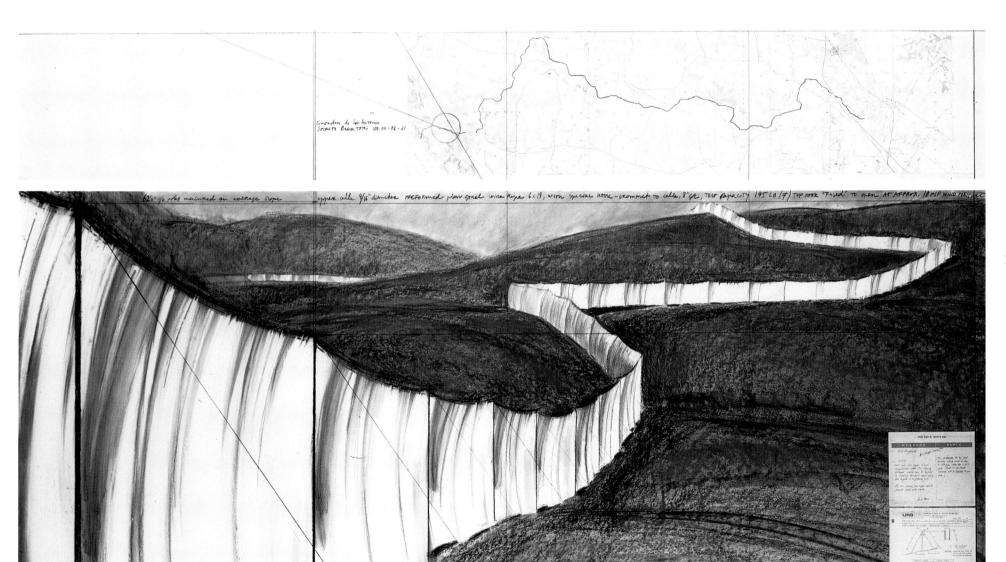

**Running Fence, Project for Sonoma
and Marin Counties, California**
Painted photograph, 1976

upper cable 9/16" Ø preformed plow steel wire rope

hight 18'0"

lower cable 5/16" Ø preformed plow steel wire rope
to soil anchore cap'y req'd = 3200 LB.

20-22'0"

Christo 1976

Running FENCE (project for Marin at Sonoma Counties, Calif.)

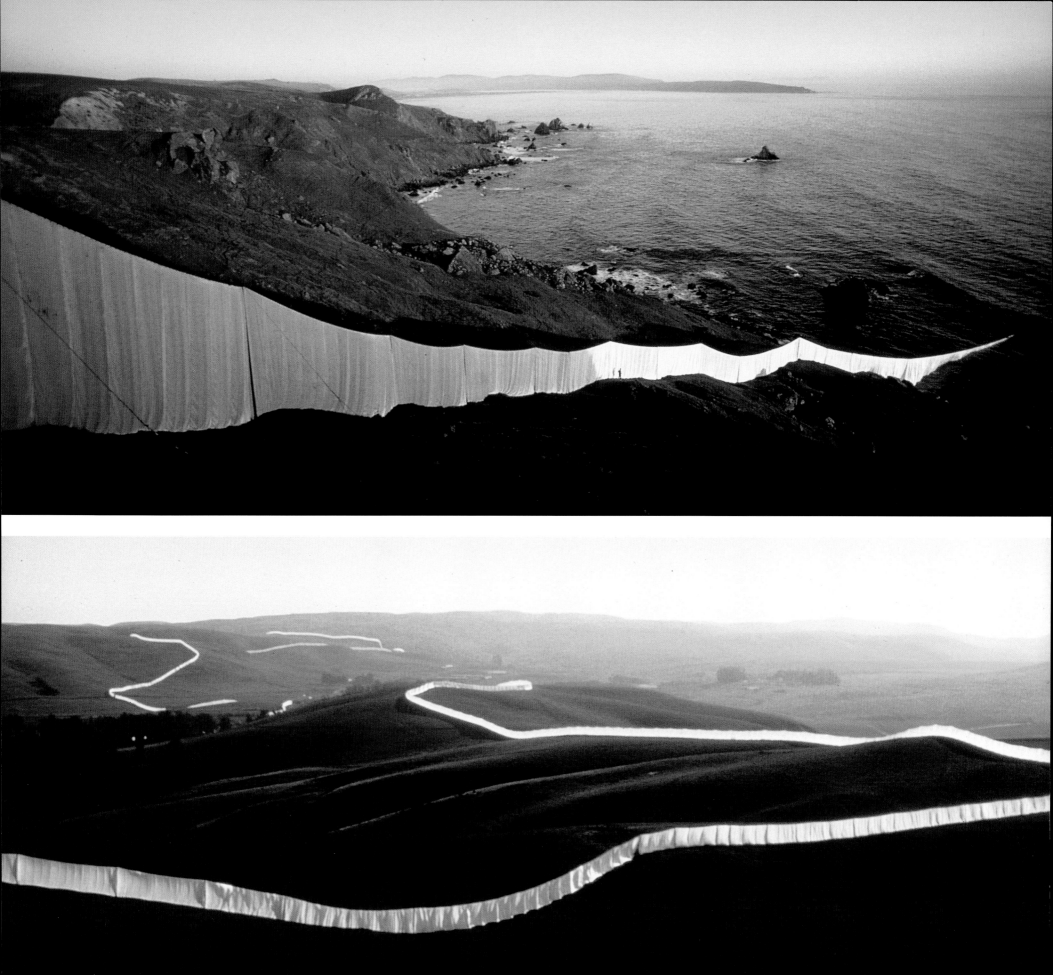

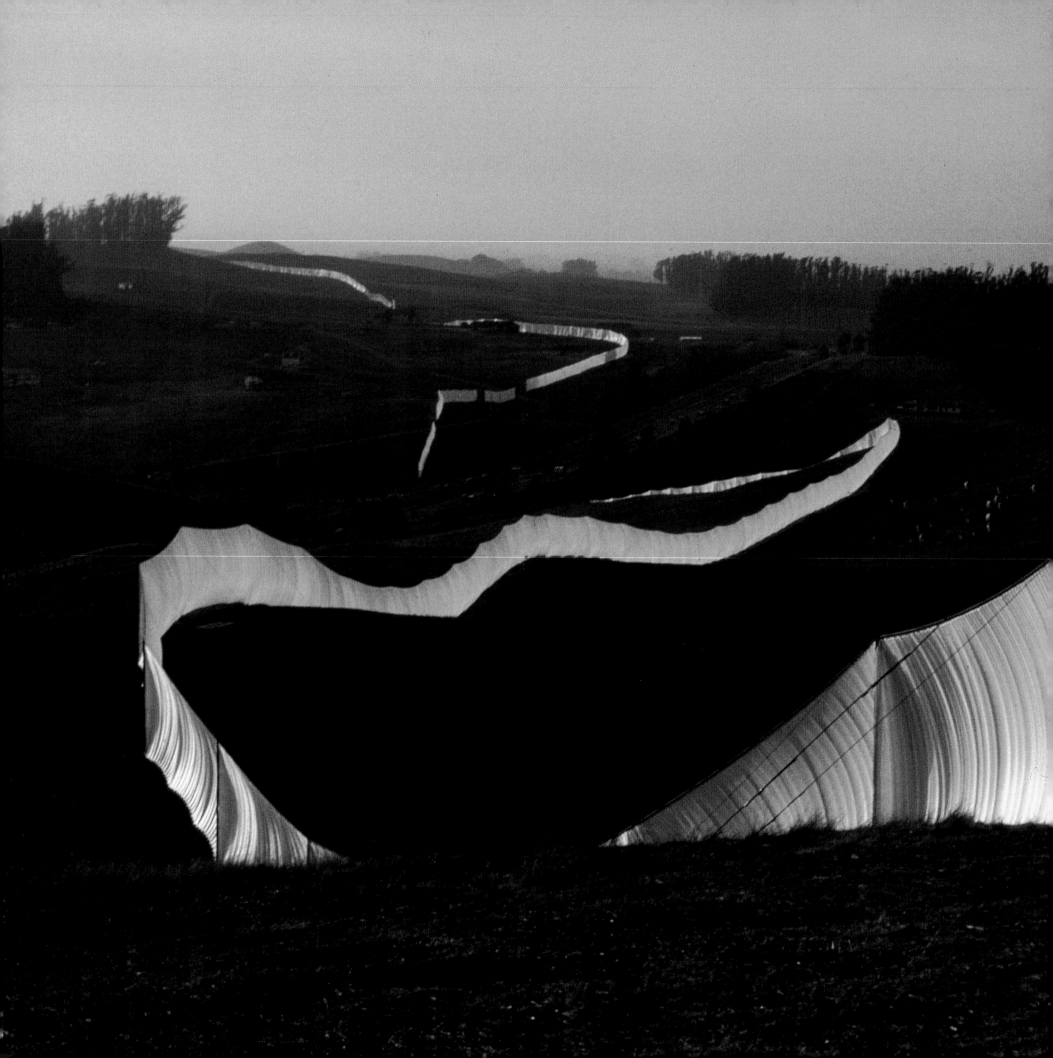

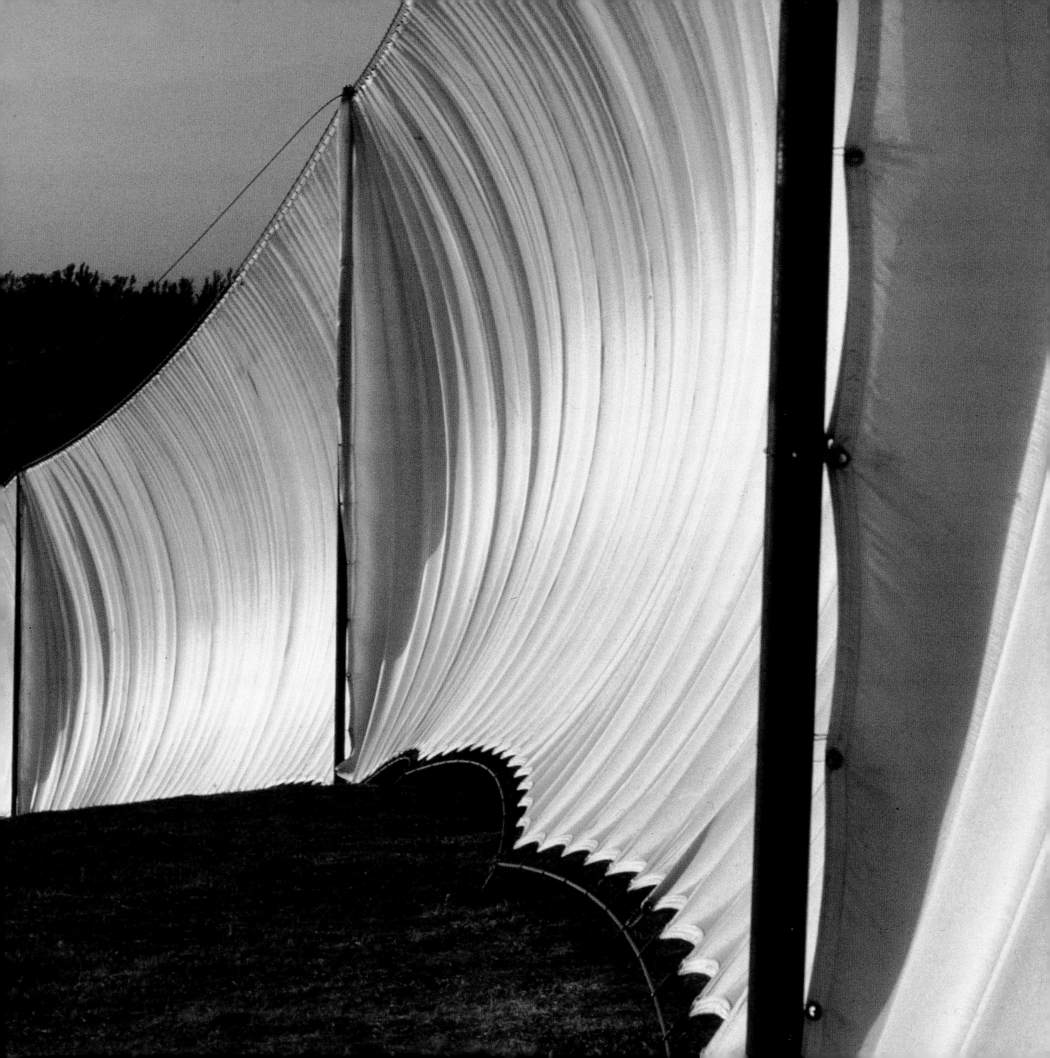

Surrounded Islands, Biscayne Bay, Greater Miami, Florida, 1980–83

On May 7, 1983 the installation of *Surrounded Islands* was completed. In Biscayne Bay, between the city of Miami, North Miami, the Village of Miami Shores and Miami Beach, eleven of the islands situated in the area of Bakers Haulover Cut, Broad Causeway, 79th Street Causeway, Julia Tuttle Causeway, and Venetian Causeway were surrounded with 603,850 square meters (6.5 million square feet) of pink woven polypropylene fabric covering the surface of the water, floating and extending out 61 meters (200 feet) from each island into the bay. The fabric was sewn into 79 patterns to follow the contours of the eleven islands.

For 2 weeks *Surrounded Islands* spreading over 11.3 kilometers (7 miles) was seen, approached and enjoyed by the public, from the causeways, the land, the water and the air. The luminous pink color of the shiny fabric was in harmony with the tropical vegetation of the uninhabited verdant islands, the light of the Miami sky and the colors of the shallow waters of Biscayne Bay.

Since April 1981, attorneys Joseph Z. Fleming, Joseph W. Landers, marine biologist Dr. Anitra Thorhaug, ornithologists Dr. Oscar Owre and Meri Cummings, mammal expert Dr. Daniel Odell, marine engineer John Michel, four consulting engineers, and builder-contractor Ted Dougherty of A&H Builders, Inc. had been working on the preparation of the *Surrounded*

Islands. The marine and land crews picked up debris from the eleven islands, putting refuse in bags and carting it away after they had removed some forty tons of varied garbage: refrigerator doors, tires, kitchen sinks, mattresses and an abandoned boat.

Permits were obtained from the following governmental agencies: the Governor of Florida and the Cabinet; the Dade County Commission; the Department of Environmental Regulation; the City of Miami Commission; the City of North Miami; the Village of Miami Shores; the U.S. Army Corps of Engineers; the Dade County Department of Environmental Resources Management. From November 1982 until April 1983, 6,500,000 square feet of woven polypropylene fabric was sewn at the rented Hialeah factory, into 79 different patterns to follow the contours of the eleven islands. A flotation strip was sewn in each seam. At the Opa Locka Blimp Hangar, the sewn sections were accordion folded to ease the unfurling on the water.

The outer edge of the floating fabric was attached to a 30.5 centimeter (12 inch) diameter octagonal boom, in sections, of the same color as the fabric. The boom was connected to the radial anchor lines which extended from the anchors at the island to the 610 specially made anchors, spaced at 15.3 meter (50 foot) intervals, 76 meters (250 feet) beyond the perimeter of each island, driven into the limestone at the bottom of the Bay. Earth anchors were driven into the land, near the foot of the trees, to secure the inland edge of the fabric, covering the surface of the beach and disappearing under the vegetation.

The floating rafts of fabric and booms, varying from 3.7 to 6.7 meters (12 to 22 feet) in width and from 122 to 183 meters (400 to 600 feet) in length were towed through the Bay to each island. There were eleven islands, but on two occasions, two islands were surrounded together as one configuration.

As with Christo and Jeanne-Claude's previous art projects, *Surrounded Islands* was entirely financed by the artists, through the sale by C.V.J. Corporation (Jeanne-Claude Christo-Javacheff, President) of the preparatory pastel and charcoal drawings, collages, lithographs and early works. The artists do not accept sponsorship of any kind.

On May 4, 1983, out of a total work force of 430, the unfurling crew began to blossom the pink fabric. *Surrounded Islands* was tended day and night by 120 monitors in inflatable boats.

Surrounded Islands was a work of art which underlined the various elements and ways in which the people of Miami live, between land and water.

Surrounded Islands, Biscayne Bay, Greater Miami, Florida, 1980–83

From the time of *Running Fence* through the *Wrapped Walk Ways*, Christo and Jeanne-Claude juggled several major projects, all of which were hung up in frustrating political struggles. [...]

So, when an invitation came in 1980 to do a major project for a community-sponsored festival of the arts in Miami, it seemed a welcome relief. It wasn't long, however, before Christo and Jeanne-Claude decided against doing an outdoor project in the heat of June in Miami (the date for which the festival was planned), and they disassociated themselves from it. They nevertheless found the idea of creating a project in Miami exciting and quickly focused on the idea of surrounding eleven of the tiny spoil islands in Biscayne Bay with floating pink fabric.

In 1936, the Army Corps of Engineers had dredged the bay to create a navigational channel for oceangoing ships and dumped the excavated material in fourteen piles that formed a chain of islands. These islands sat unnoticed for decades, between the cities of Miami and Miami Beach, in the midst of the heavy cross-bay traffic of boats and automobile causeways.

Over the next two and a half years Christo and Jeanne-Claude painstakingly studied the environmental issues as well as all the engineering problems and logistics. They found that the shallow bay contained a plethora of protected wildlife – endangered birds, manatees, and a variety of rare sea grasses. They did not use three of the fourteen islands because these had no beaches on which the fabric could be anchored. They tested different fabrics, anchors, and flotation booms, commissioned scientific studies of everything from the microorganisms in the sand to the birds, and they used high-tech instruments to locate the anchors and create computer maps for the fabric patterns.

Christo and Jeanne-Claude also met endlessly with lawyers, government agencies, and public groups to present the idea, win support, and negotiate permits. After numerous lawsuits in county, state, and even federal courts, and cliff-hanger hearings, they finally won the permits.

They installed *Surrounded Islands, Biscayne Bay, Greater Miami, Florida, 1980–83*, the most expensive project they had ever undertaken, for fourteen days in May 1983. Although the project sat nearly in the middle of a major city and stretched 7 miles from one end of the bay to the other, it nevertheless seemed oddly isolated and unreal. In addition, it so closely resembled the artist's renderings (as in all the large Christo and Jeanne-Claude projects) that, when anyone who knew the drawings saw the actual work, he or she had a sense of déjà vu, compounding the feeling of unreality. It was visually breathtaking and blended seamlessly into the surrounding environment. [...]

The *Surrounded Islands* was perhaps Christo and Jeanne-Claude's most photogenic work, and unlike any of their other projects the best view of it was either from a helicopter or on television. Most people experienced it through the media. Communicating an aesthetic idea to a mass-culture audience became one of the most important new issues in art of the late twentieth century, and Christo and Jeanne-Claude succeeded more than any other artists in developing the radical potential of mass media – including television.

Excerpts from Jonathan Fineberg, *Christo and Jeanne-Claude: On the Way to The Gates, Central Park, New York City*, exhibition catalogue, The Metropolitan Museum of Art, New York, 2004.

142

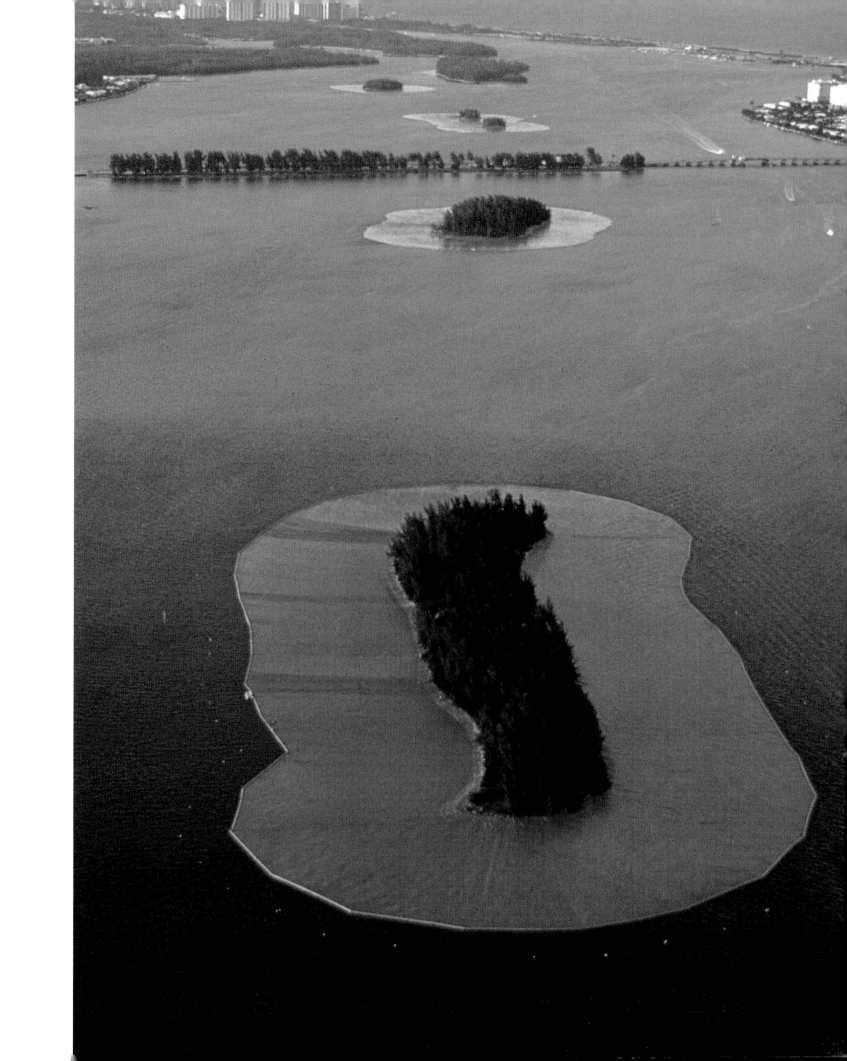

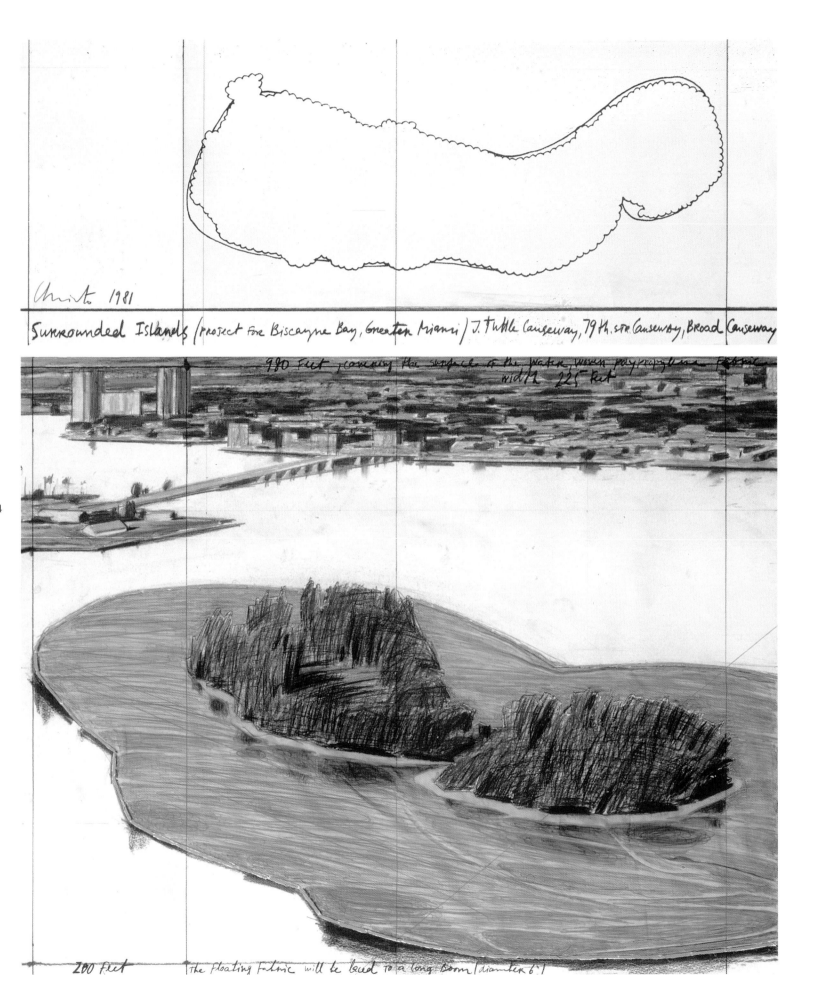

Christo 1981

Surrounded Islands (project for Biscayne Bay, Greater Miami) J. Tuttle Causeway, 79 th. str Causeway, Broad Causeway

980 feet, covering the surface of the water, woven polypropylene fabric
width 225 feet

144

200 feet The floating fabric will be laid to a long boom [diameter 6']

58.
Surrounded Islands, Project for Biscayne Bay, Greater Miami, Florida
Collage in two parts, 1981

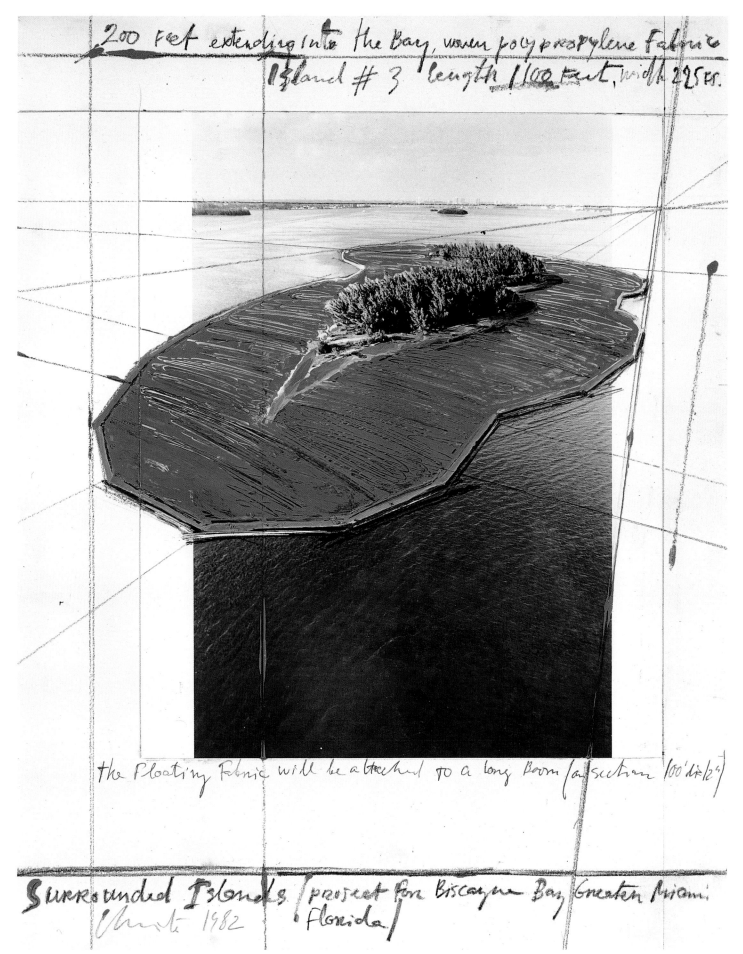

145

59.
Surrounded Islands, Project for Biscayne Bay, Greater Miami, Florida
Collage, 1982

**Surrounded Islands, Project for Biscayne
Bay, Greater Miami, Florida**
Drawing in two parts, 1982

**Surrounded Islands, Project for Biscayne
Bay, Greater Miami, Florida**
Collage in two parts, 1983

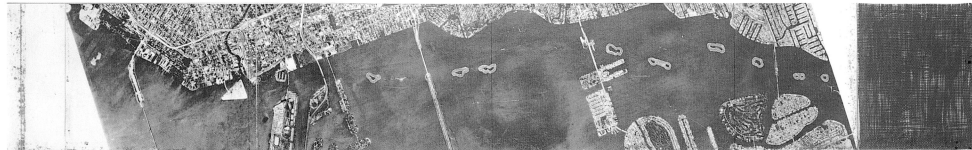

Surrounded Islands (Project For Biscayne Bay, Greater Miami, Florida) Venetian Causeway, J. Tuttle Causeway, 79th. Street Causeway, Broad Causeway and Baker's Haulover Inlet Christo 1982

Expanding into the Bay 280 Feet, covering the surface of the water woven polypropylene (Fabric) construction 7x7 per inch, GR. 0.48 anchor 4.8, Boom 5.0 width 250 Feet, Island # 1 length 975 Feet

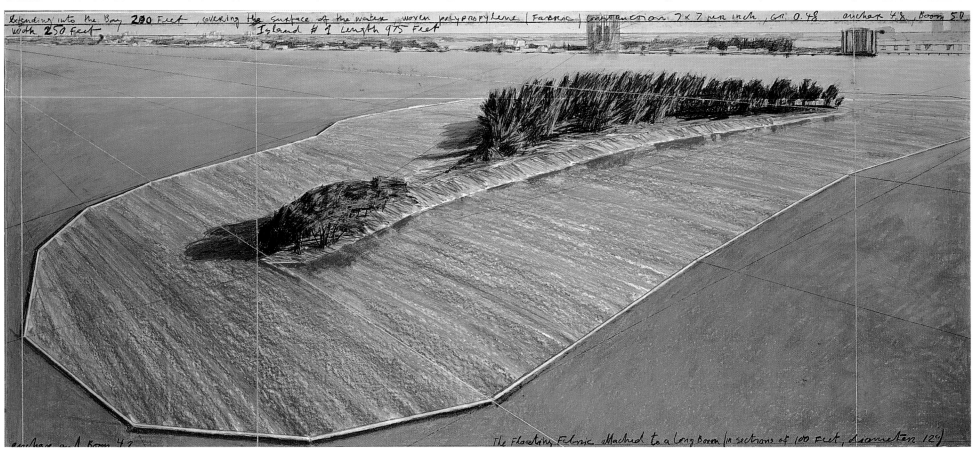

anchor a 1 Boom 4.8 The Floating Fabric attached to a long Boom (in sections of 100 Feet, diameter 12')

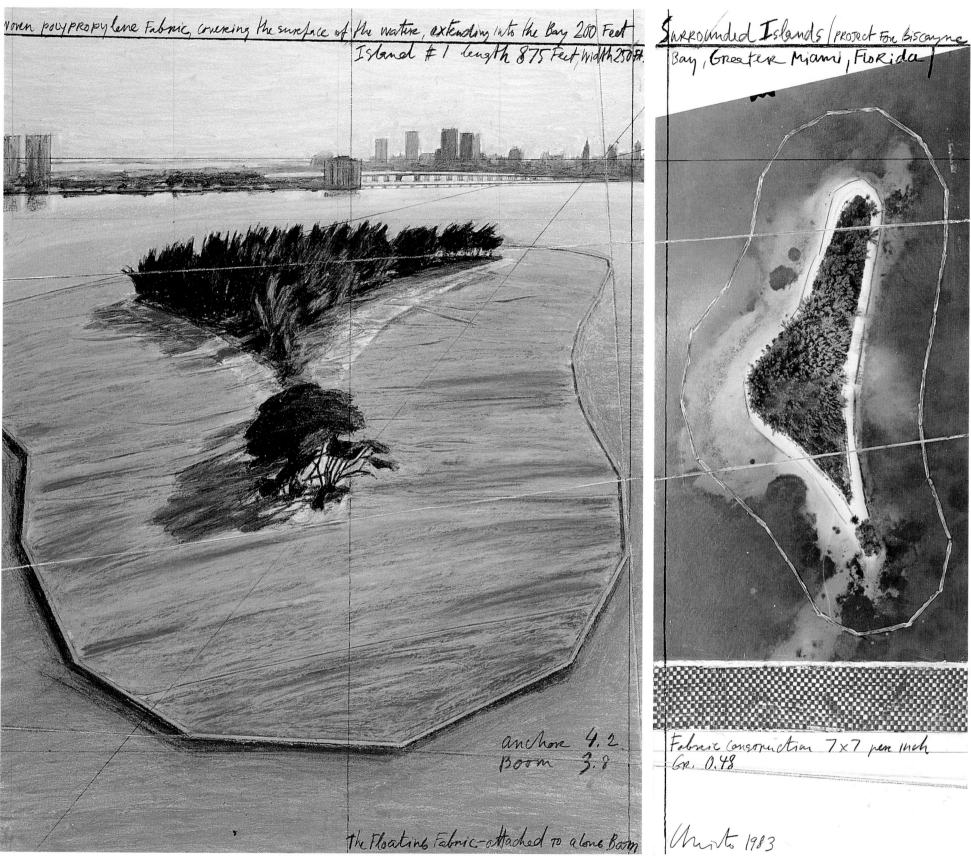

woven polypropylene Fabric, covering the surface of the water, extending into the Bay 200 Feet

Island #1 length 875 Feet, width 250 Ft.

anchor 4.2

Boom 3.8

The Floating Fabric-attached to a long Boom

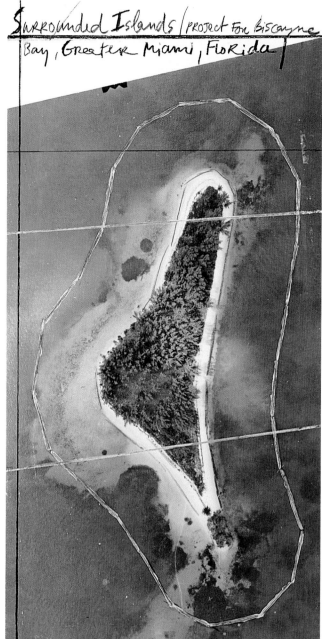

Surrounded Islands / Project For Biscayne Bay, Greater Miami, Florida /

147

Fabric construction 7x7 per inch

Gr. 0.48

Christo 1983

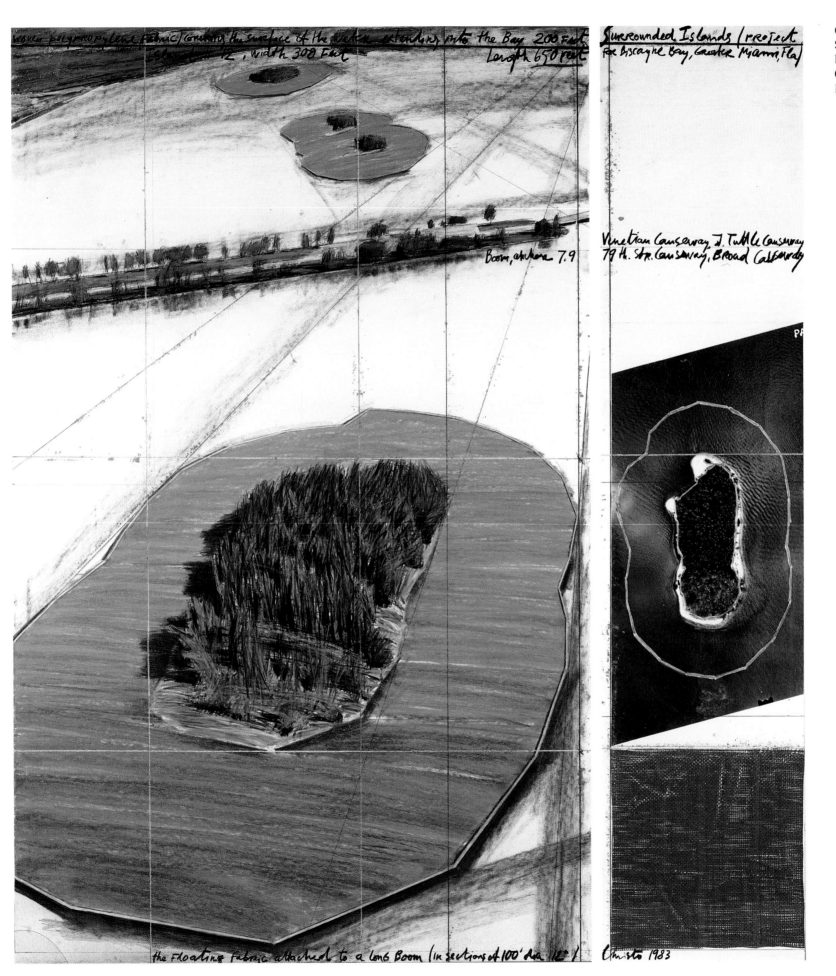

woven polypropylene (fabric) covering the surface of the water extending into the Bay 200 Feet
Island #12, width 300 Feet
Length 650 Feet

Boom, anchors 7.9

the Floating Fabric attached to a Long Boom (in sections of 100' dia 12°)

Surrounded Islands (Project
for Biscayne Bay, Greater Miami, Fla)

Venetian Causeway, J. Tuttle Causeway
79 th. Str. Causeway, Broad Causeway

Christo 1983

62.
**Surrounded Islands,
Project for Biscayne Bay,
Greater Miami, Florida**
Drawing in two parts, 1983

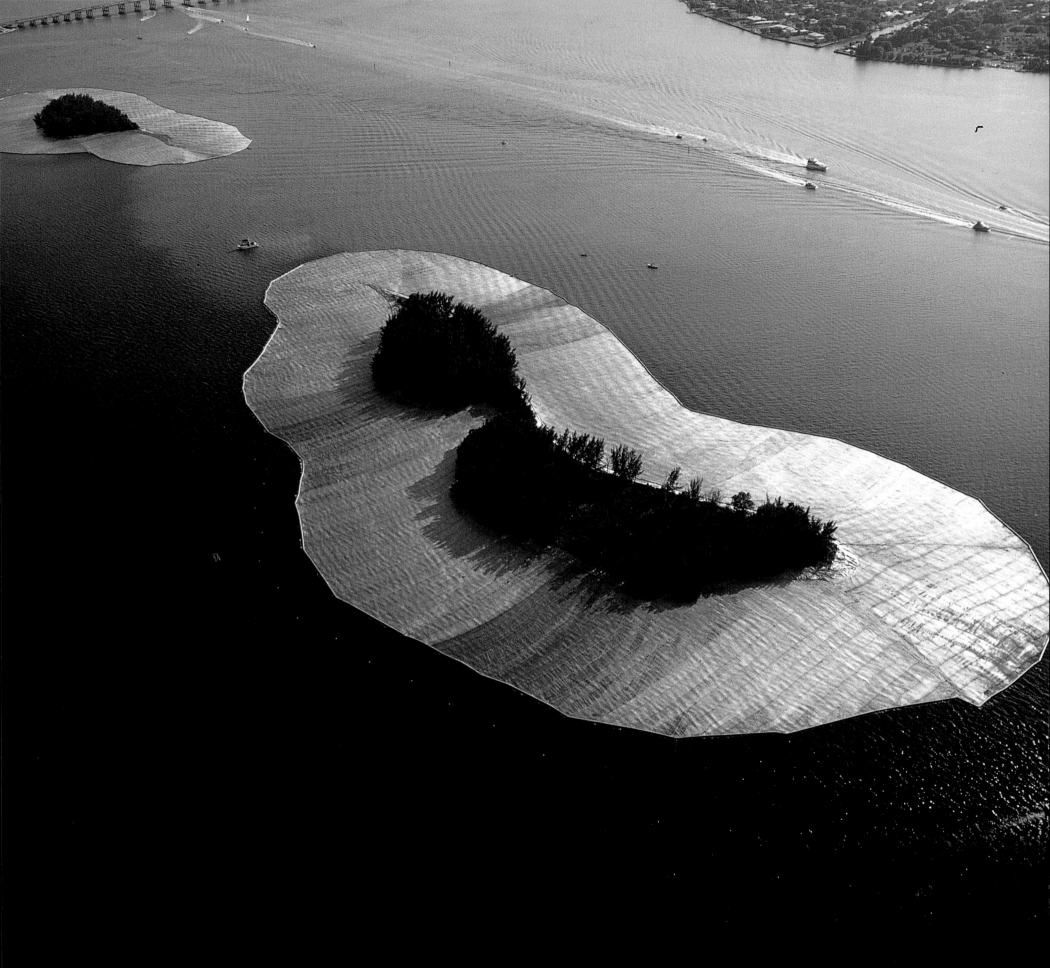

The Pont Neuf Wrapped, Paris, 1975–85

On September 22, 1985, a group of 300 professional workers completed the temporary work of art *The Pont Neuf Wrapped*.

They had deployed 40,876 square meters (454,178 square feet) of woven polyamide fabric, silky in appearance and golden sandstone in color, covering:

- the sides and vaults of the twelve arches, without hindering river traffic;
- the parapets down to the ground;
- the sidewalks and curbs (pedestrians walked on the fabric);
- all the street lamps on both sides of the bridge;
- the vertical part of the embankment of the western tip of the Ile de la Cité;
- the esplanade of the Vert-Galant.

The fabric was restrained by 13,076 meters (42,900 feet) of rope and secured by 12.1 metric tons (11.8 long tons) of steel chains encircling the base of each tower, 1 meter (3.3 feet) underwater.

The "Charpentiers de Paris" headed by Gérard Moulin, with French sub-contractors, were assisted by the USA engineers who have worked on Christo and Jeanne-Claude's previous projects, under the direction of Theodore Dougherty: Vahé Aprahamian, August L. Huber, James Fuller, John Thomson and Dimiter Zagoroff.

Johannes Schaub, the project's director, had submitted the work method and detailed plans and received approval for the project from the authorities of the City of Paris, the Department of the Seine and the State.

600 monitors, in crews of 40, led by Simon Chaput, were working around the clock maintaining the project and giving information, until the removal of the project on October 7.

All expenses for *The Pont Neuf Wrapped* were borne by the artists as in their other projects through the sale of preparatory drawings and collages as well as earlier works. The artists do not accept sponsorship of any kind.

Begun under Henri III, the Pont-Neuf was completed in July 1606, during the reign of Henry IV. No other bridge in Paris offers such topographical and visual variety, today as in the past.

From 1578 to 1890, the Pont-Neuf underwent continual changes and additions of the most extravagant sort, such as the construction of shops on the bridge under Soufflot, the building, demolition, rebuilding and once again demolition of the massive rococo structure which housed the Samaritaine's water pump.

Wrapping the Pont-Neuf continues this tradition of successive metamorphoses by a new sculptural dimension and transforms it, for fourteen days, into a work of art.

Ropes held down the fabric to the bridge's surface and maintained the principal shapes, accentuating relief while emphasizing proportions and details of the Pont-Neuf which joins the left and right banks and the Ile de la Cité, the heart of Paris for over 2,000 years.

The Pont Neuf Wrapped, Paris, 1975–85

A persistent fascination with bridges
Christo and Jeanne-Claude's intentions in wrapping a bridge may have been sparked by several factors, including admiration for its aesthetic and engineering design and an appreciation for its crucial siting in a landscape. They are keenly aware, of course, that most bridges are roadways whose vital function is to expedite transportation and commerce – and they are intrigued by those roadways that cross waterways.

The artists have incorporated roadways in many of their outdoor artworks since the early 1960s, starting with the wall of oil barrels in the Rue Visconti. Christo's lengthy store front constructions of the mid-1960s imply that viewers are passersby on a nonexistent sidewalk. Their project wrap of an *allée* of trees would have given a new and startling dimension of unity to the Champs-Elysées. In 1972, motorists in Rifle Gap, Colorado, drove through an arch in *Valley Curtain* and, in 1976, drivers in Sonoma and Marin counties in California discovered that their highways and country roads were frequently intersecting the 24.5 mile *Running Fence*. In 1978, *Wrapped Walk Ways* created for a Kansas City, Missouri, park, became one of their purest expressions of art as an ambulatory or mobile experience, designed to be seen from multiple vantage points.

Water, like roads, is another frequent theme in the artists' work, dramatically emerging in *Wrapped Coast*, the 1969 work in which they wrapped [more than] a mile of Australian shoreline, extending the fabric to water's edge. One extremity of *Running Fence* continued several hundred feet into the Pacific Ocean and seemed to disappear underwater. For a work titled *Ocean Front* (1974), they laid a fabric "sheet" across a semicircular cove of the Atlantic Ocean in Newport, Rhode Island; this work proved to be a three-dimensional sketch for *Surrounded Islands*, the 1983 project in which Christo and Jeanne-Claude ringed eleven islands with bright pink "skirts" in Biscayne Bay, Miami.

The couple first contemplated wrapping a bridge, the Ponte Sant'Angelo, in 1967. The historic stone-arch structure, which spans the Tiber River between Rome and Vatican City, was initially commissioned by the emperor Hadrian in A.D. 135 and called the Pons Aelius. Reconstructed in 1668, the bridge was embellished under the supervision of Gian Lorenzo Bernini with statues of angels carrying symbols of Christ's Passion.

Christo and Jeanne-Claude had hoped to wrap the bridge in connection with a projected exhibition, which never materialized, at the Galleria Nazionale d'Arte Moderna in Rome.

In 1972, the artists proposed wrapping the Pont Alexandre III which crosses the Seine near the Grand Palais in Paris. The bridge was built, as was the steel-and-glass "palace", for the 1900 World Exposition. But the artists soon dropped their plans for this bridge when they determined it was essentially unsuitable for their purposes. Because the structure spans the river with only one arch they concluded that its lean silhouette was not as arresting as a multiarch stone bridge that has most of its piers in water.

A year after they abandoned their designs on the Pont Alexandre III, they focused their attention on the Pont-Neuf. The older structure held greater appeal for them partly because of its superior location: the Ile de la Cité, which it crosses, has been the center of Paris for two-thousand years. Structurally, the Pont-Neuf's twelve arches promised a livelier and more rhythmic silhouette for their wrapping than the single-arch Alexandre III bridge. Equally as important, the Pont-Neuf could be viewed not only from opposite banks of the Seine and from upstream and downstream, but also from the Ile de la Cité. From that island alone, several contrasting views exist – from the Place Dauphine at sidewalk level to the quays and the Square du Vert-Galant below the roadway. At the same time, motorists could cross over the bridge or drive under it on the Georges Pompidou Expressway.

Although determined to realize their vision of a wrapped Pont-Neuf, Christo and Jeanne-Claude had to postpone extensive negotiations for a few years because they were heavily involved with other projects, such as *Running Fence* (1976), *Wrapped Walk Ways* (1978), and the political entanglements of *Wrapped Reichstag, Berlin*, which was finally completed in 1995.

Excerpts from the picture commentary by David Bourdon in *The Pont Neuf Wrapped, Paris, 1975–85*, Harry N. Abrams, New York, 1990. Edited and revised in 2001 by Susan Astwood.

152

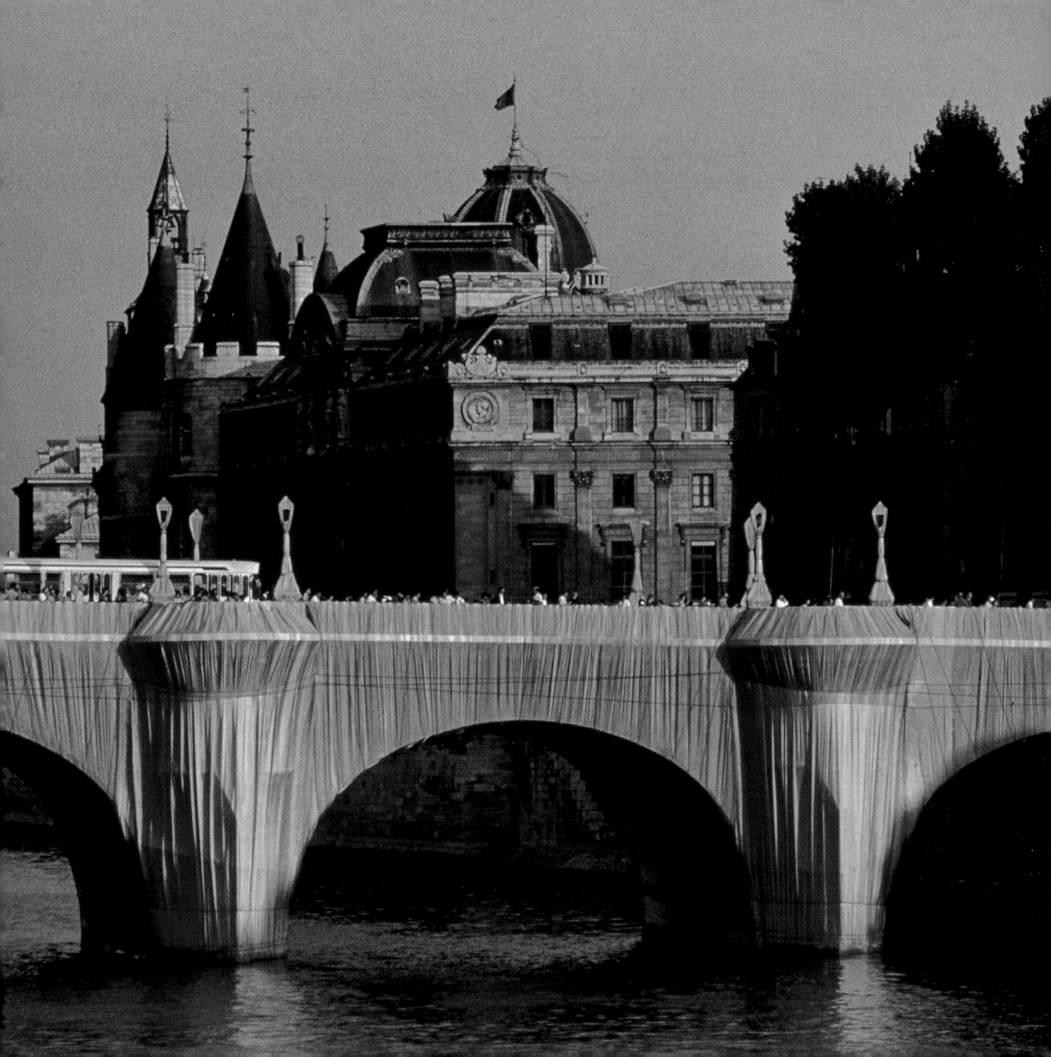

63.
The Pont Neuf Wrapped, Project for Paris
Drawing in two parts, 1979

64.
The Pont Neuf Wrapped, Project for Paris
Collage, 1978

154

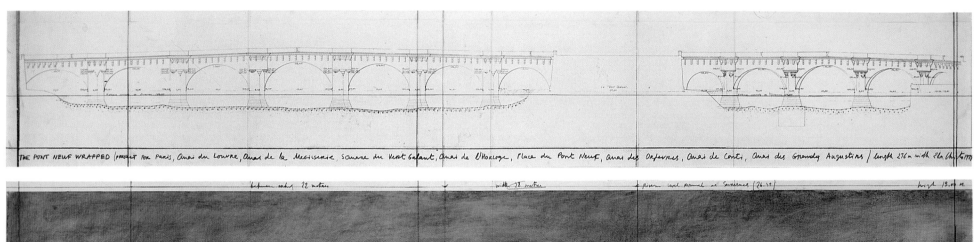

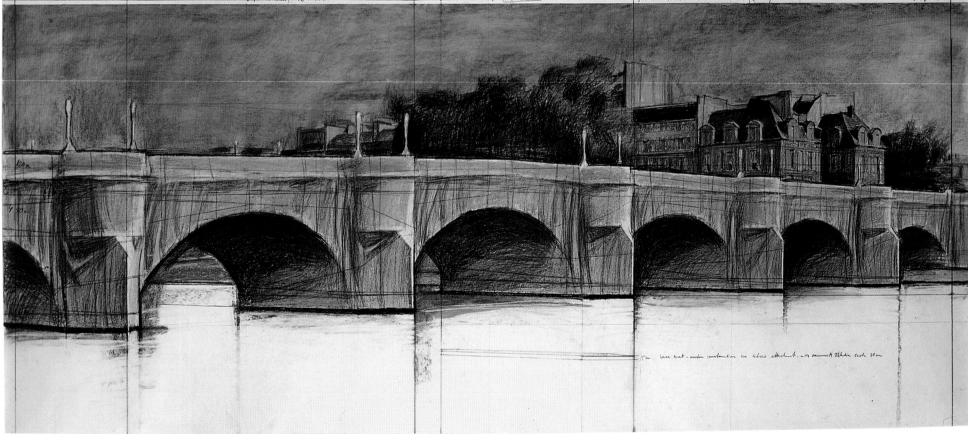

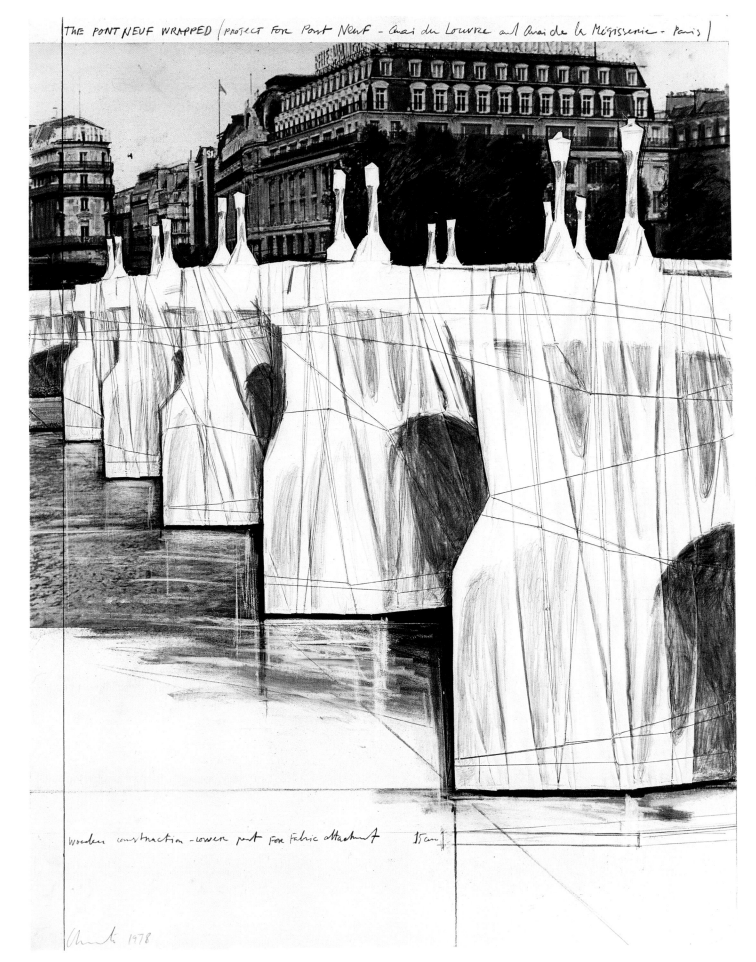

THE PONT NEUF WRAPPED (PROJECT FOR Pont Neuf - Quai du Louvre and Quai de la Mégisserie - Paris)

Wooden construction - lower part for fabric attachment 15 cm

Christo 1978

65.
The Pont Neuf Wrapped, Project for Paris
Drawing in two parts, 1982

THE PONT NEUF, WRAPPED (PROJECT FOR PARIS) Quai du Louvre, Quai de la Megissèrie, Ile de la Cité, Place du Pont Neuf, Q. de l'Horloge, Quai des Orfevres, Quai de Conti, Quai des Grands Augustins

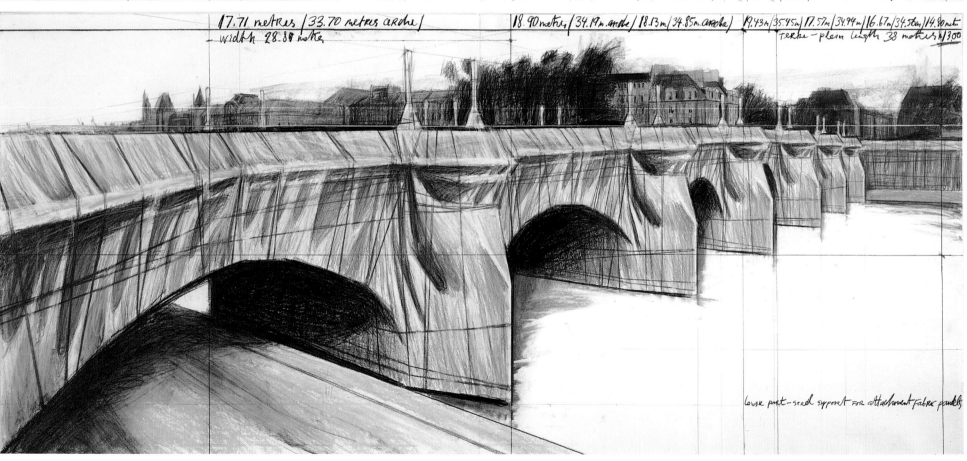

17.71 metres / 33.70 metres arche /
width 28.30 metre,

18.90 metre, / 34.19 m. arche / 18.13 m / 34.85 m. arche) 19.43 m / 35.45 m / 17.57 m / 34.94 m / 16.67 m / 34.5 m / 14.80 m
terre-plein length 38 metre, / 300

Louvre pont-seal support for attachment Fabric panels

66.
The Pont Neuf Wrapped, Project for Paris
Drawing in two parts, 1985

THE PONT NEUF, WRAPPED (Project For Paris) Quai du Louvre, Quai de la Mégisserie, Ile de la Cité Quai de l'Horloge, Place du Pont Neuf, Square du Vert Galant, Quai des Orfevres, Quai de Conti Quai des Grands Augustins Christo 1985

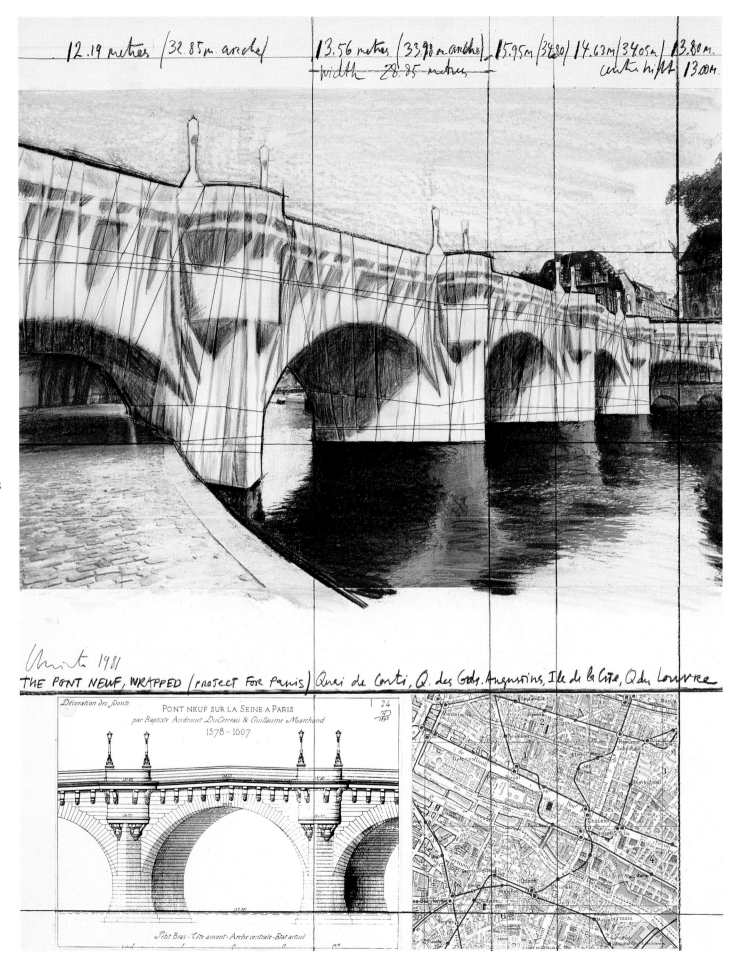

12.19 meters (32.85m arche) 13.56 meters (33.90 m arche) 15.95m (34.80) 14.63m (34.05m) 13.80m.
width 28.85 meters centre hight 13.004.

Christo 1981

THE PONT NEUF, WRAPPED (PROJECT FOR PARIS) Quai de Conti, Q. des Grds. Augustins, Ile de la Cité, Q.du Louvre

Décoration des Ponts

PONT NEUF SUR LA SEINE A PARIS
par Baptiste Androuet DuCerceau & Guillaume Marchand
1578 - 1607

Petit Bras - Tête amont - Arche centrale - Etat actuel

67.
The Pont Neuf Wrapped, Project for Paris
Collage, 1981

158

68.
The Pont Neuf Wrapped, Project for Paris
Drawing in two parts, 1985

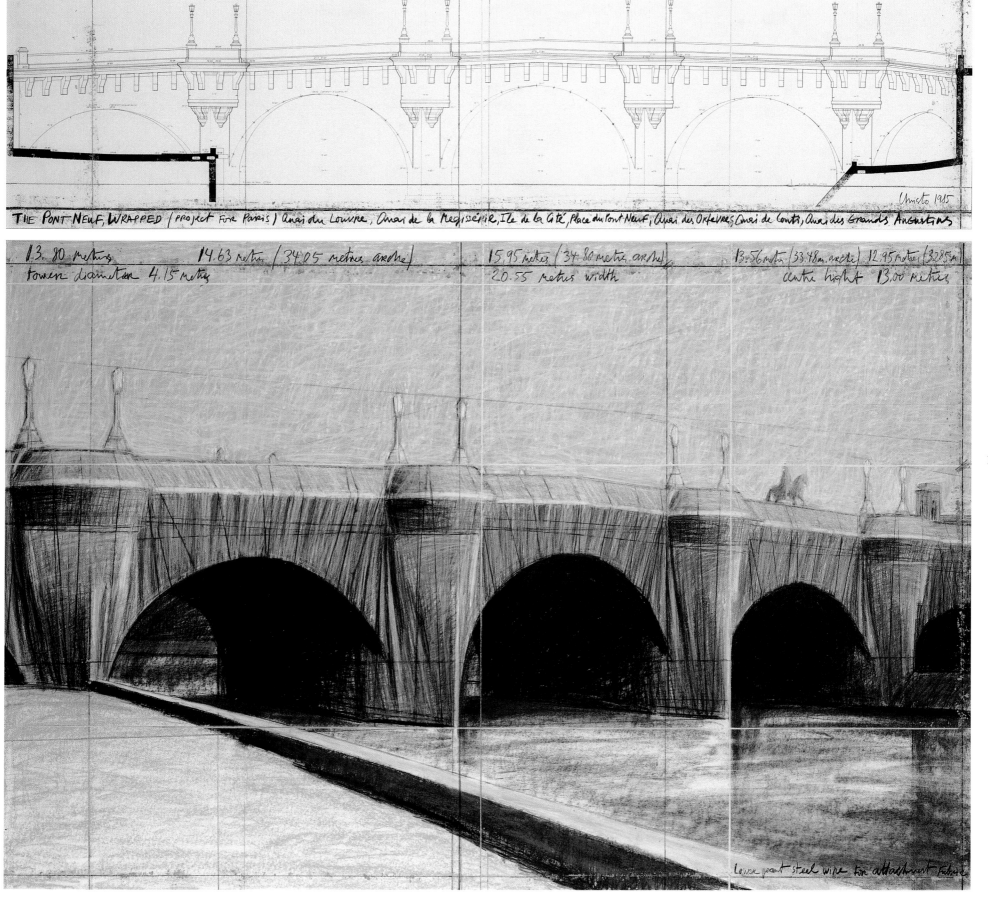

THE PONT NEUF, WRAPPED (PROJECT FOR PARIS) Quai du Louvre, Quai de la Mégisserie, Ile de la Cité, Place du Pont Neuf, Quai des Orfèvres, Quai de Conti, Quai des Grands Augustins

Christo 1985

13.80 metres 14.63 metres (34.05 metres arche) 15.95 metres (34.80 metres arche) 13.56 metres (33.48m. arche) 12.95 metres (3285 m)
tower diameter 4.15 metres 20.55 metres width centre height 13.00 metres

Lower point steel wire for attachment Fabric

159

69.
The Pont Neuf Wrapped, Project for Paris
Collage, 1985

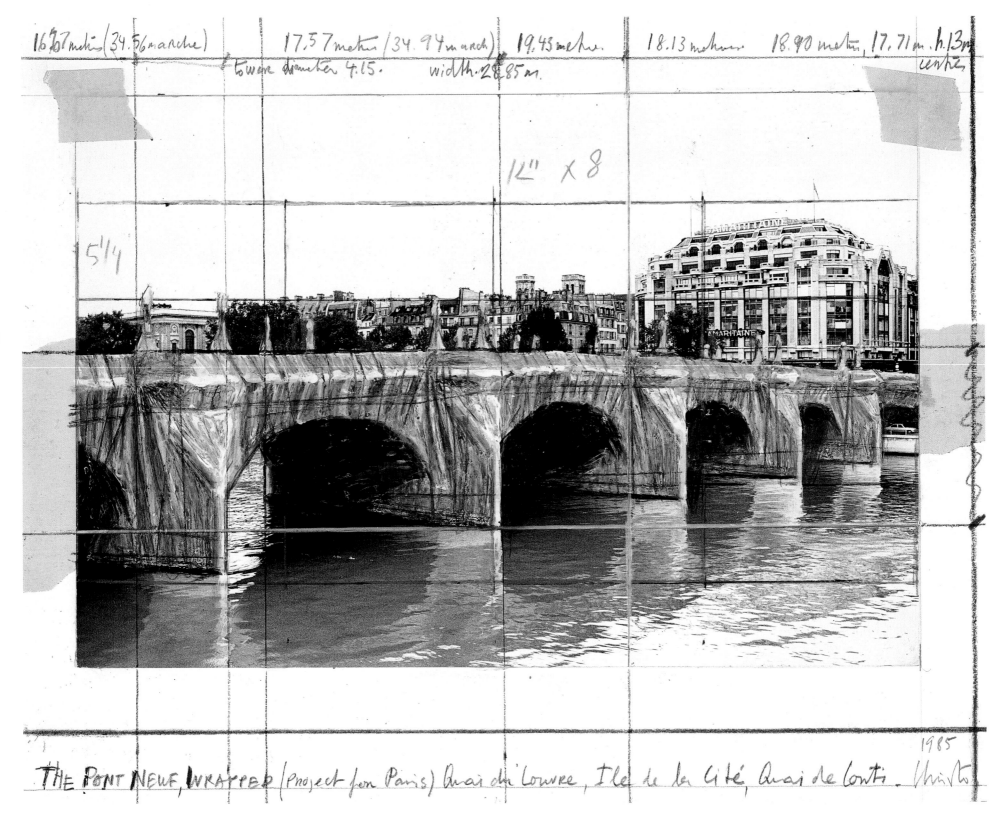

70.
The Pont Neuf Wrapped, Project for Paris
Collage in two parts, 1985

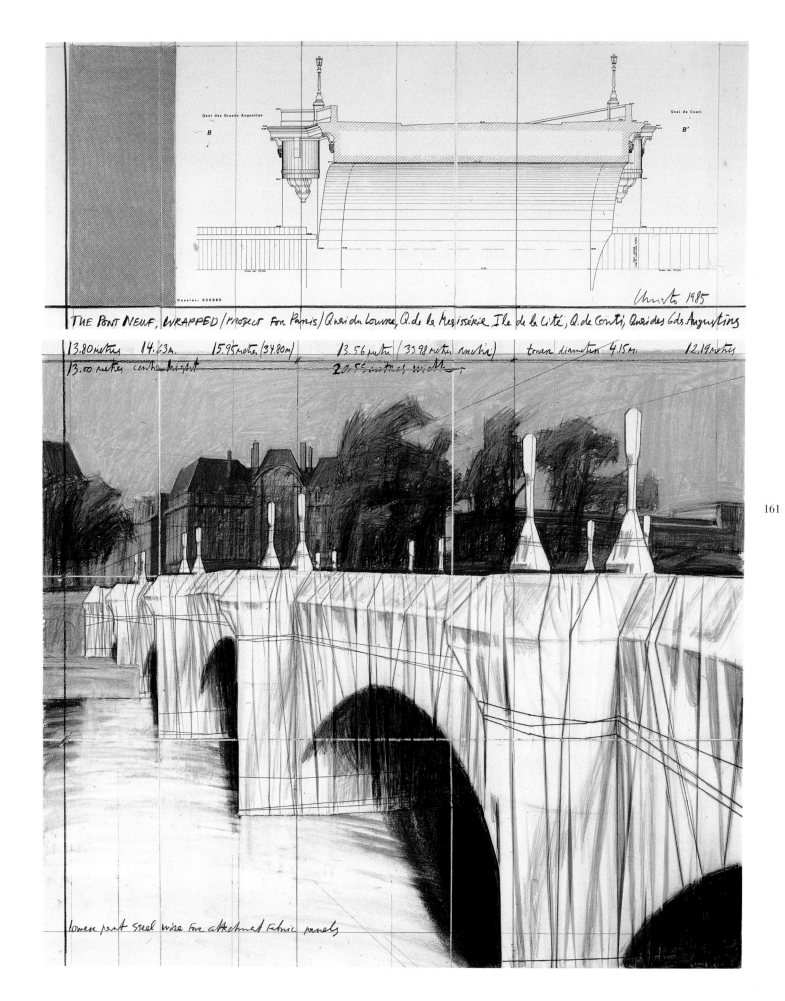

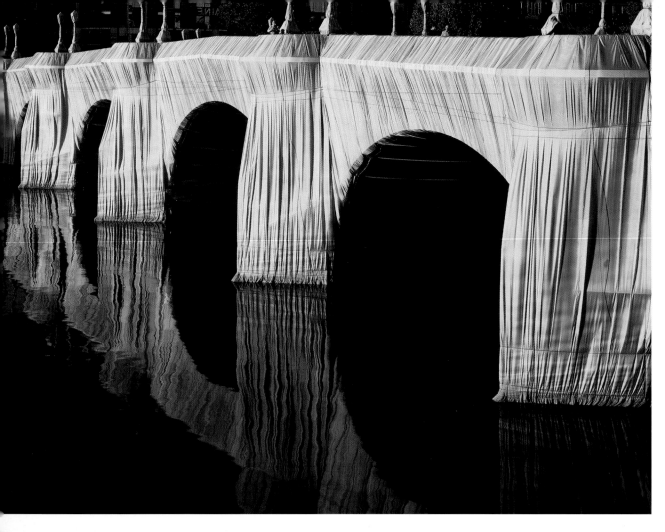

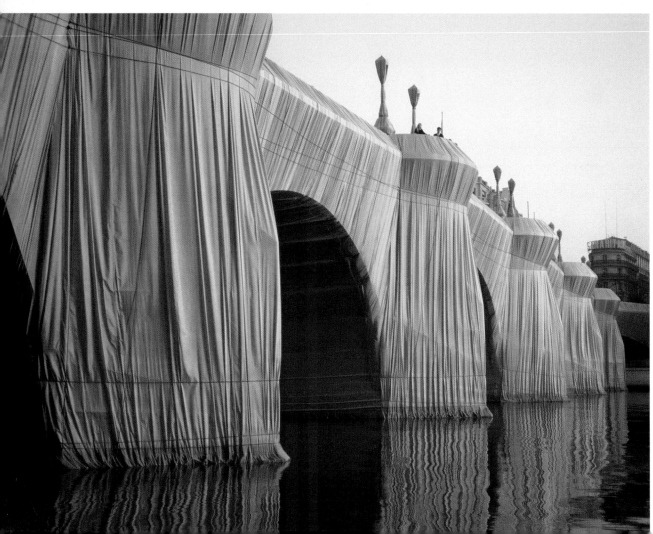

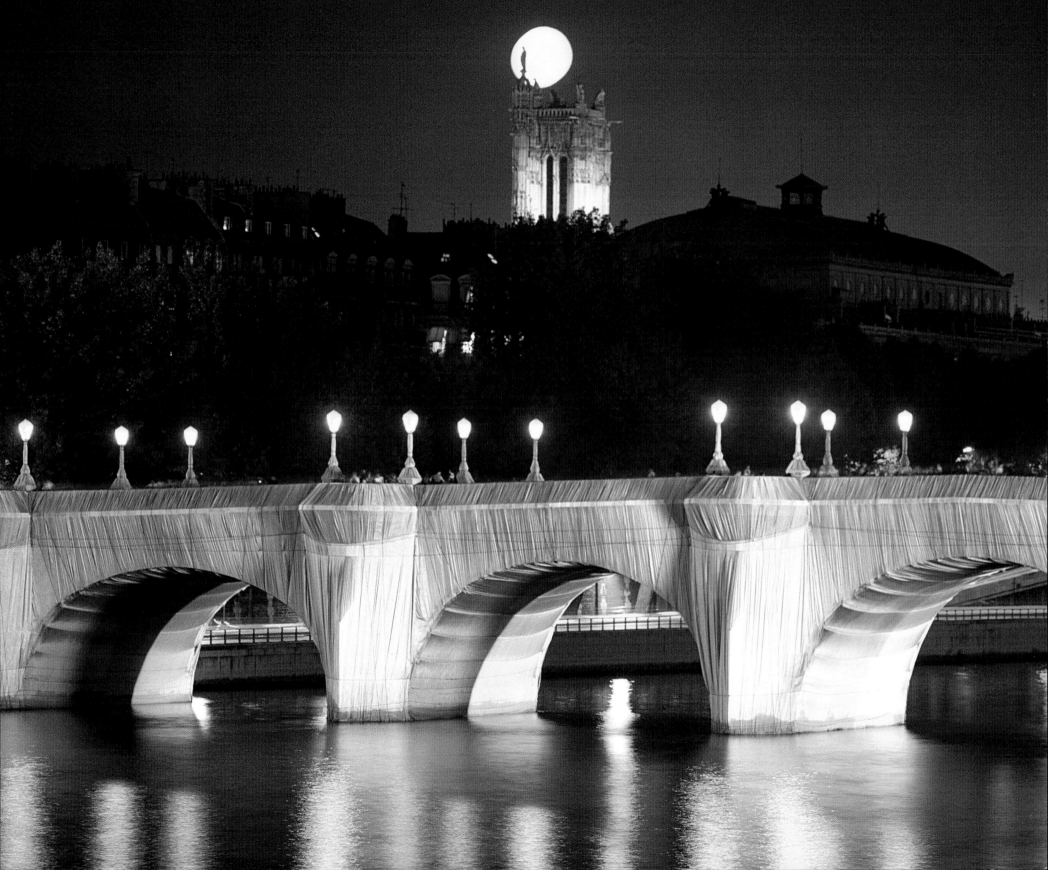

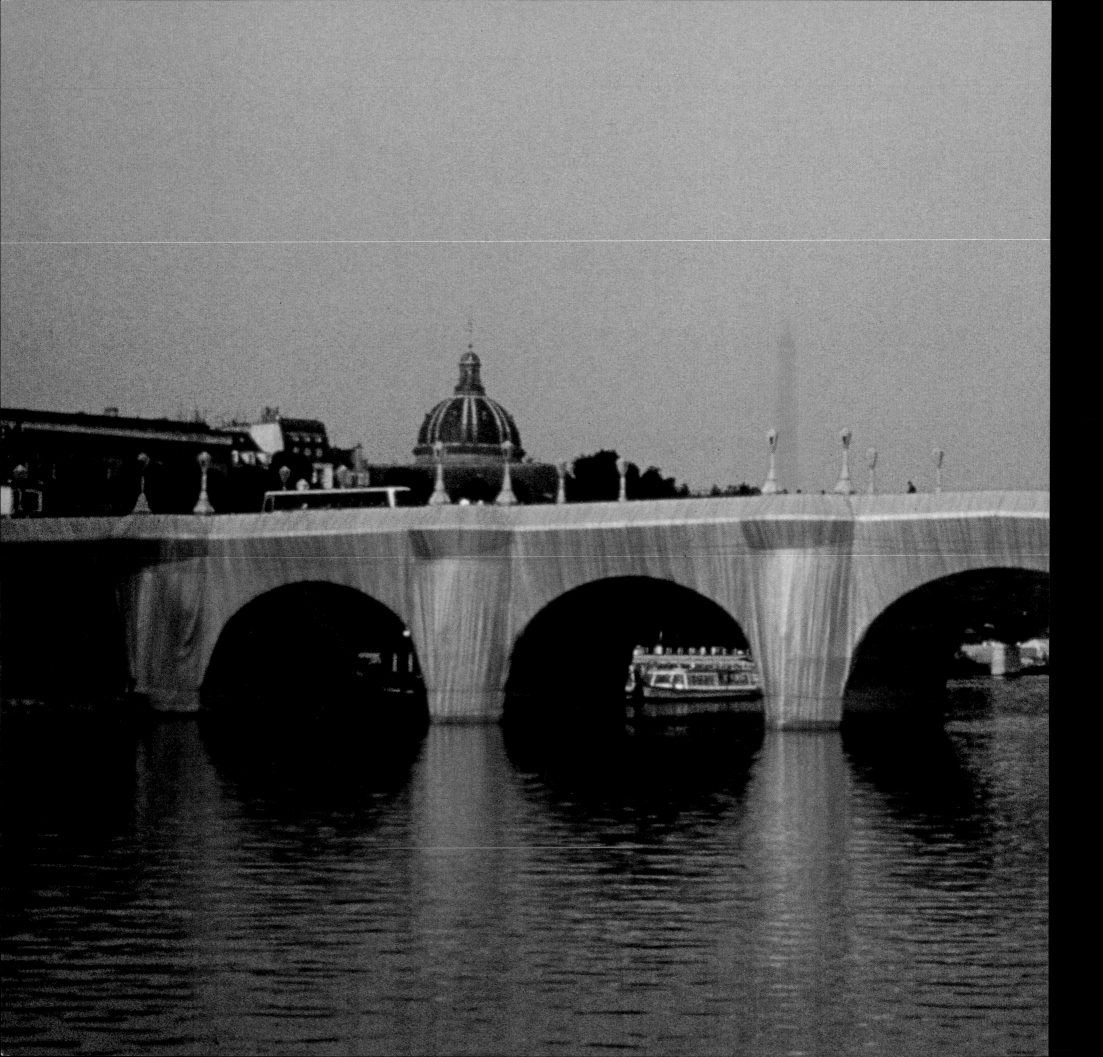

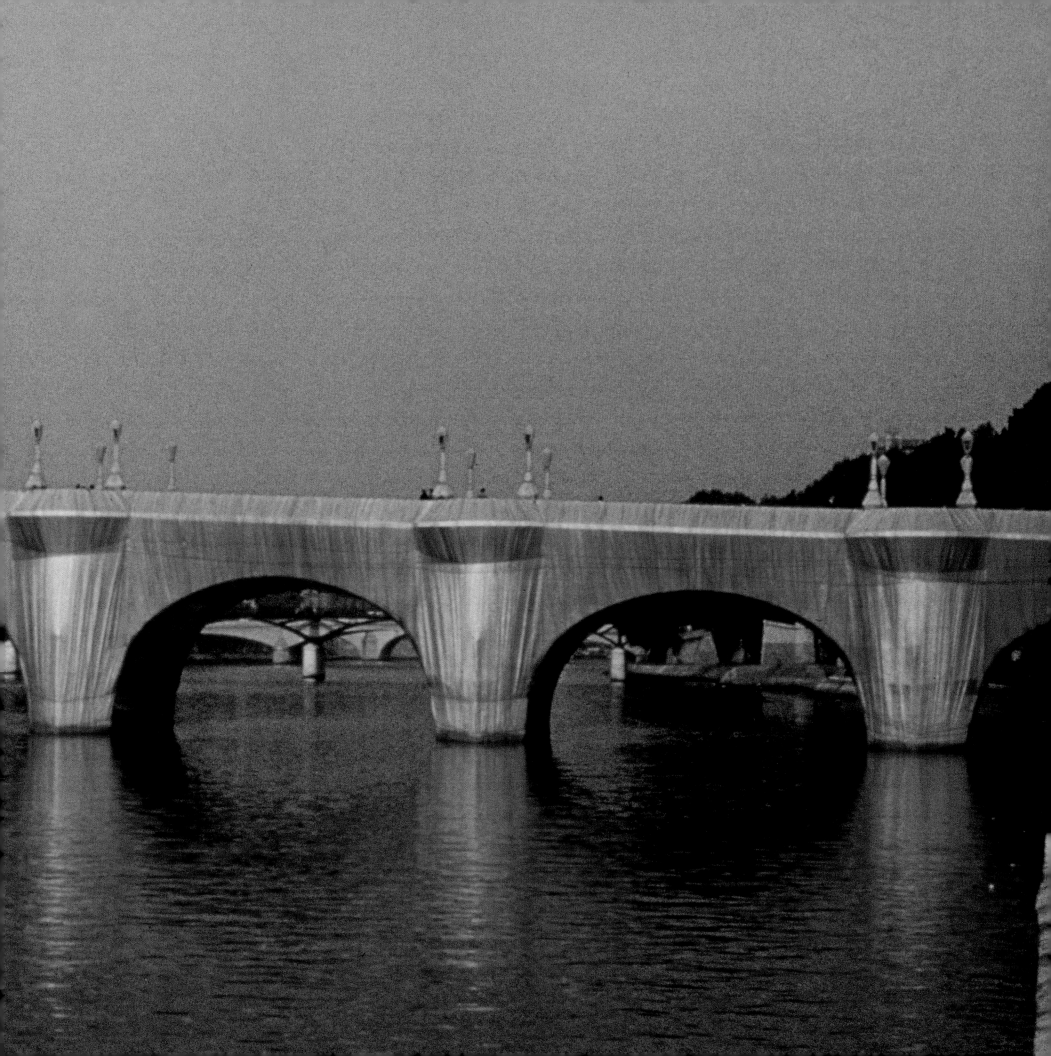

The Umbrellas, Japan-USA, 1984–91

At sunrise, on October 9, 1991, Christo and Jeanne-Claude's 1,880 workers began to open the 3,100 umbrellas in Ibaraki and California, in the presence of the artists at both sites. This Japan-USA temporary work of art reflected the similarities and differences in the ways of life and the use of the land in two inland valleys, one 19 kilometers long (12 miles) in Japan, and the other 29 kilometers long (18 miles) in the USA. In Japan, the valley is located north of Hitachiota and south of Satomi, 120 kilometers (75 miles) north of Tokyo, around Route 349 and the Sato River, in the Prefecture of Ibaraki, on the properties of 459 private landowners and governmental agencies. In the USA, the valley is located 96.5 kilometers (60 miles) north of Los Angeles, along Interstate 5 and the Tejon Pass, between south of Gorman and Grapevine, on the properties of Tejon Ranch, 25 private landowners as well as governmental agencies.

Eleven manufacturers in Japan, USA, Germany and Canada prepared the various elements of the umbrellas: fabric, aluminum super-structure, steel frame bases, anchors, wooden base supports, bags and molded base covers.

All 3,100 umbrellas were assembled in Bakersfield, California, from where the 1,340 blue umbrellas were shipped to Japan.

Starting in December 1990, with a total work force of 500, Muto Construction Co. Ltd. in Ibaraki, and A.L. Huber & Son in California installed the earth anchors and steel bases under the supervision of Site Managers Akira Kato in Japan and Vince Davenport in the USA. The sitting platform-base covers were placed during August and September 1991. From September 19 to October 7, 1991, an additional construction work force began transporting the umbrellas to their assigned bases, bolted them to the receiving sleeves, and elevated the umbrellas to an upright closed position. Each umbrella was 6 meters (19 feet 8 inch) high and 8.66 meters (28 feet 5 inch) in diameter.

On October 4, students, agricultural workers, and friends, 960 in USA and 920 in Japan, joined the work force to complete the installation of *The Umbrellas*.

Christo and Jeanne-Claude's 26 million dollar temporary work of art was entirely financed by the artists through their "The Umbrellas, Joint Project for Japan and USA Corporation" (Jeanne-Claude Christo-Javacheff, President). The artists do not accept sponsorship of any kind. All previous projects by Christo and Jeanne-Claude have been financed in a similar manner through the sale of the studies, preparatory drawings, collages, scale models, early works, and original lithographs. The removal started on October 27 and the land was restored to its original condition. The umbrellas were taken apart and most of the elements were recycled.

The Umbrellas, free-standing dynamic modules, reflected the availability of the land in each valley, creating an invitational inner space, as houses without walls, or temporary settlements and related to the ephemeral character of the work of art. In the precious and limited space of Japan, the umbrellas were positioned intimately, close together and sometimes following the geometry of the rice fields. In the luxuriant vegetation enriched by water year round, the umbrellas were blue. In the California vastness of uncultivated grazing land, the configuration of *The Umbrellas* was whimsical and spreading in every direction. The brown hills are covered by blond grass. In that dry landscape, the umbrellas were yellow.

From October 9, 1991 for a period of eighteen days, *The Umbrellas* were seen, approached, and enjoyed by the public, either by car from a distance and closer as they bordered the roads, or by walking under the umbrellas in their luminous shadows.

The Umbrellas, Japan-USA, 1984–91

The Umbrellas, Japan-USA, 1984–91, opened simultaneously in Ibaraki prefecture (about 76 miles north of Tokyo) and in California, around the Tejon Pass (roughly the same distance north of Los Angeles), on October 9, 1991, for just shy of three weeks. The project involved the seemingly random scattering of 3,100 specially designed umbrellas (1,340 blue ones in Japan and 1,760 gold ones in California) across 12 and 18 miles, respectively, of the two inland valleys. *The Umbrellas* took five years of preparation and cost $26 million […].

There was no shortage of difficulties to overcome, either. When the 1,340 umbrellas arrived in the harbor in Hitachi, the handles for the winches were not listed on the importation documents, and the customs officials refused to let them enter the port. Christo threw a screaming fit, saying (among other things), "When you import a Toyota car into the United States you don't have to list the keys on the documents!"[1]. Eventually they decided to let the umbrellas through. That problem resolved, Wolfgang and Sylvia Volz opened one of the packages of what were supposed to be blue umbrellas, and inside they found a yellow one. […] Everyone panicked, wondering if the blue umbrellas had not been shipped, so they opened every single package in the harbor and found that there was only the one mistake.

Nevertheless, from the start this project benefited from a wide public admiration for Christo and Jeanne-Claude's work, both in California and in Japan, as well as the years of experience on which they had built a finely tuned organization. […] Three million people on two continents came to see the project. It was clear that this was not the work of some anonymous avant-gardist overlooked by the authorities.

The Umbrellas took place on the property of 459 different landowners in Japan, and only 25 in the much larger area of the California site, underscoring real differences in the social character of the two countries. […] Christo and Jeanne-Claude coordinated more than two thousand workers (about evenly divided between the two venues), made extensive preparations for the more than three million visitors […]. Each umbrella had 470 different parts, weighed nearly 500 pounds, measured 28 feet 5 inches in diameter, and was accompanied by a detailed file of careful engineering, calculated to ensure its accurate location and proper attention to the unique installation requirements of its particular patch of terrain. […]

The aesthetic concept of *The Umbrellas* was completely new. Here, for the first time, Christo and Jeanne-Claude placed a collection of discrete objects into the landscape, rather than using fabric in a more receptive response to the forms of nature, as in *Running Fence* or *Surrounded Islands*. Compared with these earlier works, politics also seemed relatively less prominent than formal expression. One might almost say that *The Umbrellas* was unabashedly romantic in highlighting nature, using gold or blue accents to bring out the crest of a hill much as John Constable dramatized his paintings of the simple English countryside with brilliant flecks of white.

Christo also underscored the way that *The Gates*, *The Umbrellas*, and *Over the River* "are very strongly linked with that inner and outer space. You can go *under* the umbrellas, you can go out of the umbrellas. You can go *under* the gates, you can go out of the gates. Of course, the precursor of *The Umbrellas* was *The Gates* because *The Gates* was several years earlier than the idea of *The Umbrellas*". *The Gates* also prefigures *The Umbrellas* in its compositional principle; the structure is modular, relying on a non-axial symmetry in which each unit can be substituted for any other. This concept implies a kind of open-ended freedom in the possibility of extending indefinitely in any direction. "*The Umbrellas* and *The Gates* have similarity of that spreading quality", Christo said[2].

[1] Christo and Jeanne-Claude, conversation with Jonathan Fineberg in the artists' loft, New York, August 22, 2003.
[2] Christo and Jeanne-Claude, interview with Jonathan Fineberg, New York, July 25, 2003.

Excerpts from Jonathan Fineberg, *Christo and Jeanne-Claude: On the Way to The Gates, Central Park, New York City*, exhibition catalogue, The Metropolitan Museum of Art, New York, 2004.

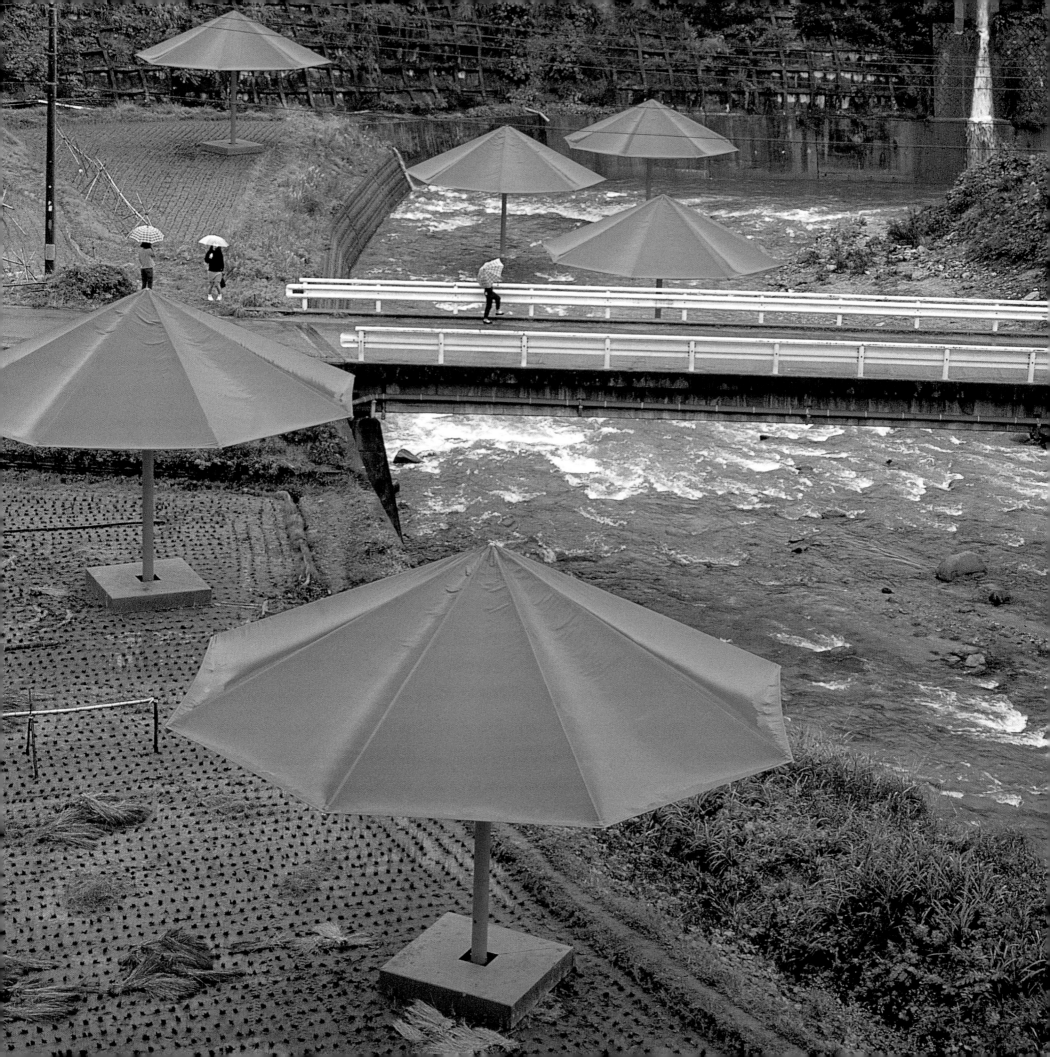

**The Umbrellas, Project for 6–8 miles,
3,000 Umbrellas**
Collage, 1985

170

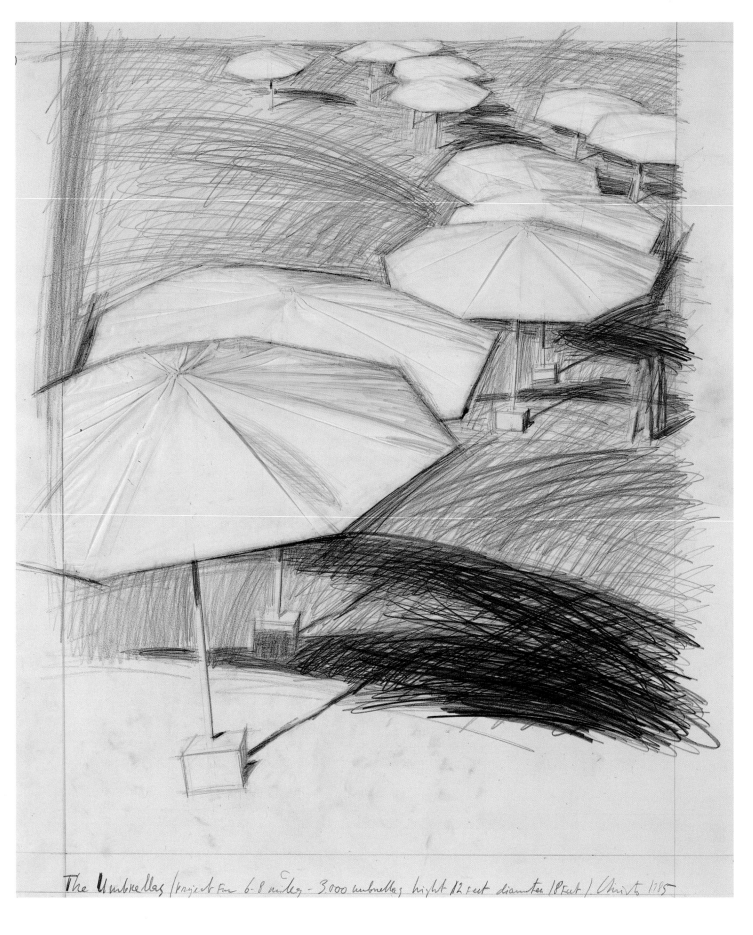

The Umbrellas (project for 6-8 miles - 3.000 umbrellas, hight 12 feet diameter 18 Feet) Christo 1985

72.
**The Umbrellas, Project for Japan
and Western USA**
Collage, 1986

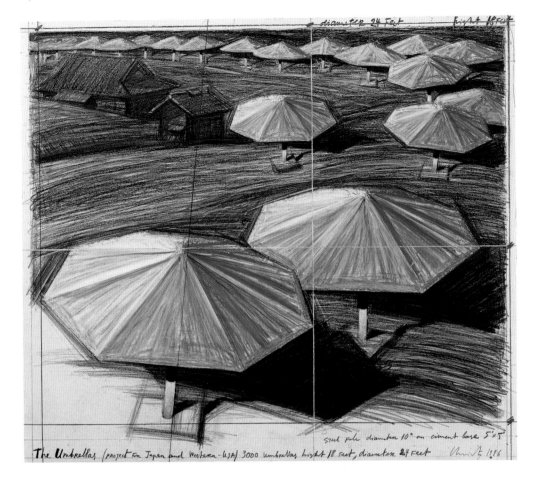

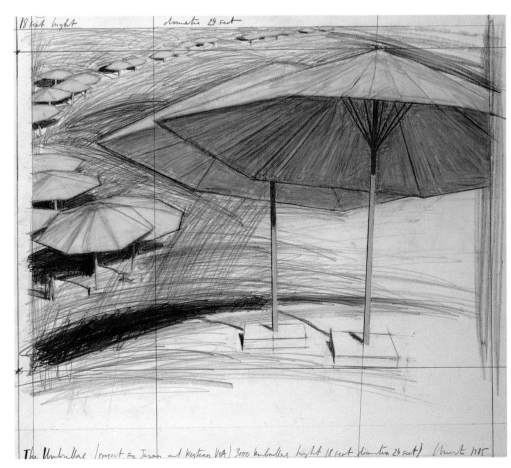

73.
**The Umbrellas, Project for Japan
and Western USA**
Collage, 1985

74.
The Umbrellas, Project for Japan and West-USA
Collage in two parts, 1986

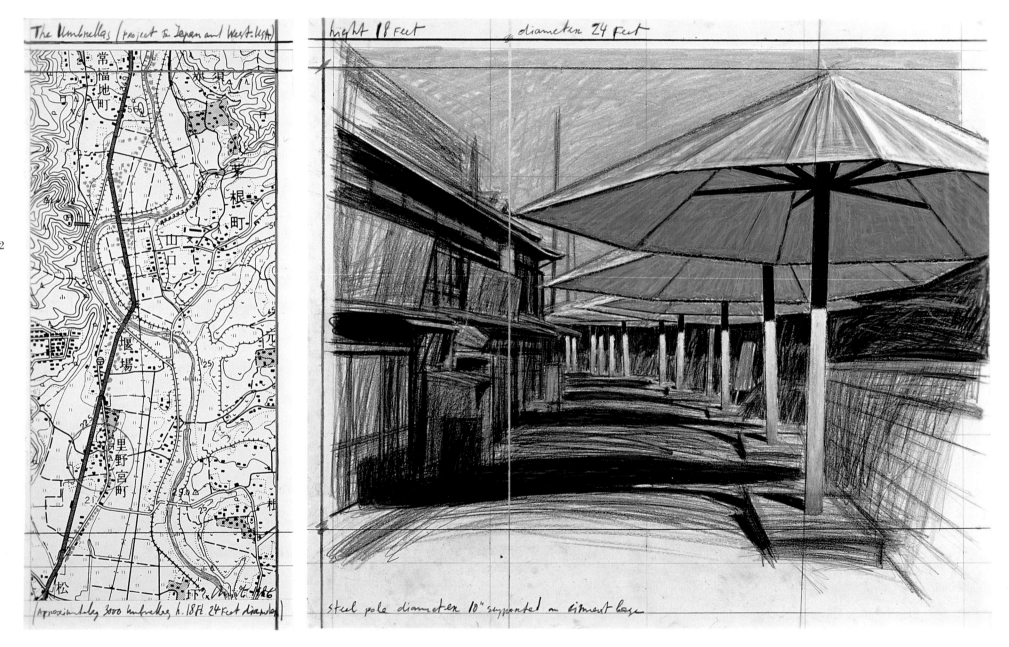

172

75.
The Umbrellas, Project for Japan and USA
Collage in two parts, 1988

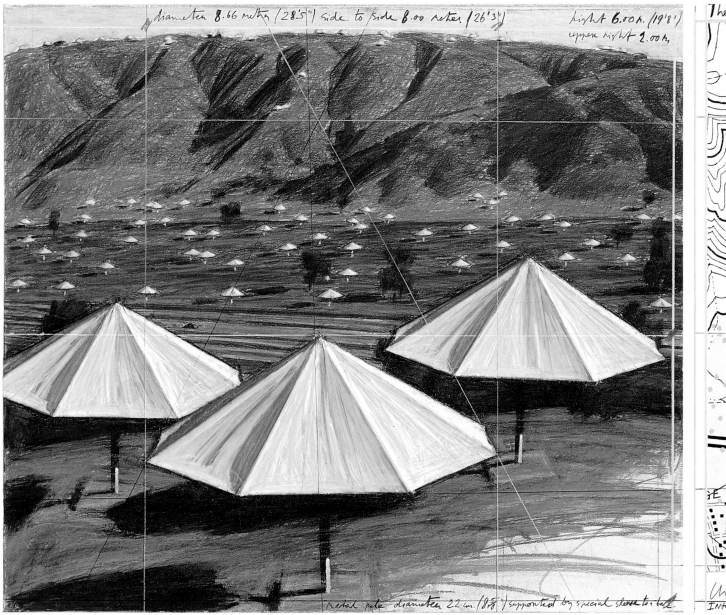

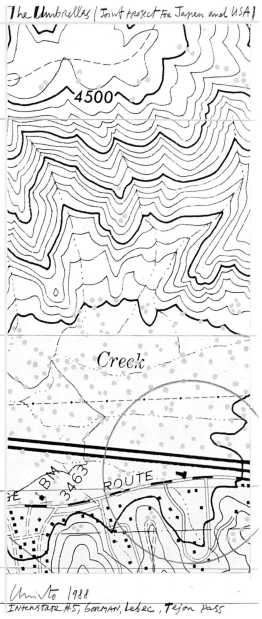

76.
The Umbrellas, Joint Project for Japan and USA
Drawing, 1990

174

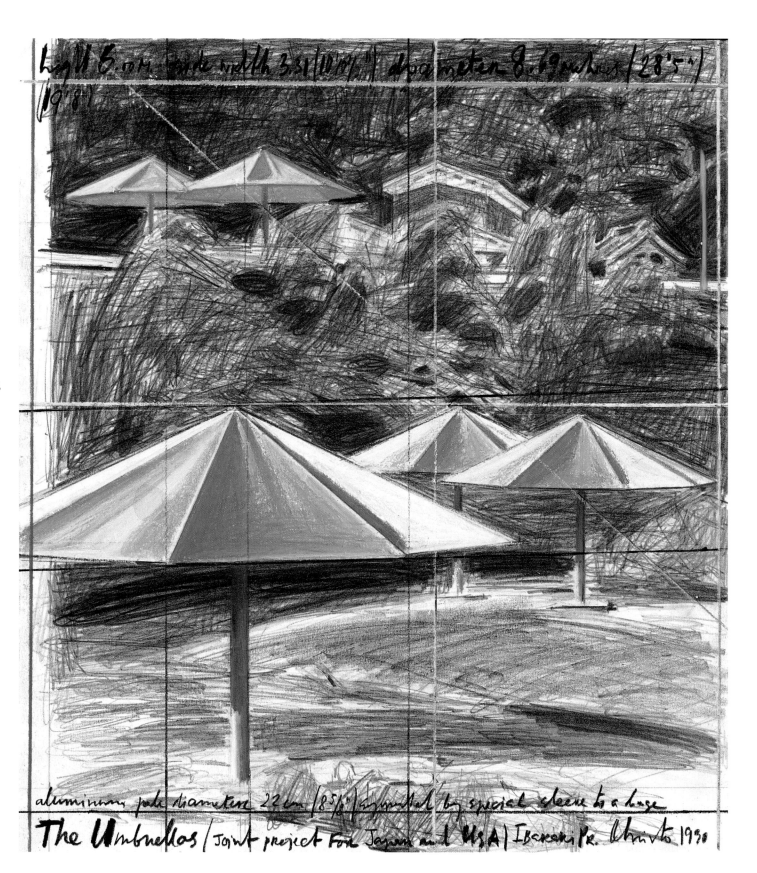

77.
The Umbrellas, Joint Project for Japan and USA
Drawing, 1990

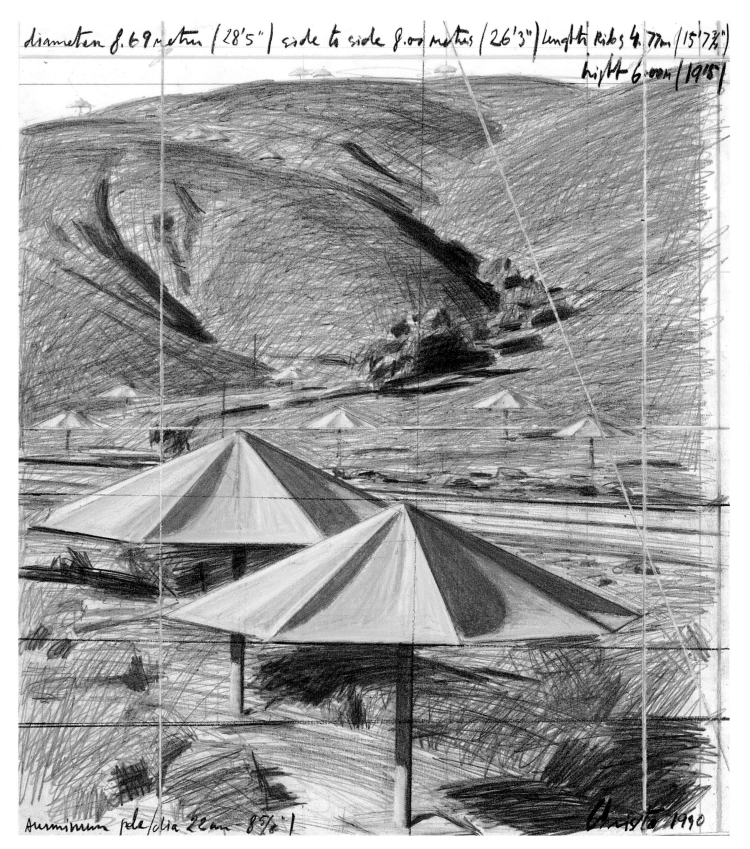

The Umbrellas, Joint Project for Japan and USA
Drawing in two parts, 1990

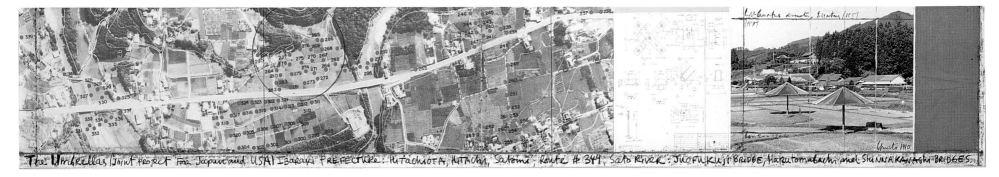

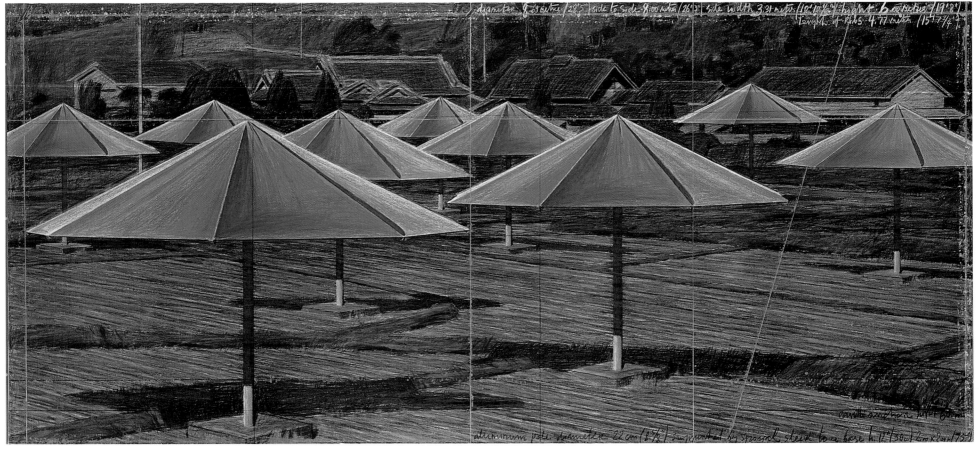

79.
The Umbrellas, Joint Project for Japan and USA
Drawing in two parts, 1990

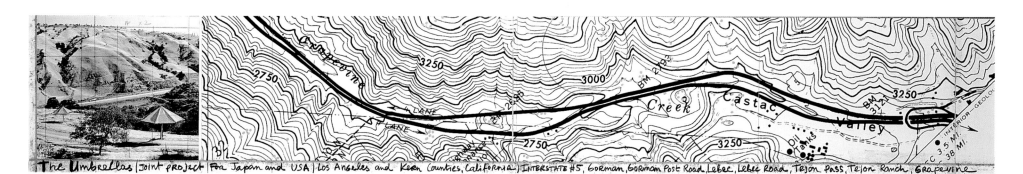

The Umbrellas (Joint Project For Japan and USA) Los Angeles and Kern Counties, California. Interstate #5, Gorman, Gorman Post Road, Lebec, Lebec Road, Tejon Pass, Tejon Ranch, Grapevine

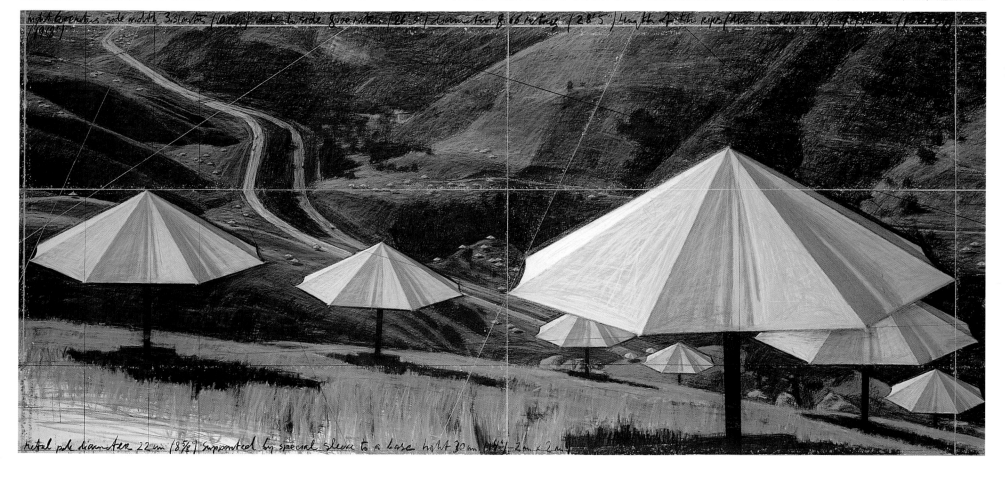

177

The Umbrellas, Joint Project for Japan and USA
Drawing in two parts, 1991

178

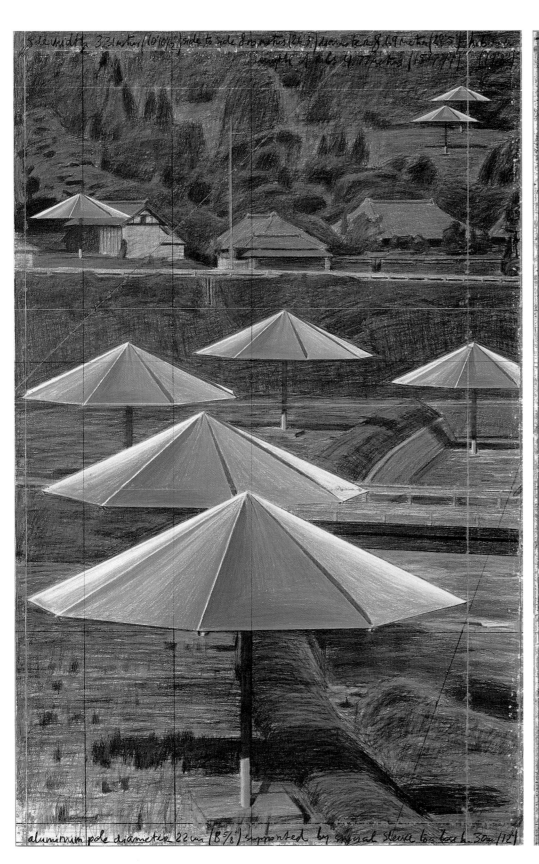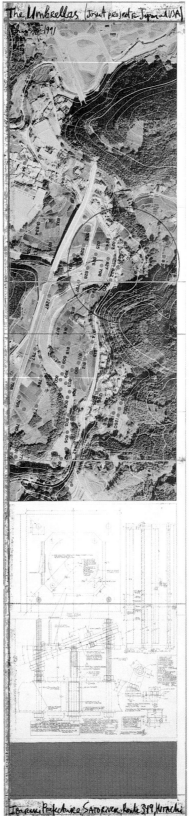

81.
The Umbrellas, Joint Project for Japan and USA
Drawing in two parts, 1991

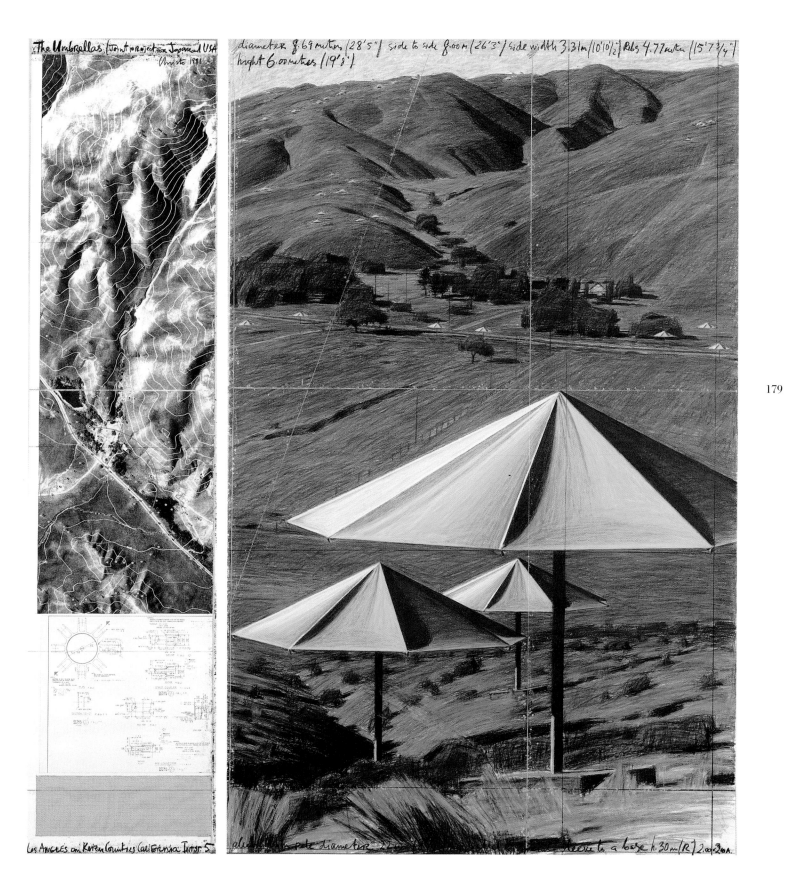

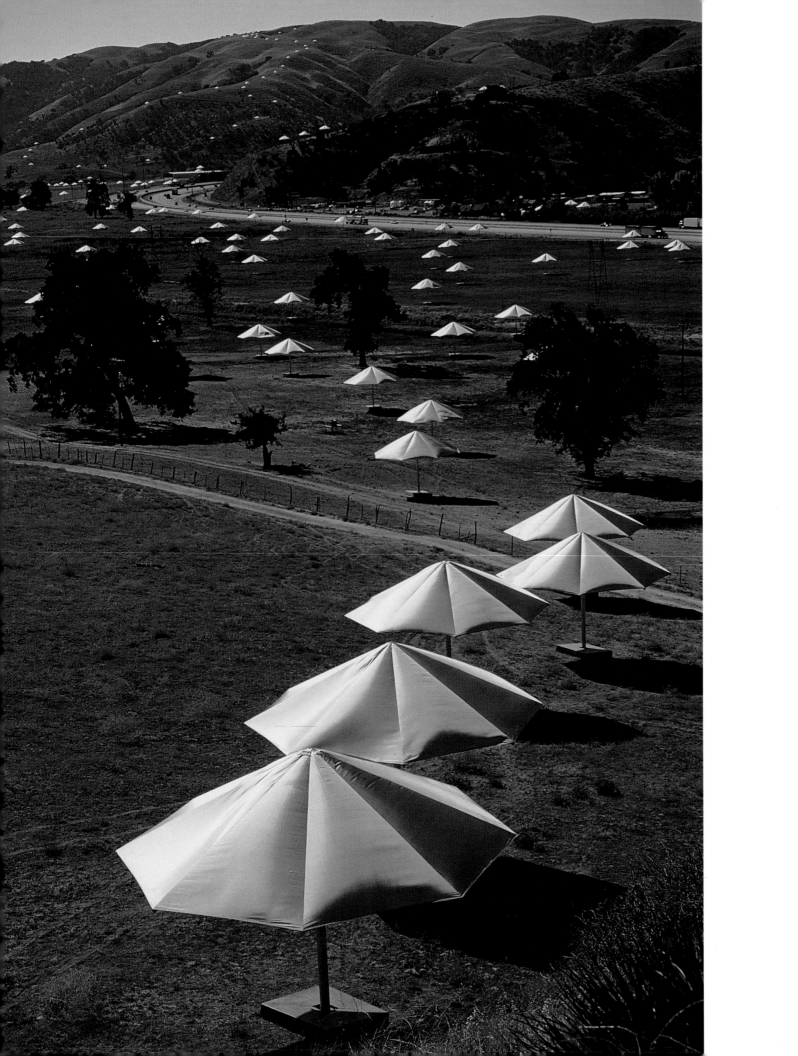

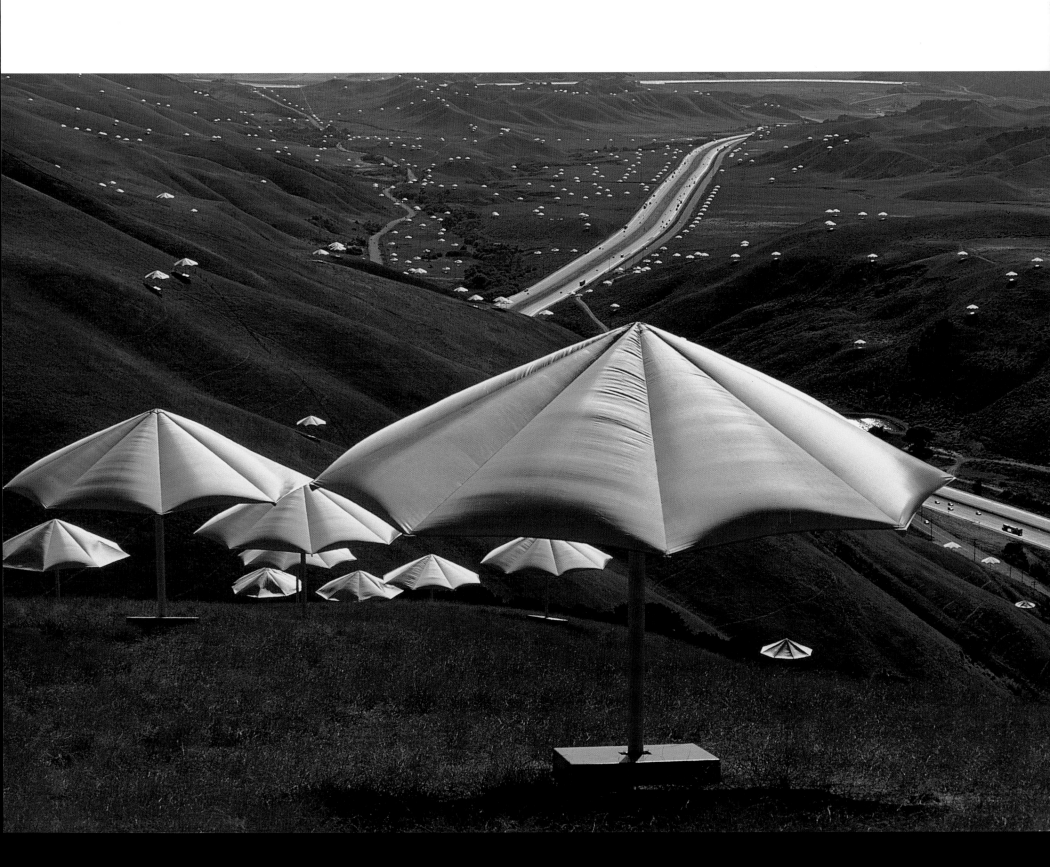

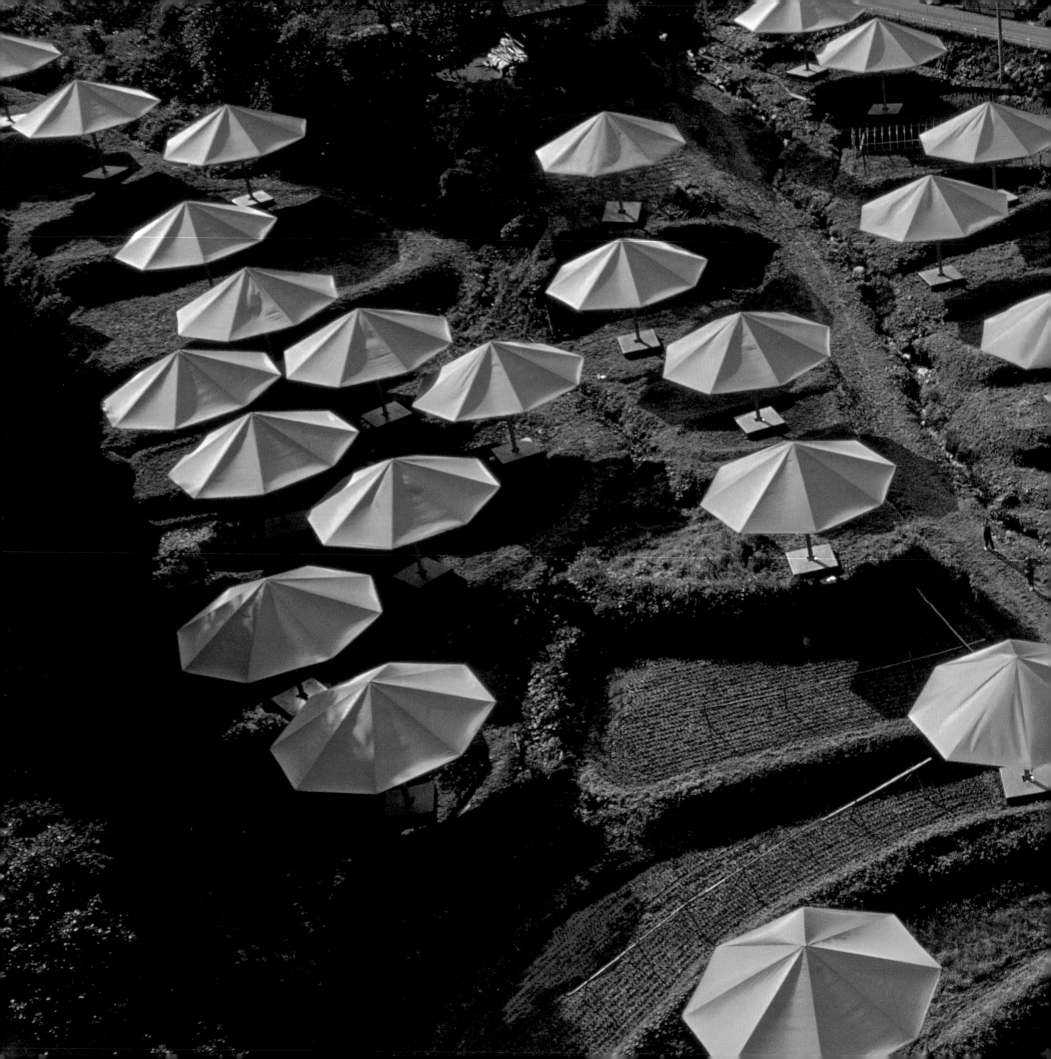

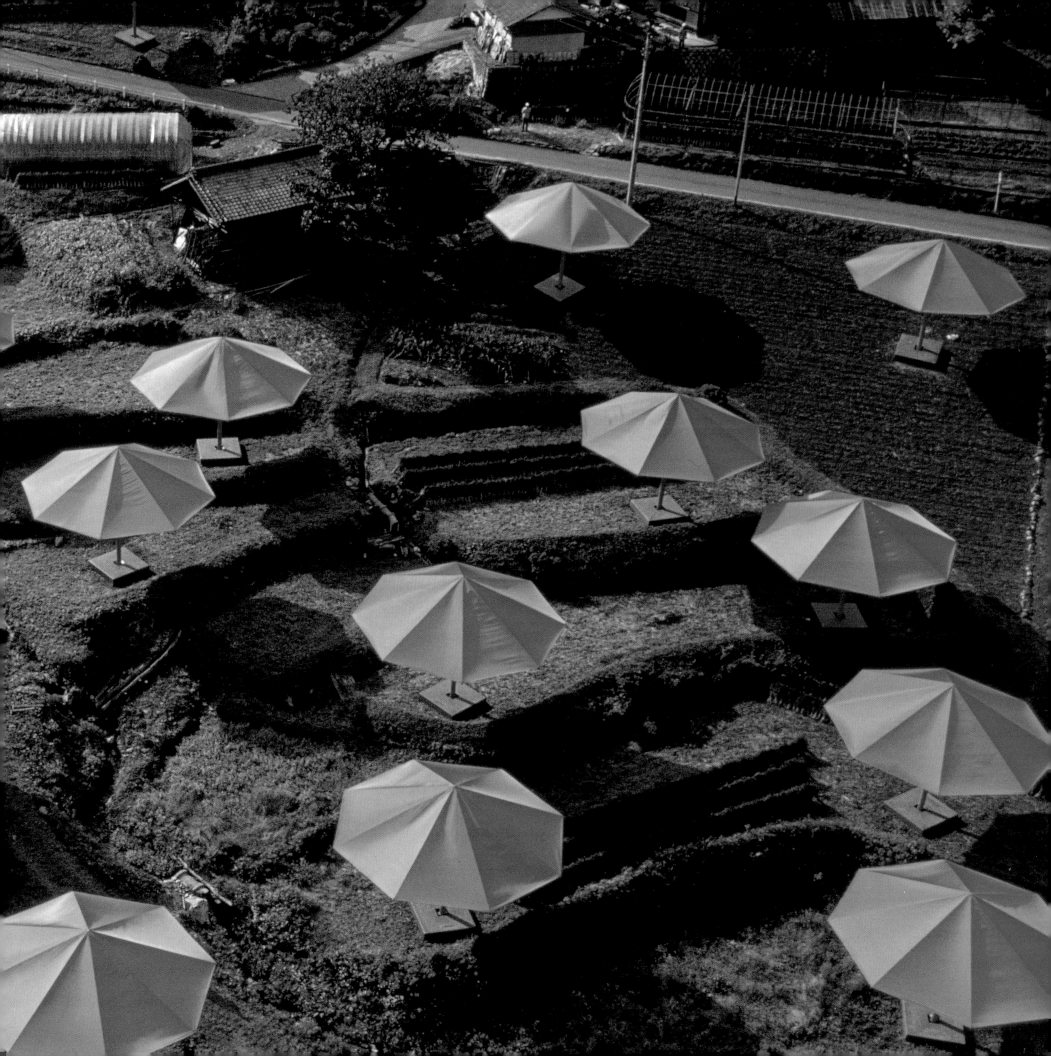

Wrapped Reichstag, Berlin, 1971–95

After a struggle spanning through the 1970s, 1980s, and 1990s, the wrapping of the Reichstag was completed on June 24, 1995 by a work force of 90 professional climbers and 120 installation workers. The Reichstag remained wrapped for fourteen days and all materials were recycled.

Ten companies in Germany started in September 1994 to manufacture all the various materials according to the specifications of the engineers. During the months of April, May and June 1995, iron workers installed the steel structures on the towers, the roof, the statues and the stone vases to allow the folds of fabric to cascade from the roof down to the ground.

100,000 square meters (1,076,000 square feet) of thick woven polypropylene fabric with an aluminum surface and 15,600 meters (51,181 feet) of blue polypropylene rope, diameter 3.2 cm (1.25 inches), were used for the wrapping of the Reichstag. The facades, the towers and the roof were covered by 70 tailor-made fabric panels, twice as much fabric as the surface of the building.

The work of art was entirely financed by the artists, as have all their projects, through the sale of preparatory studies, drawings, collages, scale models as well as early works and original lithographs.

The artists do not accept sponsorship of any kind.

The *Wrapped Reichstag* represents not only 24 years of efforts in the lives of the artists but also years of team work by its leading members Michael S. Cullen, Wolfgang and Sylvia Volz, and Roland Specker.

In Bonn, on February 25, 1994, at a plenary session, presided by Prof. Dr. Rita Süssmuth, the German Bundestag (Parliament) debated for 70 minutes and voted on the work of art. The result of the roll call vote was: 292 in favor, 223 against and 9 abstentions.

The Reichstag stands up in an open, strangely metaphysical area. The building has experienced its own continuous changes and perturbations: built in 1894, burned in 1933, almost destroyed in 1945, it was restored in the 1960s, but the Reichstag always remained the symbol of democracy.

Throughout the history of art, the use of fabric has been a fascination for artists. From the most ancient times to the present, fabric, forming folds, pleats and draperies, is a significant part of paintings, frescoes, reliefs and sculptures made of wood, stone and bronze. The use of fabric on the Reichstag follows the classical tradition. Fabric, like clothing or skin, is fragile, it translates the unique quality of impermanence.

For a period of two weeks, the richness of the silvery fabric, shaped by the blue ropes, created a sumptuous flow of vertical folds highlighting the features and proportions of the imposing structure, revealing the essence of the Reichstag.

Wrapped Reichstag, Berlin, 1971–95

In April 1978, seventeen influential German citizens formed an organization called the Kuratorium für Christos Projekt Reichstag to build support for the *Wrapped Reichstag, Project for Berlin.*

At the time, the German Reichstag sat literally on the boundary between Communist East Germany and the British sector of divided Berlin. The building was erected as the future seat of the German Parliament when Chancellor Otto von Bismarck united the nation in 1871; the Nazis burned it in 1933 when Hitler came to power (blaming the fire on communists); and then after World War II the structure was restored.

The building therefore symbolizes some of the most deeply felt issues of German national identity. Its physical location meant that any project Christo might create involving it had to involve the cooperation of the Soviet, French, American, and British armies as well as both East and West German governments. Partly for this reason, his idea of wrapping the Reichstag immediately aroused considerable controversy at the highest political and economic levels in Germany, actively involving Willy Brandt, the Nobel laureate and former mayor of West Berlin, Chancellor Helmut Schmidt of West Germany, and later Chancellor Helmut Kohl, as well as several of the most powerful industrialists in the nation.

Christo and Jeanne-Claude worked on this project for twenty-four years; only *The Gates* had a longer gestation. Trips to Germany interrupted work on *Running Fence, Wrapped Walk Ways, Surrounded Islands, The Pont Neuf Wrapped,* and *The Umbrellas*; there were dramatic moments when permission seemed so close, only to fall through again. It was a rollercoaster ride of political ups and downs. In retrospect, it is clear that the tide turned in 1989 with the election of Rita Süssmuth as president of the German Parliament. Shortly after coming to office she expressed interest in the project over dinner with an important supporter of Christo and Jeanne-Claude's idea. With the reunification of Germany in 1990, the artists realized that the building would soon be reinhabited by the parliament and, once that occurred, wrapping the building would be impossible. So the pressure was on. But Süssmuth proved a steady and skilled ally, reaffirming her intention to help them in a letter she wrote in December 1991.

Twenty-five months later – against the wishes of the German chancellor, Helmut Kohl – she deftly guided the project through a parliamentary vote. In June 1995, at a final cost of $15,233,946, Christo and Jeanne-Claude successfully wrapped the Reichstag in Berlin. They covered the entire building with silver fabric that shone brilliantly in the early summer sun. More than five million visitors came to view the work, and although the artists, as usual, said nothing about the personal meaning of the work, it is hard to avoid the conclusion that it connected with Christo's personal history in the Communist Eastern Block.

Excerpts from Jonathan Fineberg, *Christo and Jeanne-Claude: On the Way to The Gates, Central Park, New York City,* exhibition catalogue, The Metropolitan Museum of Art, New York, 2004.

186

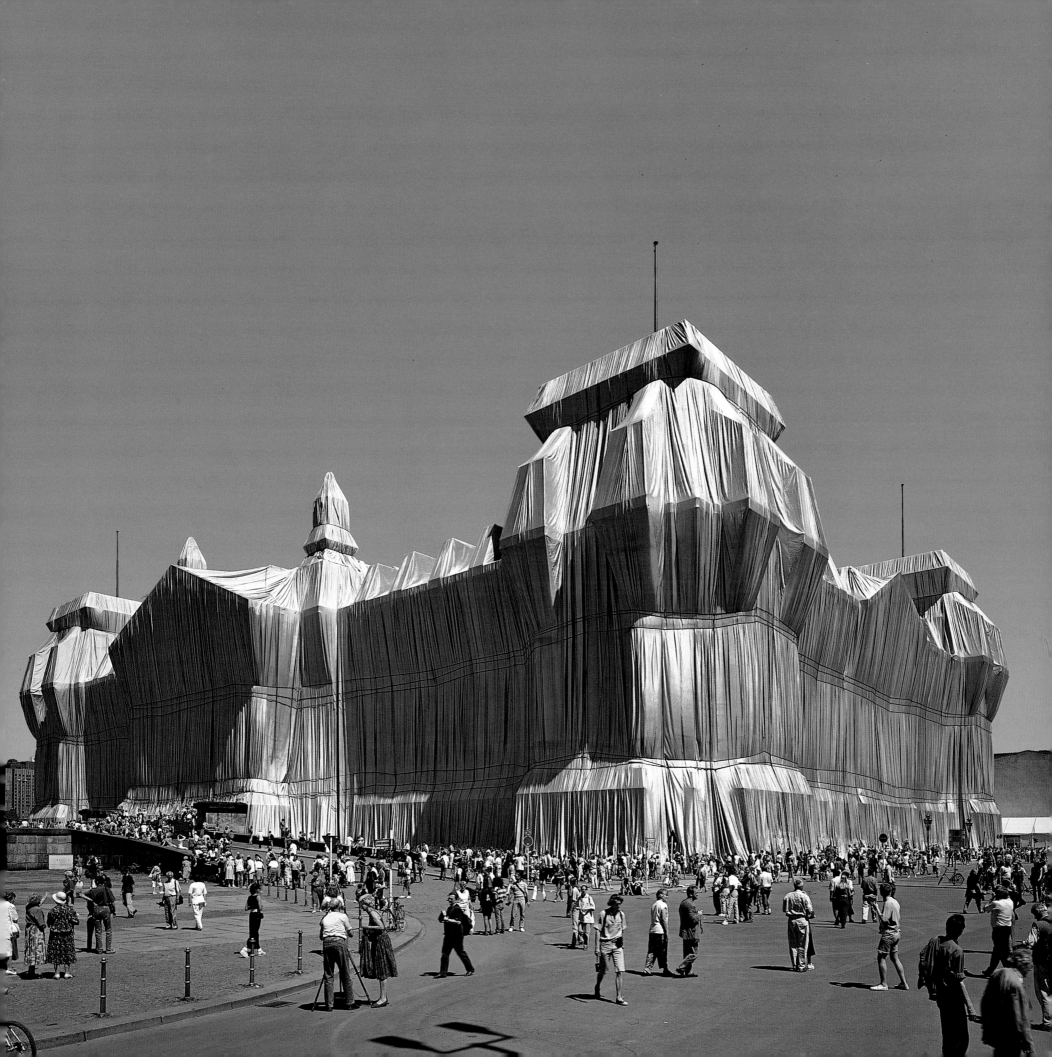

188

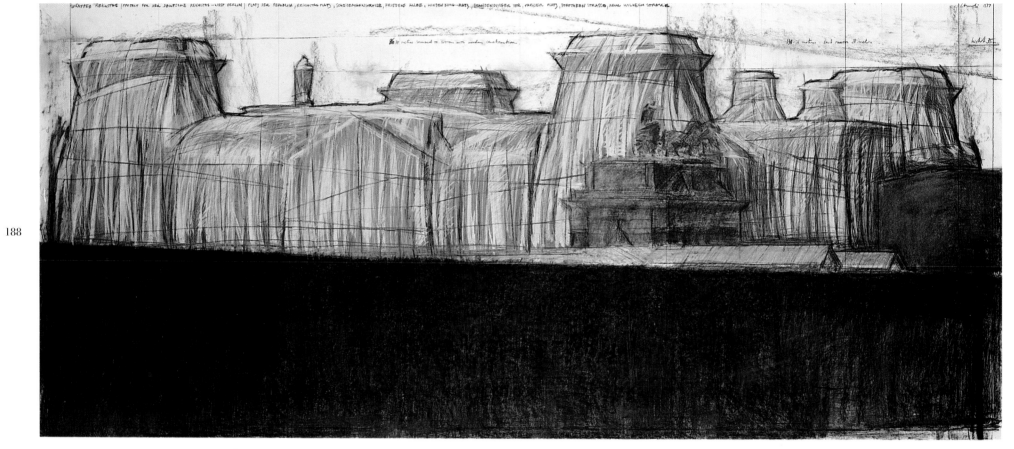

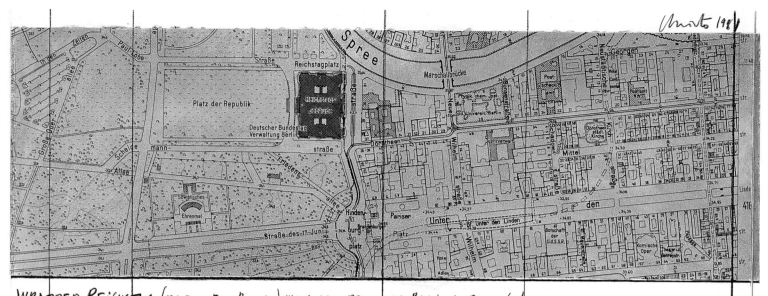

Christo 1984

WRAPPED REICHSTAG (PROJECT FOR BERLIN) PLATZ DER REPUBLIK, REICHSTAGPLATZ, SCHEIDEMANNSTR, BRANDENBURGER TOR

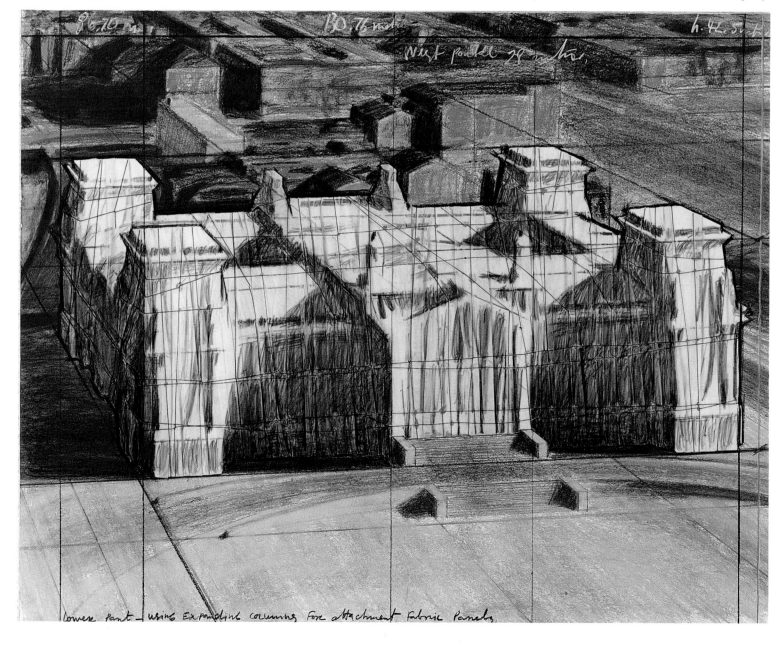

84.
Wrapped Reichstag, Project for Berlin
Collage in two parts, 1992

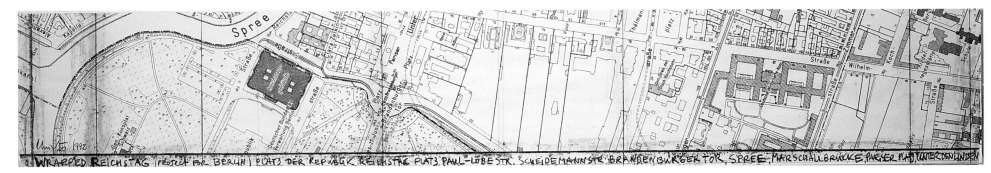

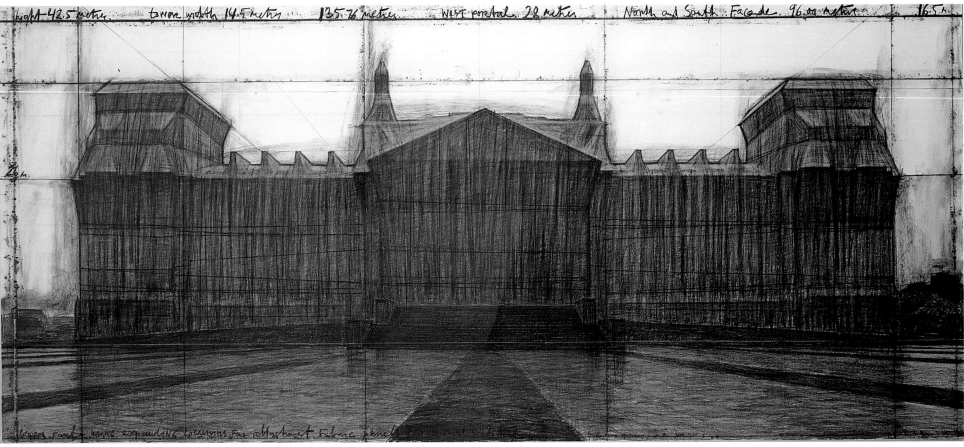

85.
Wrapped Reichstag, Project for Berlin
Drawing in two parts, 1995

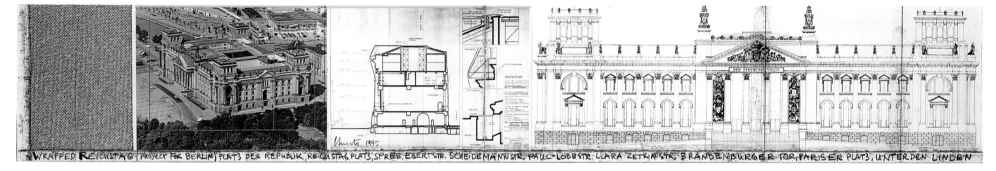

WRAPPED REICHSTAG (PROJECT FOR BERLIN) PLATZ DER REPUBLIK, REICHSTAG PLATZ, SPREE, EBERT STR. SCHEIDEMANNSTR, PAUL-LÖBESTR, CLARA ZETKIN-STR, BRANDENBURGER TOR, PARISER PLATZ, UNTER DEN LINDEN

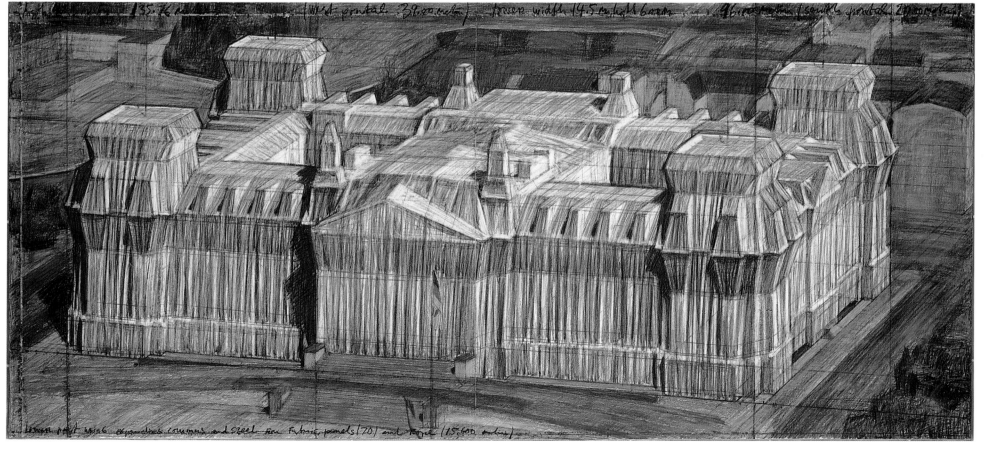

86.
Wrapped Reichstag, Project for Berlin
Drawing in two parts, 1986

87.
Wrapped Reichstag, Project for Berlin
Collage in two parts, 1993

192

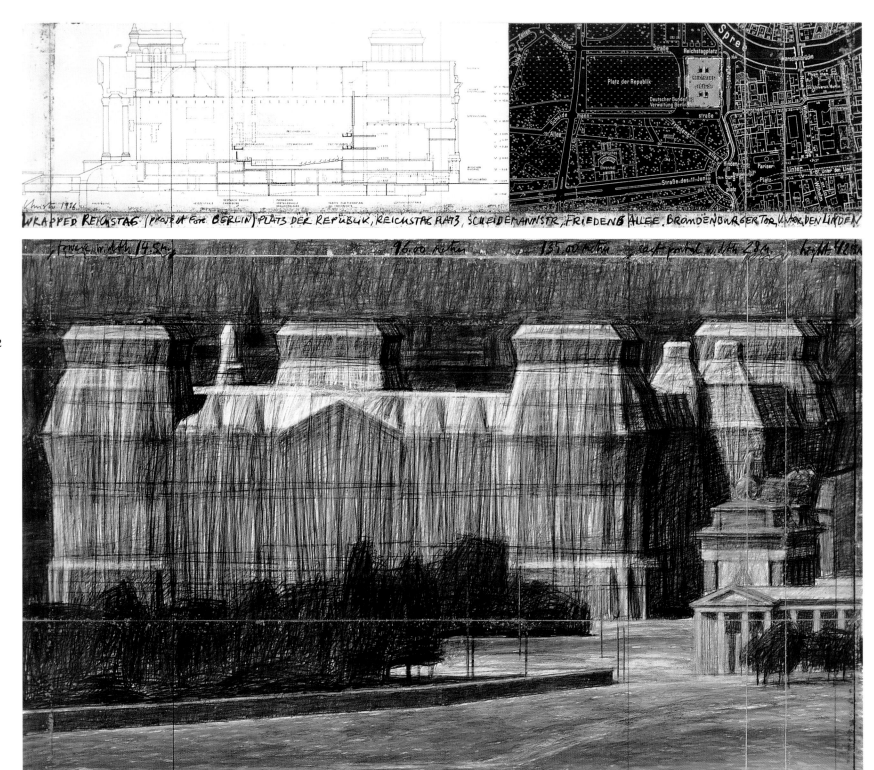

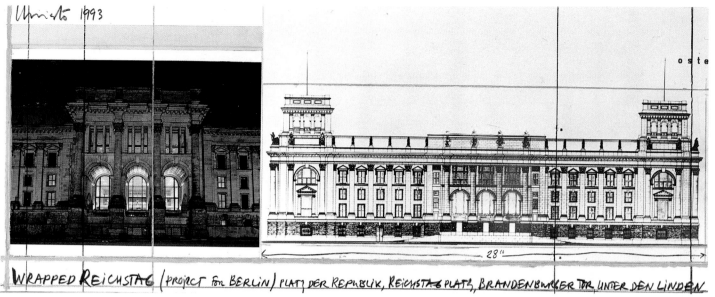

Christo 1993

WRAPPED REICHSTAG (PROJECT FOR BERLIN) PLATZ DER REPUBLIK, REICHSTAG PLATZ, BRANDENBURGER TOR UNTER DEN LINDEN

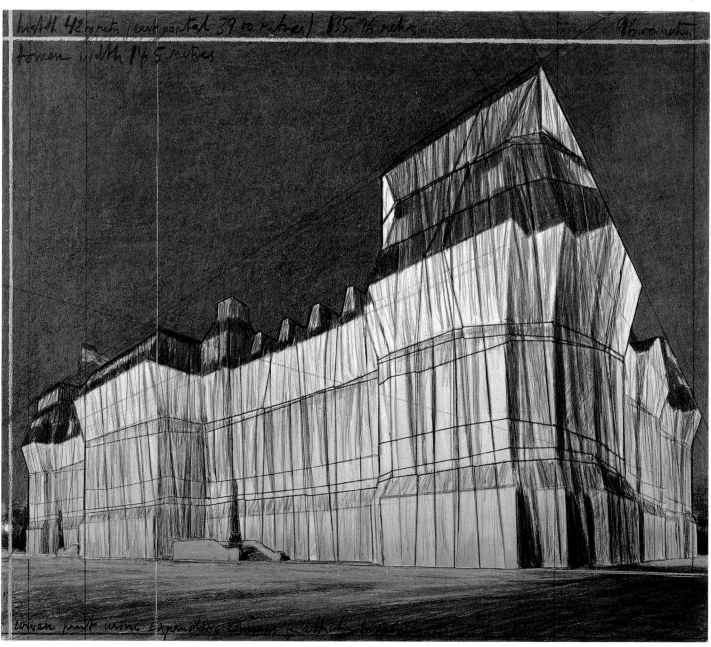

193

194

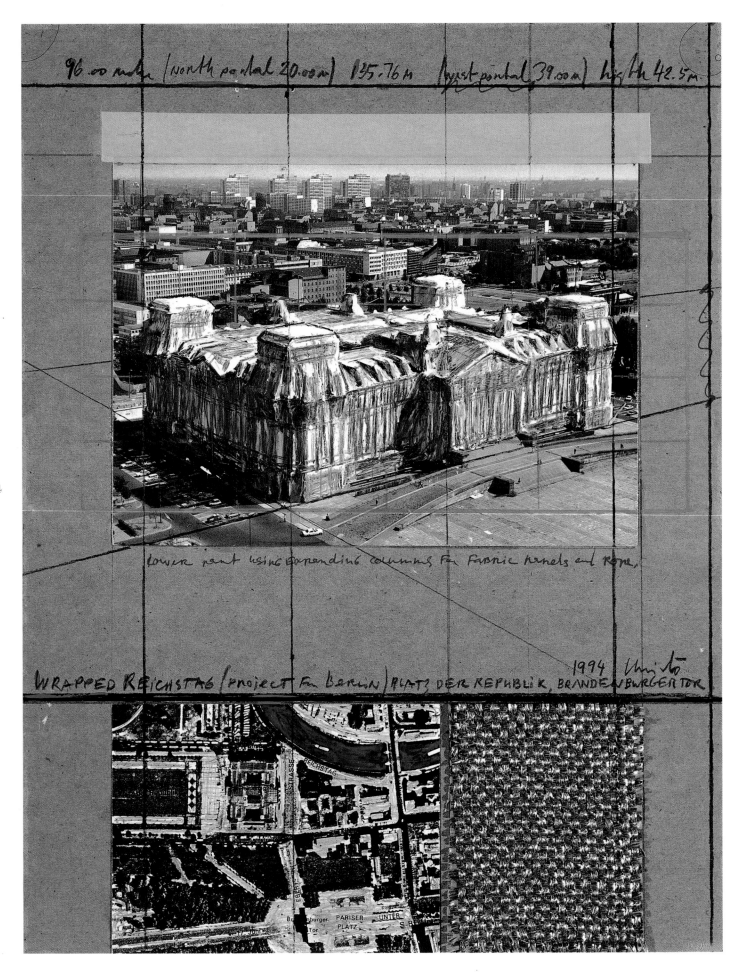

96.00 meter (North portal 20.00 m) 135.76 m (west portal 39.00 m) height 42.5 m

lower part using expanding columns for fabric panels and rope.

WRAPPED REICHSTAG (project for Berlin) PLATZ DER REPUBLIK, BRANDENBURGERTOR 1994 Christo

88.
Wrapped Reichstag, Project for Berlin
Collage, 1994

89.
Wrapped Reichstag, Project for Berlin
Scale model, 1978

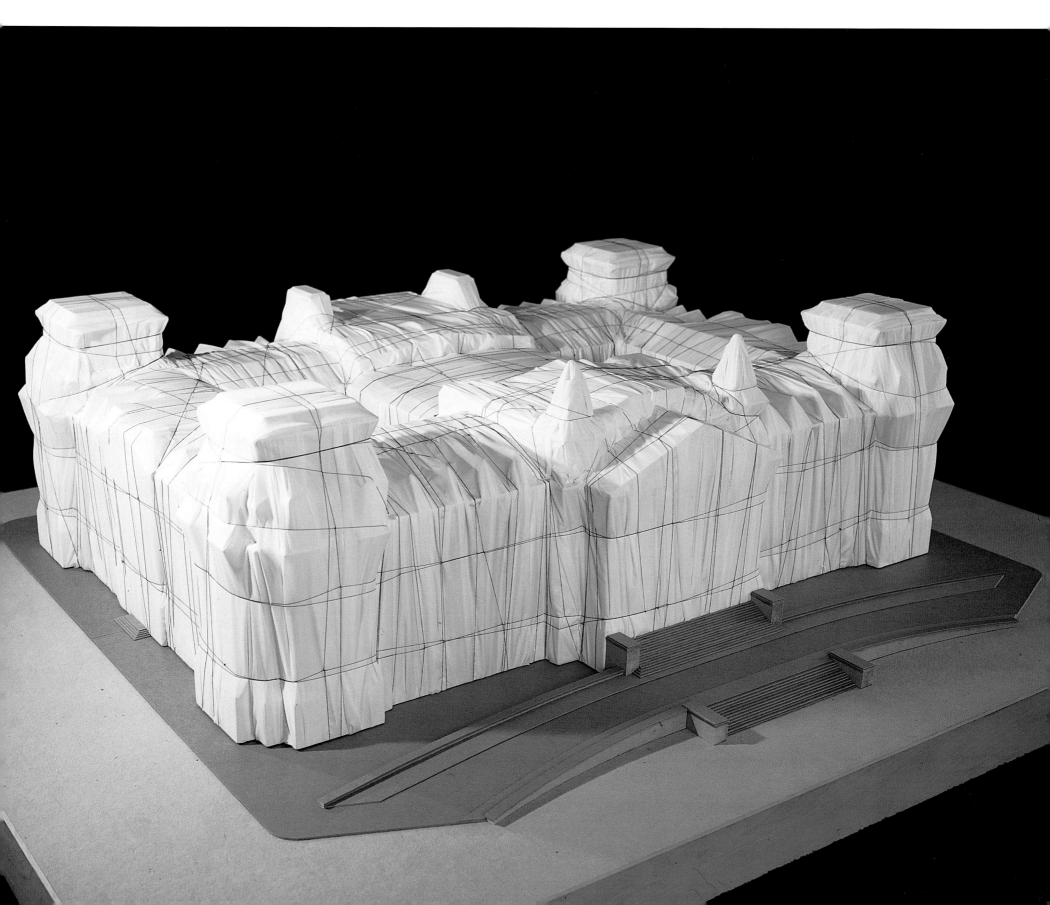

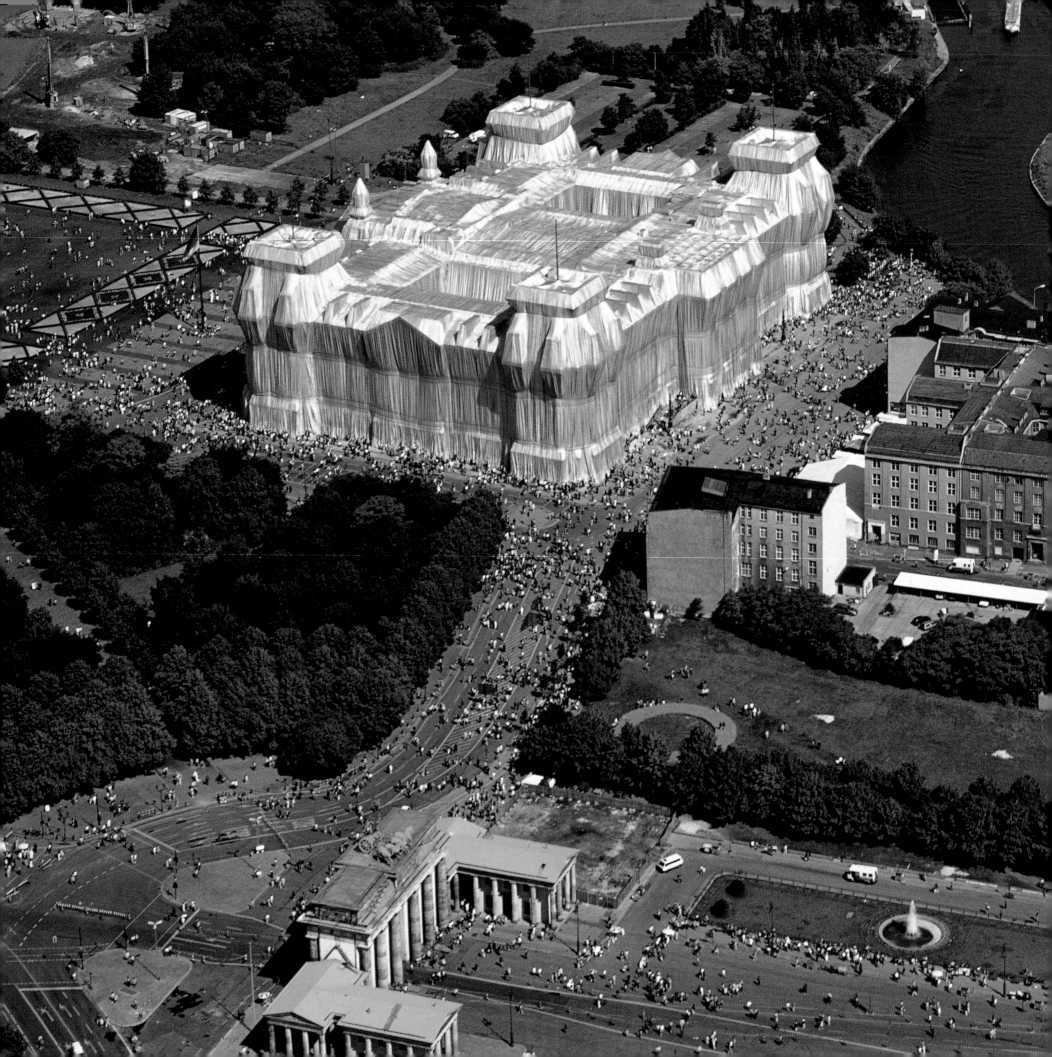

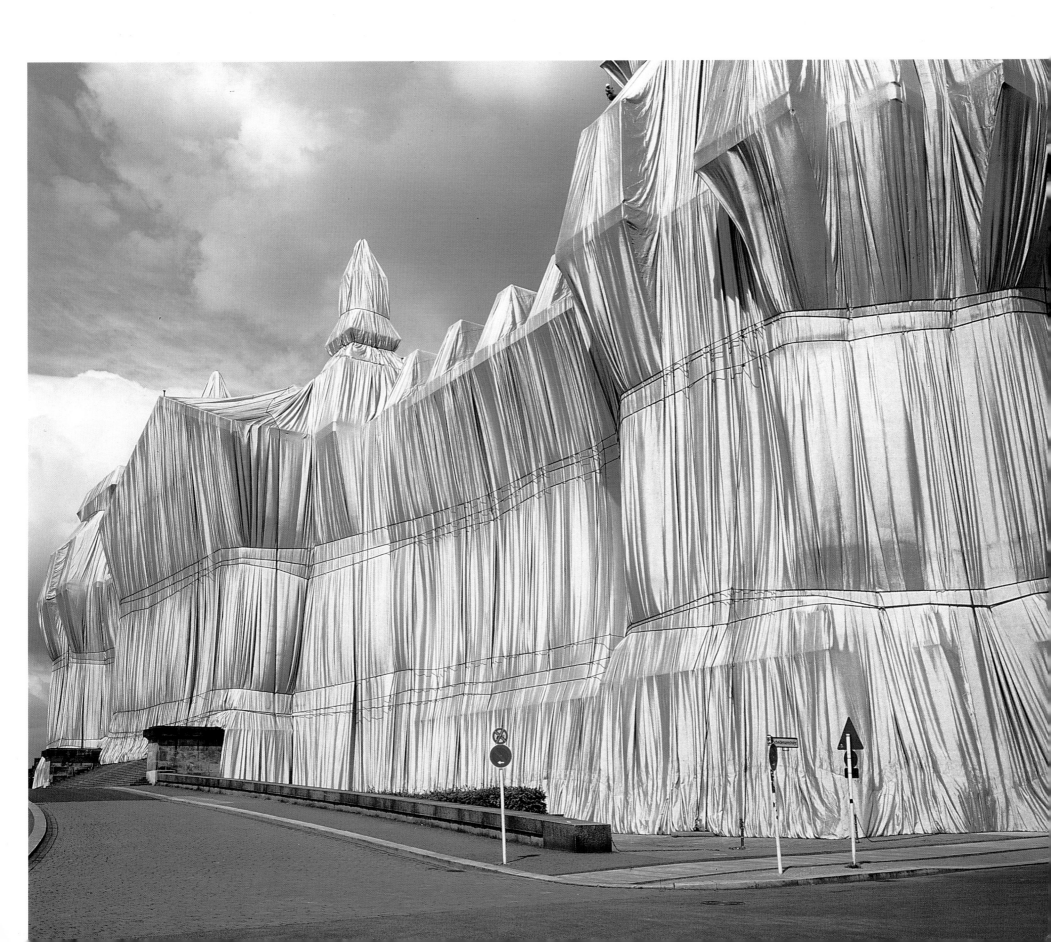

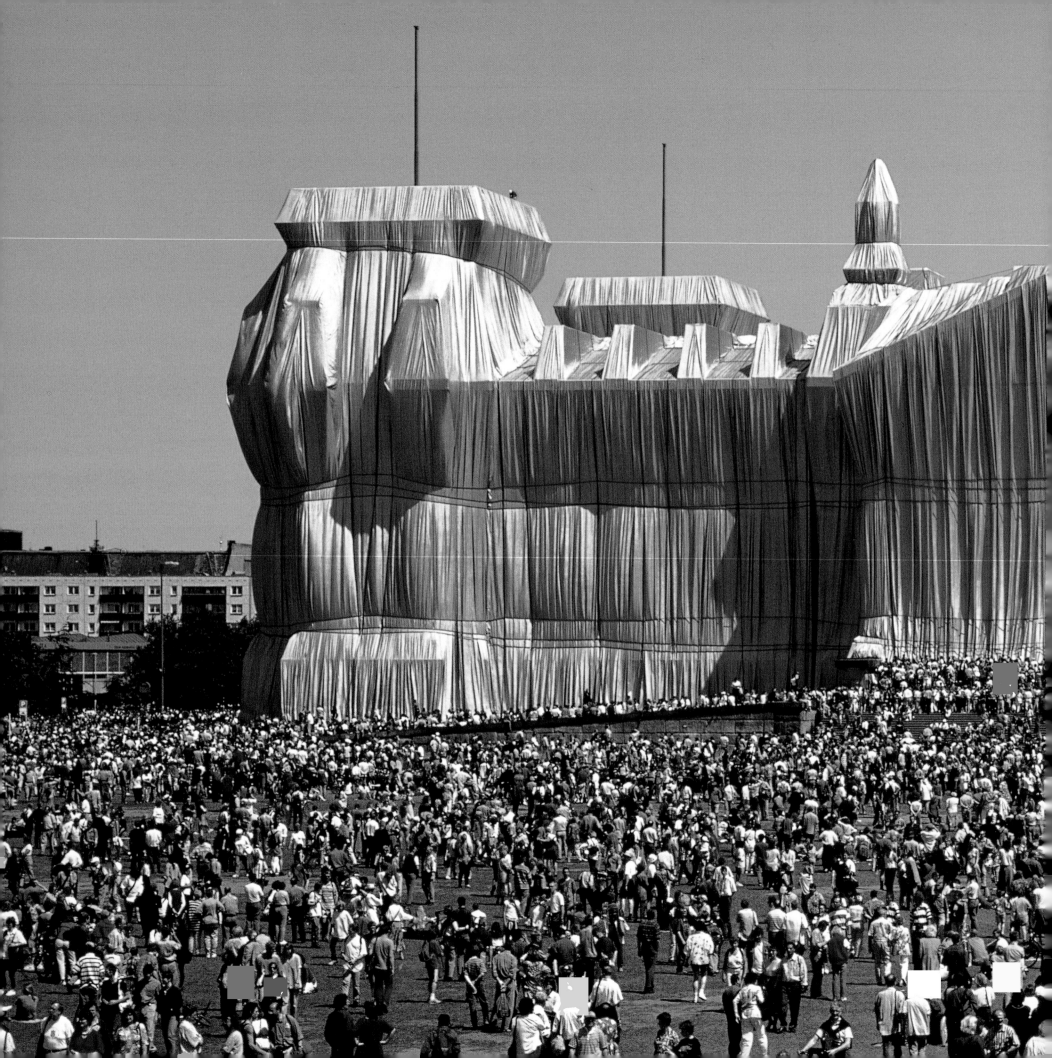

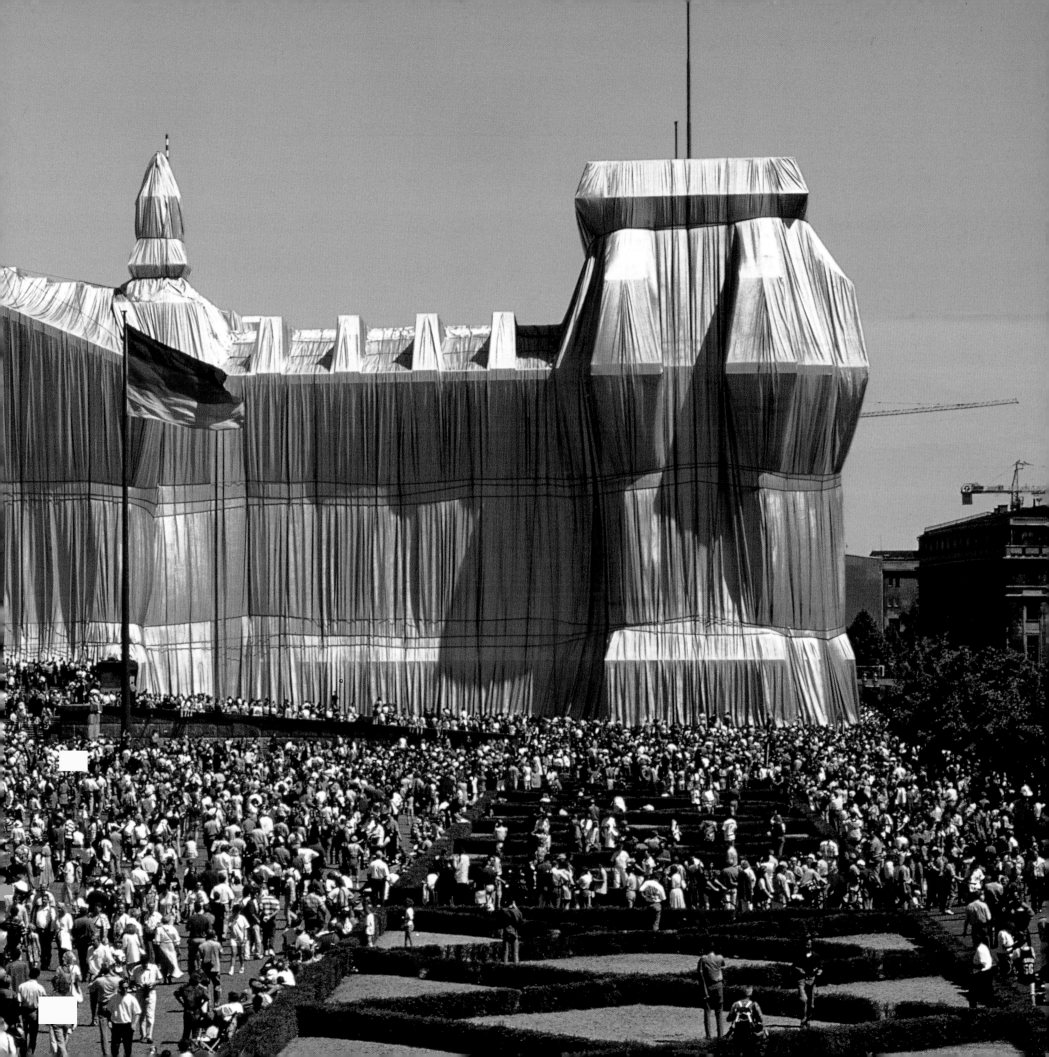

Wrapped Trees, Fondation Beyeler and Berower Park, Riehen, Switzerland, 1997–98

Starting on Friday, November 13, 1998, 178 trees were wrapped with 55,000 square meters (592,034 square feet) of woven polyester fabric (used every winter in Japan to protect the trees from frost and heavy snow) and 23.1 kilometers (14.35 miles) of rope.

The trees are located in the park around the Fondation Beyeler and in the adjacent meadow as well as along the creek of Berower Park. The first record of Berower Park goes back to the year 1551. A 1786 map of Riehen shows a small French garden and a large area of vineyards. In 1832 it was redesigned by F.R. Caillat as a privately owned English park. In 1976 the ownership of Berower Park was transferred to the community of Riehen, located northeast of Basel, at the border of Germany. The park includes a great diversity of trees: Chestnut, Oak, Ash, Plum, Cherry, Linden, Ginkgo, Beech, Birch, Sycamore, Maple, Catalpa, Hazelnut and Golden Weeping Willow. The height of the trees varies between 25 meters (82 feet) and 2 meters (6.56 feet) with a diameter from 14.5 meters (47 feet) to 1 meter (3.25 feet).

The project was organized by Josy Kraft, project director, and by Wolfgang and Sylvia Volz, project managers, who also surveyed the trees and designed the sewing patterns for each tree.

J. Schilgen GmbH & Co., Emsdetten, Germany wove the fabric. Günter Heckmann, Emsdetten, Germany cut and sewed the fabric according to each pattern. Meister + Cie. AG, Hasle-Rüegsau, Switzerland manufactured the ropes.

Field manager Frank Seltenheim of Seilpartner, Berlin, Germany, directed eight teams working simultaneously: ten climbers, three tree pruners and twenty workers.

As they have always done, Christo and Jeanne-Claude have paid the expenses of the project themselves through the sale of original works to museums, private collectors and galleries.

Before the leaves start growing again the wrapping will be removed and the materials will be recycled.

Christo and Jeanne-Claude have worked with trees for many years: in 1966 a 10 meter (33 foot) long *Wrapped Tree* was part of a personal exhibition at the Stedelijk van Abbemuseum in Eindhoven, Holland, and *Wrapped Trees* was proposed for the park adjacent to the Saint Louis Museum of Art, Missouri. In 1968, at the occasion of a personal exhibition at the Museum of Modern Art in New York, there was a project for *Wrapped Trees* for the museum's garden. In 1969, *Two Wrapped Trees* 9.5 meters (31 feet) and 5.2 meters (17 feet) were created in Sydney, Australia, for the art collector John Kaldor. Also in 1969, the artists requested permission for *Wrapped Trees, Project for 330 Trees, Avenue des Champs-Elysées, Paris,* which was denied by Maurice Papon, Prefect of Paris.

The *Wrapped Trees* in Riehen are the outcome of 32 years of effort. On November 13, 1998, an exhibition opened at the Galerie Beyeler in Basel, retracing the itinerary of those proposals with collages, drawings and scale models created through the years and preparatory studies for the *Wrapped Trees* in Riehen as well as some early works of the 1950s and 1960s. An historical exhibition from Cézanne to modern masters and contemporary artists, *The Magic of Trees*, is being held at the Fondation Beyeler. The branches of the *Wrapped Trees* pushing the translucent fabric outward create dynamic volumes of light and shadow, moving in the wind with new forms and surfaces shaped by the ropes on the fabric.

Press Communiqué
Christo & Jeanne-Claude
Riehen, Switzerland, December 3, 1998

We have seen our work of art, *Wrapped Trees, Fondation Beyeler and Berower Park, 1997–98*, as part of the exhibition *The Magic of Trees* at the Fondation Beyeler. Together with the Fondation, we had planned that the *Wrapped Trees* might remain longer than the usual fourteen days.

However, as with all of previous temporary work of art, the fourteen-day duration of the project's exhibition has been an aesthetic choice.

Therefore, after having enjoyed and shared our work of art with so many visitors, as artists, we have now decided that *Wrapped Trees, Fondation Beyeler and Berower Park, 1997–98* will remain until December 13, 1998. Then the project will be removed and all materials will be recycled.

Statement
The temporality of a work of art creates a feeling of fragility, vulnerability and an urgency to be seen, as well as a presence of the missing, because we know it will be gone tomorrow.

The quality of love and tenderness that human beings have towards what will not last – for instance the love and tenderness we have for childhood and our lives – is a quality we want to give to our work as an additional aesthetic quality.

Wrapped Trees, Fondation Beyeler
and Berower Park, Riehen, Switzerland,
1997–98

Autumn landscape in Riehen
With the wrapping of the trees surrounding the wonderfully tranquil museum building created by Renzo Piano for the Fondation Beyeler, looking at the park and strolling through it will become an experience far removed from the causal certainties of an autumn or winter walk.

Trees can be wrapped in material only in late autumn, when their leaves have fallen. Their silhouettes lose their full contours, they look like drawings. […] Christo and Jeanne-Claude are wrapping the bare trees in billowing silver-grey covers. Brown ropes will hold them together, tie them into airy shapes. Those shapes will depend on the morphology of each individual tree. The plans and collages created in the studio as a prelude to the work already give some indication of this great diversity.

Our experience in the park will have nothing in common with the idea of a precisely defined, firmly rooted form: the constantly changing light will grasp at the polyester bodies, be drawn into them, soak them up, cause volume to disappear. A rich theater of light and shadow using the whole spectrum of colors make autumn and winter in the park surrealistically different.

The project for Riehen can be traced back to the 1960s. Christo and Jeanne-Claude have often suggested a work involving trees. […] But none of the large projects – for the Fondation Maeght, the sculpture garden of the Museum of Modern Art in New York and, above all, the three hundred and thirty trees on the Champs-Elysées – has ever been realized. That delay has been good for the present project. It differs in one crucial respect from all previous ones: it finds individual expression in Riehen. What matters most is not the large scale of the project (178 trees are being wrapped) but rather each single tree.

The park's botanical diversity means that there will be many different sculptures out of air. Every tree has its own shape. A special garment has to be cut for each of them. The work demands made-to-measure craftsmanship, not mass production. […]

Someone who has not seen one of these works cannot even begin to imagine the overwhelming impression they make, which surpasses even the boldest expectation the viewer might have had. All petty, pragmatic objections definitively vanish in the face of the enthusiasm the works inspire. That is, in fact, the sole handicap of Christo's and Jeanne-Claude's system: they know in advance that only the realized project will convince the skeptics. Following their "gentle disturbance", familiar landscapes, buildings which we see daily without really noticing them, are suddenly revealed to us in unusually sharp focus – the world's describability is fragmented everywhere. […]

One further point: monumental and vast as these works may be, they do not place an additional burden on the crammed world in which we live. Like a dream, they ambush reality and then, without having destroyed or even disturbed anything, they vanish again. Christo and Jeanne-Claude are masters of the ephemeral. For a brief period, they project emotions and mirages that concern everyone, that fascinate and enchant. A game with the seasons, an autumnal picture. The ephemerality of this project reflects nature's cycle. The wrapped park is a metaphor for the passing of time. Few other works play as obsessively with fleetingness as do those of Christo and Jeanne-Claude. Therein lies their greatness – they remain dependent on fragility and disappearance.

Excerpts from Werner Spies, "Autumn Landscape in Riehen", in *Christo and Jeanne-Claude*, exhibition catalogue, Galerie Beyeler, Basel, 1998.

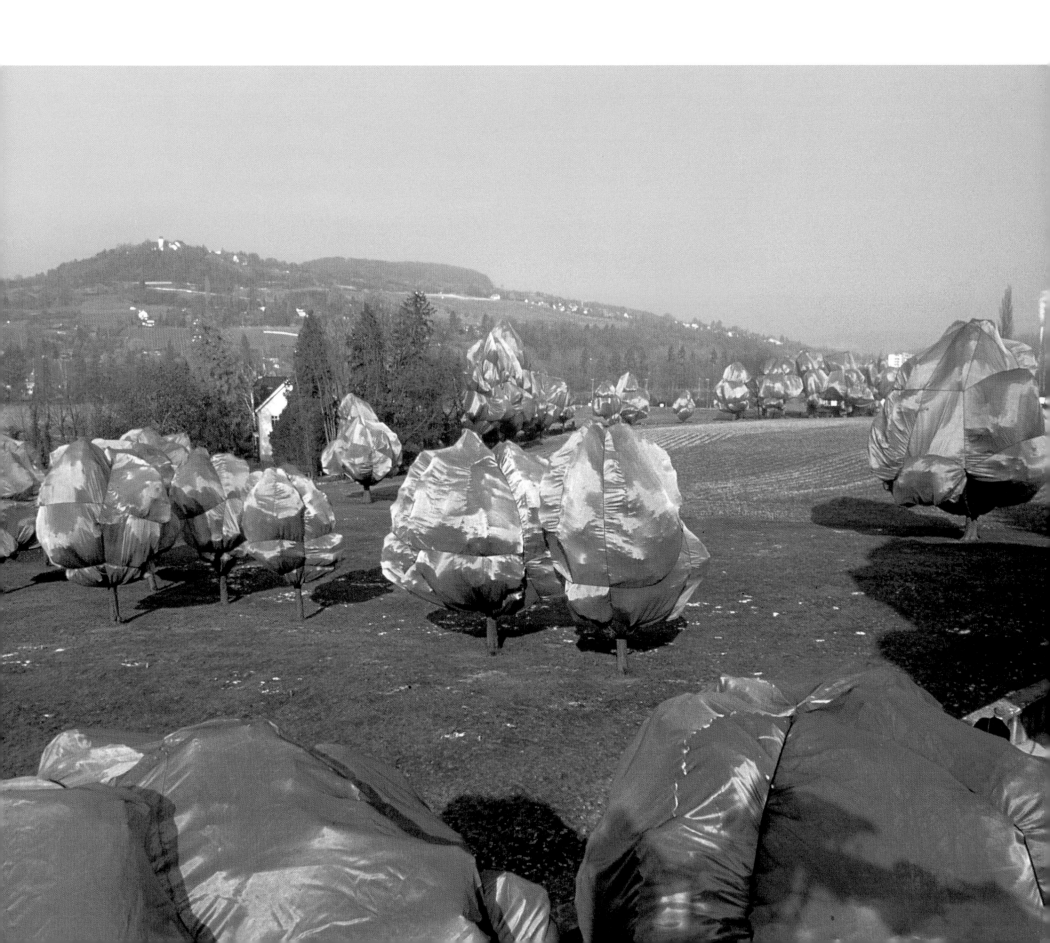

90.
Wrapped Trees, Project for the Fondation
Beyeler, Riehen, Switzerland
Collage, 1997

204

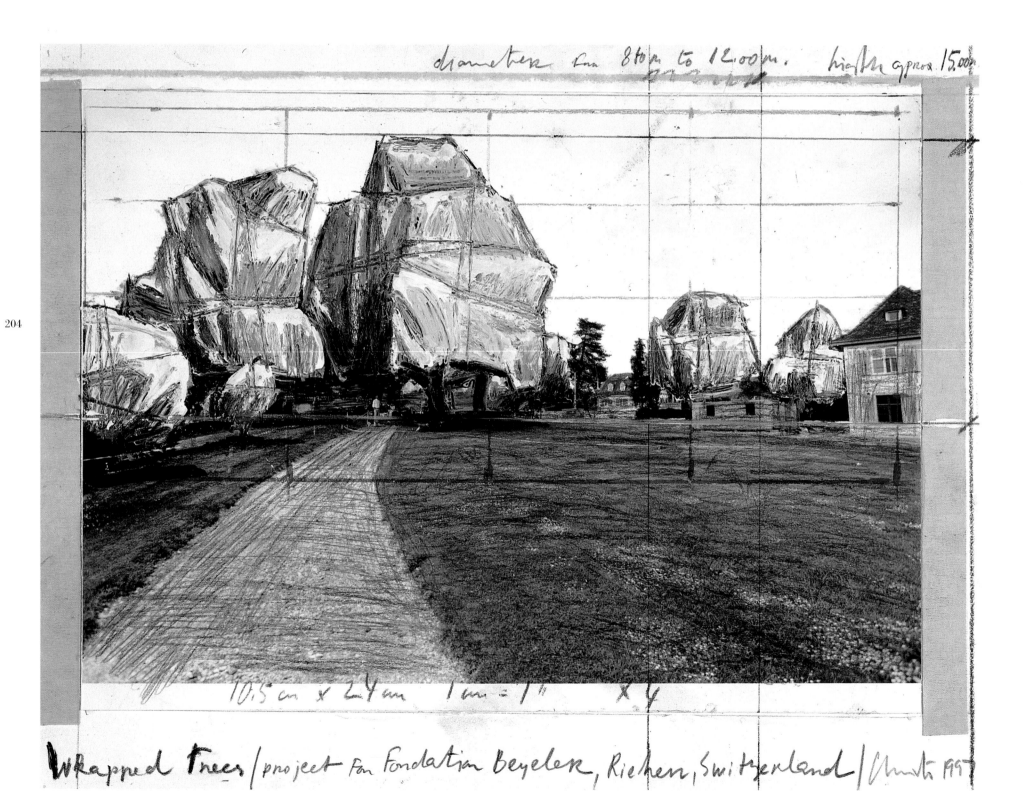

91.
Wrapped Trees, Project for the Fondation
Beyeler and Berower Park, Riehen,
Switzerland
Drawing in two parts, 1998

92.
Wrapped Trees, Project for the Fondation Beyeler and Berower Park, Riehen, Switzerland
Drawing in two parts, 1998

93.
Wrapped Trees, Project for the Fondation Beyeler and Berower Park, Riehen, Switzerland
Drawing in two parts, 1998

206

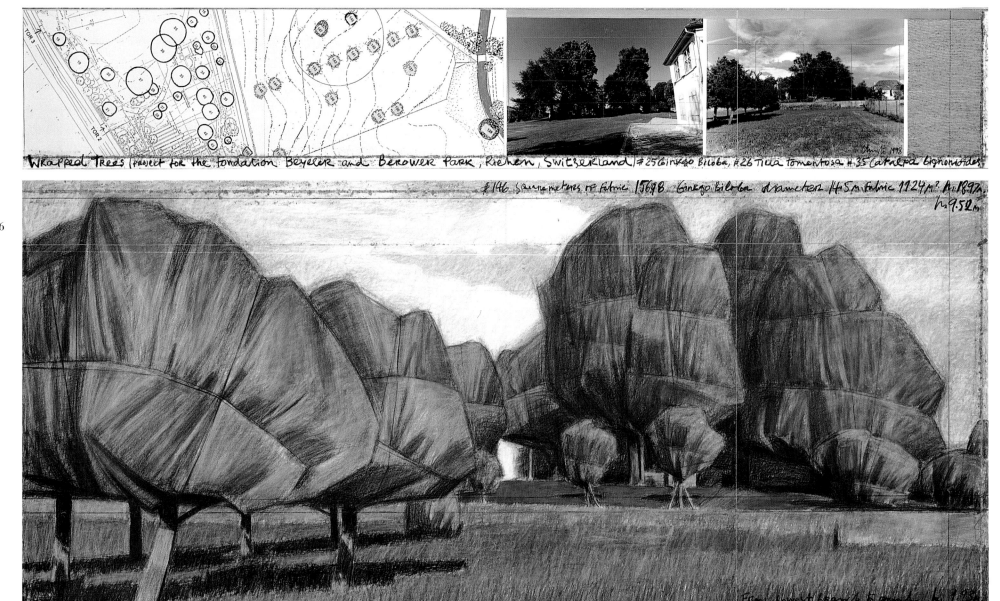

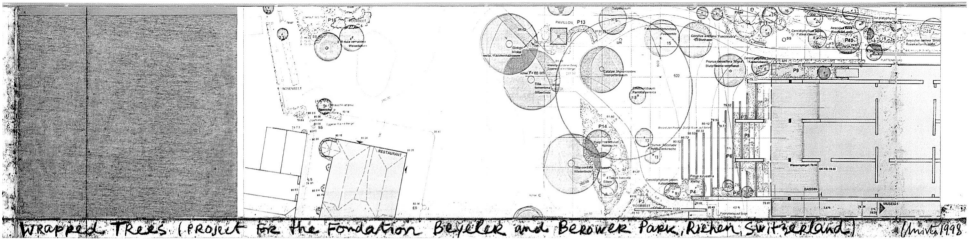

WRAPPED TREES (PROJECT FOR THE FONDATION BEYELER and BEROWER PARK, RIEHEN, Switzerland) *Christo* 1998

207

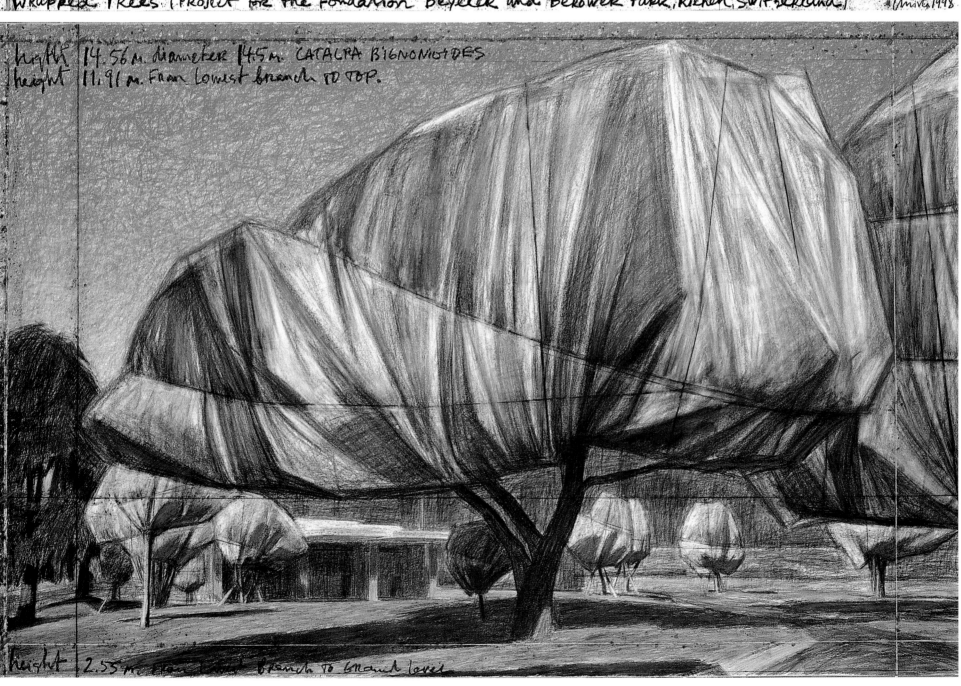

higth 14.56m diameter 14.5m. CATALPA BIGNONIOIDES
height 11.91 m. From lowest branch to top.

height 2.55 m. from lowest branch to branch level

94.
Wrapped Trees, Project for the Fondation
Beyeler and Berower Park, Riehen,
Switzerland
Collage, 1998

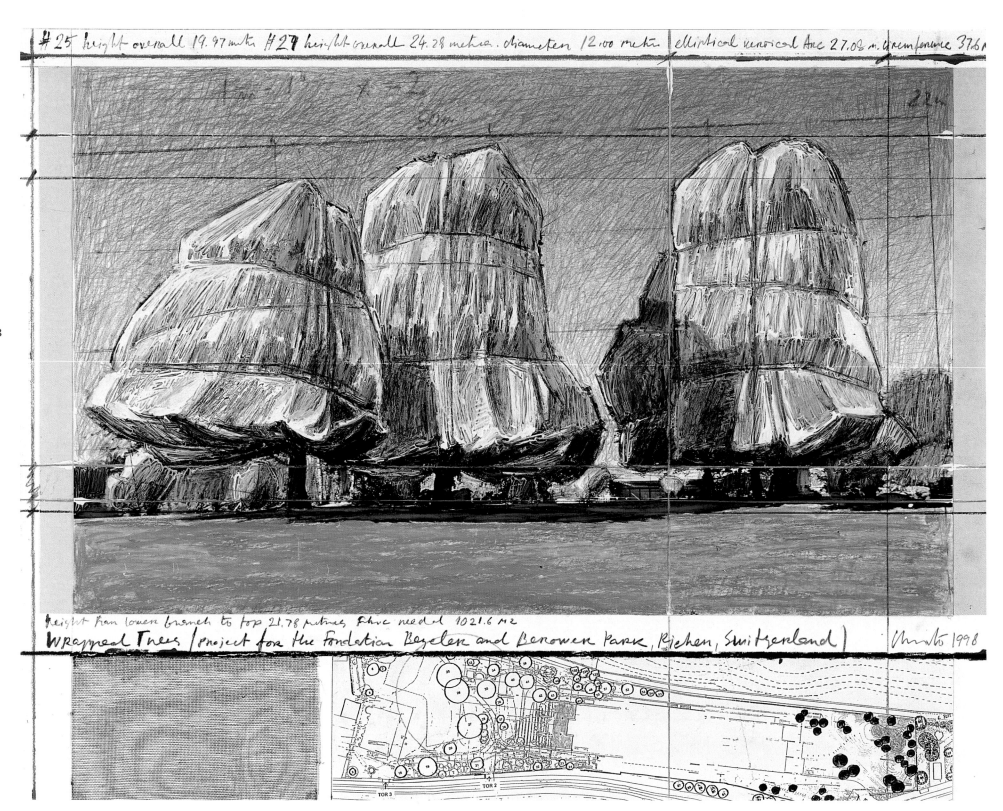

95.
**Wrapped Trees, Project for the Fondation
Beyeler and Berower Park, Riehen**
Collage in two parts, 1998

Wrapped Trees | project for Fondation
Beyeler and Berower Park, Riehen |

Christo 1998

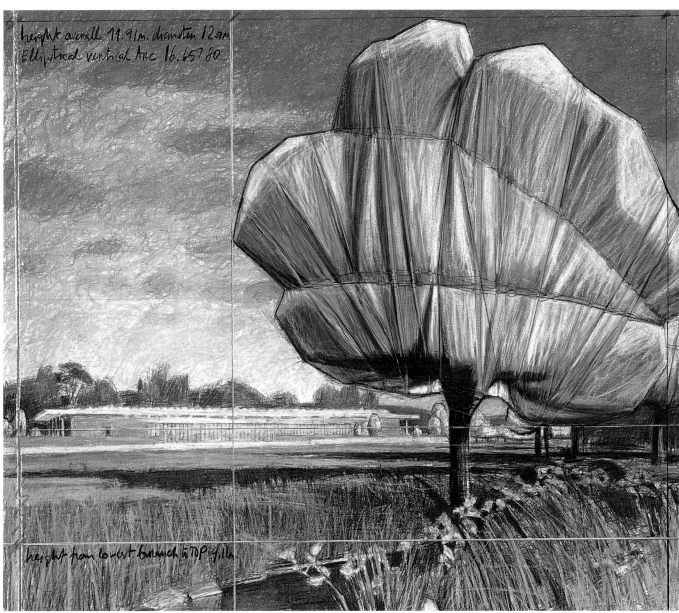

height overall 11.91m. diameter 12 om
Elliptical vertical Arc 16.65.80

height from lowest branch to TOP 9.1m

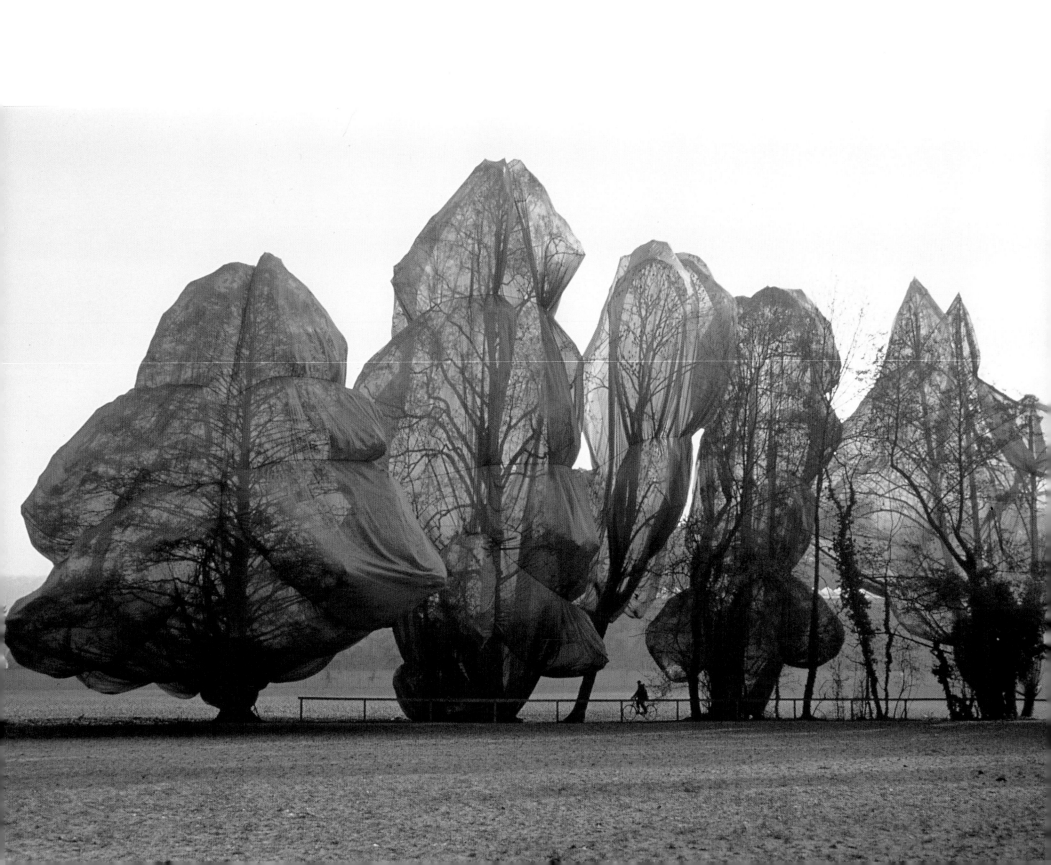

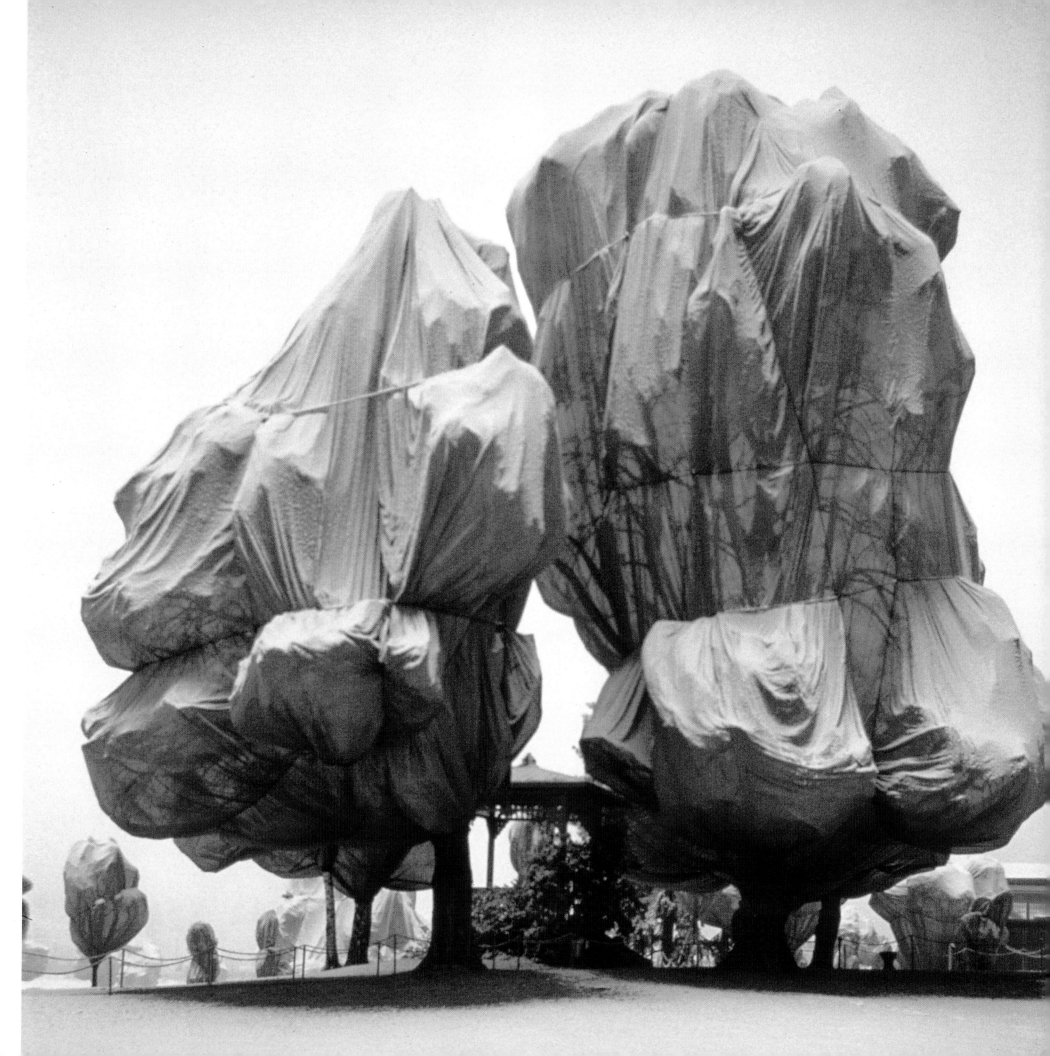

The Gates, Central Park, New York City, 1979–2005

After Michael R. Bloomberg, Mayor of New York City, announced, on January 22, 2003, that a contract had been signed permitting New York artists Christo and Jeanne-Claude to realize their temporary work of art: *The Gates, Central Park, New York City, 1979–2005*, the fabrication of all the materials was started. The installation, at the site in Central Park, was completed with the blooming of the 7,500 fabric panels on February 12, 2005.

The 7,503 gates, 16 feet (4,87 meters) tall varied in width from 5 feet 6 inches to 18 feet (1,68 to 5,48 meters) according to the 25 different widths of walkways, on 23 miles (37 kilometers) of walkways in Central Park. Free hanging saffron colored fabric panels, suspended from the horizontal top part of the gates, came down to approximately 7 feet (2,13 meters) above the ground. The gates were spaced at 12 foot (3,65 meter) intervals, except where low branches extend above the walkways. The gates and the fabric panels could be seen from far away through the leafless branches of the trees. The work of art remained for sixteen days, then the gates were removed and the materials recycled.

The 5 inch (12,7 cm) square vertical and horizontal poles were extruded in 60 miles (96,5 km.) of saffron colored vinyl. The vertical poles were secured by 15,000 narrow steel base footings, 613–837 pounds (278–380 kilograms) each, positioned on the paved surfaces. No holes were made in the ground.

The off-site fabrication of the gates' components was purchased from seven manufacturers located on the East Coast of the USA. The weaving and sewing of the fabric panels was done in Germany.

In teams of eight, 600 workers wearing *The Gates* uniforms, were re-

sponsible for installing 100 gates per team. The monitoring and removal teams included an additional 300 uniformed workers. The monitors assisted the public and gave information. All workers were financially compensated and received one hot meal a day. Professional security worked in the park after dark.

As Christo and Jeanne-Claude have always done for their previous projects, *The Gates* was entirely financed by the artists through their C.V.J. Corp. (Jeanne-Claude Christo-Javacheff, President) with the sale of preparatory studies, drawings, collages, and scale models, earlier works of the 1950s and 1960s, and original lithographs on other subjects.

The artists do not accept sponsorship or donations.

Christo and Jeanne-Claude have donated the merchandising rights to the charitable foundation NNYN (Nurture New York's Nature and the Arts) who are sharing the proceeds with The Central Park Conservancy.

The grid pattern of the city blocks surrounding Central Park was reflected in the rectangular structure of the commanding saffron colored poles while the serpentine design of the walkways and the organic forms of the bare branches of the trees were mirrored in the continuously changing rounded and sensual movements of the free flowing fabric panels in the wind.

The people of New York continued to use the park as usual.

For those who walked through *The Gates*, following the walkways, the saffron colored fabric was a golden ceiling creating warm shadows. When seen from the buildings surrounding Central Park, *The Gates* seemed like a golden river appearing and disappearing through the bare branches of the trees and highlighting the shape of the meandering footpaths.

Some of the materials

5,290 US tons of steel (4,799 metric tons) for the 15,000 steel bases, the equivalent of two thirds of the steel of the Eiffel Tower

315,491 linear feet (60 miles) (96,5 kilometers) of vinyl tube, 5 × 5 inch square (12,7 × 12,7 centimeters) for the poles

15,000 cast aluminum upper corner reinforcements, inserted in the upper part of the poles

15,000 extruded aluminum base anchor sleeves, connecting the poles to the steel bases

15,000 (1/2 × 8 × 8 inches) (1.27 × 22,8 × 22,8 centimeters) steel leveling plates, insuring the poles' verticality

165,000 bolts and self-locking nuts

15,000 (8 × 8 × 8 inches) (22,8 × 22,8 × 22,8 centimeters) vinyl leveling plate covers

1,067,330 square feet (99,155 square meters) of rip-stop nylon fabric

Vince Davenport: Chief Engineer and Director of Construction; Jonita Davenport: Project Director.
Exclusive Photographer: Wolfgang Volz.

The Gates, Central Park, New York City, 1979–2005

On January 22, 2003, Michael R. Bloomberg, the mayor of New York City, announced that he had granted permission for Christo and Jeanne-Claude to install *The Gates, Project for Central Park, New York City* in February 2005. Once the official authorization was at long last given, more than two decades after it had been flatly refused, everything but *The Gates* had to go on hold. All the artists' energy focused on selling enough work to fund the project, manufacturing the parts, and preparing for the installation of *The Gates*, all of which had to be done in a very short time for a project of such magnitude.

The Gates brings together several career-long themes in the work of Christo and Jeanne-Claude, not least the aspiration to do a project in New York, the city where they have lived and worked for forty years, the art capital of the world, and the place that offers perhaps the greatest diversity of population and concentration of people in the world, as well as the most intense nexus of the forces – economic, cultural, social, political – that govern the emergent realities of the twenty-first century. […]

The Gates will be unfurled on a Saturday morning, weather permitting, and will stand for sixteen days – two full weeks plus an extra weekend […]. In addition to the engineering and manufacturing aspects of the project, the logistics are complex. Trucks, for example, are not permitted to travel on the bridges to Long Island with loads greater than eighty thousand pounds. So all the materials will have to move slowly over the course of a year to the assembly plant in Maspeth, Queens, where workers will cut the vinyl for the poles, drill the holes, bolt the sections of the gates together, and as-

semble the sewn fabric panels, which are being imported from Germany. At the same time, keeping the materials on hand in Manhattan is prohibitively expensive, and nothing can be stored in the park. […]

The aesthetic of the project has an organic relation to Christo and Jeanne-Claude's earlier work. "Remember that there, in Kansas City", Jeanne-Claude told me, "we were enchanted by the fact that there were so many people walking." And pointing to drawings that display similarities to the *Running Fence* in the distribution of poles, the scale, and the way the fabric hung from the cables, Christo remarked: "It shows how much of our work often comes from previous projects. *The Gates* was coming from *Running Fence*"[1]. There is also a bodily corollary in all of the artists' projects and objects. "Fabric is like a second skin; it is very related to human existence", Christo says. "That fabric will move with the wind, the water, with the natural elements. […] The fabric is moving, like breathing. The *Reichstag* fabric moves, the fabric of *Running Fence* moves. Of course, that energy of the wind is so much translated with *The Gates*. It's so incredibly present"[2]. […]

In turning down the project in 1981 – though he is now a great supporter of it – Gordon Davis, then Commissioner of Parks and Recreation for New York, nevertheless expressed similar thoughts to those of Olmsted: "Over and over we have observed that the work of contemporary artists in a park setting, the creative intellect let loose in a public open space, presents a unique challenge. It forces us – the 'public' in all its variety – to see not just the work of art, but also to see that space in extraordinarily different ways and exciting new alignments. […] The experience has consistently been one of revelation. […] This experience is

the essence of what Christo's *Gates* may offer"[3].

Artists give form to the new realities of our lives before we have words to describe them. They create a language with which to explore what we perceive but don't quite have a way to talk about yet. One of the curious realities that will be debated through this project is that Central Park is "an entirely man made landscape", as Gordon Davis noted in his 230-page *Report and Determination in the Matter of Christo: The Gates*[4]. Central Park is a constructed experience of nature, in the tradition of the great "planned" natural landscapes of Romantic England. […]

The Gates in Central Park is bound to bring this issue to the foreground – the idea that we live in an increasingly constructed landscape, in every realm of our lives. In television, films, even in the national parks, our experience of "nature" is so carefully managed and yet the management is kept out of sight. The media interpret nature to us as we become more and more accustomed to accept a blurring of the boundary between nature and culture, between "manufactured" news and real events. If you look at a map of Manhattan, Central Park is a perfect rectangle cut out of a solid grid of streets and buildings; the shape of the individual gates that Christo and Jeanne-Claude have designed for the park consciously alludes to that man-made rectangle on the map and the forms of the surrounding buildings. The fabric hanging from the horizontal poles will catch the light, pick up the memory of the colors of the fall leaves, move organically in the wind – in all providing a rich evocation of nature. But the form of the individual gates is also a metaphor for encapsulating unpredictable nature inside the controlled framework of the park.

The California artist Robert Arneson,

who lived near *Running Fence* when Christo and Jeanne-Claude created that project, observed: "When the *Fence* was up it was great! The checkout ladies in the supermarket were arguing about the definition of art!"[5]. Such arguments about the definition of art have been fundamental to almost all the opposition that Christo and Jeanne-Claude's projects have engendered, because in that challenge to conventional definitions lies a metaphor for the loosening of other hierarchies as well, including the artificial distinction between "nature" and "culture" in the twenty-first century. The epiphany for viewers in all the Christo and Jeanne-Claude projects has everything to do with not only the dynamically changing cultural construction of experience but also the individual's mental evolution in relation to cultural constructions, our own internal parameters, and the dynamic environment of events. These works wake us up to the very life we're living.

[1] Christo and Jeanne-Claude, interview with Jonathan Fineberg, New York, July 25, 2003.
[2] Christo, telephone conversation with Jonathan Fineberg, October 7, 2003; Christo and Jeanne-Claude, interview with Jonathan Fineberg, New York, July 25, 2003.
[3] Gordon J. Davis, *Report and Determination in the Matter of Christo: The Gates*, Department of Parks and Recreation, New York, February 1981, pp. 39–41.
[4] Ibid., p. 43.
[5] Robert Arneson, conversation with Jonathan Fineberg, 1981.

Excerpts from Jonathan Fineberg, *Christo and Jeanne-Claude: On the Way to The Gates, Central Park, New York City*, exhibition catalogue, The Metropolitan Museum of Art, New York, 2004.

214

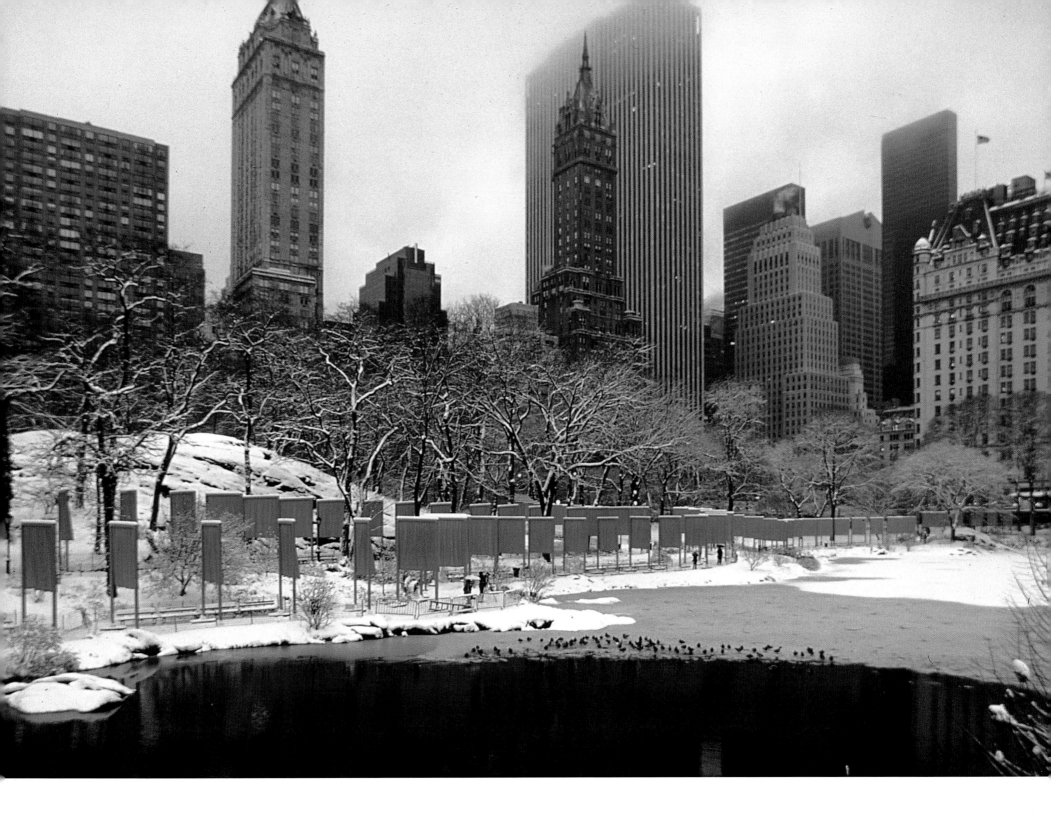

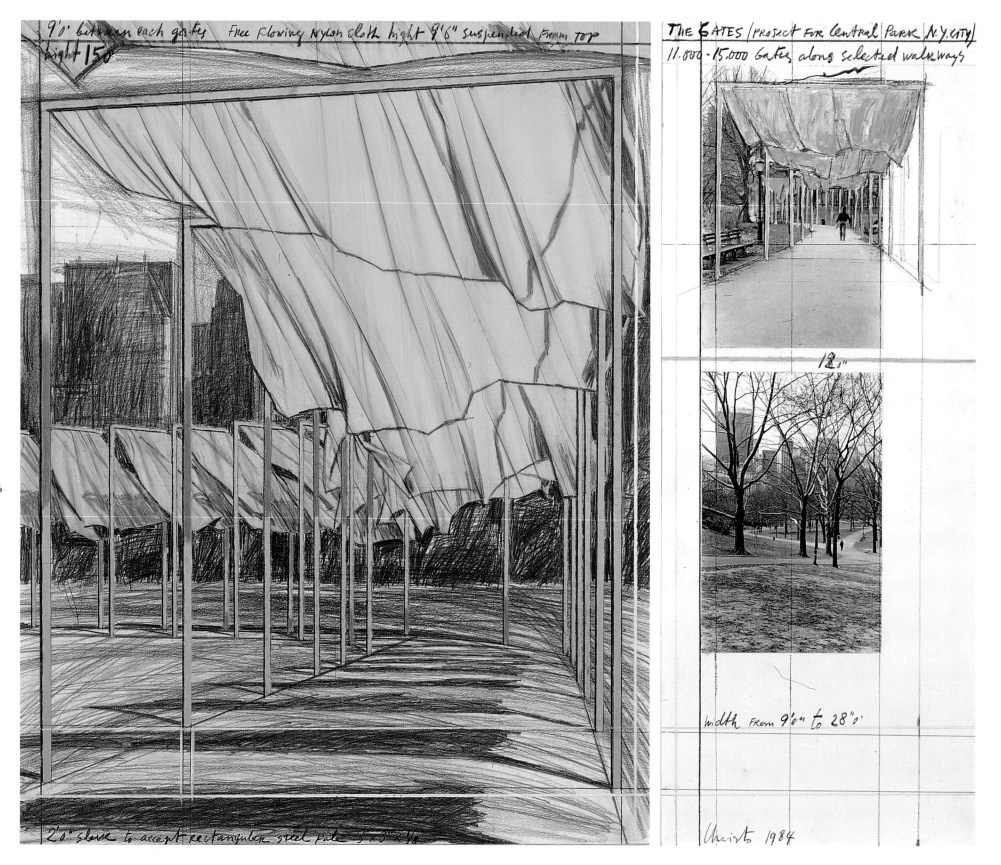

9'0" between each gates Free flowing Nylon cloth height 9'6" suspended from top
height 15'0"

THE GATES (PROJECT FOR CENTRAL PARK N.Y. CITY)
11.000 - 15.000 Gates along selected walkways

12'0"

width from 9'6" to 28'0"

2'0" sleeve to accept rectangular steel pole 3"x3"x1/8"

Christo 1984

96.
The Gates, Project for Central Park,
New York City
Collage in two parts, 1984

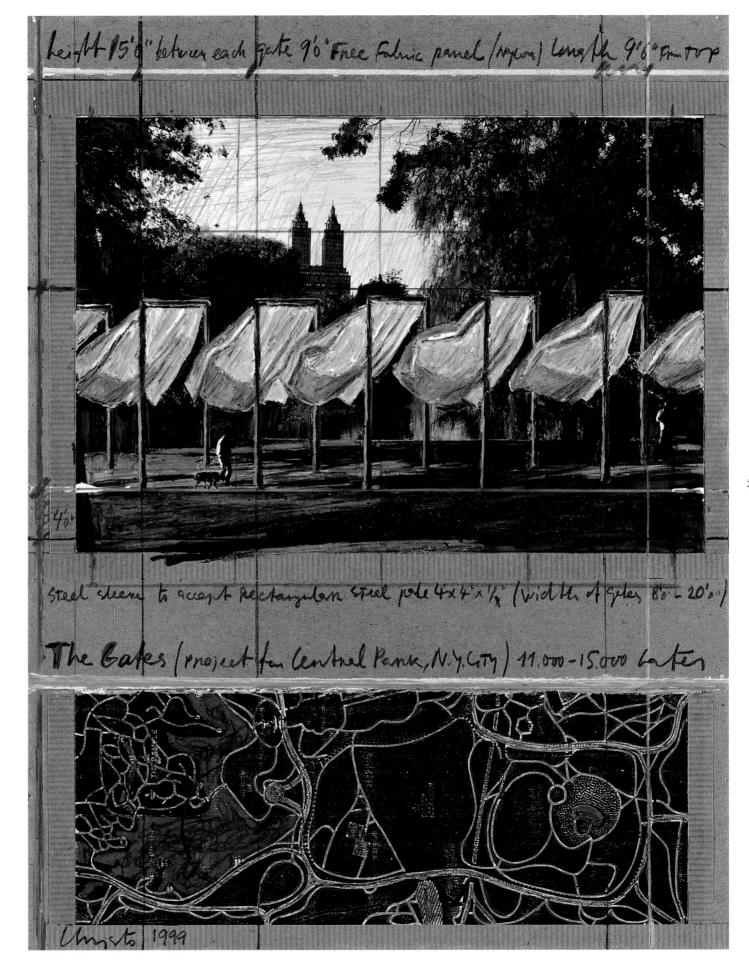

97.
The Gates, Project for Central Park,
New York City
Collage, 1999

98.
The Gates, Project for Central Park,
New York City
Drawing in two parts, 2001

99.
The Gates, Project for Central Park,
New York City
Drawing in two parts, 2001

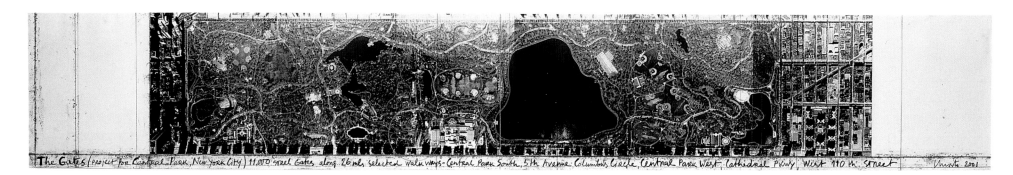

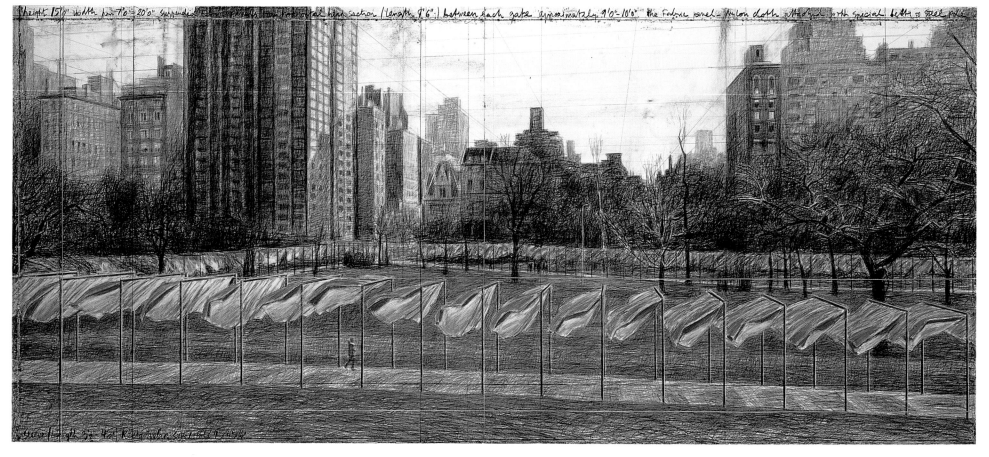

218

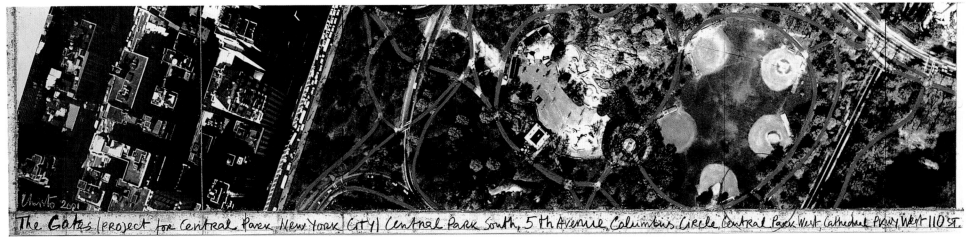

The Gates (project for Central Park, New York City) Central Park South, 5th Avenue, Columbus Circle, Central Park West, Cathedral Pkwy West 110 St.

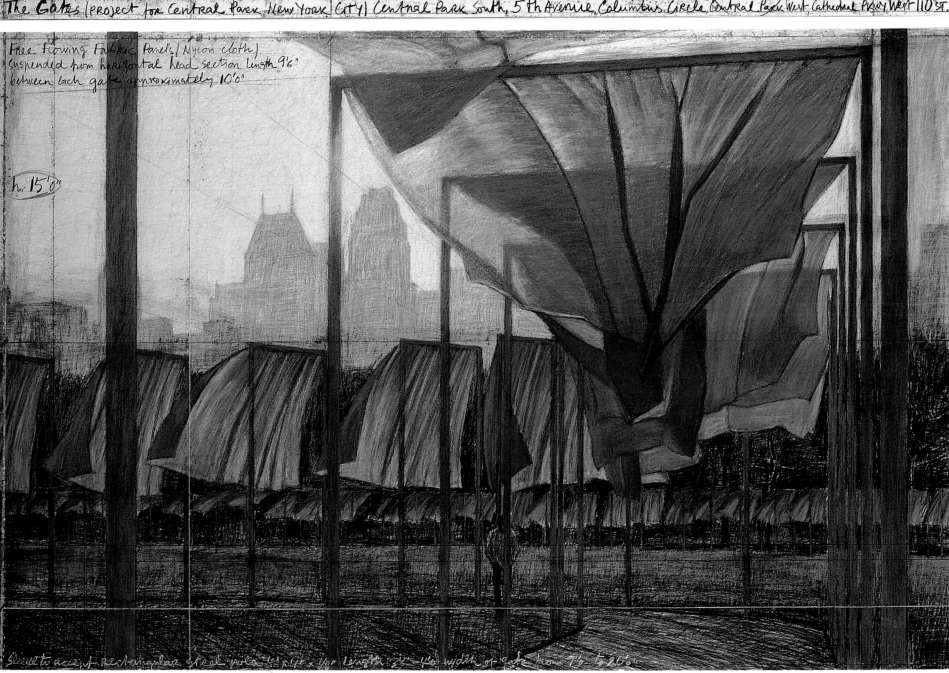

Free flowing Fabric Panels (Nylon cloth)
Suspended from horizontal head section Length 9'6"
between each gate approximately 10'0"

h. 15'0"

Sleeve to accept rectangular steel pole 4"x4" x ... length 24"... width of gate from 1'6" to 26'0"

100.
The Gates, Project for Central Park,
New York City
Drawing in two parts, 2003

101.
The Gates, Project for Central Park,
New York City
Collage in two parts, 2002

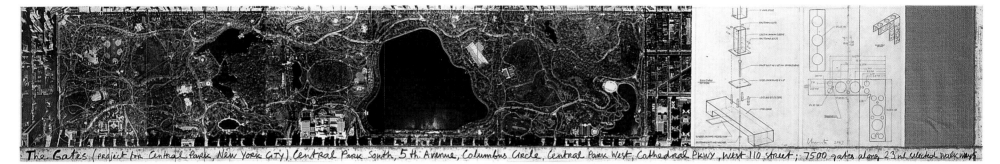

The Gates (project for Central Park, New York City) Central Park South, 5th. Avenue, Columbus Circle, Central Park West, Cathedral PKWY, West 110 Street; 7500 gates along 23 nd selected walkways

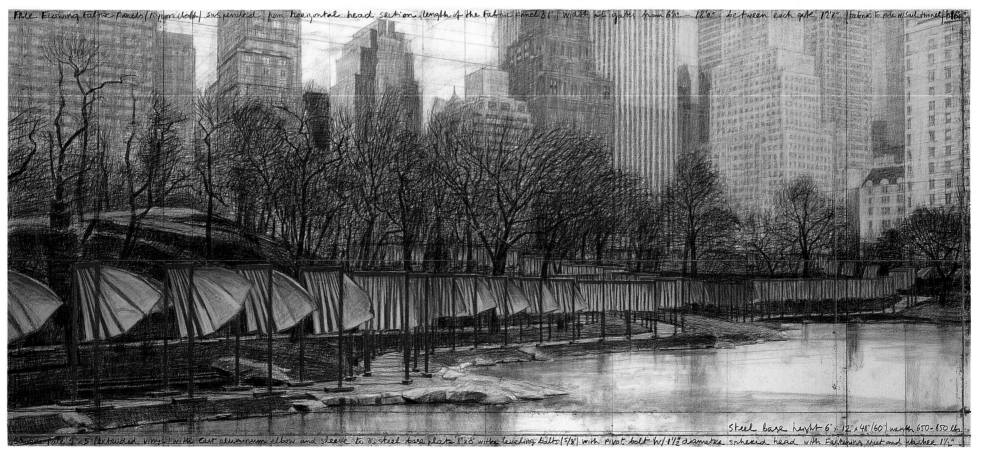

Free Flowing Fabric Panels (nylon cloth) suspended from horizontal head section (length of the Fabric panel 8'6") width of gates from 6'6" — 18'0" between each gate 12'8" fabric to be w/ sail hem of 16"

steel base height 6" x 12" x 48" (60") weight 650-650 lb

gauge pole 5" x 5" (extruded vinyl) with cast aluminium elbow and sleeve to a steel base plate 8"x8" with leveling bolts (5/8) with pivot bolt w/ 1 1/2 diameter spherical head with fastening nut and washer 1 1/2"

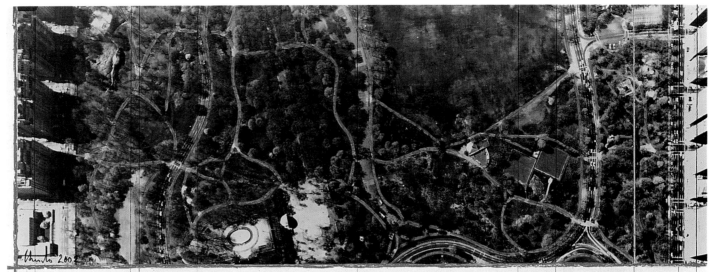

The Gates (project for Central Park New York CITY) Central Park S., 5th. Avenue, Central Park West, Cathedral Pkwy, West 110 st.

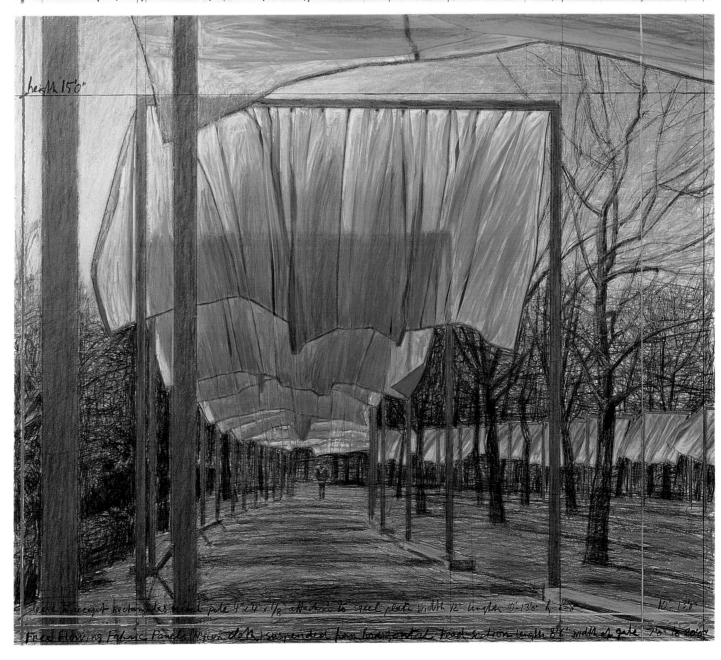

height 15'0"

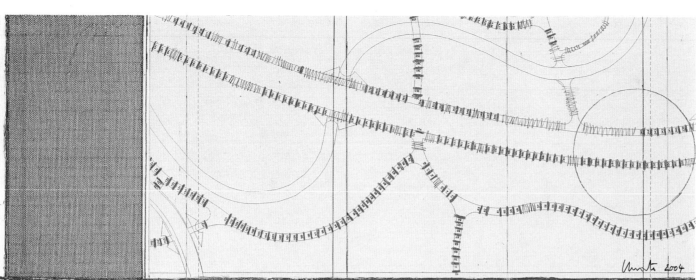

Christo 2004

The Gates (Project for Central Park, New York City) Central Park South, 5th. Avenue, Central Park West, West 110th street

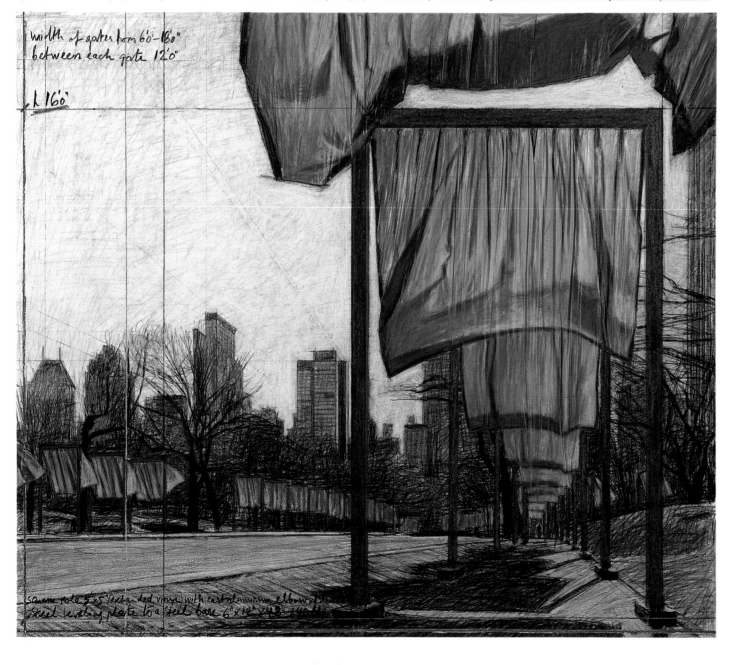

width of gates from 6'0–18'0"
between each gate 12'0"

h 16'0"

222

square pole 5"×5" (extended vinyl) with cast aluminum elbow, steel leveling plate to a steel base 6'×12"×4/8"

103.
The Gates, Project for Central Park,
New York City
Collage in two parts, 2004

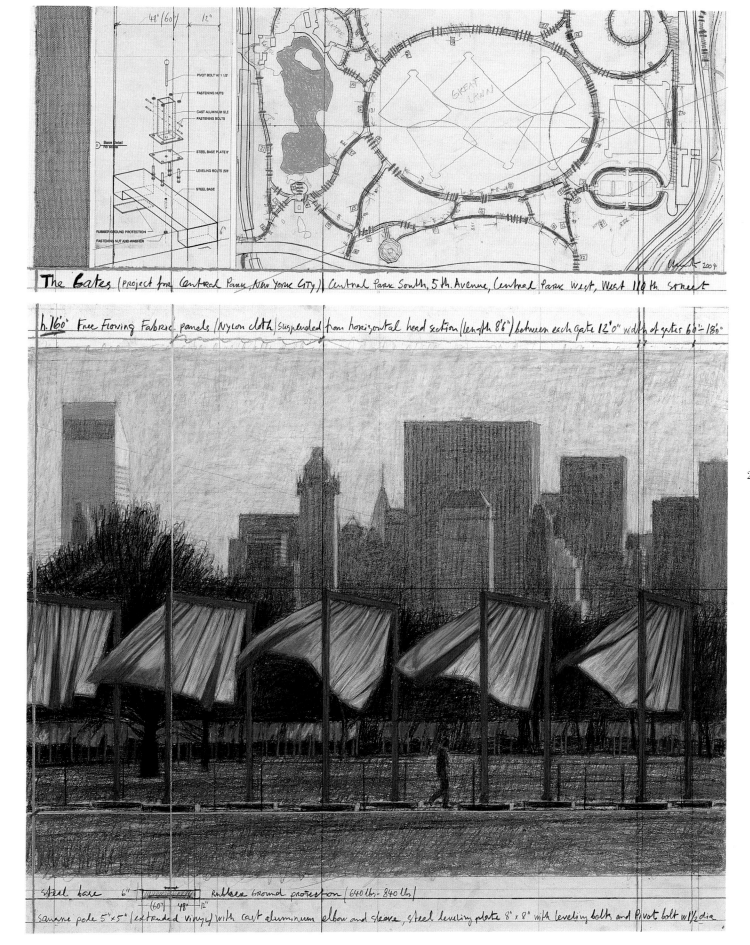

224

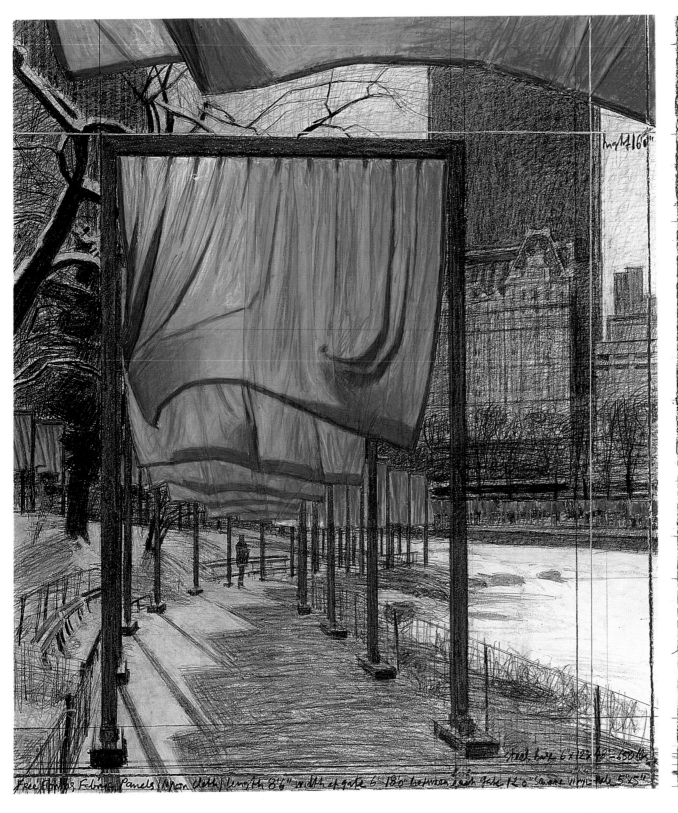

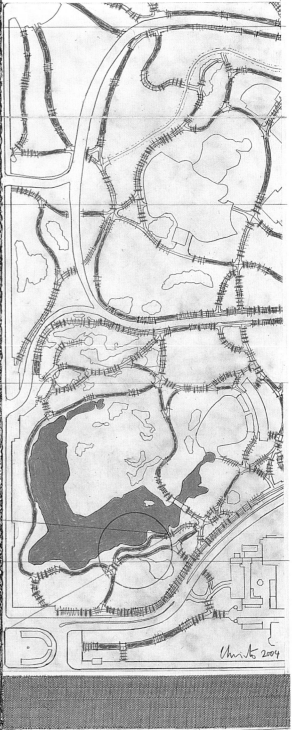

Free flowing Fabric Panels (Nylon cloth) length 8'6" width of gate 6'-18'0" between each gate 12'0" square vinyl pole 5"x5"

The Gates (project for Central Park, New York City) 7500 gates along 23 mi. of selected walkways

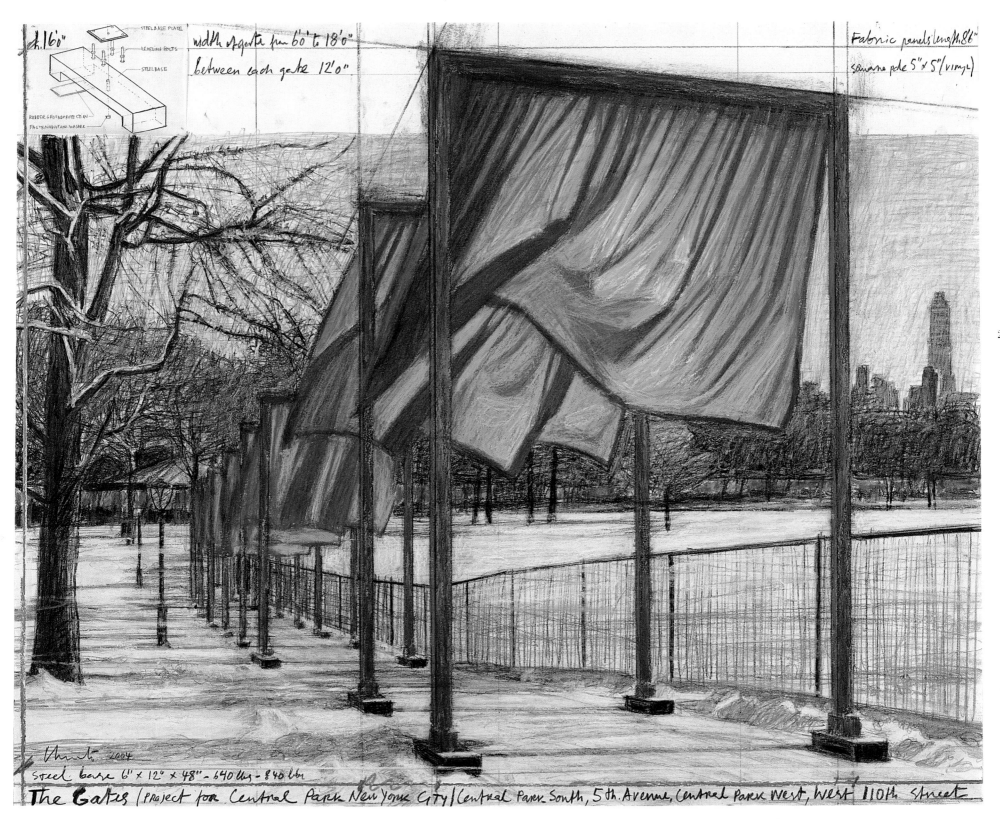

226

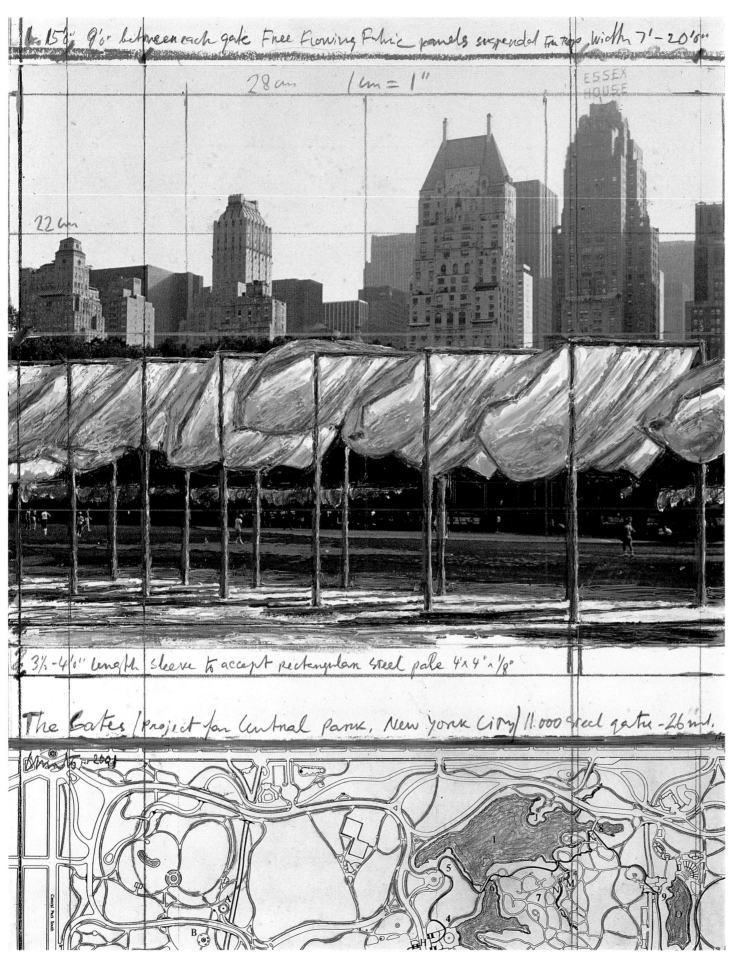

107.
**The Gates, Project for Central Park,
New York City**
Collage in two parts, 2005

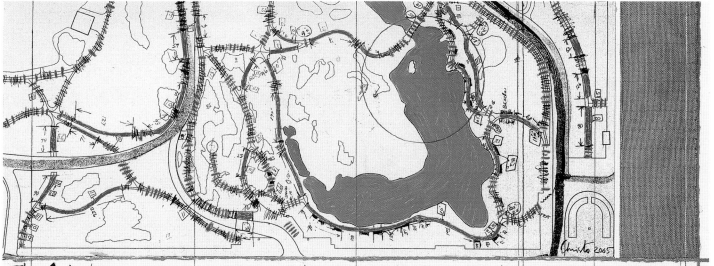

The Gates (Project for Central Park, New York City) Central Park South, 5th. Avenue, Central Park West, Central Park PKW), West 110 st.

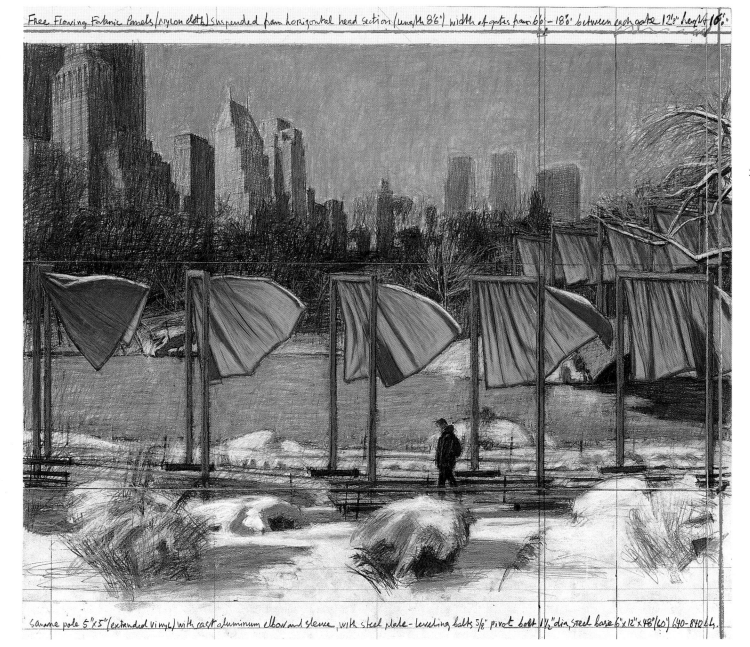

Free Flowing Fabric Panels (nylon cloth) suspended from horizontal head section (length 8'6") width of gates from 6'6" - 18'6" between each gate 12'6" height 16'.

same pole 5"x5" (extruded vinyl) with cast aluminum elbow and sleeve, with steel plate- leveling bolts 5/8" pivot bolt 1½" dia, steel base 6"x12"x48" (60') (40-84044).

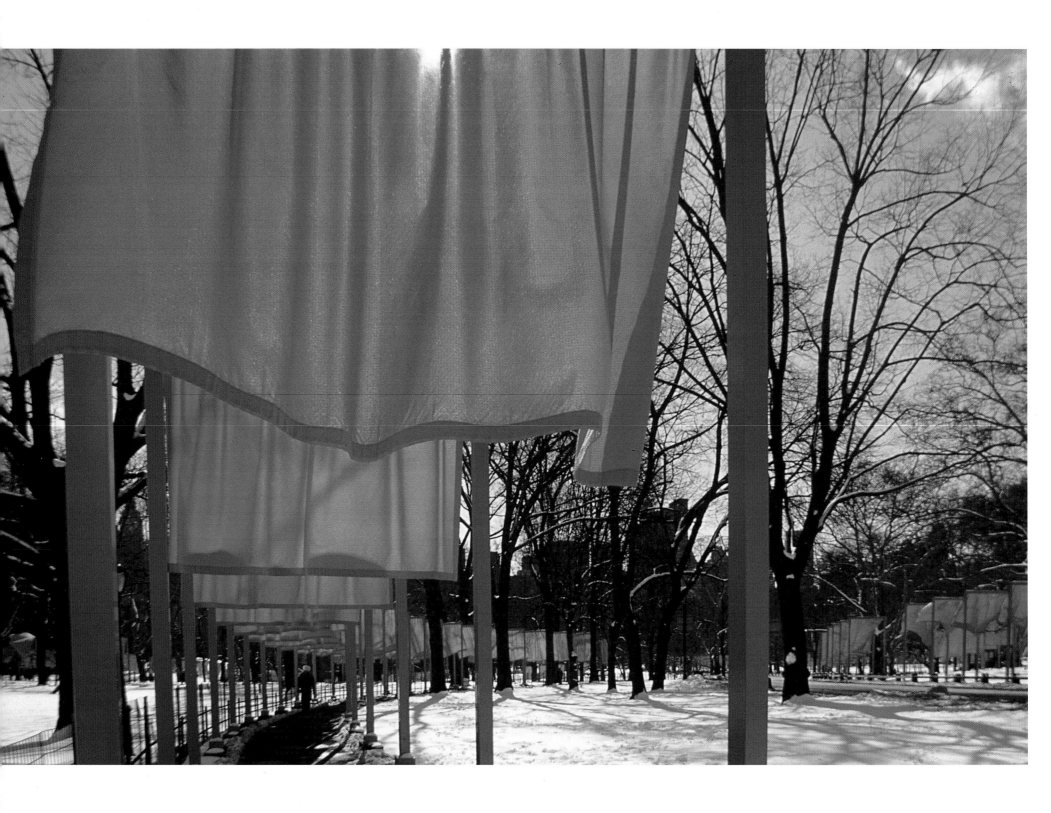

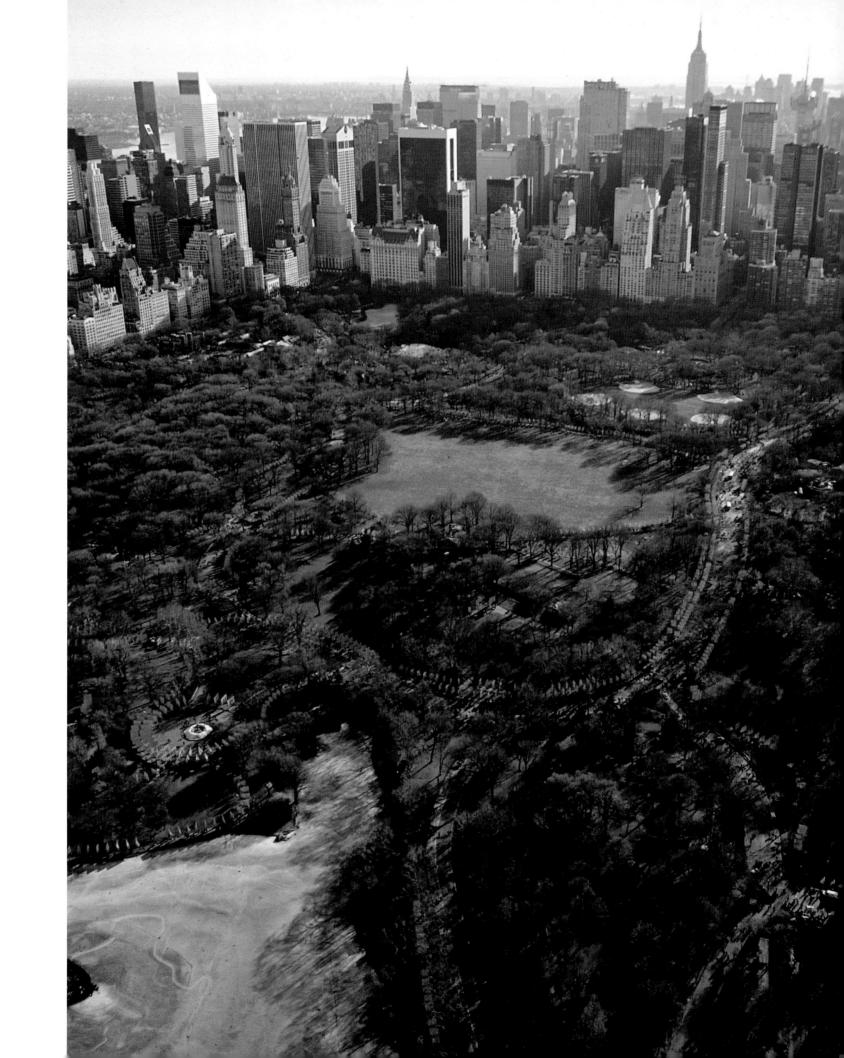

Over the River, Project for the Arkansas River, Colorado, in progress

Fabric panels suspended horizontally clear of and high above the water level will follow the configuration and width of the changing course of the river, during a period of two consecutive weeks to be selected between mid-July and mid-August of any given year in the future.

Steel wire cables, anchored on the upper part of the riverbanks, will cross the river and serve as attachment for the fabric panels. The woven fabric panels, sewn in advance, with rows of grommets at the edges perpendicular to the river, will create shimmering waves of fabric, 3 to 7 meters (10 to 23 feet) above the river bed. The 10,7 kilometer (6,7 mile) long stream of successive panels will be interrupted by bridges, rocks, trees, and bushes and for esthetic reasons, creating abundant flows of light.

Wide clearance between the banks and the edges of the fabric panels will create a play of contrast allowing sunlight to illuminate the river on both sides. When seen from underneath, standing on the rocks, at the edge of the river, at water level or by rafting, the luminous and translucent fabric will highlight the contours of the clouds, the mountains and the vegetation.

As with our previous art projects, *Over the River* will be entirely financed by Christo and Jeanne-Claude, through the sale by C.V.J. Corporation (Jeanne-Claude Christo-Javacheff, President) of Christo's preparatory drawings, lithographs, collages and early works.

The artists do not accept sponsorship of any kind.

As it was done for past projects, most of the materials will be recycled.

In the USA, most of the rivers are born in the Rocky Mountains, some

flowing east to the Mississippi River or the Gulf of Mexico, some flowing west to the Pacific Ocean. For the project, a river had to be chosen. That river should have high banks so that steel cables could be suspended, a road running continuously along the river, as well as both white and tranquil waters used for rafting.

During August 1992, 1993 and 1994, Christo and Jeanne-Claude traveled 22,530 kilometers (14,000 miles) in the United States part of the Rocky Mountains in search of a site for the project with their collaborator-friends: Project Director Tom Golden, Project Manager Richard Miller, Construction Manager O.W. Vince Davenport, Jonita Davenport, Simon Chaput, Anna-Maryke Havekes, Wolfgang and Sylvia Volz, Masa Yanagi, Harrison Rivera-Terreaux, Vladimir Yavachev and John Kaldor.

During those trips the team prospected eighty-nine rivers in the Rocky Mountains, in seven states, and six possible locations were found. After visiting the six sites again during the summer of 1996 the *Arkansas River* in Colorado was selected. Vince Davenport and Wolfgang Volz organized life-size prototype tests for Christo and Jeanne-Claude and their technical team during June and September 1997, June 1998 and June 1999.

Tests have been conducted by Scott L. Gamble and Mark A. Hunter of R.W.D.I. Inc. Consulting Engineers, in a wind tunnel in Guelph, Ontario, Canada and at the site of the life-size test in Colorado, for the project's engineers Vince Davenport and John Thomson.

C.V.J. Corporation has retained the services of: Loren R. Hettinger and Teresa O'Neil of J.F. Sato and Associates, Consulting Engineers, Littleton,

Colorado, to prepare the Environmental Assessment; Francis E. Harrison and Mark Juneau of Golder Associates Inc., Lakewood, Colorado to prepare the design engineering; Bryan Law and Richard Mariotti, of Law and Mariotti Consultants Inc., Colorado Springs, to prepare the topographic maps; David Ness and Donald Cleveland, M.J. Harden Inc., Kansas City, to prepare the aerial photography maps.

The road running along the river, and the existing footpaths leading to the water will allow the project to be seen, approached and enjoyed from above by car or bus, and from underneath on foot or by raft or kayak. For a period of two weeks, the temporary work of art *Over the River* will join the other recreational activities and the natural life of the river.

Here is more precise information about our work in progress
Within a span of 40 miles (64.3 kilometers) of the Arkansas River, between Parkdale and Salida, Colorado, we intend to install, for a duration of fourteen days in summer, a total of 7 miles (11.2 kilometers) of suspended fabric panels over the water of the river.

There will be many interruptions of 100 feet long and sometimes several miles long.

The 1,200 fabric panels will be hung from steel cables, high above the level of the water, allowing rafting and the usual recreational activities.

The width of the fabric panels will vary between 50 feet and 120 feet according to the width of the water, not the width of the river banks.

Over the River, Project for the Arkansas River, Colorado, in progress

Between 1992 and 1994, [...] the artists inspected eighty-nine possible river sites in the Rocky Mountains. By the end of 1994, they had narrowed their list to six possible rivers, all of which seemed to satisfy both aesthetic and practical considerations. [...]

In the summer of 1996, Christo, Jeanne-Claude, and some members of their team [...] decided to revisit all six final candidates: the Arkansas and Cache La Poudre rivers in Colorado, the Payette and Salmon rivers in Idaho, the Wind River in Wyoming, and the Rio Grande in New Mexico. At locations on each of these rivers, we performed the same ritual: taking photographs and stretching three yellow ropes across the river. The ropes simulated the steel cables that would eventually hold the large fabric panels. We carefully measured and documented the distance between the ropes and the surface of the water. [...]

Jeanne-Claude, wearing her Japanese farmer's hat and gloves, and carrying an umbrella for protection from the sun, observed the activities from a distance and, with her binoculars, scanned the area for wild animals. [...]

Christo scrutinized the landscape with his eyes, already creating collages and drawings in his mind.

By the fall of 1996, it had become more and more apparent that they had made up their minds: the stretch of the Arkansas River between the towns of Salida and Cañon City, Colorado. Again and again, the river

had come up in discussions; after a point, all the other rivers were being compared to it. The choice seemed to have made itself.

In November 1996, Christo and Jeanne-Claude took the first steps toward obtaining permission for *Over the River*. Their first visit to the Bureau of Land Management (BLM) left them with the impression that things might not be too complicated. The Department of the Interior owns the entire stretch of river between Parkdale Siding and Salida.

Over the River will consist of a succession of fabric panels 7 miles long over a 40-mile stretch of the river. The fabric will therefore not be continuous, but interrupted in places where there are natural obstacles, such as trees, rocks, or bridges; where the riverbank isn't high enough to support the cables; where the road does not run along the river; and for aesthetic reasons. The panels will be high enough to allow rafting underneath them. [...]

Throughout 1996 and early 1997 Christo and Jeanne-Claude contacted fishermen and rafters, as well as officials from Fremont and Chaffee counties, conservation organizations, the Department of Transportation, the Colorado State Patrol, the Arkansas Headwaters Recreation Area and the Parks Department. Everyone listened patiently, and initially there was every sign that an agreement would be possible. But it gradually became clear that the permission process would not be as simple as they had first hoped.

In April 1997, meetings were held in Salida and Cañon City, where Christo and

Jeanne-Claude presented their ideas to the public. What became immediately evident was that the two communities are markedly different. [...] In Salida almost everyone was enthusiastic about the project. In Cañon City, on the other hand, the reception was distinctly cooler.

At the end of April, the artists gathered friends at Howard Street to start planning *Over the River*. John Thomson explained that no scientific studies on fabric stretched horizontally existed, and that, from a physical and engineering point of view, the situation was very different from what would be the case for, say, sails and flags. It would therefore probably be necessary to commission some tests. While some basic questions could be addressed using experiments with bed sheets, other problems could only be resolved by on-site testing. [...]

In September 1997, the team returned to Grand Junction to experiment with new kinds of fabrics. By this point, Christo and Jeanne-Claude had chosen the hooks that would connect the fabric to the steel cables. It had also become increasingly clear what the final choice of color would be: silver. The clouds, sky, and mountains will be visible when seen from underneath. Because the fabric would be given an aluminum coating, the water and the surrounding sky and mountains would reflect off of it. [...]

In December 1997, the artists again met with the public in Colorado, this time in Cañon City and in Cotopaxi, a small town located in the center of the forty-mile stretch of the Arkansas River. Mostly hunters and

fishermen attended the meeting, and it was soon clear that many felt little sympathy for *Over the River*. Their greatest concern, they said, was protecting their valley; they worried that it would be endangered by masses of visitors – though it remains unclear how many could reasonably be expected, as the area in question is fairly remote.

This was Christo and Jeanne-Claude's first meeting with the project's opponents. Some of the more vocal critics seemed slightly taken aback by the artists' presentation; everyone read the information sheets that were made available. Experience has taught Christo and Jeanne-Claude that it would be a miracle if everything were to proceed smoothly. Success in one part of the world is not necessarily indicative of what will happen in another area; it can work against you, as well. The number of people who visited *Wrapped Reichstag* would probably not descend upon Colorado, though the opponents to *Over the River* used the five million visitors to the Reichstag as an argument against the project.

Excerpts from Burt Chernow, *XTO + J-C. Christo and Jeanne-Claude: A Biography*, with an epilogue by Wolfgang Volz, New York, 2002.

108.
The River, Project for 5-6 Miles River
Drawing-collage, 1992

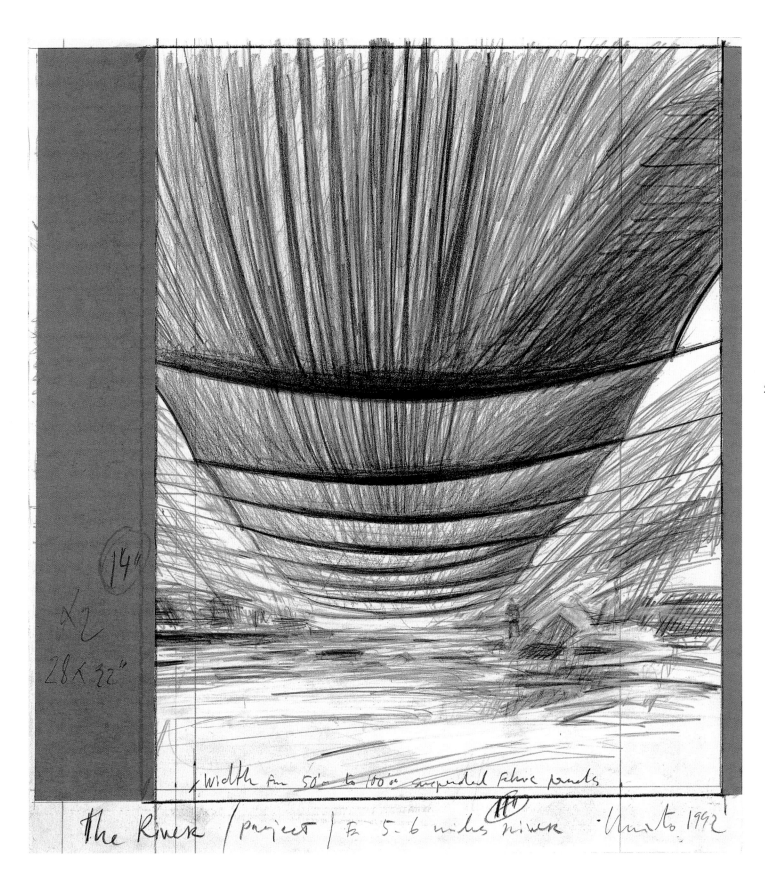

233

234

110.
**Over the River, Project for the Arkansas
River, State of Colorado**
Collage, 1997

111.
**Over the River, Project for the Arkansas
River, State of Colorado**
Collage, 1997

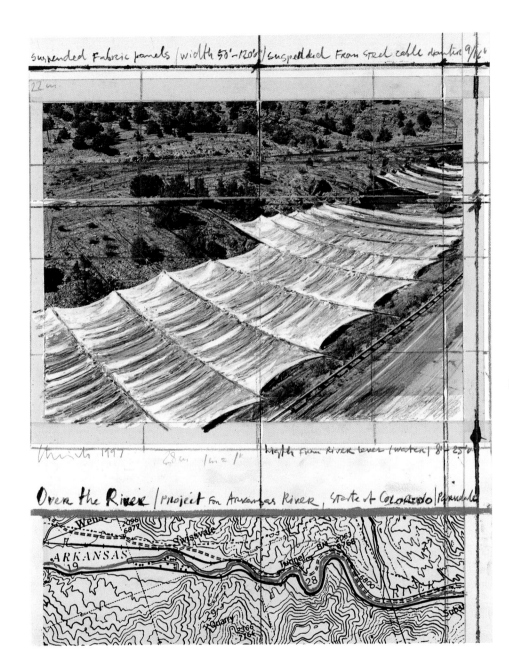

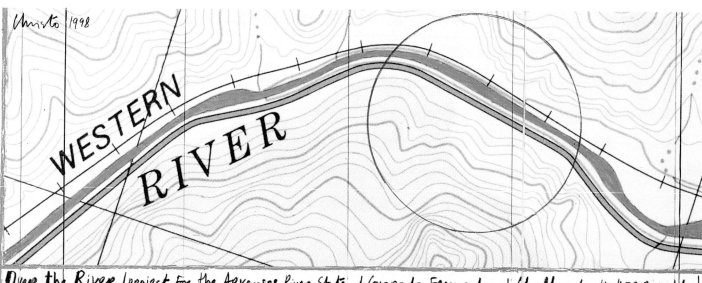

Christo 1998

WESTERN RIVER

Over the River / project for the Arkansas River, State of Colorado, Fremont and Chaffee Co. US #50, Parkdale /

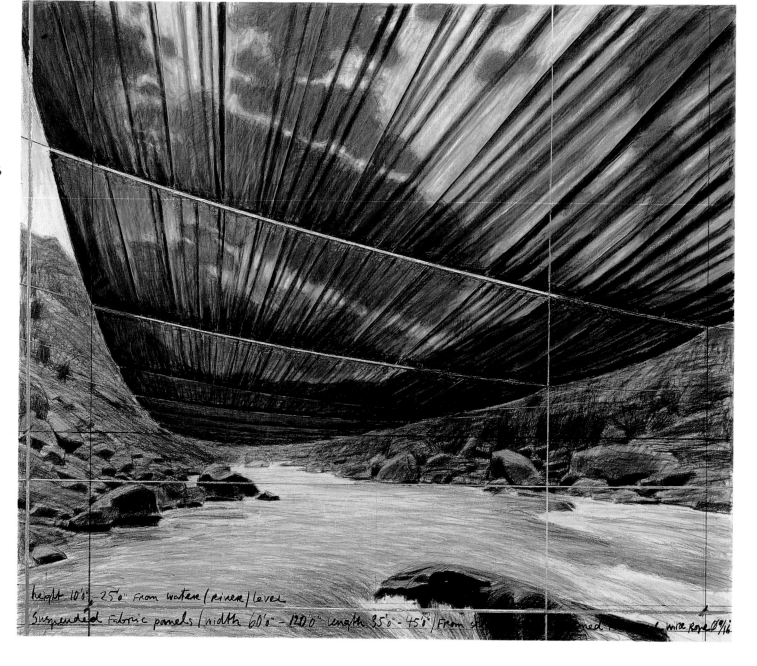

236

height 10'0", 25'0" from water (river) level

Suspended fabric panels / width 60'0" - 120'0" length 35'0" - 45'0" / from st...

112.
Over the River, Project for the Arkansas River, State of Colorado
Collage in two parts, 1998

113.
Over the River, Project for the Arkansas River, State of Colorado
Collage in two parts, 1998

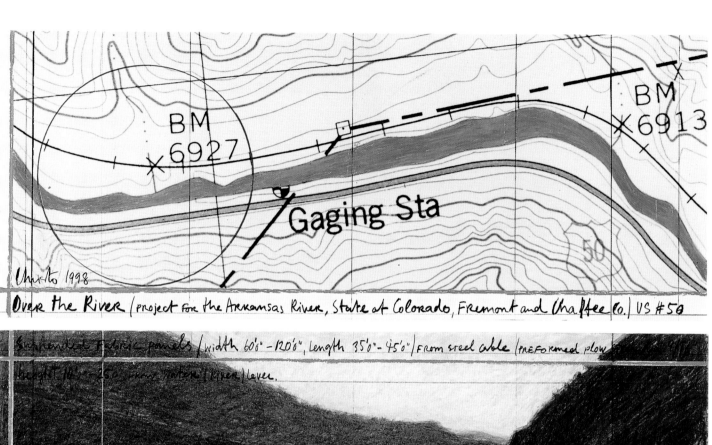

Over the River / Project for the Arkansas River, State of Colorado, Fremont and Chaffee Co. / US #50

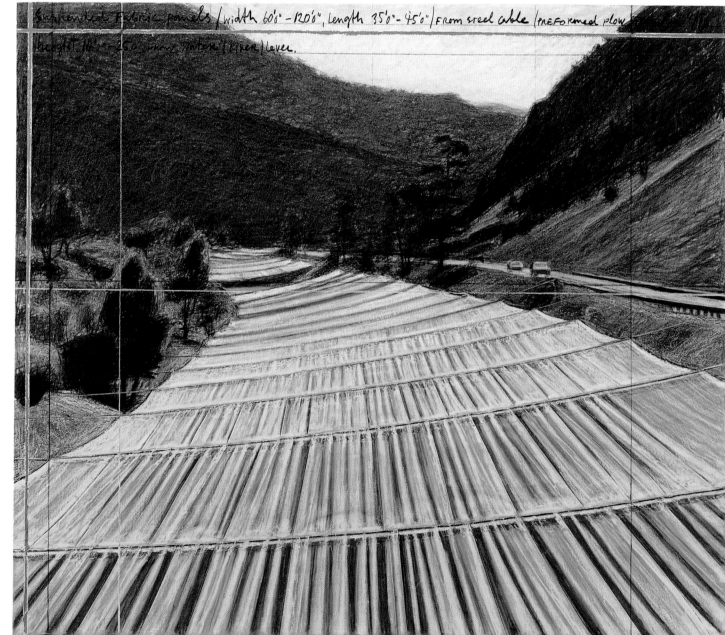

Suspended Fabric panels / width 60'0" - 120'0", Length 35'0" - 45'0" / From steel cable / Preformed plow / height 14' - 25' from water / River / Level.

237

**Over the River, Project for the Arkansas
River, State of Colorado**
Drawing in two parts, 1999

238

115.
**Over the River, Project for the Arkansas
River, State of Colorado**
Drawing in two parts, 1999

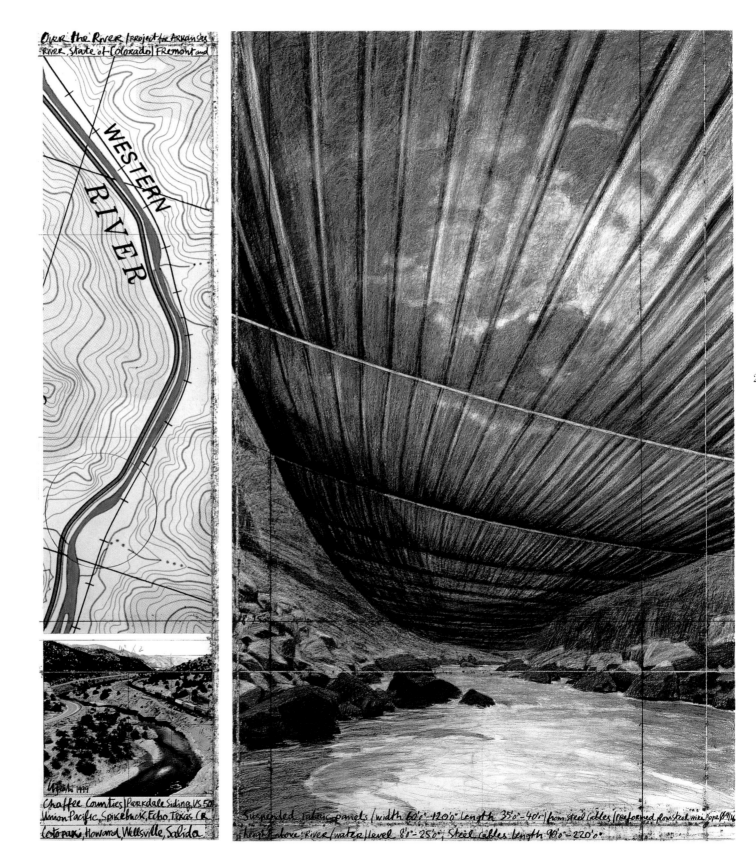

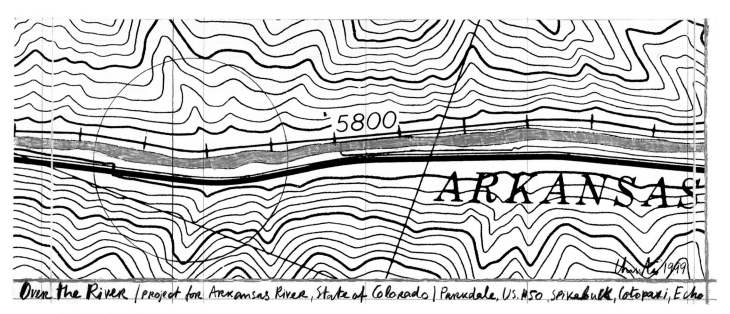

116.
Over the River, Project for the Arkansas River, State of Colorado
Collage in two parts, 1999

Over the River / Project for Arkansas River, State of Colorado / Parkdale, U.S. #50, Spikebuck, Cotopaxi, Echo

240

Suspended . . . Fabric panels (width 50'0" – 120'0"; length 35'0" – 45'0") / From steel cables / Preformed plow steel dia 9/16")

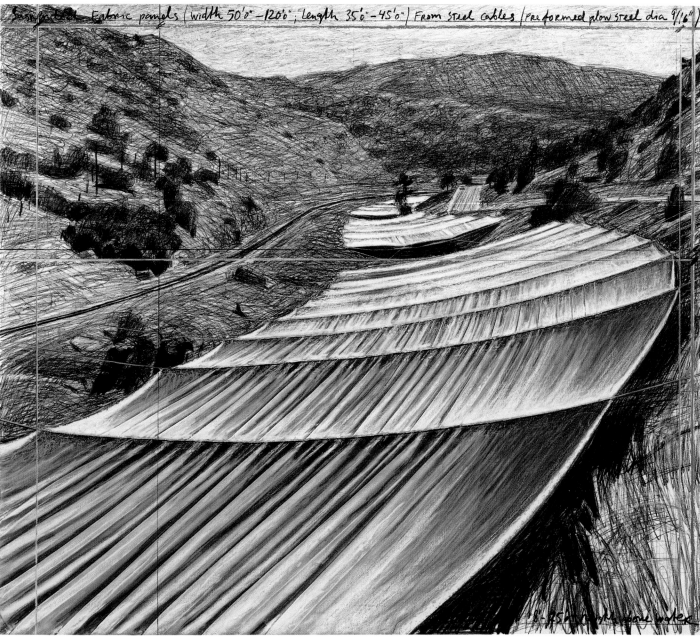

117.
Over the River, Project for the Arkansas River, State of Colorado
Collage in two parts, 2005

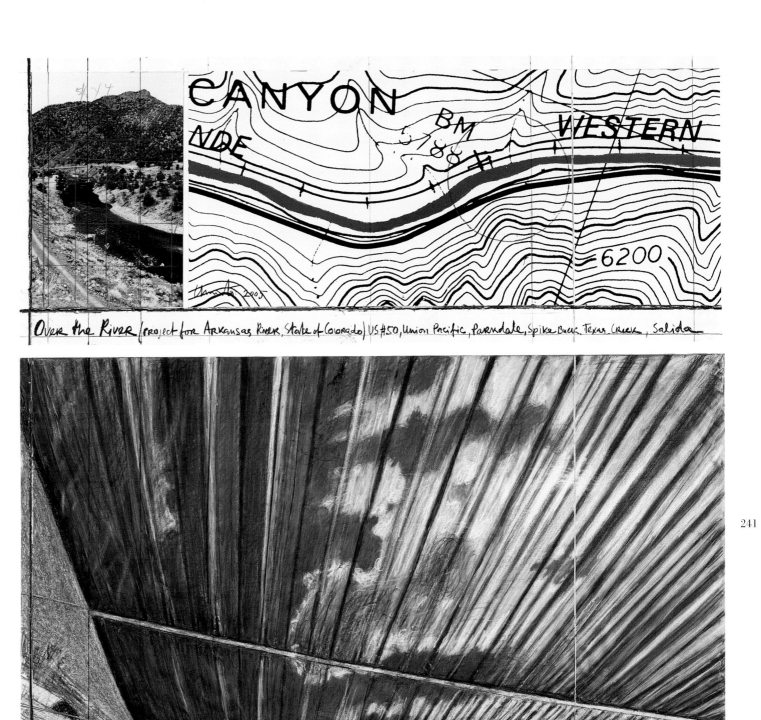

241

Over the River, Project for the Arkansas
River, State of Colorado
Drawing in two parts, 2005

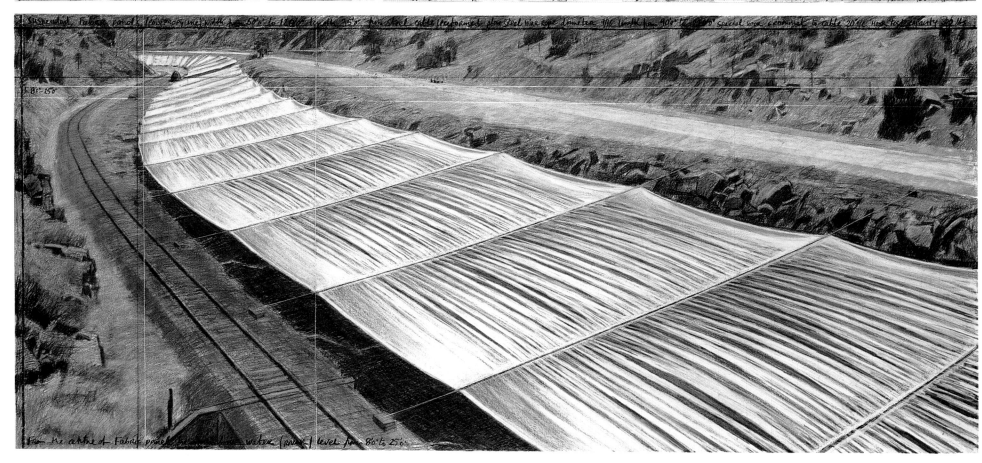

242

119.
Over the River, Project for the Arkansas
River, State of Colorado
Drawing in two parts, 2005

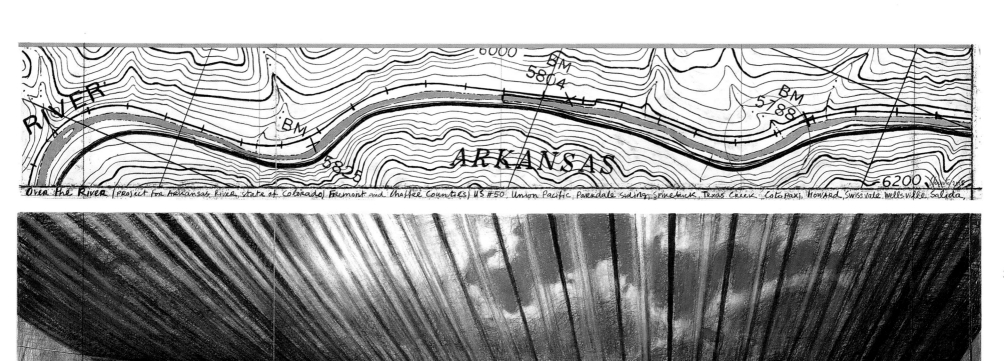

Over the River (Project for Arkansas River, state of Colorado) Fremont and Chaffee Counties) US #50, Union Pacific, Parkdale siding, spikebuck, Texas Creek, Cotopaxi, Howard, Swissvale, Wellsville, Salida,

Appendixes

Biography

1935
Christo: American, Bulgarian born Christo Javacheff, June 13, Gabrovo, of an industrialist family.
Jeanne-Claude: American, French born Jeanne-Claude Denat de Guillebon, June 13, Casablanca, of a French military family, educated in France and Switzerland.

1952
Jeanne-Claude: Baccalaureat in Latin and Philosophy, University of Tunis.

1953–56
Christo: Studies at Fine Arts Academy, Sophia.

1956
Christo arrives in Prague.

1957
Christo studies one semester at the Vienna Fine Arts Academy.

1958
Christo arrives in Paris where he meets Jeanne-Claude.
Packages and *Wrapped Objects*.

1960
Birth of their son, Cyril, May 11. Poet and writer.

1961
Projet d'un édifice public empaqueté.
Stacked Oil Barrels and *Dockside Packages* at Cologne Harbor, their first collaboration.

1962
Wall of Oil Barrels, The Iron Curtain, Rue Visconti, Paris, 1961–62.
Stacked Oil Barrels, Gentilly, near Paris.
Wrapping a Woman, London.

1963
Show Cases.

1964
Establishment of permanent residence in New York City.
Store Fronts and *Show Windows*.

1966
Air Package and *Wrapped Tree*, Stedelijk Van Abbemuseum, Eindhoven.
42,390 Cubicfeet Package, Walker Art Center and School of Art, Minneapolis.

1968
5,600 Cubicmeter Package, Documenta 4, Kassel, an air package 280 feet high, foundations arranged in a 900 feet diameter circle.
Wrapped Fountain and *Wrapped Medieval Tower*, Spoleto.
Wrapped Kunsthalle Bern, wrapping of a public building.
Corridor Store Front, total area: 1,500 square feet.
1,240 Oil Barrels Mastaba and *Two Tons of Stacked Hay*, Institute of Contemporary Art, Philadelphia.

1969
Wrapped Museum of Contemporary Art, Chicago, 10,000 square feet of tarpaulin.
Wrapped Floor and Stairway, Museum of Contemporary Art, Chicago, 2,800 square feet drop cloths.
Wrapped Coast, One Million Square Feet, Little Bay, Sydney, Australia, 1968–69, one million square feet erosion control fabric and 36 miles of ropes.
Houston Mastaba, Texas, project for 1,249,000 stacked oil barrels.
Project for *Closed Highway*.

1970
Wrapped Monuments, Milan: *Monument to Vittorio Emanuele, Piazza del Duomo; Monument to Leonardo da Vinci, Piazza della Scala.*

1971
Wrapped Floors, Covered Windows and Wrapped Walk Ways, Museum Haus Lange, Krefeld.

1972
Valley Curtain, Grand Hogback, Rifle, Colorado, 1970–72, width: 1,250–1,368 feet, height: 182–365 feet, 142,000 square feet of nylon polyamide, 110,000 pounds of steel cables, 784 tons of concrete.

1974
The Wall, Wrapped Roman Wall, Via V. Veneto and Villa Borghese, Rome.

Ocean Front, Newport, Rhode Island, 150,000 square feet of floating polypropylene fabric over the ocean.

1976
Running Fence, Sonoma and Marin Counties, California, 1972–76, 18 feet high, 24.5 miles long, 240,000 square yards of woven nylon fabric, 90 miles of steel cables, 2,050 steel poles (each 3.5 inch diameter, 21 feet long).

1977
The Mastaba of Abu Dhabi, Project for the United Arab Emirates. In progress.

1978
Wrapped Walk Ways, Loose Park, Kansas City, Missouri, 1977–78, 15,000 square yards of woven nylon fabric over 2.8 miles of walkways.

1983
Surrounded Islands, Biscayne Bay, Greater Miami, Florida, 1980–83, 6.5 million square feet pink woven polypropylene floating fabric.

1984
Wrapped Floors and Stairways and Covered Windows, Architekturmuseum, Basel.

1985
The Pont Neuf Wrapped, Paris, 1975–85, 454,178 square feet of woven polyamide fabric, 42,900 feet of rope.

1991
The Umbrellas, Japan-USA, 1984–91, 1,340 blue umbrellas in Ibaraki, Japan; 1,760 yellow umbrellas in California. Each: height:19 feet 8 inch, diameter 28 feet 5 inch.

1992
Over The River, Project for the Arkansas River, Colorado. In progress.

1995
Wrapped Floors and Stairways and Covered Windows, Museum Würth, Künzelsau.
Wrapped Reichstag, Berlin, 1971–95, 1,076,000 square feet of polypropylene fabric, 51,181 feet of rope and 200 metric tons of steel.

1998

Wrapped Floors and Stairways and Covered Windows, Palazzo Bricherasio, Turin, Italy.
Wrapped Trees, Fondation Beyeler and Berower Park, Riehen, Switzerland 1997–98, 178 trees, 592,034 square feet of woven polyester fabric, 14.3 miles of rope.

1999

The Wall, 13,000 Oil Barrels, Gasometer, Oberhausen, Germany, an indoor installation.

2005

The Gates, Central Park, New York City, 1979–2005, 7,503 vinyl gates, with free-flowing nylon fabric panels, anchored to 15,000 steel bases on 23 miles of walkways.

Selected Solo Exhibitions

1961
Cologne, Galerie Haro Lauhus, "Christo"

1962
Paris, Galerie J, "Christo: monument temporaire – mur d'assemblage"

1963
Düsseldorf, Galerie Schmela, "Christo"
Milan, Galleria Apollinaire, "Christo"
Milan, Galleria Apollinaire, "Christo: empaquetage monumental"
Rome, Galleria La Salita, "Christo"
Venice, Galleria del Leone, "Christo"

1964
Antwerp, Galerie Ad Libitum, "Christo"
Turin, Galleria Gian Enzo Sperone, "Christo"
Venice, Galleria del Leone, "Christo"

1964–65
Düsseldorf, Galerie Schmela, "Store Fronts von Christo"

1966
Eindhoven, Stedelijk Van Abbemuseum, "Christo (Empaquetage, Volumen Temporale, Store Fronts)"
Milan, Galleria Apollinaire, "Christo"
New York, Leo Castelli Gallery, "Christo"

1967
Antwerp, Wide White Space Gallery, "Christo"
Cologne, Galerie Der Spiegel, "Christo: Store Fronts, Empaquetages, Projects"

1968
New York, John Gibson Gallery, "Christo: Projects of Packages, Storefronts, and Barrels for the National Gallery, Rome"
New York, John Gibson Gallery, "Christo II: Scale Models, Photomontages & Drawings"
New York, The Museum of Modern Art, "Christo Wraps the Museum: Scale Models, Photomontages, and Drawings for a Non-Event"
Philadelphia, University of Pennsylvania, Institute of Contemporary Art, "Christo: Monuments and Projects"
Venice, Galleria del Leone, "Christo: Collages and Drawings for Projects for the Galleria Nazionale, Rome"

1969
Antwerp, Wide White Space Gallery, "Christo: Wrapped Floor and Stairway"
Chicago, Lo Giudice Gallery, "Christo"
Chicago, Museum of Contemporary Art, "Christo: Wrap in, wrap out"
Melbourne, National Gallery of Victoria, "Christo – Wool Works"
New York, John Gibson Commissions, Inc., "Christo: The Australia Projects"
Sydney, Central Street Gallery, "Christo"

1969–70
Cologne, Galerie Der Spiegel, "Christo: Wrapped Coast, Little Bay, Australia, One Million Square Feet, Documentation Exhibition"

1970
Amsterdam, Edition Seriaal, "Christo"
Aspen, Center of Contemporary Art, "Christo: Wrapped Coast, One Million Sq. Ft., Little Bay – 1969, New South Wales, Australia"
Krefeld, Kaiser Wilhelm Museum, "Christo: Wrapped Coast. Fotografische Dokumentation der Verpackten Küste von Little Bay, nahe Sydney in Australien"
Milan, Galerie Françoise Lambert, "Christo: Preparation Works. Photographic Documentation for Wrapped Monument to Vittorio Emanuele and other Milan Projects"
New York, John Gibson Gallery, "Christo"
Washington, Protetch-Rivkin Gallery, "Christo: Wrapped Coast, Little Bay, Australia, One Million Square Feet, Documentation Exhibition"
Zurich, Galerie Renée Ziegler, "Christo"

1971
Berlin, Galerie Mikro, "Christo: Wrapped Coast, Little Bay, Australia, One Million Square Feet, Photographic Documentation"
Bern, Galerie Victor Loeb, "Christo: Wrapped Coast, Little Bay, Australia, One Million Square Feet, Photographic Documentation"
Buenos Aires, Centro de Arte y Communicación, "Christo: Wrapped Coast, Little Bay, Australia, One Million Square Feet, Photographic Documentation"

Copenhagen, Ars Studeo, "Christo: Wrapped Coast, Little Bay, Australia, One Million Square Feet, 1968–69, Photographic Documentation"
Hamburg, Kunsthaus, "Christo: Wrapped Coast, Little Bay, Australia, One Million Square Feet, Photographic Documentation"
Houston, The Museum of Fine Arts, "Christo: Valley Curtain, Project for Rifle, Colorado, Documentation"
Krefeld, Museum Haus Lange, "Christo: Wrapped Floors, Wrapped Stairway and Wrapped Walk Ways"
London, Annely Juda Fine Art, "Christo: Projects Not Realized"
Milan, Colophon Galleria, "Christo: Wrapped Coast, Little Bay, Australia, One Million Square Feet, Photographic Documentation"
Monschau, open-air exhibition, "Christo: Projekt Monschau. Eine Dokumentation"
Nuremberg, Kunstsammlung Stadt Nürnberg, "Christo: Wrapped Coast, Little Bay, Australia, One Million Square Feet, Photographic Documentation"
Paris, Galerie Yvon Lambert, "Christo: Valley Curtain, Project for Rifle, Colorado"
Trieste, Centro La Capella, "Christo: Wrapped Coast, Little Bay, Australia, One Million Square Feet, Photographic Documentation"

1972
Antwerp, Wide White Space Gallery, "Christo: Works 1958–1972"
Berlin, Galerie Mikro, "Christo"
Cleveland, New Gallery (old location), "Christo: Store Front and Wrapped Floor" and New Gallery (new location), "Christo: Some non-Realized Projects"
Kansas City, Shawnee Mission, Morgan Gallery, "Christo – Some Documents, Drawings, and Photographs on Valley Curtain, Rifle, Colorado 1971–72"
La Jolla, La Jolla Museum of Contemporary Art; Santa Barbara, Museum of Art; Denver, The Friends of Contemporary Art; Omaha, Joslyn Art Museum; Cincinnati, Contemporary Arts Center, "Christo: Valley Curtain, Project for Rifle, Colorado"
New York, Allan Frumkin Gallery, "Christo: The Valley Curtain Project – Rifle Colorado 1971–72, Some Documents, Drawings and Photographs"
Zurich, Galerie Art in Progress, "Christo Retrospektive: Realisierte und Unrealisierte Projekte"
Zurich, Galerie Semiha Huber, "Christo"

1972–73
Stockholm, Galerie William Aronowitsch, "Christo: Some Non-Realized Projects"

1973
Amsterdam, Galerie Seriaal, "Christo: Some Photographs and Drawings"
Amsterdam, Stedelijk Museum, "Christo: Valley Curtain, Rifle, Colorado 1970–1972. Documenten, Tekeningen, Fotos (a documentation exhibition)"
Bologna, Galleria de' Foscherari, "Christo"
Brussels, Galerie Charles Kriwin, "Christo"
Cali (Colombia), Museo de Arte Moderno La Tertulia, "Christo: Wrapped Coast, Little Bay, Australia, 1968–69, Photographic Documentation"
Kalamazoo, Institute of Arts, "Christo: Wrapped Coast, Little Bay, Australia, 1968–69, Documentation Exhibition"
Manhattan, Kansas State University, "Christo: Wrapped Coast, Little Bay, Australia, 1968–69, Documentation Exhibition"
Miami, Miami-Dade Junior College, "Christo: Wrapped Coast, Little Bay, Australia 1968–69, Documentation Exhibition"
Milan, Galleria d'Arte Vinciana, "Christo: Progetti"
Milan, Galleria Françoise Lambert, "Christo"
Milan, La Rotonda di via Besana, "Christo: Valley Curtain, Rifle, Colorado, 1970–72, Documentation Exhibition"
Milan, Multicenter, "Christo: Spoleto 1968"
Milan, Studio Marconi, "Christo: Opere dal 1959 al 1972"
Muncie, Ball State University Art Gallery, "Christo's Valley Curtain, Drawings and Documentation"
Munich, Galerie Art in Progress, "Christo: Realisierte Projekte"
Munich, Neue Pinakothek, "Christo: Valley Curtain, Rifle, Colorado, 1970–72, Documentation Exhibition"
Seattle, University of Washington, Henry Art Gallery, "Christo's Packed Coast: A Terrestrial Wrap-up"
Washington, Max Protetch Gallery, "Christo: Three Non-Realized Projects 1968–69 (drawings, scale models, photographs, and technical data)"
Zurich, Kunsthaus, "Christo: Valley Curtain, Rifle, Colorado, 1970–72, Documentation Exhibition"

1973–74
Düsseldorf, Kunsthalle, "Christo: Valley Curtain, Rifle, Colorado, 1970–72, Documentation Exhibition"
New York, Rosa Esman Gallery, "Christo: Six Store Front Projects 1964–5"
Otterlo, Kröller-Müller Museum, "Christo: Drawings – Otterlo Mastaba, Project for Kröller-Müller"

1974
Florence, Galleria Spagnoli, "Christo"
Hovikodden, Henie Onstad Kunstsenter, "Christo: Valley Curtain, Rifle, Colorado, 1970–72"
Humlebaek, Louisiana Museum of Modern Art, "Christo: Valley Curtain, Rifle, Colorado, 1970–72, Documentation Exhibition"
Millersville, College, "Christo: Wrapped Coast, Little Bay, Australia, 1968–69, Documentation Exhibition"
Newcastle-upon-Tyne, University of Newcastle, Hat-

ton Gallery; London, Annely Juda Fine Art, "Christo: Otterlo Mastaba, Project for the Rijkmuseum Kröller-Müller, Otterlo, Holland" and "Christo: Collages and Drawings"
Stockholm, Galerie William Aronowitsch, "Christo: Projects and Studies for Store Fronts 1964–65 and Gallery Projects 1974"

1974–75
Grenoble, Musée de Peinture et de Sculpture; Geneva, Musée Rath, "Christo: Valley Curtain"

1975
Barcelona, Galeria Ciento, "Christo: Lithographs and Drawings"
Boston, Harcus Krako Rosen Sonnabend Gallery, "Christo: Wrapped Coast – Little Bay, Australia 1969. One Million Square Feet Erosion Control Mesh. Preparation Works, Documents, and Photographs"
Calgary, Alberta College of Art Gallery, "Christo: Valley Curtain, Rifle, Colorado, 1970–72, Documentation Exhibition"
Cape Town, Fabian Fine Arts, "Christo"
Caracas, Galería Adler Castillo, "Christo: Wrapped Coast, Little Bay, Australia 1968–69, Documentation Exhibition"
Caracas, Museo de Bellas Artes, "Christo: Exposición documental sobre el Valley Curtain"
Cologne, Galerie Der Spiegel, "Christo: Zeichnungen und Collagen"
Cologne, Galerie Der Spiegel, "Christo: Die Mauer 1974 / Wrapped Roman Wall 1974"
Davis, Memorial Union Art Gallery, University of California, "Christo"
Freestone, Wishing Well Nursery, "Christo: Running Fence, Exhibition of a Project in Progress"
Geneva, Galerie J. Benador, "Christo: Three Part Project for Geneva"
Grinnell, College, "Christo: Ocean Front, Newport, Rhode Island, 1974, Documentation Exhibition"
Lutry/Lausanne, White Gallery, "Christo: Wrapped Coast, Little Bay, Australia, 1969, One Million Square Feet, Documents and Drawings"
Milan, Galleria Bonaparte, "Christo"
Oakland, Museum of California, "Christo: Valley Curtain, Rifle, Colorado, 1970–72, Documentation Exhibition"
Princeton, Princeton University, The Art Museum; La Jolla, La Jolla Museum of Contemporary Art; Boston, Institute of Contemporary Art, "Christo: Oceanfront"
Rome, Galleria d'Alessandro-Ferranti, "Christo: The Wall, Wrapped Roman Wall, 1974, Documentation Exhibition"
San Francisco, M. H. de Young Memorial Museum, "Christo: Running Fence, Project for Sonoma and Marin Counties, California"
Vevey, Musée Jenisch, "Christo in the Ahrenberg Collection"
Zurich, Gimpel & Hannover, "Christo"

1976
Amherst, University of Massachusetts, Fine Arts Center, "Christo: Ocean Front, Newport, Rhode Island, 1974, Documentation Exhibition"

Kruishoutem, Stichting Veranneman, "Christo"
La Jolla, La Jolla Museum of Contemporary Art, "Christo: Running Fence, Project for Sonoma and Marin Counties, California"
Los Angeles, The Broxton Gallery, "Christo: Running Fence Project"
Pasadena, City College, "Christo"
San Francisco, Hansen Fuller Gallery, "Christo Graphics 1968–1975"
San Francisco, Museum of Modern Art, "Christo: Running Fence, Project for Sonoma and Marin Counties, California"
Vienna, Museum des 20. Jahrhunderts, "Christo: Die Mauer; Wrapped Roman Wall, 1974, Documentation Exhibition"

1976–77
Newport (Rhode Island), The Art Association, "Christo: Ocean Front, Newport, Rhode Island, 1974, Documentation Exhibition"

1977
Barcelona, Galeria Joan Prats, "Christo: Drawings, Collages and Realization of Wrapped Floor"
Barcelona, Galeria Trece, "Christo: Wrapped Monument to Cristóbal Colón, Project for Barcelona"
Colorado Springs, Fine Arts Center, "Christo's Valley Curtain"
Jerusalem, The Israel Museum, "Christo: Wrapped Coast, One Million Square Feet, Little Bay, Australia, Documentation Exhibition"
Kyoto, American Center, "Christo: Wrapped Coast, Documentation Exhibition"
London, Annely Juda Fine Art, "Christo: Project for Wrapped Reichstag, Berlin. Collages, Drawings, Scale Model, and Photographs"
Miami, Metropolitan Museum, "Christo: Ocean Front, Newport, Rhode Island, 1974, Document Exhibition"
Munich, Schellmann & Klüser, "Christo: Projects, Drawings, Collages and Lithographs"
New Orleans, Newcomb College Art Department, Tulane University, "Christo"
Tokyo, Minami Gallery, "Christo: Drawings and Collages"
Turin, Galleria d'Arte, "Christo – Il Quadrifoglio"

1977–79
Rotterdam, Museum Boijmans Van Beuningen; Bonn, Rheinisches Landes Museum; Hanover, Kestner Gesellschaft; Humlebaek, Louisiana Museum of Modern Art; Hovikodden, Henie Onstad Kunstsenter; Zurich, Kunstgewerbemuseum; Brussels, Palais des Beaux-Arts; Grenoble, Musée de Grenoble, "Christo: The Running Fence"

1978
Düsseldorf, Art Consulting Achenbach und Kimmerich, "Christo – Zeichnungen und Collagen zu Running Fence und zum Reichstag Projekt"
Hartford, Wadsworth Athenaeum, "Christo: Matrix 41"
Kaarst bei Düsseldorf, Gallery 44, "Christo – Zeichnungen, Collagen, Lithos und Litho-collagen"
Murray, State University, "Christo: Wrapped Coast,

One Million Square Feet, Little Bay, Australia, 1968–69, Documentation Exhibition"
Little Rock, University of Arkansas, University Art Galleries, "Christo: 'The Newport Beach' and Other Projects"
Miami, The American Foundation for the Arts, "Christo: Drawings and Collages and Photographs of Projects"
Munich, Galerie Art in Progress, "Christo: Galerien Maximilianstrasse: Verpacktegalerie"
Munich, Galerie Art in Progress, "Christo: Zeichnungen und Collagen von Realisierten und nicht Realisierten Projekten"
Otterlo, Kröller-Müller Museum, "Christo"
Tokyo, Minami Gallery, "Christo: Running Fence"

1978–79
Kansas City, The Nelson-Atkins Museum of Art; Greenville, County Museum of Art, "Christo: Wrapped Walk Ways, Work in Progress"

1979
Boone, Appalachian State University, "Christo: Wrapped Coast, Documentation Exhibition"
Bridgeport, Housatonic Museum of Art, "Christo: Drawings and Collages for Running Fence and Wrapped Reichstag"
Chattanooga, Hunter Museum of American Art, "Christo: Wrapped Walk Ways, Documentation Exhibition"
Dayton, Wright State University, "Christo: Wrapped Walk Ways, Documentation Exhibition"
Empoli, Spazio FO.DO. Art, "Christo – Documentazione"
Freiburg im Breisgau, Kunstverein, "Christo: Running Fence, Sonoma and Marin Counties, California, 1972–76, Documentation Exhibition"
London, Annely Juda Fine Art, "Christo: Wrapped Walk Ways, Kansas City Missouri, 1977–78"
London, Institute of Contemporary Arts, "Christo: Running Fence, Sonoma and Marin Counties, California, 1972–76, Documentation Exhibition"
Minneapolis, Katherine Nash Gallery, University of Minnesota, "Christo: Ocean Front, Newport, Rhode Island, 1974, Documentation Exhibition"
Saint-Paul de Vence, Galerie Catherine Issert, "Christo: Projects 1965–78"
Vienna, Wiener Secession, "Christo: The Running Fence. Zeichnungen, Collagen, Modelle, Technische Dokumente und Film"

1979–80
Boston, Institute of Contemporary Art; Austin, Laguna Gloria Art Museum; Washington, Corcoran Gallery of Art, "Christo: Urban Projets. A Survey"

1980
Abu Dhabi, Alliance Française, "Christo: Exposition d'art environmental"
Aptos, Cabrillo College Gallery, "Christo: Prints and Lithographs"
Chicago, Landfall Press Gallery, "Christo: Storefronts"
Cleveland, Center for Contemporary Art, "Christo: Wrapped Walk Ways, Documentation Exhibition"

DeKalb, Swen Parson Gallery, Northern Illinois University, "Christo: Ocean Front, Newport, Rhode Island, 1974, Documentation Exhibition"
Elkhart, Midwest Museum of American Art, "Christo: Ocean Front, Newport, Rhode Island, 1974, Documentation Exhibition"
Fort Collins, Colorado State University, Hatton Gallery, "Christo: Valley Curtain, Rifle, Colorado, 1970–72, Documentation Exhibition"
Jackson, Mississippi Museum of Art, "Christo: Running Fence, 1972–1976, Documentation"
Newport Beach, Newport Harbor Art Museum, "Christo: Running Fence, Sonoma and Marin Counties, California, 1972–76, Documentation Exhibition"
Winnipeg, Art Gallery, "Christo: Running Fence, Sonoma and Marin Counties, California, 1972–76, Documentation Exhibition"
Zurich, Galerie Kornfeld, "Christo – Collagen, Zeichnungen, Graphik"

1980–81
Peterborough (Ontario), Artspace, "Christo: Wrapped Walk Ways, Documentation Exhibition"
Sonoma, Sonoma County Arts Council; Santa Rosa, City Hall; Sonoma, Ruben Salazar Library, State University; Sonoma, Regional Library; Cotati, Crocker Bank; Santa Rosa, The Glenys Gallery; Sebastopol, Library, "Christo: Prints and Lithographs of Running Fence"

1981
Albuquerque, The Museum of Art and History, "Christo: Valley Curtain, Rifle, Colorado, 1970–72, Documentation Exhibition"
Amsterdam, American Graffiti Gallery, "Christo: Drawings, Collages, Photographs and Multiples"
Cookeville, Center Art Gallery, Tennessee Technical University, "Christo: Ocean Front, Newport, Rhode Island, 1974, Documentation Exhibition"
El Paso, University of Texas, University Art Gallery, "Christo: Wrapped Walk Ways, Kansas City, Missouri, 1977–78, Documentation Exhibition"
Lancaster, Community Gallery, "Christo: Wrapped Walk Ways, Kansas City, Missouri, 1977–78, Documentation Exhibition"
London, Juda Rowan Gallery, "Christo: Surrounded Islands, Project for Biscayne Bay, Greater Miami, Florida"
Miami, Hokin Gallery, "Christo: Three Works in Progress"
Miami, Metropolitan Museum, "Christo: Running Fence, Sonoma and Marin Counties, California, 1972–76, Documentation Exhibition"
Montreal, Musée d'Art Contemporain, "Christo: Running Fence, Sonoma and Marin Counties, California, 1972–76, Documentation Exhibition"
Montreal, Vehicle Gallery, "Christo"
Portland (Oregon), Center for the Visual Arts, "Christo: Running Fence, Sonoma and Marin Counties, California, 1972–76, Documentation Exhibition"
Santa Barbara, University of California, University Art Museum, "Drawings by Christo"
Santa Monica, City College, "Christo"
Thousand Oaks, Conejo Valley Art Museum, "Christo:

Artworks, Posters and Memorabilia from the Collection of Delmore E. Scott"
Tokyo, Watari Gallery, "Christo"

1981–82
Cologne, Museum Ludwig; Frankfurt am Main, Städelsches Kunstinstitut und Städtische Galerie; Berlin, Künstlerhaus Bethanien, "Christo: Projekte in der Stadt 1961–1981"
La Jolla, La Jolla Museum of Contemporary Art; Calgary, University of Calgary, The Nickle Arts Museum; Hamilton, Art Gallery; Madison, Elvehjem Museum of Art, University of Wisconsin, "Christo: Collection on Loan from the Rothschild Bank AG, Zurich"
Madison, Art Center, "Christo: Running Fence, Sonoma and Marin Counties, California, 1972–76, Documentation Exhibition"

1982
Al-Ain, United Arab Emirates, UAE University, "Christo: Environmental Art Works"
Cracow, Biuro Wystaw Artystycznych, "Christo: Photographic Images"
Miami, Miami-Dade Public Library, "Christo: Surrounded Islands, Project for Biscayne Bay, Greater Miami, Florida, Documentation Exhibition"
New Brunswick, Dumont-Landis Gallery, "Christo: Five Works in Progress"
Orono, University of Maine, Museum of Art, "Christo: Wrapped Walk Ways, Kansas City, Missouri, 1977–78, Documentation Exhibition"
Saint-Paul de Vence, Galerie Catherine Issert, "Christo: Surrounded Islands, Project for Biscayne Bay, Greater Miami, Florida"
Tokyo, Satani Gallery, "Christo"
Waterville, Colby College Museum of Art, "Christo: Wrapped Coast, One Million Square Feet, Little Bay, Australia, 1969, Documentation Exhibition"

1982–83
Munich, Schellmann & Klüser, "Christo: Editionen 1964–82"
Tokyo, Hara Museum of Contemporary Art; Fukuoka, Art Museum; Osaka, The National Museum of Art, "Christo: Wrapped Walk Ways, a Documentation Exhibition"

1983
Amsterdam, American Graffiti Gallery, "Christo: Surrounded Islands, Project for Biscayne Bay, Greater Miami, Florida"
Barcelona, Galeria Joan Prats, "Christo: Surrounded Islands, Proyecto para Biscayne Bay, Gran Miami, Florida 1980–1983"
Cincinnati, Contemporary Arts Center, "Christo: Collection on Loan from the Rothschild Bank, Zurich"
Dallas, Delahunty Gallery, "Christo: Drawings and Collages for Surrounded Islands, Biscayne Bay, Florida, 1980–83. And: Four Works in Progress"
Indiana, University of Notre Dame, Snite Museum of Art, O'Shaughnessy Galleries, "Christo: Collection on Loan from the Rothschild Bank, Zurich"
Miami-Dade, Art Mobile, "Christo: Works on Paper"
Milan, Galleria Pero, "Christo: Surrounded Islands,

Biscayne Bay, Florida, 1980–83; and Four Works in Progress"

Santa Cruz, The Art Museum of Santa Cruz County, "Christo: Wrapped Coast, One Million Square Feet, Little Bay, Australia, 1969, Documentation Exhibition. And Works by Christo from the Freestone House, Inc. Collection"

1984

Basel, Architekturmuseum, "Christo: Wrapped Floors im Architekturmuseum in Basel, 1984"

Berlin, Nationalgalerie, "Christo: Surrounded Islands, Biscayne Bay, Greater Miami, Florida, 1980–83, Documentation Exhibition"

Boston, Athenaeum, "Christo: Works on Paper"

Høvikodden, Henie Onstad Kunstsenter, "Christo: Surrounded Islands"

Indianapolis, Indiana University – Purdue University, Herron School of Art, Herron Gallery, "Christo: Documentation Exhibition, Wrapped Coast, Little Bay, Australia, 1969, One Million Square Feet"

Ketchum, Sun Valley Center for the Arts, "Christo: Lithographs and Original Work"

Salinas, Hartnell College Gallery, "Christo: Wrapped Coast, One Million Square Feet, Little Bay, Australia, 1969, Documentation Exhibition"

Santa Rosa, Luther Burbank Center for the Arts, "Christo: Wrapped Coast, One Million Square Feet, Little Bay, Australia, 1969, Documentation Exhibition"

Tokyo, Satani Gallery, "Christo: The Pont Neuf Wrapped, Project for Paris"

Venice, Palazzo Grassi; London, Juda Rowan Gallery, "Christo: Objects, Collages and Drawings 1958–1984"

Westport, Westport-Weston Arts Council, "Christo: Wrapped Coast, One Million Square Feet, Little Bay, Australia, 1969, Documentation Exhibition"

1985

Amsterdam, Galerie Barbara Farber, "Hommage à Christo"

Chicago, Fairweather Hardin Gallery, "Christo: The Pont Neuf Wrapped"

Hamburg, Kunsthalle, "Christo: Surrounded Islands, Biscayne Bay, Greater Miami, Florida, 1980–83"

New Britain, Museum of American Art, "Christo: Wrapped Walkways, Loose Park, Kansas City, Mo. Documentation"

New York, Pace Editions, "Christo: Collaged Prints"

Otterlo, Kröller-Müller Museum, "Christo: Surrounded Islands, Biscayne Bay, Greater Miami, Florida 1980–83, Een Documentaire Tentoonstelling"

Pensacola, University of West Florida, Art Gallery, "Christo: Wrapped Coast, One Million Square Feet, Little Bay, Australia, 1969, Documentation Exhibition"

Saint-Paul de Vence, Fondation Maeght, "Christo: Surrounded Islands, Biscayne Bay, Greater Miami, Florida 1980–83"

1985–86

Dallas, Carpenter & Hochman, "Christo: The Pont Neuf Wrapped and Two Works in Progress: Wrapped Reichstag, Project for Berlin and The Umbrellas, Project for Japan and the United States"

1986

Albany, College of Saint Rose Art Gallery; Hartford, Real Art Ways, "Christo: Prints and Lithographs"

Barcelona, Galeria Joan Prats, "Christo: Dibuixos i Collages. Projectes en curs: The Umbrellas, Projecte per al Japó i l'oest dels Estats Units; Wrapped Reichstag, Projectes per a Berlin and The Pont Neuf Wrapped, Paris 1975–1985"

Carbondale, Southern Illinois University, University Museum, Mitchell Gallery, "Christo: Prints and Lithographs"

Lublin, Biuro Wystaw Artystycznych Galeria Labirynt 2, "Christo: The Pont Neuf Wrapped, Paris, 1985: Photographic Documentation by Maria and Ryszard Maron"

Madrid, Fundación Caja de Pensiones, "Christo: Surrounded Islands, Biscayne Bay, Greater Miami, Florida, 1980–83, Documentation Exhibition"

Miami Beach, Bass Museum of Art, "Christo: Three Projects (Wrapped Coast, Little Bay, Australia, 1969; Wrapped Walk Ways, Loose Park, Kansas City, Missouri, 1977–78; Ocean Front, Newport, Rhode Island, 1974)"

Omaha, Alternative Worksite/Bemis Foundation, "Christo: Prints and Lithographs"

Tallahassee, Florida State University Art Gallery, "Christo: Prints and Lithographs"

Tokyo, Satani Gallery, "Christo – Wrapped Reichstag, Project for Berlin"

Utica, Utica College, Barrett Fine Art Gallery, "Christo: Prints and Lithographs"

1987

Braine-L'Alleud, Centre d'Art Nicolas de Staël, "Christo: Dessins, collages, photos"

Bronx, Lehman College Art Gallery, "Christo: Wrapped Walk Ways, Loose Park, Kansas City, Missouri, 1977–78, Documentation Exhibition"

Charleston, College of Charleston, Halsey Gallery, "Christo: Wrapped Walk Ways, Loose Park, Kansas City, Missouri, 1977–78, Documentation Exhibition"

Ghent, Museum van Hedendaagse Kunst, "Christo: Surrounded Islands, Biscayne Bay, Greater Miami, Florida 1980–83, Documentation Exhibition"

Goslar, Mönchehaus-Museum Verein zur Förderung Moderner Kunst, "Christo: Laudation zur Verleihung des Kaiserrings, Goslar, September 26, 1987"

Lausanne, Musée Cantonal des Beaux-Arts, "Christo: Surrounded Islands, Biscayne Bay, Greater Miami, Florida 1980–83"

Ossining, Elizabeth Galasso Fine Art Leasing, "Christo: Painted Photographs and Collages"

Ridgefield, Aldrich Museum of Contemporary Art, "Christo Collages and Drawings"

1987–88

Brooklyn, Salena Gallery, Long Island University, "Christo: Prints and Lithographs"

Karuizawa, The Museum of Modern Art/Seibu Takanawa; Tokyo, Seibu Museum of Art; Kobe, Hyogo Prefectural Museum of Art, "Christo: Collection on Loan from the Rothschild Bank, Zurich"

1988

Ashland, Southern Oregon University, Schneider

Museum of Art, "Christo: Prints and Lithographs"

Chicago and New York, Landfall Press, "Christo: Prints 1971–1988"

Kobe, Toa Road Gallery, "Christo: Collages, Drawings and Lithographs"

London, Annely Juda Fine Art, "Christo: The Umbrellas (Joint Project for Japan and USA). Drawings and Collages"

Tokyo, Satani Gallery, "Christo: The Umbrellas, Joint Project for Japan and the USA"

1988–89

Szentendre, Szentendrei Mühely Galeria, "Christo: Photographic Images"

Taipei, Fine Arts Museum, "Christo: from the Rothschild Bank AG Zurich"

1989

Berlin, Deutsches Theater, "Christo: Photographic Documentation"

Grand Rapids, Kendall College of Art and Design, Art Gallery, "Christo: Prints and Lithographs"

Knokke-le-Zoute, Galerie Guy Pieters, "Christo: The Umbrellas, Joint Project for Japan and USA"

Lublin, Biuro Wystaw Artystycznych Galeria Labirynt 2, "Christo: Art Documentation"

Nice, Galerie des Ponchettes and Galerie d'Art Contemporain des Musées de Nice, "Christo: A Selection of Works from the Lilja Collection"

Paris, Laage-Salomon Gallery, "Christo: The Umbrellas, Joint Project for Japan and USA"

Paris, Yvon Lambert, Art 4, La Défense, "Christo: Projects not Realized"

Saint-Paul de Vence, Galerie Catherine Issert, "Christo: Projects 1965–88"

São Paulo, Museu de Arte Contemporânea da Universidade, "Christo: Prints and Lithographs"

Saratoga Springs, Skidmore College, Art Gallery, "Christo: Prints and Lithographs"

Schwarzenberg, Galerie des Kulturbundes, "Christo"

Stanford, Stanford University, Stanford Art Gallery, "Christo: Four Works in Progress: Wrapped Reichstag, Project for Berlin; The Gates, Project for Central Park, New York; The Umbrellas, Joint Project for Japan and USA; and The Mastaba of Abu Dhabi, Project for the United Arab Emirates"

1989–90

Cleveland, Center for Contemporary Art, "Christo: Four Works in Progress"

1990

Amsterdam, Bogerd Fine Art, "Christo: Drawings and Multiples"

Hiroshima, City Museum of Contemporary Art; Shibukawa, Hara Museum ARC, "Christo: Surrounded Islands, Biscayne Bay, Greater Miami, Florida, 1980–1983, Documentation Exhibition"

Høvikodden, Henie Onstad Kunstsenter, "Christo: Works 1959–89 from the Lilja Collection"

Paris, Galerie Johanna Vermeer, "Christo"

New York, Magidson Fine Art, "Christo: Prints and Lithographs"

Santa Clara, Santa Clara University, De Saisset Museum, "Christo: Prints and Lithographs"

Seoul, Seomi Gallery, "Printmaking's Exhibition by Christo"
Tokyo, Satani Gallery, "Christo: The Umbrellas, Joint Project for Japan and USA"

1990–91
Akron, Art Museum, "Christo: Works from Area Collections"
Sydney, The Art Gallery of New South Wales; Perth, Art Gallery of Western Australia, "Christo: John Kaldor Art Project 1990"

1991
Bakersfield, College Art Gallery, "Christo: Wrapped Coast, One Million Square Feet, Little Bay, Australia, 1969, Documentation Exhibition"
Bakersfield, Museum of Art, "Christo: Prints and Lithographs"
Bakersfield, California State University, Todd Madigan Gallery, "Christo: Wrapped Walk Ways, Loose Park, Kansas City, Missouri, 1977–78, Documentation Exhibition" and "Christo: Original Works, Prints, and Drawings from the Collection of Tom Golden"
Barcelona, Galeria Joan Prats, "Christo: Obra 1958–1991"
Brussels, Galerie Eric van de Weghe, "Christo"
Chula Vista, Southwestern College Art Gallery, "Christo: Prints and Lithographs"
Ibaraki, Art Tower Mito, Contemporary Art Gallery, "Christo: Valley Curtain, Rifle, Colorado, 1970–1972, Documentation Exhibition and The Umbrellas, Joint Project for Japan and USA, Work in Progress"
London, Annely Juda Fine Art, "Christo: Projects not Realized and Works in Progress"
Reykjavík, Municipal Art Museum, "Christo: From the Lilja Collection"
San Luis Obispo, Alternatives Gallery, "Christo: Prints and Lithographs"
Sapporo, Art Park, "Christo: Surrounded Islands, Biscayne Bay, Greater Miami, Florida, 1980–83, Documentation Exhibition"
Seoul, Seomi Gallery, "Christo: Four Works in Progress"
Tokyo, Satani Gallery, "Christo: Early Works 1958–64"

1991–92
Odense, Kunsthallen Brandts Klaedefabrik, "Christo: from the Lilja Collection"

1992
Beverly Hills, Hanson Art Galleries; San Francisco, Hanson Art Galleries, "Christo"
Birmingham, University of Alabama at Birmingham, Visual Arts Gallery, "Christo: Prints and Lithographs"
Budapest, Small Gallery, "Christo: The Umbrellas, Photographic Images"
Cologne, Galerie Alex Lachmann, "Christo: Berliner Reichstag – Symbol und Vision"
Kagawa, MIMOCA Marugame Genichiro-Inokuma Museum of Contemporary Art; Nagoya, The Exhibition Hall of Toyota City Culture Hall, "Christo: Valley Curtain, Rifle, Colorado, 1970–72, Documentation Exhibition, and The Umbrellas, Japan-USA"

Klosters, Galerie 63, "Christo: Originals and Lithographs"
Santa Barbara, Westmont College, Reynolds Gallery; Malibu, Pepperdine University Art Gallery, "Christo: Prints and Lithographs"
Seoul, Seomi Gallery, "Christo: Works from the 80s and 90s (The Umbrellas, Japan-USA, 1984–91)" and Gallery Hyundai, "Christo: Works from the 80s and 90s (Surrounded Islands 1980–83, The Pont Neuf Wrapped 1975–85, Wrapped Reichstag 1972 – In Progress, The Gates 1980 – In Progress)"
Shiga, The Museum of Modern Art, "Christo: Surrounded Islands"

1993
Berlin, Akademie der Künste/Galerie im Marstall, "Christo in Berlin"
Radford, University Galleries, "Christo: Wrapped Coast/Little Bay, One Million Square Feet, Sydney, Australia, 1969"
Skopje, Museum of Contemporary Art, "Christo: Photographic Images"
Tokyo, Art Front Gallery, Hillside Terrace, "Christo: Works from the Eighties and Nineties"
Vienna, Kunsthaus, "Christo: Der Reichstag und Urbane Projekte"

1993–94
Bonn, Kunstmuseum, "Christo: The Pont Neuf Wrapped, Paris 1975–85, Documentation Exhibition"
Zurich, Galerie Kaj Forsblom, "Christo: Works in Progress"

1994
Berlin, Staatsbibliothek, Preussischer Kulturbesitz, "Christo and Jeanne-Claude: Prints and Lithographs"
Dessau, Museum für Stadtgeschichte, Johannbau, "Christo: Prints and Lithographs"
Milan, Galleria Morone, "Christo: Il gesto intellettuale come magia"
Munich, Museum Villa Stuck, "Christo: Der Reichstag und Urbane Projekte"
Purchase, Manhattanville College, Brownson Gallery, "Christo: Collages, Signed Posters"
Santa Rosa, Sonoma Museum of Visual Art, Luther Burbank Center for the Arts, "Christo: The Tom Golden Collection"
Schwarzenberg, Kunst und Kneipe/Galerie Silberstein and Annaberg, Galerie Anna, "Christo: Drawings for Projects from the Collection Beier"

1995
Aachen, Suermondt-Ludwig-Museum, "Christo und Jeanne-Claude: Der Reichstag und Urbane Projekte"
Amsterdam, Galerie A., "Christo and Jeanne-Claude: Projects, Prints, Posters, Books, Ephemera"
Berlin, Art Galerie Richter, "Christo und Jeanne-Claude"
Berlin, Galerie Georg Nothelfer, "Christo and Jeanne-Claude: Three Works in Progress: Wrapped Reichstag, Project for Berlin; The Gates, Project for Central Park, N.Y.; Over the River, Project for Western USA"
Berlin, Galerie Pels-Leusden, "Christo und Jeanne-

Claude: Zwei Europäische Privatsammlungen und Eigener Besitz"
Berlin, Kunstforum, "Christo and Jeanne-Claude: Three Works in Progress: Wrapped Reichstag, Project for Berlin; The Gates, Project for Central Park, New York; Over the River, Project for Western USA"
Bonndorf im Schwarzwald, Schloss Bonndorf, "Christo and Jeanne-Claude: Prints and Lithographs"
Budapest, Tölgyfa Galéria, "Christo és Jeanne-Claude: Nyomotok"
Emsdetten, Kunstverein, "Christo and Jeanne-Claude: Prints and Lithographs"
Künzelsau, Museum Würth, "Christo und Jeanne-Claude: Die Werke in der Sammlung Würth" and "Wrapped Floors and Stairways and Covered Windows, Museum Würth"
Ljubljana, Cankarjev Dom, Galerije, "Christo in Jeanne-Claude: Projekti 1961–1995"
London, Annely Juda Fine Art, "Christo and Jeanne-Claude: Three Works in Progress: Wrapped Reichstag, Project for Berlin; The Gates, Project for Central Park, New York City; Over the River, Project for Western USA"
Pirmasens, Galerie Ralf Plein, "Christo and Jeanne-Claude: Lithographs; and Drawings and Collages about the Wrapped Reichstag"
Podsreda, Podsreda Castle, Kozjanski Park; Piran, Obalne Galerije, "Christo in Jeanne-Claude: Dela 1962–1992"
Tokyo, Art Front Gallery, "Christo and Jeanne-Claude: Wrapped Reichstag, Berlin, 1971–95, and Works in Progress"

1995–96
Høvikodden, Henie Onstad Kunstsenter; Linköping, Östergötlands Länsmuseum; Helsinki, Amos Anderson Art Museum, "Christo and Jeanne-Claude: Projects. Works from the Lilja Collection"
Santa Fe, Laura Carpenter Fine Art, "Christo and Jeanne-Claude: Over the River: Project for Western USA"

1995–98
Richmond, Art Museum; Albany, The College of Saint Rose; Fort Wayne, Museum of Art; Fort Collins, One West Art Center; Crawfordsville, Wabash College, Fine Arts Center, Eric Dean Gallery and Permanent Collection; Coral Gables, University of Miami, Lowe Art Museum; Lincoln, University of Nebraska, Sheldon Memorial Art Gallery; Vero Beach Museum of Art; Longmont, Center for the Arts, "Twenty-One Golden Years with Christo and Jeanne-Claude: The Tom Golden Collection"

1996
Aspen, Aspen Institute, Adelson Art Gallery, "Christo and Jeanne-Claude: Over the River, Project for the Western USA"
Graz, Kulturhaus, "Christo and Jeanne-Claude: Works from the Würth Collection"
New York, Columbia University, Teachers College, 14–25 Gallery, "Christo and Jeanne-Claude: Over the River, Project for Western USA and The Gates, Project for Central Park, New York"
Paris, Galerie Fabien Boulakia, "Christo and Jeanne-Claude"

Passau, Museum Moderner Kunst, "Christo & Jeanne-Claude: Die Werke aus der Sammlung Würth"
Plön, Kunstverein Schloss, "Christo and Jeanne-Claude: Wrapped Reichstag, 1971–95, Photographs"
Zierikzee, Galerie Galerji, "Christo: Photographic Images"

1996–97
Denver, Robischon Gallery, "Christo and Jeanne-Claude: Works in Progress: Over the River, Project for Western USA and The Gates, Project for Central Park, New York"

1997
Denver, Art Museum, "Christo and Jeanne-Claude: Valley Curtain, Rifle, Colorado, 1970–1972 – A Documentation Exhibition"
Holderbank, Warehouse, "Christo and Jeanne-Claude: Early Works 1958–1969 and Works in Progress"
Lund, Skissernas Museum, "Christo and Jeanne-Claude: Projects: Works from the Lilja Collection"
Lustenau, Galerie der Marktgemeinde, "Christo und Jeanne-Claude: Ausstellung von Collagen und Originalzeichnungen zum Thema 'Wasser'"
Lustenau, Galerie Stephanie Hollenstein, "Projekte von Christo & Jeanne-Claude: 'Surrounded Islands,' 'Verhütter Pont Neuf,' und 'Over the River'"
Salzburg, Museum der Moderne Rupertinum, "Christo and Jeanne-Claude: Scale Models and Collages of Projects from 1965 to 1995. From the Würth Collection, Künzelsau"
Varna, 9th International Print Biennial, Art Gallery, "Christo and Jeanne-Claude: Photographic Images of Projects"
Wakefield, Yorkshire Sculpture Park, "Christo and Jeanne-Claude: Sculpture and Projects 1961–96"

1997–98
Brussels, Vlaams Europees Conferentiecentrum; Bruges, Halletorne-Grote Markt; Arnhem, Sonsbeek, Art & Design, "Christo and Jeanne-Claude: Expo"

1998
Knokke-le-Zoute, Galerie Guy Pieters, "Christo and Jeanne-Claude: Over the River, Project for the Arkansas River, State of Colorado, and The Gates, Project for Central Park, New York City"
Laramie, University of Wyoming Art Museum, "Christo and Jeanne-Claude: Valley Curtain, Rifle, Colorado, 1970–72, Documentation Exhibition"
Noirmoutiers-en-l'Ile, Musée du Château, "Christo et Jeanne-Claude: Editions et objets 1968–1998"
Warsaw, Muzeum Narodowe w Warszawie, "Christo and Jeanne-Claude: Prints and Objects"
Warsaw, Muzeum Plakatu w Wilanowie, "Christo and Jeanne-Claude"

1998–99
Basel, Galerie Beyeler, "Christo and Jeanne-Claude: Early Works and Works in Progress"
Riehen, Kunst Raum, "Christo and Jeanne-Claude: Works from the 60's to the 90's"
Turin, Palazzo Bricherasio, "Christo and Jeanne-Claude: Early Works 1958–1969 and Works in Progress" and "Christo and Jeanne-Claude: Palazzo Bricherasio, Wrapped Floors and Stairways and Covered Windows, Torino, Italy"

1998–2001
Colorado Springs, Fine Arts Center, Taylor Museum; Grand Junction, Western Colorado Center for the Arts; Easton, Lafayette College, Williams Center Art Gallery; Savannah, College of Art and Design, Pinnacle Gallery; New Britain, Museum of American Art; Moscow, Prichard Art Gallery, University of Idaho; Kennesaw, State University Art Gallery; Fayetteville, University of Arkansas, "Christo and Jeanne-Claude: Two Works in Progress: Over the River, Project for the Arkansas River, State of Colorado, and The Gates, Project for Central Park, New York City"

1999
Barcelona, Centro Cultural de la Fundació "la Caixa", "Christo: Realitats Somniades. Collecció d'Obra Gràfica de la Fundació 'la Caixa'"
Berlin, Galerie Georg Nothelfer, "Wolfgang Volz: Fotos vom Verhüllten Reichstag" and "Christo und Jeanne-Claude: Objekte"
Fort Collins, Colorado State University, Morgan Library, First National Bank Gallery, "Christo and Jeanne-Claude: Prints and Objects"
Hong Kong, Arts Centre; Guangzhou, Guangdong Museum of Art, "The Projects of Christo and Jeanne-Claude. Selected Works from the Würth Collection, Germany"
Nice, Musée d'Art Moderne et d'Art Contemporain, "Christo and Jeanne-Claude: Projects"
Oberhausen, Gasometer, "Christo and Jeanne-Claude: The Umbrellas, Japan-USA, 1984–91, A Documentation Exhibition; Wrapped Reichstag, Berlin 1971–95, A Documentation Exhibition; The Wall, Gasometer, Oberhausen 1999, 13,000 Oil Barrels" and Ludwig Galerie Schloss Oberhausen, "Projects and Realizations with Oil Barrels"
Pueblo, Sangre de Cristo Arts Center, "Christo and Jeanne-Claude: Twenty-Five Golden Years"

2000
Aspen, Baldwin Gallery, "Christo and Jeanne-Claude: Over the River, Project for the Arkansas River, Colorado and The Gates, Project for Central Park, New York, Two Works in Progress"
Barcelona, Galeria Joan Prats, "Christo and Jeanne-Claude: Two Works in Progress: The Gates, Project for Central Park, New York City, and Over the River, Project for the Arkansas River, Colorado"
Evanston, Northwestern University, Mary and Leigh Block Museum of Art, "The Art of Christo and Jeanne-Claude from the Collection of Scott Hodes and Maria Bechily"
Frankfurt am Main, Galerie Vonderbank, "Christo and Jeanne-Claude"
Goslar, Mönchehaus Museum für moderne Kunst, "Christo & Jeanne-Claude in Goslar – Works in Progress"
London, Annely Juda Fine Art, "Christo and Jeanne-Claude: Black and White"
Santa Rosa, Sonoma County Museum, Kress Building,

"26 Golden Years with Christo and Jeanne-Claude: The Tom Golden Collection"
Vienna, Bulgarian Cultural Institute, Haus Wittgenstein, "Christo and Jeanne-Claude: Photographic Images of Projects"

2001
Amsterdam, Gallery Delaive, "The Gates, Project for Central Park, New York and Over the River, Project for the Arkansas River, Colorado. Two Works in Progress"
Berlin, Galerie Georg Nothelfer, "Christo and Jeanne-Claude"
Berlin, Martin-Gropius-Bau, "Christo and Jeanne-Claude: Early Works 1958–69" and "Christo and Jeanne-Claude: Wrapped Reichstag, Berlin, 1971–95, A Documentation Exhibition"
Berlin, Neuer Berliner Kunstverein, "Christo & Jeanne-Claude, Two Works in Progress: The Gates, Project for Central Park, New York City; Over the River, Project for the Arkansas River, State of Colorado"
Brescia, Fondazione Ambrosetti Arte Contemporanea, Palazzo Bonoris, "Christo e Jeanne-Claude: Progetti recenti, progetti futuri (Wrapped Trees, 1966–98, Documentation Exhibition; Projects and Realizations with Oil Barrels 1958–82; 13,000 Oil Barrels, Oberhausen, 1999; and Two Works in Progress: Over the River and The Gates)"
New York, Macy Gallery, Teachers College, Columbia University, "Christo and Jeanne-Claude: The Art of Gentle Disturbance"
Saint-Paul de Vence, Galerie Guy Pieters, "Christo and Jeanne-Claude, Two Works in Progress: The Gates (Project for Central Park, New York City); Over the River (Project for the Arkansas River, State of Colorado)"
Santa Rosa, Sonoma County Museum, "Christo and Jeanne-Claude, The Tom Golden Collection"
Seoul, Park Ryu Sook Gallery, "Christo and Jeanne-Claude: The Gates, Project for Central Park, New York City, and Over the River, Project for the Arkansas River"

2001–02
Campomarino, Centro Culturale "Il Campo", "Omaggio a Christo e Jeanne-Claude"

2002
Beverly, Montserrat College of Art, "Christo and Jeanne-Claude: Photographic Images and Prints"
Chur, Kulturforum Würth, "Christo & Jeanne-Claude: Objects, Drawings and Collages of the Collection Würth, Künzelsau"
New Canaan, Silvermine Guild Arts Center, "Christo and Jeanne-Claude: The Gates, Project for Central Park, New York City and Over the River, Project for the Arkansas River, Colorado. Two Works in Progress"
Salou, Fundació "la Caixa", Centre Cultural Torre Vella, "Christo: Realitats Somniades. Graphic Works from the Collection of 'la Caixa'"
Zurich, Galerie Proarta, "Christo & Jeanne-Claude"

2002–03
La Jolla, La Jolla Museum of Contemporary Art, "Christo in the David C. Copley Collection"
Vero Beach, The Vero Beach Museum of Art and The

254

Gallery at Windsor, "Christo and Jeanne-Claude in the Weston Collection"

Zugo, Galerie Proarta, "Christo & Jeanne-Claude"

2002–04

Washington, National Gallery of Art; La Jolla, La Jolla Museum of Contemporary Art; Rio de Janeiro, Museu de Arte Moderna, "Christo and Jeanne-Claude in the Vogel Collection"

2003

Fort Myers, Edison College, Gallery of Fine Art, "Christo and Jeanne-Claude: Photographic Images and Prints"

Milan, Galleria Morone, "Christo and Jeanne-Claude: The Gates, Project for Central Park, New York City and Over the River, Project for the Arkansas River, Colorado"

Naples (Florida), Eckert Fine Art, "Christo and Jeanne-Claude: The Gates, Project for Central Park, New York City, and Over the River, Project for the Arkansas River, State of Colorado. Two Works in Progress"

Rockford, Art Museum, "Christo and Jeanne-Claude: The Gates, Project for Central Park, New York City, and Over the River, Project for the Arkansas River, Colorado. Two Works in Progress"

San Antonio, Blue Star Art Space, "Christo and Jeanne-Claude: The Gates, Project for Central Park, New York City, and Over the River, Project for the Arkansas River, Colorado. Two Works in Progress"

2003–04

Otterlo, Kröller-Müller Museum, "Christo: Works from the Collection"

2004

Aspen, Baldwin Gallery, "Christo & Jeanne-Claude: The Gates, Project for Central Park, New York City and other works"

Biel/Bienne, CentrePasquArt, "Christo and Jeanne-Claude: Swiss Projects 1968–1998"

Davis, John Natsoulas Center For the Arts, "Christo and Jeanne-Claude: The Gates, Project for Central Park, New York City and Over the River, Project for the Arkansas River, Colorado. Two Works in Progress"

Knokke-Heist, Galerie Guy Pieters, "Christo: The Gates, Project for Central Park, New York City"

Milan, Corsoveneziaotto/Tega Arte Contemporanea, "Christo and Jeanne-Claude"

New York, The Metropolitan Museum of Art, "Christo and Jeanne-Claude: The Gates, Central Park, New York City"

Passau, Medienzentrum der Verlagsgruppe, "Christo und Jeanne-Claude: Photomurals und The Gates, eine Zeichnung"

Passau, Sankt-Anna-Kapelle, "Christo und Jeanne-Claude: Prints and Objects"

Venice and Cortina d'Ampezzo, Galleria d'Arte Contini, "Christo and Jeanne-Claude"

2004–05

Portland (Oregon), Art Museum, "Christo and Jeanne-Claude: The Pont Neuf Wrapped, Paris, 1975–85"

2004–06

New York, National Academy of Design; Miami, Bass Museum of Art; Halifax, Art Gallery of Nova Scotia; Portland (Maine), Museum of Art; Austin, Museum of Art; Fresno, Metropolitan Museum, "Christo and Jeanne-Claude: The Würth Museum Collection"

2005

Kristianstad, Kristianstads Konsthall, "Christo & Jeanne-Claude: Projects"

London, Annely Juda Fine Art, "Christo and Jeanne-Claude: Over the River, Project for the Arkansas River, State of Colorado. A Work in Progress"

Mariefred, Grafikens Hus, "Christo and Jeanne-Claude: Prints & Projects"

New York, The Museum of Modern Art, "Christo and Jeanne-Claude: Projects Recorded, 1969–1998"

Passau, Museum Moderner Kunst, "Christo und Jeanne-Claude: Projekte der späten 90er Jahre und 'Over the River'"

Toronto, Art Gallery of Ontario, "Christo and Jeanne-Claude: Works from the Weston Collection"

Tucson, University of Arizona Museum of Art, "Christo and Jeanne-Claude: The Tom Golden Collection"

Westville, Purdue University North Central, Valparaiso Academic Center, "Christo and Jeanne-Claude: Selected Works 1962–2005"

Zurich, Bank Leu, "Christo and Jeanne-Claude: Two Works in Progress: The Gates and Over the River"

Selected Bibliography

Books

1965
Christo, Edizioni Apollinaire, Milan. Texts by David Bourdon, Otto Hahn and Pierre Restany, designed by Christo.

1968
Christo: 5,600 Cubic Meter Package, Verlag Wort und Bild, Baierbrunn. Photographs by Klaus Baum, designed by Christo.

1969
Christo, Harry N. Abrams, New York; Verlag Gerd Hatje, Stuttgart; Thames and Hudson, London. Text by Lawrence Alloway, designed by Christo.
Christo: Wrapped Coast, One Million Square Feet, Contemporary Art Lithographers, Minneapolis. Photographs by Shunk-Kender, designed by Christo.

1970
Christo, Harry N. Abrams, New York. Text by David Bourdon, designed by Christo.

1971
Christo: Projekt Monschau, Verlag Art Actuell, Cologne. Text by Willi Bongard.

1973
Christo: Valley Curtain, Verlag Gerd Hatje, Stuttgart; Harry N. Abrams, New York; Pierre Horay, Paris; Gianpaolo Prearo, Milan. Photographs by Harry Shunk, designed by Christo.

1975
Christo: Ocean Front, Princeton University Press. Edited by Christo, texts by Sally Yard and Sam Hunter, photographs by Gianfranco Gorgoni.
Environmental Impact Report: Running Fence, Environmental Science Associates Inc., Foster City. Edited by Paul E. Zigman and Richard Cole.

1977
Christo: The Running Fence, Harry N. Abrams, New York; Editions du Chêne, Paris; Verlag Gerd Hatje, Stuttgart. Photographs and editing by Wolfgang Volz, text by Werner Spies.

1978
Christo: Running Fence, Harry N. Abrams, New York. Chronicle by Calvin Tomkins, narrative text by David Bourdon, photographs by Gianfranco Gorgoni, designed by Christo.
Christo: Wrapped Walk Ways, Harry N. Abrams, New York. Text by Ellen Goheen, photographs by Wolfgang Volz, designed by Christo.

1980
Catalogue Raisonné of Original Works, being prepared by Daniel Varenne, with the collaboration of Ariane Coppier, Marie-Claude Blancpain and Raphaëlle de Pourtales, in progress.

1982
Christo: Complete Editions 1964–82. Catalogue Raisonné, Verlag Schellmann und Kluser, Munich; New York University Press, New York. Introduction by Per Hovdenakk.

1984
Christo: Der Reichstag, Suhrkamp Verlag, Frankfurt am Main. Edited by Michael Cullen and Wolfgang Volz, photographs by Wolfgang Volz.
Christo: Surrounded Islands, Biscayne Bay, Greater Miami, Florida, 1980–83, Dumont Buchverlag, Cologne; Harry N. Abrams, New York, 1985; Fondation Maeght, Saint-Paul de Vence, 1985; Ediciones Polígrafa, Barcelona, 1986. Photographs and editing by Wolfgang Volz, text by Werner Spies.
Christo: Works 1958–83, Sogetsu Shuppan, Tokyo. Text by Yusuke Nakahara.

1985
Christo, Art Press /Flammarion, Paris; Pantheon Books, New York, 1986. Text by Dominique Laporte.

1986
Christo: Surrounded Islands, Biscayne Bay, Greater Miami, Florida, 1980–83, Harry N. Abrams, New York. Text by Jonathan Fineberg, report by Janet Mulholland, photographs by Wolfgang Volz, introduction and picture notes by David Bourdon, designed by Christo.

1987
Helt Fel I Paris, Butler and Tanner, The Selwood Printing Works, Frome, England. Texts by Pelle Hunger and Joakim Stromholm, photographs by J. Stromholm.
Le Pont-Neuf de Christo, ouvrage d'art, œuvre d'art, ou Comment se faire une opinion, Adresse, Paris. Text by Nathalie Heinich, photographs by Wolfgang Volz.

1988
Christo: Prints and Objects, 1963–1987. Catalogue Raisonné, Schellmann, Munich; Abbeville Press, New York. Edited by Jörg Schellmann and Josephine Benecke, introduction by Werner Spies.

1990
Christo, Shinchosha Co., Ltd., Tokyo. Text by Yusuke Nakahara.
Christo, Polígrafa, Barcelona; Rizzoli, New York; Albin Michel, Paris; Meulenhoff/Landshoff, Amsterdam; Verlag Aurel Bongers, Recklinghausen; Bijutsu Shupan-Sha, Tokyo. Text by Marina Vaizey.
Christo: The Pont Neuf Wrapped, Paris, 1975–85, Harry N. Abrams, New York; Adam Biro, Paris; Dumont Buchverlag, Cologne. Texts by David Bourdon and Bernard de Montgolfier, photographs by Wolfgang Volz, designed by Christo.

1991
Christo: The Accordion, Fold Book for The Umbrellas, Joint Project for Japan and USA, Chronicle Books, San Francisco. Foreword and interview by Masahiko Yanagi, photographs by Wolfgang Volz, designed by Christo.

1993
Christo: The Reichstag and Urban Projects, Prestel, New York. Edited by Jacob Baal-Teshuva, texts by Tilmann Buddensieg, Michael S. Cullen, Rita Süssmuth and Masahiko Yanagi, photographs by Wolfgang Volz.

1994
Christo and Jeanne-Claude: Der Reichstag und Urbane Projekte, Prestel Verlag, Munich. Edited by Jacob Baal-Teshuva, texts by Tilmann Buddensieg and Wieland Schmied, interview by Masahiko Yanagi, chronology by Michael S. Cullen, photographs by Wolfgang Volz.

1995
Christo, Jeanne-Claude, Der Reichstag dem Deutschen Volke, Bastei-Lübbe, Gustav Lübbe Verlag GmbH,

Bergisch-Gladbach, Germany. Texts by Michael S. Cullen and Wolfgang Volz, photographs by Wolfgang Volz.

Christo & Jeanne-Claude, Taschen, Cologne. Edited by Simone Philippi and Charles Brace, text by Jacob Baal-Teshuva, photographs by Wolfgang Volz, designed by Christo.

Christo and Jeanne-Claude: Prints and Objects 1963–95. Catalogue Raisonné, Schellmann, Munich-New York; Schirmer Mosel Verlag, Munich. Edited by Jörg Schellmann and Joséphine Benecke.

Christo & Jeanne-Claude: Postcard Book, Taschen, Cologne.

Christo & Jeanne-Claude: Poster Book, Taschen, Cologne. Text by Thomas Berg, photographs by Wolfgang Volz.

Christo and Jeanne-Claude: Wrapped Reichstag, Berlin, 1971–95. The Project Book, Taschen, Cologne. Photographs by Wolfgang Volz.

1996

Christo and Jeanne-Claude: Projects Selected from the Lilja Collection, Azimuth Editions Limited, London, 2nd edition. Text by Per Hovdenakk, preface by Torsten Lilja, photographs by Wolfgang Volz.

Christo and Jeanne-Claude: Wrapped/Verhüllter Reichstag, Berlin, 1971–95, Taschen, Cologne. Edited by Simone Philippi, picture notes by David Bourdon, photographs by Wolfgang Volz, designed by Christo.

1998

Christo and Jeanne-Claude: The Umbrellas, Japan-Usa, 1984–91, Taschen, Cologne. Edited by Simone Philippi, picture notes by Jeanne-Claude and Masahiko Yanagi, photographs by Wolfgang Volz, designed by Christo.

Christo and Jeanne-Claude: Wrapped Trees, 1997–98, Taschen, Cologne. Edited by Simone Philippi, introduction by Ernst Beyeler, photographs and picture notes by Wolfgang and Sylvia Volz.

Erreurs les plus fréquentes, Jannink, Paris. Edited by Jeanne-Claude.

2000

Christo and Jeanne-Claude: Most Common Errors / Erreurs les plus fréquentes, Jannink, Paris. Edited by Jeanne-Claude (English and French).

XTO + J-C. Christo und Jeanne-Claude, Eine Biografie von Burt Chernow, Epilog von Wolfgang Volz, Kiepenheuer & Witsch, Cologne.

2001

XTO + J-C. Christo e Jeanne-Claude. Una biografia di Burt Chernow, epilogo di Wolfgang Volz, Skira, Milan.

2002

XTO + J-C. Christo and Jeanne-Claude: A Biography, text by Burt Chernow, with an epilogue by Wolfgang Volz, St. Martin's Press, New York.

2003

Christo and Jeanne-Claude: The Gates, Project for Central Park, New York City, Hugh Lauter Levin As-

sociates, Westport. Picture notes by Jeanne-Claude and Jonathan Henery, photographs by Wolfgang Volz.

Catalogues for solo exhibitions

1961

Christo, Galerie Haro Lauhus, Cologne. Text by Pierre Restany, poem by Stefan Wewerka.

1962

Le Docker et le Décor, Rue Visconti, Paris. Text by Pierre Restany.

1966

Christo (Empaquetage, Volumen Temporale, Store Fronts), Stedelijk van Abbemuseum, Eindhoven. Text by Lawrence Alloway.

1968

Christo: Monuments and Projects, Institute of Contemporary Art, University of Pennsylvania, Philadelphia. Text by Stephen Prokopoff.

Christo Wraps the Museum: Scale Models, Photomontages, and Drawings for a Non-Event, The Museum of Modern Art, New York. Text by William Rubin.

1969

Christo: Wool Works, National Gallery of Victoria, Melbourne. Text by Jan van der Marck.

1971

Christo: Valley Curtain, Project for Rifle, Colorado, Documentation, The Museum of Fine Arts, Houston. Text by Jan van der Marck.

Christo: Wrapped Floors, Wrapped Stairway and Wrapped Walk Ways, Museum Haus Lange, Krefeld. Text by Paul Wember.

1973

Christo: Valley Curtain, Rifle, Colorado, 1970–72, Documentation Exhibition, Kunsthalle, Düsseldorf. Text by John Matheson, photographs by Harry Shunk.

1974

Christo: Valley Curtain, Musée de Peinture et de Sculpture, Grenoble. Text by Maurice Besset.

1975

Christo: Exposición documental sobre el Valley Curtain, Museo de Bellas Artes, Caracas, Editorial Arte, Caracas. Photographs by Harry Shunk.

Christo: Lithographs and Drawings, Galeria Ciento, Barcelona. Text by Alexandre Cirici.

1977

Christo: Drawings and Collages, Minami Gallery, Tokyo. Text by Yusuke Nakahara.

Christo: Project for Wrapped Reichstag, Berlin. Collages, Drawings, Scale Model, and Photographs, Annely Juda Fine Art, London. Texts by Wieland Schmied and Tilmann Buddensieg, photographs by Wolfgang Volz.

Christo: Wrapped Reichstag, Project for Berlin,

Rheinisches LandesMuseum, Bonn. Texts by Wieland Schmied and Tilmann Buddensieg.

1978

Christo: Galerien Maximilianstrasse: Verpacktegalerie, Galerie Art in Progress, Munich. Text by Albrecht Haenlein.

Christo: The Mastaba, Kröller-Müller Museum, Otterlo. Text by Ellen Joosten, introduction by R. W. D. Oxenaar.

1979

Christo: The Running Fence. Zeichnungen, Collagen, Modelle, Technische Dokumente und Film, Wiener Secession, Vienna. Text by Werner Spies, introduction by Herman J. Painitz, photographs by Wolfgang Volz.

Christo: Urban Projects. A Survey, Institute of Contemporary Art, Boston; Laguna Gloria Art Museum, Austin; Corcoran Gallery of Art, Washington. Texts by Pamela Allara and Stephen Prokopoff, introduction by Stephen Prokopoff.

1981

Christo: Collection on Loan from the Rothschild Bank AG, Zurich, La Jolla Museum of Contemporary Art, La Jolla. Text by Jan van der Marck, introduction by Robert McDonald.

Christo: Projekte in der Stadt 1961–1981, Museum Ludwig, Cologne; Städelsches Kunstinstitut und Städtische Galerie, Frankfurt am Main; Künstlerhaus Bethanien, Berlin. Texts by Evelyn Weiss and Gerhard Kolberg, introduction by Karl Ruhrberg and Klaus Gallwitz.

Christo: Surrounded Islands, Project for Biscayne Bay, Greater Miami, Florida, Juda Rowan Gallery, London. Text by Anitra Thorhaug, photographs by Wolfgang Volz.

1982

Christo: Environmental Art Works, UAE University, Al-Ain, United Arab Emirates. Foreword by Ezzidin Ibrahim, photographs by Harry Shunk and Wolfgang Volz.

Christo: Wrapped Walk Ways, a Documentation Exhibition, Hara Museum of Contemporary Art, Tokyo, Fondation Arc-en-Ciel, Tokyo. Texts by Toshio Hara, Ellen R. Goheen and Toshio Minemura, photographs by Wolfgang Volz.

1984

Christo: Objects, Collages and Drawings 1958–84, Juda Rowan Gallery, London.

Christo: The Pont Neuf Wrapped, Project for Paris, Satani Gallery, Tokyo. Text by Yusuke Nakahara, interview by Masahiko Yanagi, photographs by Wolfgang Volz.

Christo: Wrapped Floors im Architekturmuseum in Basel, Architekturmuseum, Basel. Text by Ulrike and Werner Jehle-Schulte, photographs by Wolfgang Volz.

1986

Christo: Dibuixos i Collages, Galeria Joan Prats, Barcelona.

Christo: Wrapped Reichstag, Project for Berlin, Satani

258

Gallery, Tokyo. Interview by Masahiko Yanagi, photographs by Wolfgang Volz.

1987

Christo: Collection on Loan from the Rothschild Bank, Zurich, Seibu Museum of Art, Tokyo. Texts by Torsten Lilja, Yusuke Nakahara, Tokuhiro Nakajima and Akira Moriguchi, interview by Masahiko Yanagi, photographs by Wolfgang Volz.
Christo: Dessins, collages, photos, Centre d'Art Nicolas de Staël, Braine-L'Alleud. Text by A. M. Hammacher, interviews by Marcel Daloze and Dominique Verhaegen, photographs by Wolfgang Volz.
Christo: Surrounded Islands, Museum van Hedendaagse Kunst, Ghent. Text by Werner Spies, photographs by Wolfgang Volz.
Christo: Laudation zur Verleihung des Kaiserrings, Goslar, September 26, 1987, Mönchehaus-Museum Verein zur Förderung Moderner Kunst, Goslar. Text by Werner Spies, photographs by Wolfgang Volz.

1988

Christo: Collection on Loan From the Rothschild Bank AG Zurich, Taipei Fine Arts Museum, Taipei. Texts by Werner Spies and Joseph Wang, preface by Kuang-Nan Huang, photographs by Wolfgang Volz.
Christo: The Umbrellas, Joint Project for Japan and USA, Satani Gallery, Tokyo. Text by Masahiko Yanagi, introduction by Ben Yama, photographs by Wolfgang Volz.
Christo: The Umbrellas (Joint Project for Japan and USA), Annely Juda Fine Art, London. Interview and text by Masahiko Yanagi, photographs by Wolfgang Volz.

1989

Christo: A Selection of Works from the Lilja Collection, Musée d'Art Moderne et d'Art Contemporain, Nice. Texts by Torsten Lilja, Claude Fournet, Pierre Restany, Werner Spies and Masahiko Yanagi, photographs by Wolfgang Volz.
Christo: Projects 1965–88, Galerie Catherine Issert, Saint-Paul de Vence. Text by Raphael Sorin.
Christo: The Umbrellas, Joint Project for Japan and USA, Galerie Guy Pieters, Knokke-le-Zoute. Text by Masahiko Yanagi, picture notes by Susan Astwood, photographs by Wolfgang Volz.

1990

Christo: Drawings and Multiples, Bogerd Fine Art, Amsterdam.
Christo: Surrounded Islands, Documentation Exhibition, City Museum of Contemporary Art, Hiroshima; Hara Museum, ARC, Shibukawa; Fukuoka Art Museum, Gunma. Text by Jonathan Fineberg, photographs by Wolfgang Volz.
Christo: The Umbrellas, Joint Project for Japan and USA, Satani Gallery, Tokyo. Text by Masahiko Yanagi, photographs by Wolfgang Volz.
Christo: Works 1958–89 from the Lilja Collection, Henie Onstad Kunstsenter, Høvikodden. Text by Per Hovdenakk, introduction by Torsten Lilja, interview by Jan Åman, photographs by Wolfgang Volz.
Christo, The Art Gallery of New South Wales, Sydney.

Texts by Albert Elsen, Toni Bond, Daniel Thomas and Nicholas Baume, preface by John Kaldor, photographs by Wolfgang Volz.
Prints and Lithographs, Seomi Gallery, Seoul.

1991

Christo: Early Works 1958–64, Satani Gallery, Tokyo. Texts by Masahiko Yanagi and Harriet Irgang.
Christo: Obra 1958–1991, Galeria Joan Prats, Barcelona. Text by Marina Vaizey.
Christo: Projects Not Realized and Works in Progress, Annely Juda Fine Art, London. Preface by Annely Juda and David Juda.
Christo: Valley Curtain, Documentation Exhibition, Art Tower Mito, Ibaraki, and *The Umbrellas, Joint Project for Japan and USA, Work in Progress*. Text by Jan van der Marck, interview by Masahiko Yanagi, photographs by Harry Shunk and Wolfgang Volz.

1992

Christo: Valley Curtain, Documentation Exhibition, and *The Umbrellas, Japan-USA*, Marugame Genichiro Inokuma Museum of Contemporary Art, Kagawa. Text by Jan van der Marck, interview by Masahiko Yanagi, photographs by Harry Shunk and Wolfgang Volz.
Christo: Works from the 80s and 90s, Seomi Gallery and Hyundai Gallery, Seoul. Photographs by Wolfgang Volz.

1993

Christo: Der Reichstag und Urbane Projekte, Kunsthaus Wien, Vienna, Museum Villa Stuck, Munich, and Ludwig Museum, Aachen. Edited by Jacob Baal-Teshuva, texts by Tilmann Buddensieg and Wieland Schmied, interview by Masahiko Yanagi, chronology by Michael S. Cullen, photographs by Wolfgang Volz.
Christo: Works from the 80s and 90s, Art Front Gallery, Hillside Terrace, Tokyo. Text by Masahiko Yanagi, photographs by Wolfgang Volz.

1994

Christo: The Pont Neuf Wrapped, Paris 1975–85, Kunstmuseum, Bonn. Texts by Volker Adolphs, Bernard de Montgolfier, Dieter Ronte and Constance Sherak, photographs by Wolfgang Volz, excerpts from Jeanne-Claude's agenda.

1995

Christo and Jeanne-Claude: Projects Selected from the Lilja Collection, Anderson Art Museum. Text by Per Hovdenakk, preface by Torsten Lilja, photographs by Wolfgang Volz.
Christo and Jeanne-Claude: The Works in the Collection Würth, Museum Würth, Künzelsau. Texts by Lothar Romain and C. Sylvia Weber, photographs by Wolfgang Volz.
Christo and Jeanne-Claude: Three Works in Progress, Annely Juda Fine Art, London. Preface by Annely Juda and David Juda, photographs by Wolfgang Volz.
Christo and Jeanne-Claude: Wrapped Floors and Stairways and Covered Windows, Museum Würth, Künzelsau. Edited by C. Sylvia Weber, texts by Wulf Herzogenrath, Hans Georg Frank, Sibylle Peine, Andreas Sommer, Wolfgang Reiner and Christian Marquart, photographs by Wolfgang Volz.

Christo and Jeanne-Claude: Wrapped Reichstag, Berlin, and Works in Progress, Art Front Gallery, Tokyo. Photographs by Wolfgang Volz, Sylvia Volz, André Grossmann, Michael Cullen and Yoshitaka Uchida.

1997

Christo and Jeanne-Claude: Projects, Works from the Lilja Collection, Skissernas Museum, Lund. Introduction by Jan Torsten Ahlstrand, photographs by Wolfgang Volz.
Christo and Jeanne-Claude: Sculpture and Projects 1961–96, Yorkshire Sculpture Park, Wakefield. Preface by Peter Murray, designed and produced by Claire Glossop.

1998

Christo and Jeanne-Claude, Galerie Beyeler, Basel. Exerpts from a text by David Bourdon, text by Werner Spies.
Christo and Jeanne-Claude, The Gates, Project for Central Park, New York and *Over The River, Project for the Arkansas River, Colorado*, Galerie Guy Pieters, Knokke-le-Zoute. Picture notes by Jeanne-Claude and Jonathan Henery, photographs by Wolfgang Volz, designed by Christo.

1999

Christo and Jeanne-Claude: The Umbrellas, Japan-USA, 1984–91; Wrapped Reichstag, Berlin, 1971–95; The Wall-13,000 Oil Barrels, Gasometer, Oberhausen. Edited by Simone Philippi, texts by Marion Taube, David Bourdon and Wolfgang Volz, preface by Karl Ganser, photographs by Wolfgang Volz.

2000

Christo and Jeanne-Claude: Black and White, Annely Juda Fine Art, London.

2001

Christo and Jeanne-Claude: Early Works 1958–69, Martin-Gropius-Bau, Berlin. Texts by Lawrence Alloway, David Bourdon and Jan van der Marck, photographs by Ferdinand Boesch, Thomas Cugini, André Grossmann, Eeva-Inkeri, Jean-Dominique Lajoux, Harry Shunk, Wolfgang Volz, Stefan Wewerka and many others; *Christo and Jeanne-Claude. Wrapped Reichstag*, picture notes by David Bourdon, Michael S. Cullen, Christo and Jeanne-Claude, photographs by Wolfgang Volz.
Christo and Jeanne-Claude: The Art of Gentle Disturbance, Macy Gallery, Teachers College, Columbia University, New York (brochure: photographs by Wolfgang Volz, Jean-Dominique Lajoux and Harry Shunk).
Christo and Jeanne-Claude: The Gates, Project for Central Park, New York City, and Over The River, Project for The Arkansas River, Colorado, Two Works in Progress, Galerie Guy Pieters, Saint-Paul de Vence; two catalogues in a box; *Over the River*: picture notes by Jeanne-Claude and Jonathan Henery, photographs by Wolfgang Volz, Sylvia Volz and Simon Chaput; *The Gates*: picture notes by Jeanne-Claude and Jonathan Henery, photographs by André Grossman and Wolfgang Volz (two editions: English and German).
Christo and Jeanne-Claude, The Pont Neuf Wrapped,

Paris, 1975–85, Documentation Exhibition, Fundação Armando Alvares Penteado, São Paulo. Texts by Volker Adolphs, Albert Elsen and David Bourdon, photographs by Wolfgang Volz.

Christo and Jeanne-Claude: Two Works in Progress: Over the River, Project for the Arkansas River, State of Colorado, and The Gates, Project for Central Park, New York City, State University Art Gallery, Kennesaw, Georgia (brochure: photographs by Wolfgang Volz).

Christo e Jeanne-Claude: Progetti recenti, progetti futuri, Projects and Realisations for Wrapped Trees, 1966–98; Projects and Realisations with Oil Barrels 1958–82, and 13,000 Oil Barrels, Oberhausen 1999; Two Works in Progress: Over the River and The Gates, Fondazione Ambrosetti Arte Contemporanea, Palazzo Bonoris, Brescia. Texts by Loredana Parmesani, Ettore Camuffo, Marion Taube, Christo and Jeanne-Claude, photographs by Wolfgang Volz, Eeva-Inkeri, Jean-Dominique Lajoux, Harry Shunk, Ferdinand Boesch and André Grossmann.

2002

Christo and Jeanne-Claude in the Vogel Collection, National Gallery of Art, Washington. Text and interview by Molly Donovan, introduction by Earl A. Powell, photographs by Wolfgang Volz.

Christo and Jeanne-Claude: The Weston Collection, Toronto, The Vero Beach Museum of Art and The Gallery at Windsor. Text by Molly Donovan, preface by W. Galen Weston.

2004

Christo and Jeanne-Claude: On the Way to the Gates, Central Park, New York City, The Metropolitan Museum of Art, New York, Yale University Press, New Haven. Edited by Patricia Fidler, text and interviews by Jonathan Fineberg, picture notes by Jeanne-Claude and Jonathan Henery, photographs by Wolfgang Volz, designed and produced by Ken Wong.

Christo and Jeanne-Claude: Swiss Projects 1968–1998, CentrePasquArt, Biel/Bienne.

Films and videos

1969

Wrapped Coast, Blackwood Productions, 30 minutes.

1972

Christo's Valley Curtain, Maysles Brothers and Ellen Giffard, 28 minutes. The film was nominated for the Academy Award in 1973.

1977

Running Fence, Maysles Brothers / Charlotte Zwerin, 58 minutes.

1978

Wrapped Walk Ways, Blackwood Productions, 25 minutes.

1985

Islands, Maysles Brothers / Charlotte Zwerin, 57 minutes.

1990

Christo in Paris (The Pont Neuf Wrapped, 1975–85), David and Albert Maysles, Deborah Dickson, Susan Froemke, 58 minutes.

1996

Umbrellas, Albert Maysles, Henry Corra and Graham Weinbren, 81 minutes. The film won the Grand Prize and the People's Choice Award at the 1996 Montréal Film Festival.

Christo und Jeanne-Claude, "Dem Deutschen Volke", Verhüllter Reichstag 1971–95 (Wrapped Reichstag), Wolfram and Jörg Daniel Hissen, EstWest, 98 minutes.

1998

Christo and Jeanne-Claude, Wrapped Trees, Gebrüder Hissen, EstWest, 26 minutes.

2004

5 Films about Christo & Jeanne-Claude, A Maysles Films Production. 3 DVD set including: *Christo's Valley Curtain, Running Fence, Surrounded Islands, Christo in Paris, Umbrellas*, interview with Christo, Jeanne-Claude and Albert Maysles (December 2003), and deluxe booklet.

2005

Christo and Jeanne-Claude: On the Way to Over the River, Wolfram and Jörg Daniel Hissen, EastWest, 34 minutes.

2006

The Gates, being prepared, Maysles Productions.

List of Works

1. Shelves
1958
Group of nine cans, five wrapped
Fabric, rope, lacquer, paint, wood, glass and steel
wire mesh
90 × 30 × 18 cm
Lent by the artists
Photo Eeva-Inkeri

2. Wrapped Oil Barrels
1958
Group of five, two wrapped
Laquer paint, fabric, steel wire and oil barrels
Wrapped barrels: 65 × 37 cm; 63.5 × 36.5 cm
Private collection, Paris
Photo Wolfgang Volz

3. Wrapped Oil Barrels
1958–59
Group of eight, four wrapped
Lacquered fabric, steel wire and oil barrels
Wrapped barrels: 60 × 37.5 cm; 60 × 37.5 cm;
63 × 36 cm; 59.5 × 38.5 cm
Lent by the artists
Photo Eeva-Inkeri
Work not in the exhibition

4. Untitled (Cratères)
1959
Enamel paint, sand, paint and wood
54 × 65 cm
Rosenkranz Collection, Germany
Photo Wolfgang Volz
Work not in the exhibition

5. Untitled (Cratères)
1959
Enamel paint, sand, paint and wood
162 × 116 cm
Lent by the artists
Photo Christian Baur

6. Untitled (Cratères)
1959
Enamel paint, sand, paint, metal and wood
92 × 127 cm
Lent by the artists
Photo Christian Baur

7. Package 1958
1958
Fabric, lacquer, rope and twine
60 × 45 × 20 cm
Lent by the artists
Photo Eeva-Inkeri

8. Package 1961
1961
Fabric, rope, twine and board
130 × 180 × 33 cm
Kröller-Müller Museum, Otterlo, Holland
(former Visser Collection)
Photo courtesy Kröller-Müller Museum
Work not in the exhibition

9. Package 1961
1961
Fabric, polyethylene, rope and twine
84 × 165 × 35 cm
Lent by the artists
Photo Eeva-Inkeri

10. Package 1965
1965
Fabric, rope and twine
15.3 × 8.5 × 7.3 cm
Lent by the artists
Photo André Grossmann
Work not in the exhibition

11. Package 1961
1961
Fabric, steel wire, rope, paint, lacquer and wood
138 × 12 × 12 cm
Lent by the artists
Photo Vitor Branco

12. Package 1961
1961
Fabric, rope, twine and wood
23 × 202 × 12 cm
Lent by the artists
Photo Christian Baur

13. Package 1962
1962
Fabric, wood and rope
213.4 × 25 × 11.5 cm
Lilja Art Fund Foundation
Photo André Grossmann

14. Package 1960
1960
Fabric and rope
50 × 21 × 18 cm
Cyril Christo Collection
Photo Eeva-Inkeri

15. Package (Grand Empaquetage Noir) 1969
1969
Tarpaulin, rope and wood
200 × 200 × 160 cm
Stedelijk Museum voor Actuele Kunst, Ghent,
Belgium
Photo Dirk Pauwels

16. Wrapped Paintings 1969
1969
Tarpaulin, rope and wood
246.4 × 184.1 × 21.6 cm
Lent by the artists
Photo André Grossmann

17. Package on a Table
1961
Wooden table, three types of fabric, ropes, can
and lacquer
124 × 61.5 × 30 cm
Lent by the artists
Photo Wolfgang Volz

18. Package on Luggage Rack
1962
Polyethylene, rope, rubberized cord, mattress, baby
carriage and steel luggage rack
63.5 × 136 × 95.2 cm
Lilja Art Fund Foundation
Photo Eeva-Inkeri

19. Wrapped Magazines on a Stool
1963
Polyethylene, twine, rope, magazines and wooden
stool
54.5 × 35.5 × 43 cm
Private collection
Photo André Grossmann

20. Wrapped Table and Wrapped Chair
1963
Wooden console table, chair, crystal candelabra,
polyethylene, rope and twine
106.6 × 152.5 × 40.6 cm
Lent by the artists and Ettore Camuffo, Venice
Photo Eeva-Inkeri

21. Empaquetage sur Diable
1964
Fabric, plastic, metal and hand cart
122 × 100 × 66 cm
Sonnabend Collection
Photo courtesy Sonnabend Collection

22. Wrapped Portrait of Jeanne-Claude
1963
Polyethylene and rope around an oil on canvas
portrait by "Javacheff"
82 × 60 cm
Lent by the artists
Photo Christian Baur

23. Wrapped Magazines
1964
Polyethylene, ropes and magazines on wooden board
161.3 × 50.8 × 6.4 cm
Musées d'Art et d'Histoire de la Ville de Genève,
Geneva
Photo André Grossmann

24. Wrapped Portrait of Horace
1967
Polyethylene, rope and twine around a rolled up oil
on canvas portrait by "Javacheff"
114.3 × 51 cm
Anita Grossman Collection, New York
Photo André Grossmann

25. Show Case
1963
Metal, glass, fabric, paint and electric light
150 × 50 × 36 cm
Lent by the artists
Photo courtesy Annely Juda Fine Art

26. Store Front, Project
Collage
1964
Pencil, enamel paint, fabric, Plexiglas, charcoal, wax
crayon, steel wire, cardboard, wood and paint
160 × 125 × 10 cm
Lilja Art Fund Foundation
Photo Eeva-Inkeri

27. Store Front, Project
Collage
1964
Pencil, wax crayon, wood, masonite, cardboard,
brown wrapping paper, contact paper, fabric, enamel
paint and electric light
90 × 122 × 10 cm
Staatliche Museen zu Berlin, Nationalgalerie, Berlin
Photo Jörg P. Anders

28. Double Store Front, Project
Collage
1964
Pencil, enamel paint, wax crayon and fabric
on tracing paper and paper
3.5 × 45.5 cm
Kröller-Müller Museum, Otterlo, Holland
(former Visser Collection)
Photo Tom Haartsen

29. Yellow Store Front, Project
Collage
1965
Pencil, wax crayon, galvanized metal, fabric,
cardboard, enamel paint, charcoal and brown
wrapping paper
71 × 56 cm
Private collection
Photo Wolfgang Volz

30. Yellow Store Front
1965
Wood, Plexiglas, fabric, brown paper, galvanized
metal, pegboard and electric light
249 × 224 × 40.5 cm
Lent by the artists
Photo Wolfgang Volz

**31. Three Store Fronts, Project for the Stedelijk
Van Abbemuseum, Eindhoven, Holland**
Collage
1965–66
Pencil, wood, Plexiglas, cardboard, paper, fabric,
paint, charcoal, tape and electric light
122 × 96.5 × 5 cm
Lent by the artists
Photo Eeva-Inkeri

32. Double Show Window
1965–66
Galvanized metal, fabric, aluminum, wood, Plexiglas
and masonite
213 × 244 × 9.5 cm
Kröller-Müller Museum, Otterlo, Holland
(former Visser Collection)
Photo Kröller-Müller Museum Archives

**33. Projet du mur provisoire de tonneaux
métalliques, Rue Visconti, Paris VI**
Collage
1961
Two collaged photographs and a type-written text
by Christo
24 × 40.6 cm
Lent by the artists
Photo Harry Shunk

**34. 56 Oil Barrels Construction, Project for
Martin and Mia Visser**
Drawing
1967
Pencil, enamel paint and wax crayon on brown
cardboard
70 × 47.5 cm
Kröller-Müller Museum, Otterlo, Holland
(former Visser Collection)
Photo Kröller-Müller Museum Archives

**35. Study for 8 Barrels Construction
Sent by Mail**
Drawing
1967
Pencil, enamel paint and wax crayon
35.5 × 27 cm
Kröller-Müller Museum, Otterlo, Holland
Photo Tom Haartsen

36. 28 Barrels Structure, Project
Drawing
1968
Pencil, enamel paint and wax crayon
50.6 × 72.5 cm
Courtesy Fondazione Marconi, Milan
Photo Wolfgang Volz

37. 28 Barrels Structure
1968
Oil barrels
265 × 275 × 68 cm
Courtesy Fondazione Marconi, Milan
Photo Wolfgang Volz

38. Projet d'un édifice public empaqueté
Collage
1961
Two collaged photographs and a type-written text
by Christo
41.5 × 25 cm
Lent by the artists
Photo Harry Shunk

**39. 5,600 Cubic Meter Package, Project for
Documenta 4, Kassel**
Collage
1967–68
Pencil, coated fabric, twine, tracing paper, charcoal,
crayon and cardboard
71 × 56 cm
Lent by the artists
Photo Harry Shunk

40. 200,000 Cubic Feet Package (5,600 Cubic Meter), Project for Documenta 4, Kassel
Drawing
1968
Pencil, charcoal and wash
244 × 91.5 cm
Lent by the artists
Photo André Grossmann

41. Kunsthalle Bern Packed, Project for 50th Anniversary of the Kunsthalle, Bern, Switzerland
Drawing
1968
Pencil, wax crayon and wash
101.5 × 152.5 cm
Lent by the artists
Photo André Grossmann

42. Kunsthalle Packed, Project for Kunsthalle Bern, Switzerland
Collage
1968
Pencil, fabric, twine, wax crayon, charcoal and photographs
71 × 56 cm
Lilja Art Fund Foundation
Photo André Grossmann

43. Kunsthalle Wrapped, Project
Scale model
1967
Fabric, twine, rope, masonite, wood and acrylic paint
59.7 × 71.5 × 92.2 cm
Lent by the artists
Photo André Grossmann

44. Packed Coast, Project for Australia, near Sydney
Drawing
1969
Pencil, charcoal, pastel and crayon on tracing paper
46 × 41 cm
John Kaldor Collection
Photo Harry Shunk

45. Packed Coast, Project for Little Bay, New South Wales, Australia
Collage
1968–69
Pencil, fabric, twine, photograph, wax crayon, aerial photograph, fabric sample and tape
71 × 56 cm
Lilja Art Fund Foundation
Photo Eeva-Inkeri

46. Packed Coast, Project for Australia, Little Bay
Collage
1969
Pencil, enamel paint, photograph by Harry Shunk, crayon and map on tracing paper
38.7 × 28 cm
Private collection
Photo Harry Shunk

47. Packed Coast, Project for Australia, New South Wales, Little Bay
Drawing
1969
Pencil, crayon and charcoal
91.5 × 244 cm
George Weston Limited Collection, Toronto, Canada
Photo Thomas Moore, Toronto

48. Wrapped Coast, Project for Australia
Scale model
1969
Fabric, rope, twine, Plexiglas, wood, plaster, paint, pencil and ball-point pen
15 × 122 × 82 cm
John Kaldor Collection
Photo Kaldor Art Projects

49. Valley Curtain, Project for Rifle, Colorado
Drawing in two parts
1972
Pencil, wax crayon and topographic map
91 × 243.8 cm; 80 × 240 cm
Kunsthaus Zürich, Grafische Sammlung
Photo Wolfgang Volz

50. Valley Curtain, Project for Colorado, Grand Hogback, 7 miles North from Rifle
Drawing
1972
Pencil, charcoal, pastel and crayon
90.5 × 164 cm
Private collection, Aarau

51. Valley Curtain, Project for Rifle, Colorado
Collage
1972
Pencil, fabric, staples, pastel, crayon and ball-point pen
71 × 56 cm
Private collection
Photo Wolfgang Volz

52. Valley Curtain, Project for Rifle, Colorado
Painted photograph
1972
Pencil, enamel paint, photograph by Harry Shunk, tape, crayons, map and ball-point pen
35.5 × 28 cm
Lent by the artists
Photo Harry Shunk
Work not in the exhibition

53. Running Fence, Project for Sonoma and Marin Counties, California
Drawing in two parts
1973
Pencil, wax crayon and topographic map
35.5 × 244 cm; 91.5 × 244 cm
Lent by the artists
Photo Gianfranco Gorgoni

54. Running Fence, Project for Sonoma and Marin Counties, California
Collage
1975
Pencil, charcoal, crayon, cardboard, fabric, photograph and technical data
56 × 71 cm
Lent by the artists
Photo Christian Baur

55. Running Fence, Project for Sonoma and Marin Counties, California
Drawing in two parts
1976
Pencil, charcoal, crayon, technical data and topographic map
38 × 244 cm; 106 × 244 cm
Musée National d'Art Moderne, Centre Pompidou, Paris (gift of the artists, 1999)
Photo Eeva-Inkeri

56. Running Fence, Project for Sonoma and Marin Counties, California
Drawing in two parts
1976
Graphite, charcoal, wax crayon, pastel, topographic map and technical data on two sheets of paper
38 × 244 cm; 106.6 × 244 cm
National Gallery of Art, Washington (gift of a private collector in honor of Dorothy and Herbert Vogel, 2001)
Photo Wolfgang Volz

57. Running Fence, Project for Sonoma and Marin Counties, California
Painted photograph
1976
Pencil, photograph by Gianfranco Gorgoni, enamel paint, charcoal and crayon
20.2 × 30.5 cm
Lent by the artists
Photo Gianfranco Gorgoni

58. Surrounded Islands, Project for Biscayne Bay, Greater Miami, Florida
Collage in two parts
1981
Fabric, pastel, charcoal, pencil, crayon and engineering drawing
28 × 71 cm; 56 × 71 cm
Lent by the artists
Photo Eeva-Inkeri

59. Surrounded Islands, Project for Biscayne Bay, Greater Miami, Florida
Collage
1982
Pencil, photograph by Wolfgang Volz, enamel paint, charcoal and wax crayon
35.5 × 28 cm
Private collection, Basel
Photo Eeva-Inkeri

60. Surrounded Islands, Project for Biscayne Bay, Greater Miami, Florida
Drawing in two parts
1982
Pencil, charcoal, crayon, pastel, fabric sample, aerial photograph and enamel paint
38 × 244 cm; 106.6 × 244 cm
Private collection
Photo Eeva-Inkeri

61. Surrounded Islands, Project for Biscayne Bay, Greater Miami, Florida
Collage in two parts
1983
Pencil, fabric, pastel, charcoal, crayon, enamel paint, aerial photograph and fabric sample
71 × 56 cm; 71 × 28 cm
Lent by the artists
Photo Wolfgang Volz

62. Surrounded Islands, Project for Biscayne Bay, Greater Miami, Florida
Drawing in two parts
1983
Graphite, charcoal, pastel, wax crayon, enamel paint, aerial photograph by Wolfgang Volz and fabric sample on two sheets of paper
165.1 × 106.7 cm; 165.1 × 38.1 cm
National Gallery of Art, Washington (gift of a private collector in honor of Dorothy and Herbert Vogel, 2001)
Photo Wolfgang Volz

63. The Pont Neuf Wrapped, Project for Paris
Drawing in two parts
1979
Pencil, pastel, charcoal, wax crayon and technical data
38 × 244 cm; 106.6 × 244 cm
Private collection
Photo Wolfgang Volz
Work not in the exhibition

64. The Pont Neuf Wrapped, Project for Paris
Collage
1978
Pencil, charcoal, fabric, twine, Photostat and pastel
71 × 56 cm
Lent by the artists
Photo Eeva-Inkeri

65. The Pont Neuf Wrapped, Project for Paris
Drawing in two parts
1982
Pencil, enamel paint, wax crayon, charcoal and map
38 × 244 cm; 106.6 × 244 cm
Stefano Contini Collection, Venice
Photo Wolfgang Volz

66. The Pont Neuf Wrapped, Project for Paris
Drawing in two parts
1985
Pencil, pastel, charcoal, wax crayon, fabric sample, aerial photograph and technical data
38 × 244 cm; 106.6 × 244 cm
Lilja Art Fund Foundation
Photo Eeva-Inkeri

67. The Pont Neuf Wrapped, Project for Paris
Collage
1981
Pencil, fabric, twine, photograph by Wolfgang Volz, crayon, pastel, charcoal, technical data and map
71 × 56 cm
Lent by the artists
Photo Wolfgang Volz

68. The Pont Neuf Wrapped, Project for Paris
Drawing in two parts
1985
Pencil, charcoal, pastel, crayon and technical data
38 × 165 cm; 106.6 × 165 cm
Private collection
Photo Wolfgang Volz

69. The Pont Neuf Wrapped, Project for Paris
Collage
1985
Pencil, enamel paint, photograph by Wolfgang Volz, wax crayon, charcoal and tape
28 × 35.5 cm
Lent by the artists
Photo Wolfgang Volz

70. The Pont Neuf Wrapped, Project for Paris
Collage in two parts
1985
Pencil, fabric, twine, pastel, charcoal, crayon, fabric sample and technical data
30.5 × 77.5 cm; 66.7 × 77.5 cm
Lilja Art Fund Foundation
Photo Eeva-Inkeri

71. The Umbrellas, Project for 6–8 miles, 3,000 Umbrellas
Collage
1985
Pencil and fabric
77.5 × 66.7 cm
Lent by the artists
Photo Eeva-Inkeri

72. The Umbrellas, Project for Japan and Western USA
Collage
1986
Pencil, charcoal, fabric, crayon and pastel
66.7 × 77.5 cm
Lent by the artists
Photo Eeva-Inkeri

73. The Umbrellas, Project for Japan and Western USA
Collage
1985
Pencil, fabric, pastel, charcoal and crayon
66.7 × 77.5 cm
Lent by the artists
Photo Eeva-Inkeri

74. The Umbrellas, Project for Japan and West-USA
Collage in two parts
1986
Pencil, fabric, charcoal, pastel, wax crayon, enamel paint and topographic map
66.6 × 30.5 cm; 66.6 × 77.5 cm
Lilja Art Fund Foundation
Photo Wolfgang Volz

75. The Umbrellas, Project for Japan and USA
Collage in two parts
1988
Pencil, fabric, charcoal, pastel, crayon, enamel paint and map
66.7 × 77.5 cm; 66.7 × 30.5 cm
Lent by the artists
Photo Christian Baur

76. The Umbrellas, Joint Project for Japan and USA
Drawing
1990
Pencil, charcoal, pastel and crayon
38.7 × 35.3 cm
Lent by the artists
Photo Wolfgang Volz

77. The Umbrellas, Joint Project for Japan and USA
Drawing
1990
Pencil, charcoal, pastel and crayon
38.7 × 38.3 cm
Lent by the artists
Photo Wolfgang Volz

78. The Umbrellas, Joint Project for Japan and USA
Drawing in two parts
1990
Pencil, crayon, photograph by Wolfgang Volz, pastel, charcoal, enamel paint, aerial photograph, technical data and fabric sample
38 × 244 cm; 106.6 x 244 cm
Lent by the artists
Photo Wolfgang Volz

79. The Umbrellas, Joint Project for Japan and USA
Drawing in two parts
1990
Pencil, pastel, charcoal, photograph by Wolfgang Volz, wax crayon, enamel paint and topographic map
38 × 244 cm; 106.6 × 244 cm
Lent by the artists
Photo Wolfgang Volz

80. The Umbrellas, Joint Project for Japan and USA
Drawing in two parts
1991
Pencil, pastel, charcoal, crayon, aerial topographic map, technical data and fabric sample
165 × 106.6 cm; 165 × 38 cm
Private collection
Photo Wolfgang Volz

81. The Umbrellas, Joint Project for Japan and USA
Drawing in two parts
1991
Pencil, charcoal, pastel, crayon, technical data, aerial topographic map, enamel paint and fabric sample
165 × 38 cm; 165 × 106.6 cm
Private collection
Photo Wolfgang Volz

82. Wrapped Reichstag, Project for West-Berlin
Drawing
1977
Pencil, charcoal and crayon
107 × 244 cm
Museum Boijmans Van Beuningen, Rotterdam
Photo Wolfgang Volz

83. Wrapped Reichstag, Project for Berlin
Collage in two parts
1981
Pencil, fabric, twine, charcoal, crayon, pastel and map
28 × 71 cm; 56 × 71 cm
Private collection, Basel
Photo Christian Baur

84. Wrapped Reichstag, Project for Berlin
Collage in two parts
1992
Pencil, wax crayon, charcoal and map
38 × 244 cm; 106.6 × 244 cm
Private collection (courtesy Galleria Tega, Milan)
Photo Wolfgang Volz
Work not in the exhibition

85. Wrapped Reichstag, Project for Berlin
Drawing in two parts
1995
Pencil, charcoal, pastel, crayon, fabric sample, photograph by Wolfgang Volz, technical data and tape
38 × 244 cm; 106.6 × 244 cm
Private collection, Switzerland
Photo Wolfgang Volz

86. Wrapped Reichstag, Project for Berlin
Drawing in two parts
1986
Pencil, pastel, charcoal, wax crayon, technical data and map
40 × 165 cm; 107 × 165 cm
Finter Bank Collection, Zurich
Photo Wolfgang Volz

87. Wrapped Reichstag, Project for Berlin
Collage in two parts
1993
Pencil, fabric, twine, pastel, charcoal, crayon, photograph by Wolfgang Volz, technical data and tape
30.5 × 77.5 cm; 66.7 × 77.5 cm
Cyril Christo Collection
Photo Wolfgang Volz

88. Wrapped Reichstag, Project for Berlin
Collage
1994
Pencil, enamel paint, postcard, pastel, charcoal, crayon, ball-point pen, map, fabric sample and tape on brown/grey cardboard
35.5 × 28 cm
Lent by the artists
Photo R. Koehler

89. Wrapped Reichstag, Project for Berlin
Scale model
1978
Fabric, twine, wood, cardboard and paint
58.4 × 165 × 190.5 cm
Lilja Art Fund Foundation
Photo Wolfgang Volz

90. Wrapped Trees, Project for the Fondation Beyeler, Riehen, Switzerland
Collage
1997
Pencil, enamel paint, photograph by Wolfgang Volz, crayon and tape
21.5 × 28 cm
Private collection, Basel
Photo Wolfgang Volz
Work not in the exhibition

91. Wrapped Trees, Project for the Fondation Beyeler and Berower Park, Riehen, Switzerland
Drawing in two parts
1998
Pencil, crayon, fabric sample, topographic map, tracing paper and tape
77.5 × 70.5 cm; 77.5 × 30.5 cm
Private collection, Basel
Photo Wolfgang Volz

92. Wrapped Trees, Project for the Fondation Beyeler and Berower Park, Riehen, Switzerland
Drawing in two parts
1998
Pencil, charcoal, pastel, crayon, photograph by Wolfgang Volz, topographic map, fabric sample and tape
38 × 244 cm; 106.6 × 244 cm
Lent by the artists
Photo Wolfgang Volz

93. Wrapped Trees, Project for the Fondation Beyeler and Berower Park, Riehen, Switzerland
Drawing in two parts
1998
Pencil, charcoal, pastel, crayon, fabric sample and topographic map
38 × 165 cm; 106.6 × 165 cm
Fondation Beyeler, Riehen/Basel
Photo Wolfgang Volz

94. Wrapped Trees, Project for the Fondation Beyeler and Berower Park, Riehen, Switzerland
Collage
1998
Pencil, enamel paint, crayon, photograph by Wolfgang Volz, tape, fabric sample and topographic map
43.2 × 55.9 cm
Lent by the artists
Photo Wolfgang Volz

95. Wrapped Trees, Project for the Fondation Beyeler and Berower Park, Riehen
Collage in two parts
1998
Pencil, charcoal, pastel, crayon, fabric, twine, topographic map and fabric sample
66.7 × 30.5 cm; 66.7 × 77.5 cm
Private collection, Basel
Photo Wolfgang Volz

96. The Gates, Project for Central Park, New York City
Collage in two parts
1984
Pencil, charcoal, crayon, pastel, cardboard, enamel paint and photographs
71 × 56 cm; 71 × 28 cm
Lent by the artists
Photo Christian Baur

97. The Gates, Project for Central Park, New York City
Collage
1999
Pencil, enamel paint, photograph by Wolfgang Volz, crayon, map and tape on brown cardboard
35.5 × 28 cm
Lent by the artists
Photo Wolfgang Volz

98. The Gates, Project for Central Park, New York City
Drawing in two parts
2001
Pencil, charcoal, pastel, wax crayon and aerial photograph
38 × 244 cm; 106.6 × 244 cm
Lent by the artists
Photo Wolfgang Volz

99. The Gates, Project for Central Park, New York City
Drawing in two parts
2001
Pencil, charcoal, pastel, wax crayon and aerial photograph
38 × 165 cm; 106.6 × 165 cm
Lent by the artists
Photo Wolfgang Volz

100. The Gates, Project for Central Park, New York City
Drawing in two parts
2003
Graphite, charcoal, pastel, wax crayon, enamel paint, fabric sample, aerial photograph, hand-drawn technical data and tape
38 × 244 cm; 106.6 × 244 cm
Whitney Museum of American Art, New York (purchase, with funds from the Melva Bucksbaum, Raymond J. Learsy and the Martin Bucksbaum Family Foundation)
Photo Wolfgang Volz

101. The Gates, Project for Central Park, New York City
Collage in two parts
2002
Pencil, fabric, wax crayon, charcoal, pastel and aerial photograph
30.5 × 77.5 cm; 66.7 × 77.5 cm
Bank Leu Collection, Zurich
Photo Wolfgang Volz

102. The Gates, Project for Central Park, New York City
Collage in two parts
2004
Pencil, fabric, charcoal, wax crayon, pastel, enamel paint, map and fabric sample
30.5 × 77.5 cm; 66.7 × 77.5 cm
Verlagsgruppe Passau Collection
Photo Wolfgang Volz

103. The Gates, Project for Central Park, New York City
Collage in two parts
2004
Pencil, fabric, charcoal, wax crayon, pastel, technical data, fabric sample and tape
30.5 × 77.5 cm; 66.7 × 77.5 cm
Private collection, Zollikon/Zurich
Photo Wolfgang Volz

104. The Gates, Project for Central Park, New York City
Collage in two parts
2004
Pencil, fabric, wax crayon, charcoal, enamel paint, pastel, hand-drawn map, tape and fabric sample
77.5 × 66.7 cm; 77.5 × 30.5 cm
Private collection
Photo Wolfgang Volz

105. The Gates, Project for Central Park, New York City
Drawing
2004
Pencil, charcoal, pastel, wax crayon, hand-drawn technical data and tape
56 × 71 cm
Private collection
Photo Wolfgang Volz

106. The Gates, Project for Central Park, New York City
Collage
2001
Pencil, enamel paint, photograph by Wolfgang Volz, wax crayon and map
35.5 × 28 cm
MCM Group Art Collection
Photo Wolfgang Volz

107. The Gates, Project for Central Park, New York City
Collage in two parts
2005
Pencil, fabric, charcoal, wax crayon, pastel, enamel paint, fabric sample and map
30.5 × 77.5 cm; 66.7 × 77.5 cm
Private collection, Italy
Photo Wolfgang Volz

108. The River, Project for 5–6 Miles River
Drawing-collage
1992
Pencil, crayon and brown paper
38.7 × 35.3 cm
Lent by the artists
Photo André Grossmann

109. The River, Project
Drawing
1992
Pencil and pastel
22.8 × 34 cm
Lent by the artists
Photo André Grossmann

110. Over the River, Project for the Arkansas River, State of Colorado
Collage
1997
Pencil, enamel paint, photograph by Wolfgang Volz, crayon, map and tape
35.5 × 28 cm
Lent by the artists
Photo Wolfgang Volz

111. Over the River, Project for the Arkansas River, State of Colorado
Collage
1997
Pencil, enamel paint, photograph by Wolfgang Volz, crayon, map and tape
35.5 × 28 cm
Lent by the artists
Photo Wolfgang Volz

112. Over the River, Project for the Arkansas River, State of Colorado
Collage in two parts
1998
Pencil, fabric, pastel, charcoal, crayon and topographic map
30.5 × 77.5 cm; 66.7 × 77.5 cm
Lent by the artists
Photo Wolfgang Volz

113. Over the River, Project for the Arkansas River, State of Colorado
Collage in two parts
1998
Pencil, fabric, pastel, charcoal, crayon and topographic map
30.5 × 77.5 cm; 66.7 × 77.5 cm
Lent by the artists
Photo Wolfgang Volz

114. Over the River, Project for the Arkansas River, State of Colorado
Drawing in two parts
1999
Pencil, charcoal, pastel, photograph by Wolfgang Volz and topographic map
165 × 106.6 cm; 165 × 38 cm
Private collection
Photo Wolfgang Volz

115. Over the River, Project for the Arkansas River, State of Colorado
Drawing in two parts
1999
Pencil, charcoal, pastel, photograph by Wolfgang Volz and topographic map
165 × 38 cm; 165 × 106.6 cm
Hamacher Family Collection
Photo Wolfgang Volz

116. Over the River, Project for the Arkansas River, State of Colorado
Collage in two parts
1999
Pencil, fabric, pastel, charcoal, crayon and topographic map
30.5 × 77.5 cm; 66.7 × 77.5 cm
Lent by the artists
Photo Wolfgang Volz

117. Over the River, Project for the Arkansas River, State of Colorado
Collage in two parts
2005
Pencil, fabric, pastel, wax crayon, charcoal, enamel paint, photograph by Wolfgang Volz and topographic map
30.5 × 77.5 cm; 66.7 × 77.5 cm
Lent by the artists
Photo Wolfgang Volz

118. Over the River, Project for the Arkansas River, State of Colorado
Drawing in two parts
2005
Pencil, pastel, charcoal, wax crayon and aerial photograph with topographic elevations
38 × 244 cm; 106.6 × 244 cm
Lent by the artists
Photo Wolfgang Volz

119. Over the River, Project for the Arkansas River, State of Colorado
Drawing in two parts
2005
Pencil, pastel, charcoal, wax crayon, hand-drawn topographic map and tape
38 × 244 cm; 106.6 × 244 cm
Lent by the artists
Photo Wolfgang Volz

Photo credits

Jörg P. Anders: p. 67 (no. 27)

Annely Juda Fine Art: p. 65

Klaus Baum: p. 99

Christian Baur: pp. 38–39, 47, 61, 133, 173, 189, 216

Vitor Branco: p. 46

Balz Burkhard: p. 105

Thomas Cugini: p. 109

Eeva-Inkeri: pp. 33, 35, 41, 44, 49, 56, 58, 66, 70, 115, 134, 144–146, 155, 157, 161, 170–171

Gianfranco Gorgoni: pp. 132, 136

André Grossmann: pp. 45, 48, 53, 57, 62–63, 101, 106–108, 233–234

Tom Haartsen: pp. 67 (no. 28), 79

Jeanne-Claude: pp. 138–139

Kaldor Art Projects: p. 118

R. Koehler: p. 194

Kröller-Müller Museum: p. 43

Kröller-Müller Museum Archives: pp. 71, 78

Jean-Dominique Lajoux: p. 75

Thomas Moore, Toronto: p. 117

Dirk Pauwels: p. 51

Harry Shunk: pp. 77, 85, 100, 113–114, 116, 119, 123, 126 (no. 52)

Sonnabend Collection: p. 59

Wolfgang Volz: pp. 34, 37, 55, 68–69, 80–81, 124, 126 (no. 51), 127, 131, 135, 137, 143, 147–149, 153–154, 156–160, 162–165, 169, 172, 174–183, 187–188, 190–193, 195–199, 203–211, 215, 217–229, 235–243